Spatiality and Symbolic Expression

On the Links between Place and Culture

Edited by Bill Richardson

palgrave
macmillan

First published in 2015 by
PALGRAVE MACMILLAN®
in the United States—a division of St. Martin's Press LLC,
175 Fifth Avenue, New York, NY 10010.

Where this book is distributed in the UK, Europe and the rest of the
World, this is by Palgrave Macmillan, a division of Macmillan Publishers
Limited, registered in England, company number 785998, of
Houndmills, Basingstoke, Hampshire RG21 6XS.

Palgrave Macmillan is the global academic imprint of the above
companies and has companies and representatives throughout the world.

Palgrave® and Macmillan® are registered trademarks in the United
States, the United Kingdom, Europe and other countries.

ISBN: 978–1–137–50289–6

Library of Congress Cataloging-in-Publication Data

Spatiality and symbolic expression : on the links between place and
 culture/edited by Bill Richardson.
 pages cm. — (Geocriticism and spatial literary studies (GSLS)
 Summary: "This book explores the links between concepts of space
 and place and some of the ways in which cultural expression
 occurs, focusing in particular on language, literature, translation,
 pedagogy, film, music, art and the use of iconic imagery in
 nation-building projects. It presents a theoretical framework for
 such a discussion, and examines four key facets of that
 framework, relating each one to the above-mentioned modes of
 symbolic expression" — Provided by publisher.
 Includes bibliographical references and index.
 ISBN 978–1–137–50289–6 (hardback)
 1. Place (Philosophy) in literature. 2. Geocriticism. 3. Space
 perception. 4. Symbolism. 5. Space and time in language.
 6. Geographical perception in literature. 7. Place (Philosophy)
 in motion pictures. 8. Place (Philosophy) in art. I. Richardson,
 Bill, 1953– editor.
 PN56.P49S63 2015
 809′.93358—dc23 2015005449

A catalogue record of the book is available from the British Library.

Design by Integra Software Services

First edition: July 2015

10 9 8 7 6 5 4 3 2 1

Geocriticism and Spatial Literary Studies

Series Editor:
ROBERT T. TALLY JR., Texas State University

Series description:
Geocriticism and Spatial Literary Studies is a new book series focusing on the dynamic relations among space, place, and literature. The spatial turn in the humanities and social sciences has occasioned an explosion of innovative, multidisciplinary scholarship in recent years, and geocriticism, broadly conceived, has been among the more promising developments in spatially oriented literary studies. Whether focused on literary geography, cartography, geopoetics, or the spatial humanities more generally, geocritical approaches enable readers to reflect upon the representation of space and place, both in imaginary universes and in those zones where fiction meets reality. Titles in the series include both monographs and collections of essays devoted to literary criticism, theory, and history, often in association with other arts and sciences. Drawing on diverse critical and theoretical traditions, books in the *Geocriticism and Spatial Literary Studies* series disclose, analyze, and explore the significance of space, place, and mapping in literature and in the world.

Robert T. Tally Jr. is Associate Professor of English at Texas State University, USA. His work explores the relations among narrative, representation, and social space in American and world literature, criticism, and theory. Tally has been recognized as a leading figure in the emerging fields of geocriticism, spatiality studies, and the spatial humanities. Tally's books include *Fredric Jameson: The Project of Dialectical Criticism*; *Poe and the Subversion of American Literature: Satire, Fantasy, Critique*; *Utopia in the Age of Globalization: Space, Representation, and the World System*; *Spatiality*; *Kurt Vonnegut and the American Novel: A Postmodern Iconography*; and *Melville, Mapping and Globalization: Literary Cartography in the American Baroque Writer*. The translator of Bertrand Westphal's *Geocriticism: Real and Fictional Spaces*, Tally is the editor of *Geocritical Explorations: Space, Place, and Mapping in Literary and Cultural Studies*; *Kurt Vonnegut: Critical Insights*; and *Literary Cartographies: Spatiality, Representation, and Narrative*.

Titles to date:

Cosmopolitanism and Place: Spatial Forms in Contemporary Anglophone Literature
By Emily Johansen

Literary Cartographies: Spatiality, Representation, and Narrative
Edited by Robert T. Tally Jr.

The Geocritical Legacies of Edward W. Said: Spatiality, Critical Humanism, and Comparative Literature
Edited by Robert T. Tally Jr.

Spatial Engagement with Poetry
By Heather H. Yeung

Literature's Sensuous Geographies: Postcolonial Matters of Place
By Sten Pultz Moslund

Geoparsing Early Modern English Drama
By Monica Matei-Chesnoiu

Africa's Narrative Geographies: Charting the Intersections of Geocriticism and Postcolonial Studies
By Dustin Crowley

Women and Domestic Space in Contemporary Gothic Narratives: The House as Subject
By Andrew Hock Soon Ng

Spatiality and Symbolic Expression: On the Links between Place and Culture
Edited by Bill Richardson

CONTENTS

FIGURES

SERIES EDITOR'S PREFACE

The spatial turn in the humanities and social sciences has occasioned an explosion of innovative, multidisciplinary scholarship. Spatially oriented literary studies, whether operating under the banner of literary geography, literary cartography, geophilosophy, geopoetics, geocriticism, or the spatial humanities more generally, have helped to reframe or to transform contemporary criticism by focusing attention, in various ways, on the dynamic relations among space, place, and literature. Reflecting upon the representation of space and place, whether in the real world, in imaginary universes, or in those hybrid zones where fiction meets reality, scholars and critics working in spatial literary studies are helping to reorient literary criticism, history, and theory. *Geocriticism and Spatial Literary Studies* is a book series presenting new research in this burgeoning field of inquiry.

In exploring such matters as the representation of place in literary works, the relations between literature and geography, the historical transformation of literary and cartographic practices, and the role of space in critical theory, among many others, geocriticism and spatial literary studies have also developed interdisciplinary or transdisciplinary methods and practices, frequently making productive connections to architecture, art history, geography, history, philosophy, politics, social theory, and urban studies, to name but a few. Spatial criticism is not limited to the spaces of the so-called real world, and it sometimes calls into question any too facile distinction between real and imaginary places, as it frequently investigates what Edward Soja has referred to as the "real-and-imagined" places we experience in literature as in life. Indeed, although a great deal of important research has been devoted to the literary representation of certain identifiable and well-known places (e.g., Dickens's London, Baudelaire's Paris, or Joyce's Dublin), spatial critics have also explored the otherworldly spaces of literature, such as those to be found in myth, fantasy, science fiction, video games, and cyberspace. Similarly, such criticism is interested in the relationship between spatiality and such different media or genres as film or television, music, comics, computer programs, and

other forms that may supplement, compete with, and potentially problematize literary representation. Titles in the *Geocriticism and Spatial Literary Studies* series include both monographs and collections of essays devoted to literary criticism, theory, and history, often in association with other arts and sciences. Drawing on diverse critical and theoretical traditions, books in the series reveal, analyze, and explore the significance of space, place, and mapping in literature and in the world.

The concepts, practices, or theories implied by the title of this series are to be understood expansively. Although geocriticism and spatial literary studies represent a relatively new area of critical and scholarly investigation, the historical roots of spatial criticism extend well beyond the recent past, informing present and future work. Thanks to a growing critical awareness of spatiality, innovative research into the literary geography of real and imaginary places has helped to shape historical and cultural studies in ancient, medieval, early modern, and modernist literature, while a discourse of spatiality undergirds much of what is still understood as the postmodern condition. The suppression of distance by modern technology, transportation, and telecommunications has only enhanced the sense of place, and of displacement, in the age of globalization. Spatial criticism examines literary representations not only of places themselves but of the experience of place and of displacement, while exploring the interrelations between lived experience and a more abstract or unrepresentable spatial network that subtly or directly shapes it. In sum, the work being done in geocriticism and spatial literary studies, broadly conceived, is diverse and far reaching. Each volume in this series takes seriously the mutually impressive effects of space or place and artistic representation, particularly as these effects manifest themselves in works of literature. By bringing the spatial and geographical concerns to bear on their scholarship, books in the *Geocriticism and Spatial Literary Studies* series seek to make possible different ways of seeing literary and cultural texts, to pose novel questions for criticism and theory, and to offer alternative approaches to literary and cultural studies. In short, the series aims to open up new spaces for critical inquiry.

Robert T. Tally Jr.

INTRODUCTION

THE "SPATIO-CULTURAL DIMENSION": OVERVIEW AND A PROPOSED FRAMEWORK

Bill Richardson

The aim of this volume is to explore some of the ways in which notions of space and place inform cultural products and processes, as well as symbolic expression more generally. We do this by examining the links between a selection of those phenomena and a variety of aspects of human spatiality. Underpinning the study is an approach to the relationship between spatiality and symbolic expression that seeks to identify and make explicit the main elements of that relationship. We believe this affords an opportunity to focus on those elements in ways that bring to the fore the most salient characteristics of each. Despite the much vaunted "spatial turn" witnessed in humanities research in recent decades, there is still a tendency to elide discussion of this element of symbolic expression, or to offer only superficial interpretations of its significance in the discussion of topics such as those addressed here.

A focus on the spatial can help elucidate important facets of symbolic expression and cultural production, whether we are exploring literary texts, music, dance, film, the plastic arts, the meanings associated with iconic figures or even pedagogical practice, or the more general phenomenon of human language itself. Our sense of self, our view of others, the position we adopt with respect to the national or geographical parameters within which we live, the interpretations we

place on historical events, not to mention the ways in which we see power being enacted around us, are all imbued with an awareness of, and, frequently, an attempt to manipulate or transform, the spatial contexts within which such phenomena and events exist. To say that "we are where we are" is true not just in the sense that the challenge of achieving an adequate understanding of such phenomena requires us to take cognizance of the spatial (and temporal) context in which we are currently located, it is also true in terms of the latent human desire to, in Henri Lefebvre's terms, *produce* space,[1] to create a reality in which our aspirations can come to fruition, in which dreams can be enacted. We are "situated" beings, so that a large part of whatever meanings we establish for ourselves has to do with our "being in the world," and objects and entities—including the living beings that we are—do not just exist "in space" but, *qua* Heidegger, constitute space itself and are inconceivable without space; furthermore, we are aware of this facet of our existence and are often self-conscious about it. Thus, no account of our capacity to express ourselves symbolically can avoid addressing the multiple ways in which spatiality informs our relationships with others.

In this volume, experts from a diverse range of fields within the humanities address their chosen topics in a way that positions them with regard to the issue of how to devise a framework—a "map" in at least some sense of that word—that could capture the diversity mentioned above, while also allowing us to see the relationships between the various aspects of space that impinge on symbolic and cultural expression. In other words, the assumption underlying this study is that, while we are duly wary of the temptation to produce grand narratives that would strive to offer some kind of "total explanation" of the phenomena being examined, it is worth taking another, focused, look at the fragmentation that characterizes much of the discussion of the spatial dimension of the arts and creative activity, with a view to identifying commonalities and situating these diverse analyses in relation to one another. The way we do this is through the study of eight specific cultural phenomena, relating each one to a conceptual framework that positions them vis-à-vis human spatiality. By this means, we hope to gain a greater sense of how spatial realities inform symbolic expression and of how a variety of forms of symbolic expression and cultural production rely on those spatial realities to achieve their ends.

The theoretical model underpinning the current discussion is based on our observations of the approaches adopted by a wide range of scholars in these fields, which have led us to conclude that there are certain fundamental concerns in operation in such discussions, and

that these are amenable to a kind of abstract "mapping" that may be helpful in order to move such discussions forward. Among the topics that scholarly work on spatial matters in cultural contexts has focused on we find social concerns, including issues of social-class divisions and their relationship to space. We also find philosophical concerns, including ways of articulating an appreciation of the diverse roles that place can play in myriad forms of artistic expression, or linguistic practices and their links to boundary demarcations, or formal aspects of the use of space in cultural production. We can also identify concerns such as the need to come to grips with human loss, with frustrated ambition, or emotional trauma, whether individual or collective, and how this relates to a sense of shared identity or the spatial zones within which we are capable of coping with those vicissitudes. All of the above themes have featured in such studies; what we contend is that, underlying this diversity, there is a pattern of analysis and reflection amenable to incorporation into a conceptual model. This will situate those varying concerns in relation to one another and allow us both to appreciate the ways in which they vary and to better understand how they relate to each other.

Arising out of an appreciation of these diverse concerns within "spatio-cultural" studies, we posit a theoretical framework or model based on the intersection of two conceptual "axes," the abstract/concrete axis and the individual/collective axis. These axes represent an attempt to identify certain fundamental parameters—of human existence and of the relationship between space and culture—that underpin a wide variety of ways of looking at the world and of articulating spatio-cultural concerns. The first axis goes from an extreme of "abstraction" to an opposite extreme of "concreteness"; the second goes from an extreme sense of "individuality" to an emphasis on the "collective."

With reference to the first axis, "abstraction" here refers to philosophical concerns about space; it attempts to conceptualize the nature of human spatiality or to relate spatial concerns with the widest and broadest dimensions of space and place—such as time, for example—that are (or can be conceived as being) most removed from the "concrete" spatial realities of our "grounded" existence as physical entities. On the other hand, the dimension we call "concreteness" emphasizes those aspects associated with the facts of physical existence, with the spatial presence of the entities and objects that surround us, and with what comes from living in particular places.

The second axis we are positing goes from "individual" to "collective," from the notion of the self qua individual to the idea of

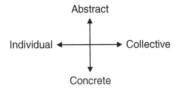

Figure I.1 Two intersecting axes: Abstract/Concrete and Individual/Collective[2]

humans as social beings. This allows us to contrast individual realities with social realities: the spatiality that is linked to persons as separate, "isolated" human beings, on the one hand, and that which is linked, on the other hand, to the shared, collective spatialities of the social realm. In relation to the latter, we might think, for instance, of aspects of cultural or national identity or the spatial element that is central to an understanding of social power and the lack of power, or of other manifestations of a sense of shared ownership and identity within a range of causes, interests, geographical territories, and so on.

These axes may be represented as intersecting, as shown in figure I.1.

Based on such a schema, we may talk about the four zones of human spatial experience sketched out by the intersecting axes, each one characterized by a combination of the features that are highlighted by those axes. These zones are as follows: (1) Abstract-Individual, (2) Concrete-Individual, (3) Abstract-Collective, and (4) Concrete-Collective.

The zones may be mapped as in figure I.2.

Each zone is associated with two predominant features or aspects of spatiality that characterize it. This is not to suggest that such features adhere exclusively to one or another zone; there is an inherent fuzziness about the boundaries between all of the zones, but the contention here is that drawing the various features referred to together as illustrated below and, conversely, separating them using the axes provided here can assist with the task of highlighting the diverse range of ways in which spatiality impinges on symbolic expression. Let us consider each of the resulting zones in turn.

THE ABSTRACT-INDIVIDUAL ZONE

The first zone combines the idea of "abstraction" with the idea of "individuality," with an emphasis on the notion of *philosophy*. It highlights the *idea* of space, the fact that human experience can be

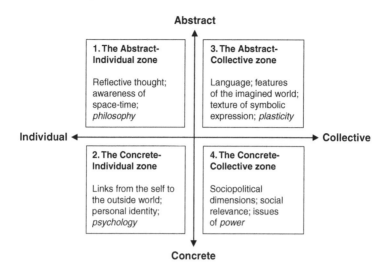

Figure I.2 Four spatio-cultural zones resulting from the two intersecting axes

characterized as existence in space, at least as much as it can be described as existence in time. We are *spatial* creatures, and therefore it is perhaps the Heideggerian account of that spatial "situatedness" that best expresses the fundamentally spatial nature of our being.[3] What the highlighting of this zone suggests is that, while we must acknowledge the truth of Heidegger's frequently quoted assertion that we are essentially "situated" beings, beings "in-the-world," we must also bear in mind our ability to achieve an *abstract* appreciation of that spatiality; thus, this zone is a way of focusing on our capacity to philosophize.[4] While we are never unaware of our spatial situatedness, then, we are also aware of that awareness itself. The self-reflexive dimension of our being entails an appreciation of the dynamic relationship we enter into with the spaces around us: we engage consciously with the spatial parameters of our existence, reflecting on where we are and on our experience of place. We are often acutely aware of the power we exercise in relation to the place we are in, and may devote considerable energy and attention to the exercise of that power—taking steps to alter that place or to change place through movement. We not only rejoice or lament the fact of being, say, in one place rather than another—as happens when the exile succumbs to nostalgia, when the economic migrant ventures into a new country, or when the office worker simply revels in the joys of the tourist location she is due to stay in on her vacation—but we also make decisions, with

a greater or lesser degree of consciousness, about changing location, about transforming the place we occupy, or about controlling it, or renaming it or attempting to change its identity. And the fact of the matter is that we also *know* we can do these things.

There is an intimate link, then, between knowledge and space, between the abstractness of our mental activity and the spatial nature of our existence. The anxieties we self-consciously express about the temporal dimension of our lives—from the proverbial conceit of *tempus fugit*, to Proustian concerns about the recovery of the past, to the reconciliation processes undertaken within "truth commissions"—are matched by the attempts we are capable of making to order and shape our locatedness, to mark, define, and control our spatial environment, while also articulating what we see as its impact and identity. This helps explain why spatial metaphors so often assist with the expression of temporal concepts—"from here on in," "we'll do it in stages," "the other side of midnight,"; "let's put this in historical perspective"—and it may also lie behind some of the uncannily spatial articulations of the human condition we encounter in great art.

This self-conscious reflexivity in relation to spatiality and temporality is an awareness of the intimate connection between the two notions of space and time, neither of which can be conceived of without the other. It is what gives rise to the Bakhtinian notion of the chronotope. Although this term may have multiple meanings within the work of M. M. Bakhtin,[5] its core is the notion of location within time and space, whether what is being referenced is the idea of specific chronotopic figures such as particular journeys that have special significance, or locations that carry precise meanings in communities, or the concept of a literary genre and the way in which each genre represents a kind of demarcation of literary or, more generally, artistic territory and implies a set of assumptions about the formal aspects of various types of cultural production. It constitutes a kind of mapping of temporal and spatial parameters, a world within which particular types of meaning-making can occur. We are here concerned with a cognitive zone that highlights the "intrinsic connectedness of temporal and spatial relationships." Within this inseparability of time and space, "time [...] thickens, takes on flesh, becomes artistically visible; likewise, space becomes charged and responsive to the movements of time, plot and history."[6]

Instances of this could be cited from many sources and in many artistic forms. One famous literary example is the reflections on the human condition that Hamlet utters when, in the company of Rosencrantz and Guildenstern, he comments on Denmark and the

universe in general in the famous sequence from Act II, Scene 2, of Shakespeare's play *Hamlet*. He asks his visitors, "What have you, my good friends, deserved at the hands of Fortune, that she sends you to prison hither?" The dialogue then continues,

> *Guildenstern*: Prison, my lord?
> *Hamlet*: Denmark's a prison.
> *Rosencrantz*: Then is the world one.
> *Hamlet*: A goodly one, in which there are many confines, wards, and dungeons, Denmark being one o' the worst.
> *Rosencrantz*: We think not so, my lord.
> *Hamlet*: Why, then 'tis none to you; for there is nothing either good or bad, but thinking makes it so. To me it is a prison.
> *Rosencrantz*: Why, then your ambition makes it one. 'Tis too narrow for your mind.
> *Hamlet*: O God, I could be bounded in a nutshell and count myself a king of infinite space, were it not that I have bad dreams.

This summary of Hamlet's relationship with the world links his personal, individual space with the vast universe, drawing attention to the fact that he is located within a potentially infinite space, and reminding us that it is the individual relationship we establish with the wider universe that is the key to our understanding of it. His words raise explicitly the question of how we perceive our "place in the world" and relate that question both to physical space and to an abstraction over which we as individuals have more, or less, control. In effect, he is saying that we are where we are, but where we are is not some contingent circumstantial factor that is ultimately irrelevant to us; rather, it is something that impinges on us as individuals, as we—through a mental process—impinge on it. That mental process entails the use of our personal imagination. My dreams, in effect, establish a relationship with the wider universe, and, as a thinking human being, I am conscious of the fact that I am situated, and that my awareness of my spatial location is connected with how I feel and how I behave. Hamlet articulates a view that sees human beings as puny in relation to the entire universe in which we are located; and he knows that the key factor is not the size of the space one is in but rather the attitude one assumes in relation to whatever space one is in, and that that attitude is a function of our individual imaginative powers, signaled in this instance by references to "dreams." Through those dreams, the abstraction that is my knowledge of the boundless universe links directly to my own sense of where I am—a notion that, in a different context, is also alluded to when, in *Paradise Lost* (Book I, lines

254–55), John Milton has Satan say, "The mind is its own place and in itself, can make a Heaven of Hell, a Hell of Heaven."

In this volume, the zone of intersection of abstraction and individuality is the main focus of two contrasting studies. In the first, in Chapter 2, I explore the literary production of two major Latin American writers, Juan Rulfo and Jorge Luis Borges, demonstrating how their work captures the essential situatedness of human existence and hints at ways of probing the limits of such existence. I suggest that while, in art as in life, we can either highlight or downplay the everyday significance of spatiality, ultimately there is no escape from it. In the second study, in Chapter 3, Christiane Schönfeld and Ulf Strohmayer examine the spatial metaphor of the bridge, employed in a range of different cultural contexts, and explore the link between a given spatialized existence and human agency. The bridge constitutes a singular kind of boundary or threshold, marking a liminal space toward some unknown. The ambiguity that the notion of the bridge embodies is discussed in the context of films in which the trope of the bridge plays a central role, and it is then suggested that within classroom teaching, this can allow for a new kind of pedagogical practice, one that invites experimentation as much as it aims for transfers of meaning.

THE CONCRETE-INDIVIDUAL ZONE

If the Abstract-Individual zone is philosophical in its orientation, the Concrete-Individual zone is focused on the *psychological* dimension of spatial expression. The term "psychology" is being used here to summarize the many ways in which we as individuals express identity. Thus, we are interested in spatiality as it relates to aspects of our individual identity, as it embodies those dimensions of ourselves that signal the ways in which we present ourselves to the world. Our ability to speak is a reflection of the central role played by human language in our cognitive processes, to the extent that language may be considered *the* essential trait of humanness. What we speak, however, is not "language" but a particular language, and the concrete reality of that particular language that we speak not only serves the purpose of communication but is always related, to a greater or lesser degree, to aspects of our identity. In the same way, spatial expression may be a means of saying "I am where I am," that is, I am a "located" individual in the sense of acknowledging the spatial nature of my existence in general; spatial expression is also, however, a way of saying "I am *where* I am," that is, there are dimensions of my spatial reality (perhaps the

place of my birth, or references to where I have chosen to live) that are bound up with what I consider myself to be: my nationality, my political orientation, or some other aspect of my identity.

In this zone, we are cognizant of the "webs of significance" that relate us as individuals to the world around us. Foucault reminds us of this aspect of spatiality in the following terms:

> [W]e do not live in a kind of void, inside of which we could place indi-viduals and things. We do not live inside a void that could be colored by diverse shades of light, we live inside a set of relations that delineates sites which are irreducible to one another and absolutely not superimposable on one another.[7]

The relations we live within are both spatial and temporal; just as the historical context elucidates our attempts at articulating meanings, so the geographical settings we move around in will provide clues as to what we wish to express and how our meanings are created. In works of art of any kind, spatial features can serve to articulate such meanings, which can encompass issues of identity, including national identity, allegiances and affiliations to cities, towns, rural contexts, and so on, and, within those, to particular areas and neighborhoods. A shift from one context to another often signifies a shift in "identity," or evokes an experience of exile, of dislocation, or the transgression of boundaries, that may raise the degree of tension, or imply threat and danger. By the same token, we may be able to identify ways in which particular spaces or places are "gendered," so that we can observe patterns of spatial behavior associated with gender significance, per-haps conveying adherence to conventional gender norms, or perhaps transgressing those norms.[8]

John Donne's dictum to the effect that "no man is an island" is an expression of the same idea: the presence of the other is required in order for us to be ourselves. But, by the same token, it is only in relation to ourselves that identity can truly be articulated. In other words, each of us is a *different* individual, so that the particular webs of significance that are relevant to any individual are unique to them; nobody else has quite the same set of identitarian spatialities impinging on them. Thus, we emphasize the importance of context: like time, space provides contextual clues that supply the one who experiences a work of art, for instance, with meanings. In a word, space provides context; context, meanings.

By way of example, we can note how, in Shakespeare's *Macbeth*, a succession of references to Scotland serve to establish a direct

connection between the person of the protagonist and the country of
which he becomes the monarch. That spatial context, in this instance
a national one, is a crucial dimension of the character of Macbeth, and
the fate of the nation and that of the individual are depicted as being
intimately linked, in line with traditional assumptions about how a
monarch is identified with the country in which he or she reigns.
A significant part of the dynamic of the play relates to the notion
of the restoration to health of the nation, so that Macbeth's murder
of the good king Duncan and his own evil usurpation of power form
the prelude to a tale of spatial disjointedness. Repeated geographical
references throughout the work signal a kind of ontological crisis, sug-
gesting the decay of the realm, and help in turn to give the sense that
the crisis is ultimately resolved when the tyrant is killed. Thus, in Act
IV, Scene 3, when Macduff goes to England to encourage Malcolm
to rise against Macbeth, he describes Scotland in the following
terms:

> . . . each new morn
> New widows howl; new orphans cry; new sorrows
> Strike heaven on the face, that it resounds
> As if it felt with Scotland, and yell'd out
> Like syllable of dolour.

Macduff, Malcolm, and Macbeth are all Scots, and the struggle
between good and evil being played out in this work is linked by
means of such statements to their Scottish identity, while Macbeth's
betrayal of his own humanity through his violent behavior is a viola-
tion that can only be corrected by means of actions implying links
with that identity. Hence, a central feature of the dynamic of the
drama is the evocation of Scotland as a meaning-enhancing spatial
reality.

That link between spatial context and the meanings of relevance
to individuals is teased out in this study through an examination of
the intimate relationship between place and meaning in two particu-
lar instances, each centered respectively on places located on opposite
sides of the world. In the first, in Chapter 4, Lillis Ó Laoire explores
Irish song texts that disclose values founded on place and reveal the
intimate connectedness of culture and spatiality. This reading of the
texts, and of their performance contexts and emergent meanings,
shows a cogently sensed link between individuals, communities (in this
case, a subaltern island community off the west coast of Ireland),
language, and place. In Chapter 5, Paul Carter focuses on the pro-
cess of brokering new shared spaces in Australia, as reflected in a

nineteenth-century text, James Dawson's *Australian Aborigines*. This shows how the process in question depended on recognizing the value of indigenous place vocabularies in orienting the settler newcomers to the land. Dawson understood the importance of the poetic character of place-names and their power to generate new connections, and his ethnographic work thus reconnects with the larger discourse of postcolonial *métissage* and the ongoing poetic and political challenge of producing a "new" literature in a more just society.

The Abstract-Collective Zone

Spatial entities, locations, and movement are essential conceptual components of human expression of all kinds; hence, they are also essential components of symbolic and cultural expression. The spatiality that is a fundamental component of our everyday lives is also operative at all times in symbolic and cultural expression, conjuring entities into existence, referring to or describing spatial locations and their significances, and depicting motion. The outcome of this is an invented cultural space, what Maurice Blanchot referred to, in the literary context, as the "space of literature,"[9] that is, an imagined world that we can inhabit in the company of its creator when we read, view, or otherwise experience instances of symbolic or cultural expression. Within that world, we can observe and savor places and record and appreciate movements. The ebb and flow of spatiality in an artistic work and the cadence and rhythm afforded through the medium in which the work is created function together to fix the reader's attention both on the universe created within that work and the constituents of the medium in which it is created. In this particular spatio-cultural zone, therefore, we suggest that the key notion is that of *plasticity*, understood not just as "malleability" but also, more generally, as the plastic qualities of the phenomenon we are examining: we appreciate both the *plastic qualities of the imagined world* and the *plastic qualities of the work itself*, and, at least in those cases where the work succeeds in its aims, we are moved by what we experience. We do not just track locations and dislocations that may be described, depicted, or alluded to within the work, but we also follow the curve of a narrative, the contours of a musical trajectory, the patterns of a dance, or the phases in the activities of groups and individuals engaged in symbolic acts. Here, those qualities we might think of as being archetypally *aesthetic* prevail, and spatiality contributes to, and resonates with, the inventiveness of the artist and the very sensual material qualities of the cultural product or symbolic presentation.

In Shakespeare's *The Taming of the Shrew*, for example, the rapid-fire exchanges that take place between Katharina and Petruchio in Act II, Scene 1, not only serve to highlight the nature of the fiery relationship that is beginning to develop between these two central characters, but also to draw attention to the very rhythm of the language itself as it is being self-consciously played with by the speakers. Thus, the puns and double meanings multiply accordingly as the characters spar with each other, and a large part of the effect of the passage is attributable to the very qualities of the language used. Petruchio's perverse strategy of praising Katharina's supposed virtues, beauty, and mildness leads directly to the following hilariously blunt declaration of his intention to marry her:

> Hearing thy mildness prais'd in every town,
> Thy virtues spoke of, and thy beauty sounded, –
> Yet not so deeply as to thee belongs, –
> Myself am mov'd to woo thee for my wife.

The sequence continues as follows:

> *Katharina*: Mov'd! In good time: let him that mov'd you hither
> Remove you hence. I knew you at first,
> You were a moveable.
> *Petruchio*: Why, what's a moveable?
> *Katharina*: A joint-stool.
> *Petruchio*: Thou hast hit it: come, sit on me.

The spatial imagery here includes references to the "movement" of Petruchio to a position where he can interfere in Katharina's life, her desire that he should be shifted back out of it, as well as to the poor-quality piece of furniture, the "joint-stool," a roughly constructed seat traditionally associated with individuals of low social status, by which Petruchio is characterized by Katharina. Their verbal fencing is itself implicitly alluded to in Petruchio's riposte, "Thou hast hit it," which is quickly followed by another spatial reference ("come, sit on me") that evokes stillness and immobility, with connotations of sexual activity and a desire for consummation. The spatial dimension in this passage functions as a marker of the link between the central themes of sexual conquest and the imbalance in gender roles and relations and the artifice that is the work of art itself; the piece is, in this sense, self-referential, and offers the audience a way of both appropriating the issues raised and viewing them with a sense of ironic detachment that draws attention to the very form in which this work is constructed.

Dramatic art, in particular, often functions effectively as a way of linking the wider world to the world conjured up within the work in question, and a play as a lived spatial experience can often evoke a wide range of universal themes while also offering the spectator a multidimensional exploration of tangible sensual realities. Thus, a play may be seen as a lived reality in the sense that it only exists at the moment when it is duly performed in front of an audience. Presumably it is this kind of tangible experience that the playwright David Hare had in mind when he made the straightforward but important—and spatially focused—assertion that "a play is not actors, a play is not a text; a play is what happens between the stage and the audience."[10]

Once again, the above also suggests the idea that location is associated with the notion of access to special human (and, optionally, supernatural) meanings, while part of the originality of any successful work of art or effective instance of cultural communication is likely to be bound up with the attention that is paid to its shape, texture, style, and form, thus adding an aesthetic dimension to the appreciation of the phenomenon in question. Language itself may constitute a part of that experience, for it is, of course, central to any consideration of human meanings, including necessarily the spatial aspects of such meanings. In Chapter 6 of this volume, Paolo Bartoloni takes language to be, in Heidegger's words, "the house of being," and the reflections offered in that chapter center on the nature and state of that "house" today. Are we "in-place," or have we moved into a different domain where both we and language could be said to be "out-of-place"? By stressing the innate movement of language, it is suggested, one is naturally encouraged to see language as opening spaces, and discovering places, which can, but also cannot, contain us.

In Chapter 7, Karen Le Rossignol explores the theme of the "Abstract-Collective," both within the particularities of individual communities and on a globalized scale. Recognizing that communities are necessarily spatial entities within which relationships are fostered through narrative, we see how Deleuze's notion of "maximized abstraction"—interpreted both spatially and linguistically—creates increased narrative and sensory opportunities within virtual–actual spaces. Effective narrative storytelling exploring this terrain proceeds on the understanding that the senses and symbolization are interdependent. In particular, this chapter reports on the activities of the Virtual Village Project, which aims to stimulate well-being within globally dispersed autochthonous communities and in which virtual-actual communities play out the plasticity of their stories.

THE CONCRETE-COLLECTIVE ZONE

Finally, in the quadrant created by the intersection of the *concrete* and *collective* ends of the axes in figure I.2, the focus is on the notion of *power*. Here, we highlight those aspects of an artistic or other cultural phenomenon that link it to society, so that the space that is created in an artistic product or any instance of cultural expression is a *socially produced* space. In this zone, we focus on the fact that symbolic expression is never devoid of referential content, and can never be totally divorced from social context. Indeed, as David James puts it in relation to works of literary fiction, a novel's "synthesis of texture and topography, style and setting" is "inseparable from the political concerns to which it deliberately or implicitly gives voice." Fictional settings, he suggests, should be analyzed for "the way they dynamically influence narrative perception."[11]

This suggests a surprisingly intimate relationship between social concerns and the spatiality that is an imaginary outcome of the universe conjured up by means of whatever cultural phenomenon we are engaged with, so that, even when we express ourselves experimentally or we indulge in deliberate distortions, our expression occurs within a context and grows out of that context, a context that always carries some socially shared significances relating to human social realities. The space associated with any instance of cultural or symbolic expression, therefore, is both a moral space and a socially produced space.

Henri Lefebvre's analysis of human spatiality[12] provides a useful way of appreciating this aspect of space, and his tripartite classification of space highlights the various ways in which it is experienced as a symbolic phenomenon in everyday life. He is concerned to address the dichotomy between lived experience and the human capacity to apprehend aspects of reality on an intellectual plane. His analysis contrasts spatial practice—the ways in which people function spatially in their everyday lives—with representations of space (maps, urban plans, etc.), and contrasts both of these with "spaces of representation." Broadly speaking, this last term refers to the ways in which power is enacted, often in places of special significance, and frequently associated with the ritual use of symbols or with role-playing, in places such as churches, courts, or the parliament. Lefebvre's three categories are not neatly divided from each other, however, and each may be of relevance to a particular place at a particular time, and may be applicable in any number of circumstances. Lefebvre spoke of spatial

practice as "perceived space" (*espace perçu*), often overlooked by those who engage in planning activities, including architects and cartographers. Their focus is space in terms of its representation in maps and similar constructs, that is, as "conceived space" (*espace conçu*). Transcending these two areas and refiguring the balance between them means, as Shields puts it, that a person "is fully human [and] dwells in a 'lived space' (*le vécu*) of the imagination which has been kept alive and accessible by the arts and literature."[13]

This particular aspect of the spatio-cultural field is the zone where we might locate any number of artistic works that comment on their social and historical contexts, from the novels of Victor Hugo to Picasso's *Guernica*. These works, and others like them, comment on and critique a wide range of human issues and values, not least questions about interrelations between life and death. They also link into specific sociopolitical realities, however, evoking particular historical contexts and commenting on them, either directly or obliquely. Sometimes, as in *Guernica*, the comment is bleakly direct and devastating, with visual imagery that unmistakably conveys the horror of violence. At other times, the link with the sociopolitical context may be oblique, and the form taken by the artistic work may be such that the relevant connection can only be made by dint of a creative, intellectual effort on the part of the perceiver. We might think, for example, of certain musical pieces that have historical associations, such as Tschaikovsky's 1812 Overture, Philip Glass's *Two Trains*, or the sonata for cello and piano written by the avant-garde composer Ian Wilson, called *The Little Spanish Prison* (2012), inspired in turn by Robert Motherwell's *Elegies to the Spanish Republic* (1948–1967), a set of abstract paintings that Motherwell created as a response to the suffering endured in the course of the Spanish Civil War.

In the works of Shakespeare, links with the sociopolitical context may also be either quite direct, as in some of the History plays, or more oblique, as in *Julius Caesar* or *Macbeth*. The spatio-cultural content permeates those works, and is reflected quite precisely in some of the spatial metaphors used to convey universal truths about how power functions in society and how individuals function politically in identifiable historical contexts. Without the need for such works to convey accurate historical details, they can still convey much that is relevant to the sociopolitical dynamics of human behavior, in temporal and geographical settings that are clearly identifiable. An example of this would be Brutus's depiction of human ambition, when we hear him employing a spatial metaphor to characterize the rise of ambition

within political actors, in the following lines from Act II, Scene 1, of
Julius Caesar:

> ...But 'tis a common proof
> That lowliness is young ambition's ladder,
> Whereto the climber-upward turns his face;
> But when he once attains the utmost round,
> He then unto the ladder turns his back,
> Looks in the clouds, scorning the base degrees
> By which he did ascend.

This is matched in *Macbeth* by similar comments on the human con-
dition and summaries of characters' circumstances that also draw on
spatial imagery for their effect. For example, note these lines, uttered
by the protagonist of the play in Act I, Scene 7, when he hints at
the dangers of moral decadence that may accompany overweening
ambition:

> ...I have no spur
> To prick the sides of my intent, but only
> Vaulting ambition, which o'erleaps itself,
> And falls on th'other.

Of course, the spatiality in question is not confined to explicit refer-
ences to spatial concepts, as in these examples. The social and political
context forms part of the imaginative chronotopic frame of the work
in question; the myriad references within such works to the society
where they are set, and the metaphorical extension of the works'
ambits to other geographical or historical contexts, all serve to link
the work to certain recognizable realities. In drama, in particular, the
staging of a play and its reality as a physical experience make it in
itself a lived experience that may operate as a kind of representation of
the wider spatial reality around it, but which, as outlined earlier, also
constitutes part of that lived space.

Chapter 8 is focused on the idea that no lived space makes a
stronger claim on us as a social reality than the home. Based on
an examination of Ursula Meier's 2008 film *Home*, Conn Holohan
argues that the home is experienced as a place set apart from the flux of
capitalist exchange, that it is constructed primarily through ritual and
repetition. Situating the home within the spatiotemporal categories
that collectively constitute our globalized modern, or postmodern,
culture, the home-space in the movie is seen as being opposed to
the motorway that passes by its doorway, a utilitarian space which

seems to embody Marc Augé's category of the "non-place." However, as the film progresses, the distinction between these two spaces becomes less clear, revealing the dubious quality of all such spatial oppositions.

In Chapter 9 Catherine Emerson also addresses spatiality in the context of socially produced meanings. She focuses on the ways in which communities define themselves spatially in their visual productions and performances. Examining the case of the iconic figure of the Manneken Pis, she suggests that, on the one hand, fixed landmarks are made mobile and travel, but that, on the other hand, geographically indescribable places, such as online communities, are rooted in geography through practices that reference and mimic the landmarks of the external world.

These four zones, and the four summary notions—*philosophy, psychology, plasticity,* and *power*—that we have identified here as being associated with them, constitute an attempt to capture—in a sense, to "map"—both the complexity of the relationship between space and symbolic expression, and the fact that space is fundamental to all aspects of human existence, and hence to the capacity of human beings to reflect on that existence and to articulate versions of it through cultural and symbolic expression. The advantage of this schema is that it can help to highlight the diversity and range of the ways in which human spatiality and cultural and symbolic expression are linked to human experience generally. It assists us with the task of contextualizing the discussions of those spatial experiences that feature in the manifestations of cultural and symbolic expression of concern to us, whether we approach those studies as literary specialists or as musicologists, as observers of ethnographic phenomena or as classroom practitioners, or as analysts of film, language, or the plastic arts. In setting out the aspects of this topic that have been presented here, we have sought to demonstrate that the topic is of fundamental relevance to cultural and symbolic expression generally.

The eight specific studies that form the core of the volume are bookended by two more general, philosophical chapters. In Chapter 1, Felix Ó Murchadha analyzes some of the key approaches to understanding space and place, discussing a variety of accounts offered by thinkers ranging from Kant in the eighteenth century to Agamben and Balibar in our time. Following the general direction of the volume from abstraction and individuality toward concrete, collective spatio-cultural concerns, Miles Kennedy, in Chapter 10, addresses the thorny issue of Heidegger's affiliation to National Socialism and attempts to relate concerns of an intellectual nature to more mundane

and more visceral issues linked to that affiliation, citing the work of the poet, Tom Paulin.

NOTES

1. Henri Lefebvre, *The Production of Space*, translated by Donald Nicholson-Smith (Oxford: Blackwell, 1991).
2. Figures I.1 and I.2 first appeared in a slightly different form in Bill Richardson, *Borges and Space* (Oxford: Peter Lang, 2012) and are reproduced here with permission.
3. See Felix Ó Murchadha, "Space, Time and the Articulation of a Place in the World: The Philosophical Context," in Chapter 1 of this volume, for a more detailed discussion of this; c.f. also Miles Kennedy, "The Politics of Space: Poetical Dwelling and the Occupation of Poetry" in Chapter 10 of this volume.
4. The capacity to philosophize is taken here to be universal, that is, not to be the prerogative of people from any particular set of cultures or those with higher levels of formal education; everyone can philosophize, and, in one way or another, everyone does. As Claude Lévi-Strauss concluded in *Myth and Meaning* (New York: Schocken Books, 1995; originally published 1978), "notwithstanding the cultural differences between the several parts of mankind, the human mind is elsewhere one and the same and [...] it has the same capacities" (p. 19). See especially Chapter 2, " 'Primitive' Thinking and the 'Civilized' Mind."
5. See Robert T. Tally, *Spatiality* (London and New York: Routledge, 2013), pp. 56–9, for a concise exposition of these multiple meanings.
6. M. M. Bakhtin, *The Dialogic Imagination: Four Essays* (Austin: University of Texas Press, 1983), pp. 84, 85.
7. Michel Foucault and Jay Miskowiec, "Of Other Spaces," *Diacritics*, 16, 1, 1986: 23.
8. See Doreen Massey, *Space, Place and Gender* (Cambridge: Polity Press, 1994); Daphne Spain, *Gendered Spaces* (Chapel Hill: University of North Carolina Press, 1992), Chapter 1, "Space and Status," pp. 1–29.
9. See Maurice Blanchot, *The Space of Literature*; translated, with an introduction, by Ann Smock (Lincoln: University of Nebraska Press, 1989).
10. Quoted in Carol Homden, *The Plays of David Hare* (Cambridge University Press, 1995), p. 45.
11. David James, *Contemporary British Fiction and the Artistry of Space: Style, Landscape, Perception* (London/New York: Continuum: 2008), p. 18.
12. Henri Lefebvre, *The Production of Space*.

13. Rob Shields, "Henri Lefebvre," in Phil Hubbard and Rob Kitchin (eds) *Key Thinkers on Space and Place* (London: Sage, 2010), p. 281.

BIBLIOGRAPHY

Bakhtin, M. M. *The Dialogic Imagination: Four Essays* (Austin: University of Texas Press, 1983).

Blanchot, Maurice. *The Space of Literature*; translated, with an introduction, by Ann Smock (Lincoln: University of Nebraska Press, 1989).

Foucault, Michel and Jay Miskowiec. "Of Other Spaces," *Diacritics*, 16, 1, 1986: 22–27.

Homden, Carol. *The Plays of David Hare* (Cambridge: Cambridge University Press, 1995).

Hubbard, Phil and Rob Kitchin (eds). *Key Thinkers on Space and Place* (London: Sage, 2010).

James, David. *Contemporary British Fiction and the Artistry of Space: Style, Landscape, Perception* (London/New York: Continuum, 2008).

Lefebvre, Henri. *The Production of Space*, translated by Donald Nicholson-Smith (Oxford: Blackwell, 1991).

Lévi-Strauss, Claude. *Myth and Meaning* (New York: Schocken Books, 1995).

Massey, Doreen. *Space, Place and Gender* (Cambridge: Polity Press, 1994).

Richardson, Bill. *Borges and Space* (Oxford: Peter Lang, 2012).

Shields, Rob. "Henri Lefebvre," in Phil Hubbard and Rob Kitchin (eds) *Key Thinkers on Space and Place* (London: Sage, 2010), pp. 208–13.

Spain, Daphne. *Gendered Spaces* (Chapel Hill: University of North Carolina Press, 1992).

Tally, Robert T. *Spatiality* (London and New York: Routledge, 2013).

CHAPTER 1

SPACE, TIME, AND THE ARTICULATION OF A PLACE IN THE WORLD: THE PHILOSOPHICAL CONTEXT

Felix Ó Murchadha

The question of space is fundamentally a question of orientation: to take up space is to have a location facing toward or away from other places. Space is, in that sense, relative to a place, a location from which and toward which it is. In this directedness toward another place, every location is a place contingent to another. The contingency of place is twofold: the orientation from this place and not another, the priority therefore of this place as the location orientated toward other places, is the result of historically accountable, but specific, reasons; and, second, the place is contingent in the sense of touching upon (*con-tingere*) another place in relation to which it is. To be in place is to be in this place rather than that place, to be in this time not another possible time, and in consequence to be in a time and a space that is both contingent and inescapable. Such emplacement is a being within articulations of space and time. Again the twofold meaning of this term is helpful: space and time are articulated in place in the sense that the latter appears as separated into joints, as structured according to differences that constitute continuities of space, space as places; second, these joints make up the divisions, the boundaries of space that are marked by names, but also by remembrances and haunting presences of past events and of future hopes and fears. Articulated

space, space as lived place, has a temporal structure as growth and decay, and as familiar (habitual) and strange (novel).

This intertwining of time and space marking a place of a self and a place where a self encounters itself as strange, as out of place, is itself an event of production, literally of bringing forth through language and building of a place in which human beings are. But, to describe such a place, it is necessary to understand it in terms of the self in its attempts at self-articulation. The question of space is at once a question of the self for whom space is, but for whom that space is as home or as strange, as set in clear boundaries or as disrupted and obscure, as orientated centrifugally from the self or as a place in which the self dwells only on the periphery. This problematic has been at the core of much of the philosophical accounts of space since Immanuel Kant. While Kant understands space from the place of the transcendental subject, which is both a place and no place in the world, the discussions of space since Kant tend to gradually undermine the basic tenets of his account. What we can see here is a desubjectification, a pluralization, a temporalization, and a displacement of space. In this chapter I wish to trace these developments from Kant to Giorgio Agamben, from commanded space to exilic (dis-)place.

Form of Space

For Kant there is only one space. The oneness of space is, however, ensured by the experience of a subject. The subject experiences the outer world through the a priori form of space. Space is not an empirical concept, because, if it were, the subject would be able to represent space as an object. In fact what I perceive are objects, and to perceive them at all is to perceive them already in spatial relations—as outside of myself, as near or far. Such spatial relations, for Kant, are not themselves perceived but rather make possible external perception. As he puts it, "[T]he representation of space cannot be obtained through experience from the relations of outer appearance. On the contrary, this outer experience is itself possible at all only through that representation."[1]

As an a priori intuition, space is necessary for all access to external reality. While I can think a world in which nothing existed, I cannot think a world without space. Space is not a discursive concept; it is not produced through generalization of experienced relations, but rather is a pure intuition.

Furthermore, for Kant there is only one space and "if we speak of diverse spaces, we mean thereby only parts of one and the same unique

space."[2] Understood in this way, space is a purely geometric concept, a concept of the dimension of extended objects. The certainty of geometry derives from its roots in the a priori structure of spatial intuition, which is pure of the contingency of empirical representation.

It is, nevertheless, the case that we can only speak of space from the standpoint of a human being.[3] More specifically, space is conditional on the form of sensibility of human beings. The fundamental premise of critical philosophy, namely, that the condition of possibility of the object of perception is the condition of possibility of the perception of the object, entails here that space is constitutive of things in their appearance to a perceiving subject, but not of things in themselves. In this sense, space is both ideal and real: ideal with respect to things in themselves, but real with respect to things as appearances. For something to appear to me as an object of perception is for that thing to appear as spatial. So while, for example, the color, taste, and so on, of such objects are relative to the sense organs of the perceiving subject, the objects cannot be as appearing objects except as really spatial, that is, as really appearing in spatial relations of proximity and distance, of inner and outer.[4]

The specificality of space, that which makes a space *this* space rather than that, is a matter of the perceiving subject, not of the objects making up that space. Orientation in space is a matter of the subject's orientation, such that spatial indicators—in front, behind, above, below, to the right, and to the left—all refer to the subject, indeed to the sense of orientation (*Gefühl*) of an embodied subject. Kant terms this a "sense" or "feeling" because the differences of left and right are not to be found in external intuition.[5] Orientation in space requires both objective reference (e.g., to the sun) and a subjective basis of distinction in order to tell the difference between north and south or east and west. Without this capacity an astronomer would not be able to tell the difference in the night sky if by some miracle the direction of the stars was changed but their order remained the same.[6]

The subjectivity of spatial orientation does not affect the objective reality of space itself. This is so because subjective orientation occurs within space, and space is irreducible to the relations between objects. As such, space is fundamentally an empty concept; space is that in which objects are, but which can be thought independently of any objects. What characterizes this space is its infinity, as there is no other space outside it, and its existence all at once (*zugleich*). Fundamental to the intuition of space is that whatever I perceive exists simultaneously with all other things in this one space. As such space is not alone fundamental to external perception, prior to any objects of that

perception, but is also characterized by a particular temporal relation, namely, as existing simultaneously, at the same time.

As is well known, Kant illustrates this simultaneity with the example of perceiving a house, as opposed to a boat sailing up a river[7]: in the case of the house, the simultaneity is shown by the fact that the order of my perceptions is indifferent: I can perceive the hall first, and then the kitchen, and then the bedroom, or I can go in the opposite direction; the boat sailing up the river, on the other hand, imposes on me a particular order of perceptions: I perceive it first at one stage and then at another of its journey. These are two temporal experiences, in one case, of an object in motion, in the other, of a stationary object that can be circumambulated. The event quality of the boat journey imposes on me a temporal order, an order of succession in my perceptions, which spatial experience does not. Nevertheless, the experience of simultaneity depends on a possible action, that of reversing the order of perception. The possibility of such a reversal of perception depends not on the inner sense of those experiences—which in terms of my temporal consciousness allow no such reversal—but rather on the continual existence of the formerly perceived objects. In other words, simultaneity understood in terms of appearance depends on the succession of experiences. Such succession, however, does not so much disclose the causal relation of succession as the dynamic community of causal interrelation that lies at the roots of our understanding of space. To quote Kant:

> [W]e cannot empirically change our position (perceive this change), unless the existence of matter throughout the whole of space rendered possible the perception of the positions we occupy; and that this perception can prove the contemporaneous existence of these places only through their reciprocal influence, and thereby also the co-existence of even the most remote objects.[8]

The issue that arises for us here is this: if space is purely a formal intuition, then how do we explain the difference in spatial positions? For Kant this is to be understood in terms of a community of reciprocal causation, but such reciprocal causation does not so much explain different positions in space as the relation of my position to the infinity of coexisting spatial positions. Furthermore, how does coexisting space relate to temporal succession? The successive nature of causal relations, such that even if cause and effect occur at the same time the relation of cause to effect is one of before to after, allows us to understand temporal relations in space, but not how space can itself be temporally constituted.

Historical Space

If, following Kant, we say that there is one space, we can think this empirically only if we think an infinite community of reciprocal causation. But such a community is thinkable only from the center, from a center of experience from which place objects coexist in relations of greater or lesser distance from one another. Such a center is that of a subject who lives in a world with other subjects. While existing in a world together, such subjects, nonetheless, represent multiple centers of experience, multiple centers of orientation through spatial sense or feeling.

It is already necessary to think such a plurality of spatial centers if we are to understand movement. This is Georg W. F. Hegel's insight (but in essence it is already present in Aristotle): movement is not originally movement in one place, because for movement to happen, each place is becoming the next place. Movement is the simultaneity of departure and arrival, the crossing of thresholds.[9] To think movement in this way is already to move beyond any purely formal account of space and time. In the *Encyclopaedia*, Hegel makes clear that there can be no motion without matter or matter without motion, but matter itself cannot be understood independently of space and time. Against Kant's formalized account of the latter, Hegel explicitly rejects the matter/form schema underlying Kant's analysis. For Hegel the separation of space and time as two forms of intuition is an abstraction from the basic characteristic of nature, which he terms "being-outside-of-itself (*Aussersichsein*)."[10] Such "being-outside-of-itself" understood positively is space, understood negatively is time. In turn, these abstract moments when considered concretely are matter, when considered in their self-relation are movement. In other words, if we are to understand space and time as natural kinds correctly, we need to understand them relative to material bodies. Space and time are only with respect to material bodies in their exteriorizing being and in their movement. As such it is misleading to speak of the emerging and passing of things as occurring in time and in space, as if time and space were empty containers in which material things come to be and go out of being. It is rather the case that "time itself is this becoming, this coming-to-be and passing away."[11] Time is manifest in the material body itself, in its present, past, and future. Time is the now of the material thing, which is in a continual process of becoming past through its always emerging future. This now is also the here of the material body, and the unity of the here and now Hegel terms "place (*Ort*)."[12]

As this account suggests, place is nothing static, but is rather move-
ment as the "*vanishing and self-regeneration* of space in time and of
time in space."[13] It is on the basis of such an account of place that
Hegel can overcome Zeno's paradox. Famously Zeno argued that an
arrow in flight would not move. He states that in any one (dura-
tionless) instant of time, the arrow is neither moving to where it is,
nor whence it is not. It is in one place at that moment, and because
in that moment no time elapses for it to move to the next place, it
cannot move there. At every instant of time there is no motion occur-
ring. If everything is motionless at every instant, and time is entirely
composed of instants, then motion is impossible. What Hegel points
out is that Zeno is assuming that place can be understood as pure
"here" without reference to any "now." As the unity of time and
space, place is rather a threshold, a becoming other than itself. This
becoming other than itself is the dialectical nature of place, which
Hegel describes as a circular movement: that which is past is that into
which it first was to come.[14]

This dialectical relation, this movement of becoming, is for Hegel
not simply that which happens to material things, but rather is def-
initional of matter itself, such that matter sublates itself. This occurs
through what he calls spirit (*Geist*). In effect what Hegel is pointing to
here is the manner in which matter, even in its dark opacity, is consti-
tuted by a rational principle and that, in nature, this rational principle
comes increasingly to expression and to self-realization. The expres-
sion of spirit in human culture as politics, art, and religion does not
mark a break from nature but rather a more reflexive manifestation of
the dialectical movement itself. Understood in this way the account of
space that emerges from the philosophy of nature must be restated in
the philosophy of spirit as historical place.

Human space is itself geographical and topological; to be tempo-
rally and spatially is to be in a natural place. Such a place is one which
is *affected* by climate and location, by the solar system, and the earth.
But while nature is *determined* by natural processes, human place is
not. While human places are influenced by natural relations, they are
not determined by them. This is so because unlike animal life, for
example, the human relation to nature is one guided by consciousness
rather than instinct. It is this which lies at the roots of human freedom
and also the denial of inequality based on race, for example[15]; for our
purposes what is more significant is that the human relation to embod-
iment is one of meaning understood as spiritual expression, such that
bodily movement is not simply a reaction to instinctual drives, but is
a free expression of meaning. The human hand differs fundamentally

from that of the ape because "this tool of tools, is suited to serve an endless multitude of expressions of the will."[16] Bodily movements— voluntary embodiments (*freiwillige Verblieblichungen*)—are gestures, which mean and signify, which are spatial and temporal meanings, and which are emplacements of the body. The body is matter and motion, it is a place in the sense of the unity of time and space, but in its gestures it expresses this unity through a free expression of meaning. The dialectical movement, evident here, occurs all around us, but can also take on a significance that transcends the particular situation of an individual. The individual movement, the gesture that emplaces, can express more than a subjective peculiarity, but rather can "express an age, a people, a culture, in striking vividness and clarity."[17]

But if that is so, then every movement is potentially historical, in the sense that every movement emplaces, gives place as space and time, as an emergence into being. It is not so much that crossing the Rubicon is only historical for Caesar and refusing to vacate a seat on a bus is only historical for Rosa Parks, it is that these instances bring the historicity of movement to light. Space is, as Kant says, only in appearing for subjects, but these subjects are selves directed in their actions toward a future state of affairs, and selves who never begin from a point zero, but always from a remembered place, a place remembered and recalling. Places are historical spaces as those that embody memories and gestures of future sense. So understood, to move from one place to another is to move not within the form of intuition, but rather within the concrete reality of spaces with meaning, spaces that are bounded by meaning, spaces as historical places.

Hegel's contemporary in Tübingen, Friedrich Hölderlin, expresses, in many of his poems, this sense of remembered places, places that bear within them that which recalls beginnings going beyond or rather before human action.[18] Indeed, there is a sense in which historical space refers not so much to a naming of place but to an immemorial name, a named space for which the "original" name, the place as origin in name, remains clouded. Sedimented in every place-name is a history, a remembrance that makes that place a place within a plurality of places and a sense of coming later, of being a name that writes upon an already given name. The dream of a natural place, of a God-given place, is a dream of a place that has not been named or rather has a name that is born with the place itself. But such a place is precisely a non-place, u-topia. The narratives of idealized places point not to a place beyond all places, but rather to a loss inherent in place, namely the loss captured in the genitive: the name *of* this place. The name of this place grammatically suggests the name belonging to this place,

the place's true name. But the place is a place in its being named, the name does not disclose a place but rather produces it. It is impossible to distinguish here between the subjective and objective genitive: place and name intertwine. The non-place in this place is the moment of silence that the name dismisses and excludes.

DWELLING IN SPACE

If space is named, if space is plural, and if place is defined by the modes in which boundaries between spaces are passed over and passed through, the question then is this: what does it mean *to be in* such places? While movement is between spaces, place is only through delaying, through lingering in one space. To linger is to dwell. To dwell is to be in space, but to be in space is not like being in a container but rather to be in relation to things, as Martin Heidegger tells us in *Being and Time*.[19] To be in relation to things is a relation of transcendence, that is, of relating to things in the horizon of meaning in which they are for me. In strictly spatial terms, Heidegger understands this relation toward things as de-distancing and directionality (*Entfernung* and *Ausrichtung*). What Heidegger is pointing to here is the way in which, as beings in the world, our spatial relation to things is in terms of an interplay of nearness and distance, and of placing ourselves and things in different trajectories. "Dasein understands its here from its environmental there,"[20] he says. We are spatially never simply here present as objects taking up space, but rather we are "there" where our concerns are, and we understand ourselves in terms of those spatial projections by which we overcome distance and, in our nearness to things, we take up a place. To take up a place is to be in relation to things as those which concern us.

As spatially concernful beings, we orientate ourselves and do so in relation to a world already familiar to us. My spatial orientation has an a priori structure in the sense that it allows me to organize myself in relation to the objects of my spatial environment; but that orientation is possible only for a being in the world for whom left and right relate to the objects of my concern as I exist among them. As we have seen, Kant had understood such orientation as made possible by a subjective feeling: if I enter a darkened room with which I am familiar and somebody has moved the furniture, then I will not be able to orientate myself except by a feeling of the difference between left and right. But this very example, Heidegger claims, shows the opposite, namely, that left and right are orientations of space, not of subjective feeling. They are orientations of space understood as that

place in which Dasein dwells and in which objects are there for it as things with which it is concerned.[21]

In dwelling we do not simply use things and employ them, but rather we hold back our striving toward things and instead sojourn with them. This preserving sojourning (*Aufenthalt*) Heidegger associates with freedom: "To free actually means to conserve."[22] To "free" here means to make open, in the sense of opening up a world in which things can be as things. A place is only for a being that sojourns with things and in doing so lets them be in a world. To dwell is to build because only in building is the specifically human manner of letting space appear possible. This is so because dwelling is a setting up of place in which things can have a place. As Heidegger points out, the German word *Raum* has the original meaning of clearing a space for settlement and lodging—space is to make space, make room. This making space is building and it is that which is bounded, which begins precisely at its boundary. "Things, which as places allow a site [...] we call buildings."[23]

To "make space for" is to allow; to "construct" is to clear away. These, Heidegger claims, happen together, but in this happening is a setting up of place, a setting up of boundaries, which both allows things to be and limits how they are to be. But this setting of boundaries is not so much a claim to mastery over space as it is an investing of space in things through building. The building in investing space is placed on and formed out of the earth and faces outward to the expanse of space as free and open, which, following the Greeks, we can call the "heavens" (*ouranos*). It is a place that is marked also by human mortality and yet gestures beyond this to that which Heidegger terms the divine.

Building is marked by mortality, with the ever present possibility of ruination shown by the very preserving and conserving, which Heidegger understands to be essential to building. Georg Simmel describes such a process as follows: "[t]he unique balance between ... matter and the forming, upward pressing spirit breaks down in that moment when the building falls into ruin."[24] It is the fragility of the "equilibrium between nature and spirit which the building represents"[25] that appears in the ruin. What is striking about the ruin in its decay is not simply a lack, but that it seems to disclose something about the work itself. For Simmel the explanation for this is that in poetry, painting, and sculpture, the material is subordinated to the goal of spirit, almost to the point of invisibility, whereas material guides building. In the other arts the decay of material is simply a diminishing, because it plays no equal role, but, in building, decay

shows nature as a forming element. In architecture the resistance of
nature is an essential moment in the creative process. When we look
at the fate of a building, the possibility of decay is neither accidental
nor incidental: the completion of the building is simply the temporary
truce between nature and spirit.

Simmel's account is very suggestive for the consideration of space,
but needs to be pressed in a different direction. First, it is not clear
that the arts outside of architecture necessarily reduce their material to
the point of near invisibility; as such, the relation of spirit and matter,
which he describes in architecture, may be found in varying degrees
in the other arts. But, unlike painting (although similar perhaps to
sculpture), architecture is the making of works that relate directly to
a natural environment. The building encloses a space and in that way
sets up boundaries between the human and the natural. Second, while
Simmel remains tied to aesthetic categories, the problem of ruins is
ultimately one of dwelling: a ruin is a building that displays the fragility
of dwelling.

Simmel's account shows the dynamic structure of ruins; the man-
ner in which the ruin is neither the work of the human artifice nor
a thing of nature but rather "nature makes the artwork into mate-
rial for its action of forming, just as previously art had made use of
nature as its stuff."[26] This dynamic is essential to dwelling, and if we
think of this in Heidegger's terms as a relation of heavens and earth,
then we can see that what the ruin teaches is that the human is not
lord of the earth and is not protected from the heavens. Dwelling, as
Heidegger describes it, is a recognition of suffering, in the sense that
human beings as spatial beings are essentially subject to being acted
up (*pathos*). Suffering belongs to the essence of dwelling, and it is suf-
fering that appears in ruins. To dwell is to live in suffering sojourning
with things and is then letting ruination be. Far from a safe and secure
homeliness, dwelling is a letting fall into ruin, not out of indifference,
but rather out of a living in the difference between heavens and earth
and mortals and immortals.

RECIPROCITY IN SPACE

In *Phenomenology of Perception*, Maurice Merleau-Ponty points out
that the problem of other minds (and hence other centers of experi-
ence and of space) does not arise for Kant because "the transcendental
ego . . . is just as much other people's as mine."[27] This indicates a fun-
damental problem with respect to spatial relations, namely, that tran-
scendental philosophy assumes the world already given as a spectacle

and transcendental subjectivity as the condition of possibility of that spectacle. In such a view, the reciprocal relations in space, the relation that binds me to another being who is other precisely as another place, another view taking me in as an other, does not even arise as a problem. We have seen how such a question does arise once we understand space in terms of movement and when further we recognize the historicity of movement. But now we need to ask as to the implications of such a question for subjectivity and the relation of self and world.

The issue here revolves around a question of constitution: given that meaning is for a knowing subject, does the meaning of spatial relations depend on such a subject's constituting acts? To approach this question we need to ask what constitutes spatial meaning. I can conceive of a tree in isolation; I can draw it on a page and turn it upside down. If a tree can be turned upside down, then it must have an up and down side, it must, in other words, have a spatial orientation that is normative for it. Objects as such have orientations, which are definitional for them. Indeed, "[T]his general direction in space is not a contingent characteristic of the object, it is the means whereby I recognize it and am conscious of it as an object."[28]

Conversely, the knowing subject is a spatially engaged being, a being that is irreducibly corporeal and as such always already orientated in space, and through that bodily being engaged in "a communication with the world more ancient than thought."[29] At the core of such communication is the aspect of depth. As Merleau-Ponty points out, philosophers and psychologists have tended to reduce depth to breadth. This is so because depth is indissolvably relative to the perspective of the perceiving subject, while breadth seems to perceive things in their actual (and measurable) spatial relations. The man on the horizon is not really smaller than my thumb; it is only my distance from him that makes him appear so. But distance is not an eliminable element of spatial relations: things appear to me in relations of distance and proximity. Apparent size is nothing other than such appearance of things at a certain distance.[30] Proximity and distance are here understood as relations of hold or grip on an object such that "increasing distance is not, as breadth appears to be, an augmenting externality: it expresses merely that the thing is beginning to slip away from the complete grip which is proximity."[31]

Space, as we have already seen with Kant, is simultaneous: in this case the depth of a thing is the simultaneity of that which is nearer and which is more distance from a self. This simultaneity is one of mutual implication, such that the depth of things is the dimension in which they "envelop each other."[32] Such enveloping is a spatiotemporal

phenomenon whereby as I have the immediately past perception in retention, and the immediately to come perception in protention, so too my perception of the object in its proximity contains the objects at a distance not through any positing of spatial breadth, but rather as that which I hold at a distance. Merleau-Ponty is here drawing an analogy with Husserl's account of time consciousness.[33] For Husserl the present is constituted by the immediately past and the immediately future such that perception does not rely on recollection, but rather is itself a temporal synthesis of past, present, and future. In a similar way, Merleau-Ponty wishes to show that perception involves a "field of presence," which has both a spatial—here/there—and a temporal—past/present/future—dimension. But space is here elucidated by time, because perception is structured primarily in temporal terms: it is because we perceive temporally that we perceive space as depth. "When I say that I see an object at a distance, I mean that I already hold it, or that I still hold it, it is in the future or in the past as well as being in space."[34]

This spatiotemporal constitution of space is made explicit in the phenomenon of movement. As Merleau-Ponty points out, to understand movement in terms of the properties of a moving object is to dissolve it and as such to make movement incomprehensible. The problem of Zeno's arrow emerges here again as it did for Hegel, and Merleau-Ponty similarly resists any reduction of movement to the static. In doing so, he distinguishes between the moving object, that is, the object that has movement as a property and the "mobile entity," as something that moves: in the latter case, we understand the object on the basis of its behavior of moving, not the reverse. This, Merleau-Ponty argues, is phenomenally prior: what we experience is not a bird with such and such properties but rather "a greyish power of flight" flying across my garden.[35]

In the course of this discussion, Merleau-Ponty refers repeatedly to "thickness." This term he understands in temporal and spatial terms: an object appears to me in space as that which recedes from my present vision, as something with a depth which is that which both constitutes it as here and present, and which makes it there and past. Such thickness does not exclude the perceiving self but, on the contrary, I perceive because of the thickness of my being as both temporal and spatial. It is precisely this intuition that lies at the basis of Merleau-Ponty's later concept of the "flesh of the world," the account of which deepens the account of space as reciprocal being.

In his final published text, *Eye and Mind*, Merleau-Ponty says of Descartes that his mistake was to "erect it [space] into a positive

being, outside all points of view, beyond all latency and all depth, having no true thickness (*épaisseur*)."[36] "Épaisseur" has the sense also of darkness. A philosophy of light—Descartes begins and ends with the natural light of reason—sees things in space in terms of that which shows in the light, but to be a thing is to precisely hide from the light, to turn away from the light in the thickness of its being, while at the same time facing the light. Again in such a view, the world is an exterior spectacle, space is something outside the self. However, as Merleau-Ponty insists,

> I live in [space] from the inside; I am immersed in it. After all, the world is all around me, not in front of me. Light is viewed once more as action at a distance. It is no longer reduced to the action of contact or, in other words, conceived as it might be by those who do not see in it.[37]

But precisely this is that which philosophy does not think—and neither does psychology or physics. It remains a "philosophy to come," but one that is already anticipated by the painter who, in Cézanne's words, "thinks in painting."[38]

Echoing thoughts we have already encountered in the *Phenomenology of Perception*, Merleau-Ponty speaks of the enigma of depth:

> The enigma consists in the fact that I see things, each one in its place, precisely because they eclipse one another, and that they are rivals before my sight precisely because each one is in its own place. Their exteriority is known in their envelopment and their mutual dependence in their autonomy.[39]

The depth of things is their autonomy: things in space do not derive their meaning from the subject projecting meaning on to them, but rather we can understand depth only if we let things speak to us in their thickness. According to Merleau-Ponty, Cézanne's paintings show this because they practice a "deflagration of Being" whereby the outer shell of a thing is shattered to disclose its inner depth. In this sense Cézanne is the father of Cubism.[40] But this comes to be not through a projection of the artist, but rather it is "the painter to whom the things of the world give birth by a sort of concentration or coming-to-itself of the visible."[41] The spatial depth of the thing gives birth to the painter, who through color brings that depth into being again on canvas. There is here a mutual communication of space, where the artist and the thing to be painted implicate each other in a play of depth.

This reciprocity in space implies movement, and Merleau-Ponty suggests that again the painting reveals for us something essential about motion in space. The painter shows motion precisely when he paints that which could not actually have been: in painting a man walking, he paints both feet off the ground; most dramatically, in de Géricault's *Epsom Derby*, the horses are in motion in a posture that no photograph would capture. This is so because the artist allows an internal discordance into his painting, allows in effect the position of the horses within depth, within the "field of presence" to emerge. All flesh "radiates beyond itself" due to its inner depth, which manifests itself in its continual emergence out of depth, such that locomotion is a specific and in many ways derivative manifestation of that fundamental kinetic capacity of self-motion.

EXILES IN SPACE

To be in space, to take up space, and to be as emplaced, is to be in reciprocal relation between one another in a place, which is historical and communal. It is this communal space that binds us temporally in a common sharing of place. But this very commonality, this very community in space, appears fractured in late (or post) modernity. This fracturing of community and in particular the community of place, is a theme that we find in Heidegger, in Benjamin, and later in Arendt, Foucault, and Nancy. It is a theme that particularly animates the work of the Italian philosopher Giorgio Agamben and the French political theorist Étienne Balibar. From Arendt to Balibar a decisive experience that guides many of these reflections is that of the refugee in exile.

If ruins reveal suffering and the precariousness of place, exile discloses place in non-belonging. The root meaning of exile is to banish (*exilare*), which implies a place of belonging and a place of exclusion. To be an exile, or more specifically to be a refugee, discloses in its non-belonging the conditions of belonging, namely, those of law and ethnicity. To be unprotected by any law or ethnic ties is to be merely a human being, and to be merely a human being is to be displaced, without any "place in the sun" to quote Pascal, or, in the term pejoratively used by the Nazis, *Bodenlos*, that is, without ground. Such a state implies a boundary between those who are allowed and those who are refused, and a power that presides over this boundary, which decides between inclusion and exclusion. Agamben understands this power of decision as the sovereign's power to suspend law and in so doing produce the "state of exception." As Agamben explains, "[T]he sovereign exception is the fundamental localization (*Ortung*), which

does not limit itself to distinguishing what is inside from what is out-side but instead traces a threshold (the state of exception) between the two."[42]

Localization here refers both to real space, places of exception, places where those characteristics of the life (*bios*) of citizenship become reduced to what he calls bare life (*zoe*) (the concentration camps of Nazi Germany and of other regimes, but also the "zone d'attente" at airports where refugees are detained), but also to the boundary of fact and right, of sovereignty and that which lies out-side of it. Constitutive of this is the binding in sovereignty of violence and law. In setting up the limits of law, sovereignty at once produces legality and sets up a space of exception to the law. In this space of exception, the law has force while being suspended. Agamben sees this exemplified in the Nazi state where law becomes the will of the Führer and as increasingly becoming the norm in Western society: he begins the *State of Exception* with a discussion of the US Patriot Act. Crucial for our concerns is that the exile in such a view is the one who is identified with "bare life," the one who cannot be integrated, and it is the exile who, as the one excluded, banished, reveals most clearly the basic political act of exception. As such, "[H]e is pure *zoe*, but his *zoe* is as such caught in the sovereign ban [the state of exception as zone of indistinction between inner and outer] and must reckon with it at every moment [...] In this sense, no life [...] is more political than his."[43]

The exile reveals in a very stark way a fundamental ontological as well as political characteristic of place, namely, that all things suffer: in the sense that all things take place, are in place, and place is that which makes them possible as things. For something to be is for it to be in place, is for it to take up space, it is to take up that which is already there to enclose it, but which is radically indeterminate and plastic. The taking up of space reveals space as a transcendental element in everything which is. As Agamben puts it, "the pure transcendent is the taking-place of everything."[44] This taking-place is the mark of sin-gularity on each thing which is, and it is this singularity that exile reveals. To be singular is neither to be universal nor individual; such singularity is disclosed in love. Love reveals singularity because it is directed toward its object not because of its properties (of beauty, intelligence, and so on) but as the taking place of "the loved one *with all of its predicates*."[45] To understand community on the basis of that which love knows is, for Agamben, to recognize that what constitutes community is not a common identity, not a place held in common, but an empty space in which communication between singularities can

become possible. Hence, Agamben can say that "[t]aking-place, the communication of singularities in the attribute of extension, does not unite them in essence, but scatters them in existence."[46] A singularity takes up space not as identities but rather as relations to the totality of its possibilities. A singularity is indeterminable according to a concept, but rather relates to itself only with respect to the empty space that bounds it. Its relation to boundaries is not that of a limit but of a threshold.[47]

As Agamben points out, in many European languages, the notion of outside is expressed by a word that means "at the door" (*fores* in Latin, *thyrathen* in Greek). The exiled, the refugee, is in a place in which the very conditions of belonging have been suspended, and lives in a kind of threshold, a zone of indistinction, as Agamben puts it, between inside and outside. In Agamben's words,

> The *outside* is not another space that resides beyond a determinate space, but rather, it is the passage, the exteriority that gives access—in a word, it is its face, its *eidos*. The threshold . . . is, so to speak, the experience of the limit itself, the experience of being-*within* an *outside*.[48]

This experience of thresholds, of boundaries, and the zones of indistinction that surround them, is a crucial concern in Balibar's work. One of his fundamental concerns is what he terms as the issue of "anthropological difference." It is characteristic of modernity, for Balibar, that a perfect adequacy between the capacities of the human and the powers of the citizen is postulated. The political implication of this is the developing of a "new regime of the *becoming subject* of the citizen."[49] What Balibar is pointing to here is the underside of the emancipatory movement of modernity in which "the only consistent way to deny citizenship to individuals in the regime of civic-bourgeois universality is to deny them full humanness."[50] This motivates the drawing of differences on the basis of masculine and feminine, normal and pathological, adult and infantile, intellectual and manual, differences of ethnicity and race, as differences that govern the conferring of citizenship, and hence rights, on individuals. Such anthropological differences produced unstable patterns of separation between inner and outer, such that a class of humans developed that were "at the same time human and less than human, or imperfectly human," which had to be cared for but also segregated from those deemed fully human. Drawing on Foucault, Balibar discusses "different modalities of exclusion" that produced the foreign body, that is,

"the 'body' who is essentially out of place, because it emerges inside a space where it should not be normally or 'ideally.'" This foreign body can be a "stranger, racially and culturally other(ed) within a nation-state," but has also a moral connotation, including "the sexual transgressor who escapes the codes of binarism, while produced by them and reacting against them."[51]

The boundary of inner and outer shifts is to be found within as well as around the nation state. Indeed, for Balibar the notion of boundary has shifted in a fundamental way in modernity, no longer simply demarcating a territorial space but rather drawing lines of inclusion and exclusion, of bodies that belong and that do not belong. He speaks of this as a "global apartheid" cutting across states and demarcating the realms of rights and those excluded from rights. Hannah Arendt's question concerning the "rights to have rights"[52] is for Balibar an issue concerning boundaries and the manner in which borders are thresholds without rights, places of entry into citizenship and the place where rights are politically conferred.[53] Place here is a political place in a fundamental sense of that place in which the human can be recognized as fully human. A true "democratization of borders," for which Balibar argues, would entail a radical undermining of those relations of privilege that govern relations of belonging to and in a place.

Conclusion

To be in place is to risk displacement, to dwell is to be with ruination, to move is also to be moved, and to be spatial is also to be subject to spatiality. At the core of the philosophical attempts to think place from Kant through Hegel to Simmel, and Heidegger to Merleau-Ponty, and on to Agamben and Balibar is the problem of what it means to be a spatially constituted, hence open and vulnerable being, which lives in space through the temporality of its own being and other beings past and present, and the material temporality of things among which it dwells. What has occurred here is a shift from the understanding of space as a transcendental and geometric structure of experience to an existential and political account of place. At times in these discussions it can appear as if space and place are being used more metaphorically than conceptually, but arguably space is irreducibly metaphorical (as indeed metaphor is irreducibly spatial). What this points to is that which is evident through all these post-Kantian discussions, namely, the understanding of space as dynamic. Spatial relations are relations

of motion, of change, of remembrance and forgetting, of hope and despair. It is precisely this dynamism that points to the way in which space both produces and is produced, indeed, in which space is not so much constituted by the subject as it is constitutive of the subject in the interrelations of selves and others. Such interrelations form the possibilities of community and cooperation, of dispossession and violence, in a global world without fixed boundaries, made up of diverse and unequal places.

NOTES

1. Immanuel Kant, *Critique of Pure Reason*, translated by Norman Kemp Smith (New York: St. Martin's Press, 1929), B 38/A24.
2. Kant, *Critique of Pure Reason*, B39/A25.
3. Kant, *Critique of Pure Reason*, B43/A27.
4. Kant, *Critique of Pure Reason*, B45/A29.
5. Immanuel Kant, "What Does it Mean to Orient Oneself in Thought?," in Allen Wood and George Di Giovanni (eds) *Religion Within the Boundaries of Mere Reason and Other Writings* (Cambridge: Cambridge University Press, 1998), p. 4.
6. Kant, "What Does It Mean to Orient Oneself in Thought?" pp. 4–5.
7. Kant, *Critique of Pure Reason*, B236-237/A191-192.
8. Kant, *Critique of Pure Reason*, A212/B259.
9. On this issue, see Jay Lampert, *Simultaneity and Delay: A Dialectical Theory of Staggered Time* (London: Continuum, 2012), pp. 82–93.
10. Georg W. F. Hegel, *Hegel's Philosophy of Nature: Encyclopaedia of the Philosophical Sciences (1830), Part II*, translated by Arnold Vincent Miller (Oxford: Oxford University Press, 2004), p. 28 (translation modified).
11. Hegel, *Hegel's Philosophy of Nature*, p. 35.
12. Hegel, *Hegel's Philosophy of Nature*, p. 40.
13. Hegel, *Hegel's Philosophy of Nature*, p. 41. Emphasis in original.
14. Hegel, *Hegel's Philosophy of Nature*, p. 43.
15. See Hegel, *Philosophy of Mind*, translated from 1830 edition, with "Zusätze," by William Wallace and Arnold Vincent Miller, revised by Michael Inwood (Oxford: Clarendon Press, 2007), p. 35.
16. Hegel, *Philosophy of Mind*, p. 138.
17. Hegel, *Philosophy of Mind*, p. 248.
18. See in particular Friedrich Hölderlin's "Germanien" and "Der Rhein," in Michael Hamburger (ed) *Hölderlin: Selected Verse* (London: Anvil Press, 1986), pp. 154–59 and 160–70.
19. Martin Heidegger, *Being and Time*, translated by Joan Stambaugh (Albany: New York, 1996), pp. 50–51.
20. Heidegger, *Being and Time*, p. 107.

21. Heidegger, *Being and Time*, pp. 109–10.
22. Martin Heidegger, "Building, Dwelling, Thinking," in David Farell-Krell (ed) *Basic Writings* (London: Routledge, 1993), p. 351. (Translation modified)
23. Heidegger, "Building, Dwelling, Thinking," p. 149. (Translation modified)
24. Georg Simmel, "Die Ruine," in *Philosophische Kultur* (Frankfurt am Main: Suhrkamp, 1911), p. 287. For a fuller account of ruins in Simmel and in Heidegger, see my "Being as Ruination: Simmel and Heidegger on the Phenomenology of Ruins," *Philosophy Today*, 46, 5, 2002: 10–18.
25. Simmel, *Philosophische Kultur*, p. 287.
26. Simmel, *Philosophische Kultur*, p. 290.
27. Maurice Merleau-Ponty, *Phenomenology of Perception*, translated by Colin Smith (London: Routledge, 1969), p. 62.
28. Merleau-Ponty, *Phenomenology of Perception*, p. 253.
29. Merleau-Ponty, *Phenomenology of Perception*, p. 254.
30. Merleau-Ponty, *Phenomenology of Perception*, p. 261.
31. Merleau-Ponty, *Phenomenology of Perception*, p. 261.
32. Merleau-Ponty, *Phenomenology of Perception*, p. 265.
33. See Edmund Husserl, *The Phenomenology of Internal Time-Consciousness*, translated by James Churchill (The Hague: Nijhoff, 1964).
34. Merleau-Ponty, *Phenomenology of Perception*, p. 265.
35. Merleau-Ponty, *Phenomenology of Perception*, p. 275.
36. Maurice Merleau-Ponty, "Eye and Mind," in Thomas Baldwin (ed) *Maurice Merleau-Ponty: Basic Writings* (London: Routledge, 2003), p. 305.
37. Merleau-Ponty, *Basic Writings*, p. 309.
38. Merleau-Ponty, *Basic Writings*, p. 309.
39. Merleau-Ponty, *Basic Writings*, p. 311.
40. Merleau-Ponty, *Phenomenology of Perception*, p. 311.
41. Merleau-Ponty, *Phenomenology of Perception*, p. 312.
42. Giorgio Agamben, *Homo Sacer*, translated by Daniel Hellar Roazen (Stanford: Stanford University Press, 1998), p. 19.
43. Agamben, *Homo Sacer*, p. 184.
44. Giorgio Agamben, *The Coming Community*, translated by Michael Hardt (Minneapolis: University of Minnesota Press, 1993), p. iv.
45. Agamben, *The Coming Community*, p. i.
46. Agamben, *The Coming Community*, p. v.
47. Agamben, *The Coming Community*, p. xvi.
48. Agamben, *The Coming Community*, p. xvi.
49. Étienne Balibar, "Civic Universalism and Its Internal Exclusions: The Issue of Anthropological Difference," *Boundary 2*, 39, 1, 2012: pp. 207–29, p. 208.

50. Balibar, "Civic Universalism and Its Internal Exclusions," p. 209.
51. Balibar, "Civic Universalism and Its Internal Exclusions," pp. 225–26.
52. See Hannah Arendt, *The Origins of Totalitarianism* (Orlando: Harcourt, 1973).
53. See Étienne Balibar, *We, the People of Europe? Reflections on Transnational Citizenship*, translated by James Swenson (Princeton: Princeton University Press, 2004), pp. 115–24.

Bibliography

Agamben, Giorgio. *The Coming Community*, translated by Michael Hardt (Minneapolis: University of Minnesota Press, 1993).
——. *Homo Sacer* (Stanford: Stanford University Press, 1998).
Arendt, Hannah. *The Origins of Totalitarianism* (Orlando: Harcourt, 1973).
Balibar, Étienne (ed). *We, the People of Europe?: Reflections on Transnational Citizenship*, translated by James Swenson (Princeton: Princeton University Press, 2004).
——. "Civic Universalism and its Internal Exclusions: The Issue of Anthropological Difference," *Boundary 2*, 39, 1, 2012: 207–29.
Hamburger, Michael. *Hölderlin: Selected Verse* (London: Anvil Press, 1986).
Hegel, Georg, W. F. *Hegel's Philosophy of Nature: Encyclopaedia of the Philosophical Sciences (1830), Part II*, translated by Arnold Vincent Miller (Oxford: Oxford University Press, 2004).
——. *Philosophy of Mind*, translated by William Wallace and Arnold Vincent Miller, revised by Michael Inwood (Oxford: Clarendon Press, 2007).
Heidegger, Martin. "Building, Dwelling, Thinking", in David Farrell-Krell (ed) *Basic Writings* (London: Routledge, 1993), pp. 343–364.
——. *Being and Time* (Albany: New York, 1996).
Husserl, Edmund. *The Phenomenology of Internal Time-Consciousness*, translated by James Churchill (The Hague: Nijhoff, 1964).
Kant, Immanuel. *Critique of Pure Reason*, translated by Norman Kemp Smith (New York: St. Martin's Press, 1929).
——."What Does It Mean to Orient Oneself in Thought?," in Allen Wood and George Di Giovanni (eds) *Religion Within the Boundaries of Mere Reason and Other Writings* (Cambridge: Cambridge University Press, 1998), pp. 3–14.
Lampert, Jay. *Simultaneity and Delay: A Dialectical Theory of Staggered Time* (London: Continuum, 2012).
Merleau-Ponty, Maurice. *Phenomenology of Perception*, translated by Colin Smith (London: Routledge, 1969).
——. "Eye and Mind," in Thomas Baldwin (ed) *Maurice Merleau-Ponty: Basic Writings* (London: Routledge, 2003), pp. 290–324.
Ó Murchadha, Felix. "Being as Ruination: Simmel and Heidegger on the Phenomenology of Ruins," *Philosophy Today*, 46, 5, 2002: 10–18.
Simmel, Georg. *Philosophische Kultur* (Frankfurt am Main: Suhrkamp, 1911).

CHAPTER 2

SYMBOL, SITUATEDNESS, AND THE INDIVIDUALITY OF LITERARY SPACE

Bill Richardson

The aim of this chapter is to examine some of the ramifications of implicit or explicit references to space, place, or displacement in works of narrative literature, and to consider some of the ways in which this may help elucidate the depth of the significance of such references in terms of our experience of life in general. It is suggested that a specific focus on space can enable us to see how spatiality and the related concepts of entity, location, and movement play a major role in the constitution of the self.

In *The Poetics of Space*, Gaston Bachelard reminds us that place can eclipse time, surprisingly, in relation to something as quintessentially temporal as memory, claiming that "[f]or a knowledge of intimacy, localization in the spaces of our intimacy is more urgent than determination of dates."[1] This statement highlights the important role played by spatiality in the human imaginary. It suggests there is an essential link between the materiality of spatial phenomena and mental processes, so that memories are identified as being linked to *whereness*. Not only does it matter where we are when we recall something and not only is the nature of what we recall affected by location, but it may also be the case that mental representations are fundamentally spatial in nature, rather than temporal. If this is so, then the mental appropriation of meaning that our contact with a literary text facilitates is constituted as much by our own sense of the spatial as it is by the temporal. Of all the (traditional) types of artistic expression available

to us, it may be that narrative literature exemplifies this more than others. In contrast to the plastic arts, and in contrast to more social uses of language or even lyrical poetry, the typically private experience of the construction of a narrative in a short story or novel reminds us of the essentially nonmaterial nature of the meanings we make. In the case of modern nontraditional arts, including digital arts, the "non-materiality" of the medium simply reinforces this: engaging with the cybernetic space in which we encounter digital material, we are similarly challenged to make the mental leap from those "marks on the screen" into an invented world, a space we concoct and inhabit in our imaginations. There, the distinction between narrative and other literary forms is no less one of mode of representation than in the case of print, since the narrative depends crucially on our individual willingness to engage in the same process of creation of spatial reality.

That subjective appropriation of verbal utterances entails an encounter with the self at the moment when mind meets text, and the degree of engagement of the self with the material being read is likely to relate to the extent to which the text has an impact on our own sense of "location," that is, the mentally constructed experience of a "where" and a "when" with which we can identify. We are, then, exercising an imaginative appropriation of an invented space, and the development of the narrative affords us an opportunity to explore that space, to savor it and to apprehend the multiple meanings that the contingent locatedness we invent can have in that context. And, while the invented spaces also bear some relationship to the social and the concrete—as hinted at by the quote from Bachelard above—the experience in question is always ultimately an individual and an abstract one, and we desist from our reading with the realization that, on some level, it has all been only "in our head."

In what follows, we explore this through a consideration of some key works by two twentieth-century Latin American authors, the Mexican Juan Rulfo and the Argentinean Jorge Luis Borges, both of whom exemplify these phenomena well, albeit in starkly contrasting ways. The Rulfo novel and the Borges stories we discuss below enable us to better appreciate both the ultimately subjective impact of the spatiality of narrative literature and the crucial fact of the intersection of the two Kantian parameters of time and space.

Juan Rulfo (1917–1986) manages to evoke the arid plains and bereft villages of central Mexico in terms that make them not just a background setting for the actions of the characters who populate his novel *Pedro Páramo* (1955), but a fundamental component of an imaginative inquiry into the relationship between self and universe.

This relationship is highlighted from the very start of this novel as we meet Juan Preciado, who is arriving in the apparently deserted village of Comala ostensibly to find his father, Pedro Páramo, and to connect with his roots, a process that is figured in spatial terms as a return to the place where he was born. Indeed, critics have pointed to the central role played by the ambience of desolation in the novel, just as several have highlighted the centrality of spatiality in the work.[2] The predominance of considerations of space and place is already signaled in the very title, *Pedro Páramo*. Besides being the surname of the central character, it is significant that the Spanish word *páramo* means a flat expanse of ground, often rocky and bare. Among others, the great Mexican poet and critic Octavio Paz drew attention to the connotations of the name, suggesting that, perhaps without realizing it, Rulfo had announced his symbolic intentions in that title. Paz suggests seeing "Pedro" ("Peter") as "the founder, the rock, the origin, the father, guardian and lord of paradise" with the *páramo* in question being "his ancient garden, now a dry plain, thirst and drought, the whispering-place of shades and eternal incommunication." In his commentary, Paz went on to claim that, on the basis of this novel, it could be said that Rulfo was "the only Mexican novelist who has given us an image, rather than a description, of our landscape."[3] But, while the world Rulfo conjures up in *Pedro Páramo* may be recognizably Mexico in the early twentieth century, it is also a demimonde inhabited by creatures that combine the real and the fantastic, the natural and the supernatural, the knowledge of everyday place and time with the capacity to distort spatial and temporal realities for the purpose of exploring the nature of human existence.

As mentioned above, the opening scene of the novel presents us with an image of Juan Preciado on his way to the village of Comala, a town that, in turn, is depicted as lying in the center of a bowl of land. Preciado's trajectory is downward as he makes his way to the town, descending into a netherworld of excessive heat and stillness. As we soon learn from the series of fragments of narrative that constitute the novel (which is not written in conventional chapters), the world he enters is also a world of death and horror, and the people he interacts with are shadowy, spectral characters who appear and disappear inexplicably around him. We realize, in the course of the first half of the novel, that Preciado has entered a kind of Dantean Sixth Circle; indeed, the critic Rodríguez-Alcalá has asserted that Dante's *Inferno* is the archetype for the world created in *Pedro Páramo*.[4] Certainly, this is a hellish world of tormented souls expressing regret for past actions, a world of sinners who do not shirk from admitting their culpability,

and of individuals who occupy a kind of purgatory from which there is no hint of escape and where there is no sense of a heaven to which they might gain entry. Halfway through the novel, any vestige of naturalism dissipates, as Juan Preciado appears to die but is able to recount his death, and as the characters who are in his company at that point discuss his passing with him. Subsequent scenes in the novel include very little that is centered on Preciado, except instances where he converses in his grave with other dead people or where he overhears stories told by some of the dead inhabitants of Comala who are buried near him. Most of the material in the latter half of the book relates to the life of his infamous father, the local strongman (*cacique*), Pedro Páramo, who had exercised tyrannical power over the people of the area.

The worldview in operation in this novel has its roots in Christian tradition and in a medieval conception of the assumed connections between the natural and the supernatural. There is no clear division between this world and the next, and the obsessions and preoccupations that people have in life remain with them when they pass on. It is a bleak, uncompromising vision of unmitigated failure, regret, and despair, a vision of a world in which people suffer oppression in life from which there is no relief even in death. Despite this bleakness, the novel is not without touches of black humor, at least some of which relates to the spatial positioning of the characters, and in particular their situation as buried corpses. In the conversation that takes place in Fragment 36 after Juan Preciado's death, between the dead Juan and the old woman he has encountered, Dorotea, who has been living in a sexual union with her brother and who is now in the grave beside Juan, there is a discussion of the circumstances of the latter's death. His own understanding of what happened to him is that he suffocated for lack of air. But Dorotea assures him that that cannot be the case because, if it were, she and her brother would not have been able to drag him from where they found him into the shade of a doorway and, subsequently, bury him. They both then conclude that in fact he died from a combination of causes that were, on the one hand, fear itself and, on the other, the murmuring voices that he hears around him in Comala. "Me mataron los murmullos" ("The murmuring killed me"), Juan says. And he continues, "I was trying to contain my fear. It had been building up inside me until I couldn't put up with it any longer. And when I came face to face with those murmurings, it exploded inside me."[5]

Thus, abstractions of two sorts kill Juan Preciado. There are the sounds of the voices he hears, the murmurings of spectral figures whose evanescent existence permeates this place, less as physical

presences and more as emanations of memories. The memories in question, however, belong not to Juan himself but to other people such as his dead mother, and so they operate at an even higher level of abstraction since they are really memories of memories. Something as abstract as fear itself is also figured here as being responsible for his death. The very evocation of this sense of fear makes of it something that has both abstract and concrete qualities. Assigning to fear the capability to kill, that is, to bring about Juan's death, is a way of conveying how a phenomenon we normally envisage as abstract actually has concrete qualities: fear, after all, is felt in our gut, and the abstraction in question has very tangible physical and chemical correlates. But it is in the abstraction of the world Rulfo creates that we are able to experience, at least vicariously, those tangible correlates of fear, and it is the verbal constructs of the passages we are discussing and the novel as a whole that allow us the opportunity to do so. Each of us readers, individually, thus creates the abstract structure within which these possibilities arise.

As the conversation referred to above advances, it becomes increasingly clear that we have entered the world of the dead. Dorotea, Juan's interlocutor—who functions as one of a series of "guides" accompanying him on this journey through an infernal "otherworld"—makes explicit reference to her own deceased state. She almost casually mentions her regret at having lived long enough to meet up with her lost son—a son whose own existence is called into doubt, since he never appears in the novel and she herself states that he was only an illusion, a son she never actually had. But all of that is couched within the frame of an opportunity for reflection afforded to her by the fact of her own death. She says,

> You have longings? They'll cost you dearly. The price I paid was to live more than I should have. That's how I paid the debt I owed for finding my son, who was really just one more longing; because in truth I never actually had a son. Now that I'm dead I've had time to think about things and understand them properly . . . [6]

Later, in reference to her belief that she had had a child, she remarks, "and as long as I was alive, I never stopped believing that it was true; because I felt him in my arms, a tender little thing, all mouth and eyes and hands"[7]

That belief of hers had arisen from a vivid dream she had had, in which she was presented with the child. But this dialogue is not only subverting and dissolving the boundaries between life and death, it is

also reinforcing a vision of the cosmos that allows of easy transitions between the natural and the supernatural, between earth and heaven, as well as between reality and dream. Dorotea, in the course of this conversation in the grave with Juan Preciado, in fact recounts two dreams, the one in which she gives birth, but also another in which she is informed that she is mistaken in thinking she has a child. The setting for this latter dream is heaven itself, and in it, a saint appears, delves with his hand into Dorotea's stomach, and produces a nutshell that he holds up for her to see, while he enigmatically pronounces, using quasi-evangelical phrasing, "Esto prueba lo que te demuestra"[8] ("This proves what it shows you").

The point here is that, while the level of reality on which the dream is operating is clearly one level removed from that in which Dorotea and Juan are conversing, the fact that they are both dead and in their graves undermines the idea that the dream sequence that is described should be viewed as less "real" than any other accounts of talk or action, including the references to the two companions in the grave. After all, Dorotea's life, according to her, was dominated by the presence of the child she thought she had, and it was only late in her stay on earth that she became convinced the child did not exist: "I found out about it when it was too late, when my body had shriveled up, when my spine was protruding from my head, when I could no longer walk."[9]

This entire passage is replete with spatial references, and, like the novel itself, much of the effect that is achieved hinges on the interplay between spaces existing at different levels of reality, and on the dissolution of those boundaries between natural and supernatural, and between earth, heaven, and at least by implication, hell. All this, as well as Dorotea's and Juan's status as buried beings at this juncture, is played for darkly humorous effect. Dorotea's own gradual dissolution into death and nothingness is depicted by her as a relinquishing of contact with others and a loosening of the bonds that tie the community. She says, "And, to top it all off, the village was gradually being abandoned; everyone was heading off to other places and with them went the charity that I lived off."[10] And she resignedly sits down to await death: "I sat down to wait for death. After we found you, my bones resolved to stay in one place. 'Nobody will bother me,' I thought. 'I am now a thing that will not trouble anyone.'"[11]

The increasingly abstract quality of her existence is finally couched in explicitly spatial terms, as she points out that, in death, she does not even take up space, or at least does not require any separate space of her own. She explains that she has been buried in Juan's own grave and

is reposing now in "the hollow of his arms," where she can talk with him easily. "So, you see, I didn't even take up any space on the earth. I was buried in your very grave and fitted very well into the hollow of your arms. Here in this little corner where you have me now."[12]

When Juan again expresses his sense of fear, given that he can feel someone walking on their grave, she reassures him with the words, "No need to be afraid; nobody can frighten you now. Get used to thinking pleasant thoughts because we're going to be buried down here for a long time."[13]

Each of the 69 fragments of text that comprise the novel is presented as an individual passage, with its own temporal and spatial parameters that may or may not coincide with those operating in fragments contiguous to it. Normal chronological sequencing is disrupted and the settings for the action, as we have just seen, are potentially located at any point in the cosmos. Each fragment stands like a vignette on its own, as it paints a quick picture or narrates a short sequence over at most a few pages; and these fragments then stand in our imagination like a series of images placed alongside each other, each one resonating with its own atmosphere and message while also relating to those around it and to others that stand far away from it in the sequence, so that all the fragments appear to be located "artificially" in juxtaposition to each other.[14] The apparently haphazard nature of the sequence is a classic modernist device that conveys the complexity of the human condition and the sense of chaos that we associate with modern life, but the subversion of temporal sequencing is matched by the consistent attempt to convey a sense of placelessness or of spatial fragmentation. Fragment 32, for instance, opens with the line "Como si hubiera retrocedido el tiempo" (As if time had turned back). Written as if it were a complete sentence, this suggests a subverting of normal meanings and standard parameters both in its content and its form. But the chaotic character of the cosmos inhabited by these characters is not confined to the temporal realm; rather, immediately after the above partial sentence, we are told, "Again I saw the star beside the moon. Clouds dissipating . . . The flocks of thrushes. And straight away the evening still full of light."[15]

In a world where time can go backwards and where the moon and the stars can appear in a sky that without warning transforms itself into bright sunshine, people can appear and disappear, can seem to be alive while perhaps being dead, and, as readers, we are induced to invent in our imagination a universe that does not obey any of the normal rules.

This fragmentation adds complexity and is potentially confusing, although it is of course part of the achievement of this novel that

it conveys the notion that we can be virtually anywhere, as well as
the idea that all points in space are connected with each other. While
Fragment 36, in which Juan and Dorotea have their conversation in
the grave, takes place underground, the fragment we have just dis-
cussed, 32, directs our attention heavenward. By this means the text
alludes to the connections that exist between these individuals—and,
potentially, any and all individuals—and the wider universe in which
we have our being. The town in which the novel is set, Comala, is
thus envisaged as connecting to the wider universe; its inhabitants are
seen, at one and the same time, as being trapped within a very specific
location and also linked cosmically to that universe. Our engagement
with the text thus has the effect of lifting us from a particular point in
space and time and linking us to an infinite—or, at least, potentially
infinite—space and an eternity of time, encompassing past, present,
and future. When Juan Preciado asks Dorotea how one leaves Comala,
her answer evokes those links between individual human beings, the
locales in which they find themselves, and the immensity with which
they are surrounded, when she says,

> "There are lots of roads. One goes in the direction of Contla; another
> one comes from there. Another one goes straight up toward the sierra.
> That one you can see from here I don't know where it goes to," and she
> pointed her finger at a hole in the roof, where the roof was broken with a
> gaping hole in it. "This other one then, it goes right by the Media Luna
> ranch. And there's another one that runs the length of all the territory
> around here; it's the one that goes the furthest."[16]

The vision she offers is one of a multiplicity of routes and paths,
trajectories that extend in all directions and seem to hold out the
promise of establishing meaningful links with other locations, both
natural and supernatural; but, given the context in which they are
evoked, they serve only to act as crisscrossing axes pinning the charac-
ters in place and emphasizing the condition of stasis in which they find
themselves. Dorotea's confinement is absolute: "I never go out. Here
where you see me, this is pretty much where I've always been . . . Well,
not really always. Only since he made me his wife. Since then I have
stayed locked away in here all the time, because I'm afraid people will
see me."[17]
 The philosophical aspect of human spatiality, then, asks us to
come to grips with the awesome reality of our "place in the world,"
understood in the broadest and most abstract sense of that term.
The word "place" in that phrase encompasses both spatiality and
temporality; from this perspective, we are cognizant of the indissoluble

link between space and time, and we apprehend the essential unity of these two concepts. The novel under consideration here exemplifies the way in which literary texts can hinge on certain evocations of location, understood in the sense of characters and actions being "placed" within particular spatial and temporal parameters, viewed *sub specie aeternitatis*, while simultaneously being appreciated in terms of the particular temporal and spatial contexts in which they are found. This serves to unite the general with the particular in the most abstract way possible, but always with due recognition of the fact that the abstraction operating within the work reflects a genuine level of abstraction existing within each and every one of us.

The Argentinean writer Jorge Luis Borges (1899–1986) famously concocted stories wherein characters move around imaginary worlds that are the ultimate product of extreme versions of philosophical theories. In these stories, inquiries into the nature of human spatiality take the form of explorations of the relationship between the thinking subject and the material facts of existence, and a Heideggerian concern with "being in the world" comes face to face with ultimate questions about what drives our ambitions, our hopes, and our emotional longings. Many Borges stories surprise us with insights into such relationships, and by positing an evasion of concrete realities, including, as we shall see in an example below, the very materiality of existence. They often, paradoxically, capture the essence of what it means to exist in a concrete world encompassing not just time and space but also representations of these as conceptualized by us all. Borges's work opens up perspectives on human spatiality that ensure we can capture the essential "situatedness" of our being, while also holding out tantalizing possibilities for expanding our vision of the world we ourselves inhabit.[18]

Critics as diverse as Lubomir Dolezel or Maurice Blanchot have envisaged the novel as a space imagined by the reader.[19] We can appreciate this point when commentators such as Georg Lukacs or Margaret Anne Doody emphasize the ways in which realistic and naturalistic novels in effect create spaces resembling the real world and, in that sense, map onto the world out of which they emerge.[20] It may not be as obvious that this is the case when we consider fictions such as Rulfo's novel discussed above or the short stories created by Borges, in which spatial entities often have a less-than-solid existence. Frequently, in an apparent attempt to elucidate the nature of the relationship between the individual human being and the spatial realities around him or her, Borges's stories hinge on ideas about the *search* for spatial entities or the attempts made by his characters to rid themselves of objects.

In effect, the status of objects, indeed of all spatial situatedness, is repeatedly contested in Borges's work. In his 1941 story, "The Library of Babel,"[21] Borges conjures up a universe composed entirely of hexagonal cubicles whose walls are covered in books. The contents of the books consist of all the possible combinations and permutations of the alphabet. The search undertaken in the library, in this instance, is a search for the "total book" that would operate as a key to reveal the meaning of all other books and of the universe in which the narrator and his fellow citizens carry on their existence—an existence we would be unlikely to dignify with the term "living." Given that the number of books in this putative universe, that is the library, is greater than the number of atoms in the actual universe in which we live,[22] the chances of finding a particular book are effectively nil, including the chances of finding the book that would unlock ultimate meanings. It is as if the book both does and does not exist: it is impossible for the book not to exist because all possible books exist, but it would not be possible in any realistic sense for us to witness it or to locate any specific book we seek, that is, to experience them as concrete spatial entities. Their ontological status, therefore, is always questionable.

That total book is not unlike the book with an infinite number of pages that is the focus of attention in another text by Borges, the 1975 story "The Book of Sand."[23] Even when we hold the book of sand in our hands, its existence as a material entity is of no use to us; by dint of having an endless number of pages, it is in effect "immaterial," for we cannot get the book to stand still as an object we can use. Its status as a Heideggerian "tool" is ambivalent, given that we can never return to the same page twice: that infinite number of pages allows no repeat experiences. This is because it is always another page that opens up and because the sequential numeration that would enable us to locate a particular page again is absent—and numbers are evacuated of meaning anyway once the total number involved reaches infinity. Each viewing of each page is thus depicted as a unique "event," the event of our encounter with that page, never to be repeated, always to be experienced as a singularity that allows of no scientific generalization. Borges's thinking is here implicitly aligned with the kind of advances that were taking place in the middle of the twentieth century in fields such as cosmic science and particle physics: the observer is part of the phenomenon observed, and the world does not stand still as an objective reality amenable to scientific description.

Bertrand Westphal has observed how Borges's story "El jardín de senderos que se bifurcan" ("The Garden of Forking Paths") constitutes a prime example of the way in which an author may spatialize

time, so that the notion of time that is evoked in this 1941 story is one where timelines are seen to bifurcate incessantly and extend in all directions.[24] Indeed, Westphal suggests that this is probably "the first explicit example of spatiotemporal belief generated by a profusion of timelines," and as such that it anticipates the "decades to come," not just in literary terms but also in science itself.[25] Borges was keenly interested in developments in modern mathematics;[26] what he does in this story, in effect, is conjure up the theoretical construct of multiple universes, all existing in parallel to one another. The coexistence of these different "versions" of reality is a feature of the conception of time attributed to a character called Ts'ui Pên within the story. The latter, we are told, was the ancestor of another character called Yu Tsun, a Chinese man working in the service of Germany during the First World War and the one who is now the protagonist of this Borges story. Within "The Garden of Forking Paths," we follow Yu Tsun as he undertakes his mission to assassinate a famous British sinologist, Stephen Albert, in a remote rural area in England. The motivation for his intended murder is simple: Yu Tsun is on a mission to communicate back to his headquarters in Berlin a crucial piece of information, viz., that British forces are concentrated at a French town called "Albert," in order to enable the Germans to bomb that town and destroy those forces in advance of the Battle of the Somme.[27] The only way in which Yu Tsun can achieve that aim, given the nature of communications in 1914, is by ensuring that his name and the name "Albert" appear in newspaper reports together; his bosses back in Germany will be able to interpret his message effectively.

Yu Tsun achieves his objective of killing Stephen Albert in his country home, and when we first encounter the spy in the story, he has done the deed and is awaiting execution since he has been captured by the authorities soon after the assassination. The additional dimension to this tale centers on the sense that Borges offers of an awareness of the grandeur—and the spatiality—of temporal realities. This is thrown into sharp relief when Yu Tsun comes face to face with Stephen Albert and the latter engages him in an intellectual conversation about the nature of time and about the biography of his ancestor, Ts'ui Pên. The latter, we are told, had retired from public life at a particular juncture in his career, declaring that he had set himself two tasks, viz., to write a novel and to build a labyrinth. After his death, people had not been able to identify anything that looked like a labyrinth—after all, they were expecting to encounter a spatial entity—and all that remained of his writings was what seemed to be an incoherent series of disparate individual chapters of something that could hardly constitute a

novel since it did not appear to follow any logical sequence of action. Of course, as Albert explains to the young Chinese–German spy in the incongruous setting of an English country house, the novel and the labyrinth were "one and the same object" ("eran un solo objeto"), since they both reflected the illustrious ancestor's conception of time as a bifurcating phenomenon. In Ts'ui Pên's "novel," when a conflict arises in the action, all possible outcomes to that conflict are allowed to become part of the narrative; thus, if person A attacks person B, a subsequent chapter will narrate how A ended up killing B, and this will be followed by another chapter telling how B successfully defended himself by killing A, followed by another account that tells how neither A nor B was killed, and so on. These options are necessary due to the fact that one of Ts'ui Pên's requirements for his proposed novel was that it be "strictly infinite" ("estrictamente infinito"), since time, in his conception, is infinite. The result of such a conviction (that the novel, like time itself, should be endless) is that all outcomes are possible, since every possible outcome to every situation will eventually transpire.

Just before Yu Tsun enters the sinologist's house, he traverses the large garden around it and uncannily senses the existence of other levels of reality around him, in a context where he seems to himself to be a "percibidor abstracto del mundo" ("an abstract perceiver of the world"). He tells us he envisages Ts'ui Pên's labyrinth as being infinite and as comprising "ríos y provincias y reinos…" ("rivers and provinces and kingdoms"). He thought of it as a "labyrinth of labyrinths" that would somehow encompass past, present, and future. This suggestion of the simultaneous existence of past, present, and future is a foreshadowing of what he discovers from Albert's account, and it focuses precisely on the spatial nature of the temporal realities being conjured up in the story: if all time and timelines exist to the point of infinity, then they must exist simultaneously, with the result that the barrier between space and time that we normally regard as a natural separation of two dimensions of our existence simply does not exist. Time, then, is spatial; as Albert puts it to Yu Tsun, his ancestor's novel is an "incomplete, but not false," image of the universe as Ts'ui Pên conceived it. And he continues, "Unlike Newton and Schopenhauer, your ancestor did not believe in uniform, absolute time. He believed in an infinite series of times, in an ever-growing and vertiginous network of diverging, converging and parallel times."

This is what Yu Tsun senses presciently in the garden before entering Albert's house, at a point when he feels himself to be an "abstract perceiver of the world." Thus, the countryside around him seemed

to teem with life, even though he was on his own on a lonely night in a foreign country. Here we have an image of that abstraction and individuality that characterizes the relationship between narrative and spatiality: the imagined reality is an outcome of the individual's capacity to invent alternative worlds, to conjure up multiple universes that are the product of the human imagination, in a setting that invites us to look for ways of explaining the space within which we are located, and to combine that with a series of actions and consequences to which we are committed.

As mentioned earlier, in another Borges story, "Tlön, Uqbar, Orbis Tertius" (1940),[28] spatial reality itself is called into question, and the narrator posits a universe in which there are no material objects, or one where objects exist only if someone thinks about them. This story is inspired by the notion of an exaggerated Berkeleyan idealism and is an attempt to conduct a thought experiment to see what it would be like if indeed it were literally true that *esse est percipi*, if perception were all that existed. In the story, a doorway may disappear, for instance, if a particular beggar who happened to frequent it goes elsewhere. Later, there is a debate about some lost coins that are subsequently found, the debate centering on whether the lost coins and the coins that are found could possibly be considered the "same" coins just because we happen to perceive them in a way that suggests that they are the same. After all, we are told, if nine men each have an acute pain on nine successive nights, we would hardly claim that they all had the "same" pain, even though all nine men had the same perception of pain; and anyway, if equality were to entail identity, we might as well claim that all of the nine coins in question were in fact one and the same coin.

One feature of literature highlighted by Borges in his attempt to come to terms with the nature of human spatiality is language itself, and the lucubrations on language that feature in his stories contribute to the construction of the space that is his fiction. In the world of "Tlön, Uqbar, Orbis Tertius" there are no material objects; hence, the languages spoken in that world are, naturally, devoid of nouns. The example is given of how it would be impossible to produce an utterance of the sort "The moon rose above the river." This would be rendered, in Tlönian language, as *hlör u fang axaxaxas mlö*, or, literally, "upward behind the onstreaming it mooned." A universe that consists entirely of just two elements—time passing and the sense of perception—is bound to have difficulty producing a language with nouns in it, but it is of course in the very process of attempting to describe such phenomena that the essentially spatial nature of the actual universe becomes highlighted. After all, what is this object, the

moon, which, it is claimed, has no material existence or a noun that
might designate it? In this story, furthermore, the existence of the
imaginary world that is being described is discovered by means of a
corrupted encyclopedia. One copy, and only one, of an encyclopedia
called the *Anglo-American Cyclopedia* is found to include a reference
to Uqbar, a clue that leads our narrator to realize eventually that the
universe he is learning about is the product of the imaginations of
a conspiratorial group of academics who have set about inventing it.
The source of this putative reality is, therefore, a book, but of course
our attention is also drawn in the course of the story to the fact that
the source of *our* knowledge of that universe is another book, that is,
the book in which we are now reading the story "Tlön, Uqbar, Orbis
Tertius."

This self-referentiality serves to heighten our awareness of the fact
that the literary creation we are engaging with only exists as such a
creation at the moment when we experience it in our imaginations.
As individuals, we relate to the text before us, but, needless to say of
course, the work of art that is the text only comes alive when we imag-
inatively appropriate it: the black marks on the page that are the text
are just marks until and unless we as readers appropriate them. Unlike
in the case of the plastic arts, however, the marks in this instance
are never pure form but are the symbolic representation of words
loaded with meanings. John Dewey stated the idea in the following
terms:

> [L]iterature exhibits one unique trait. Sounds...are not sounds as such,
> as in music, but sounds that have been subjected to transforming art
> before literature deals with them. For words exist before the art of
> letters and words have been formed out of raw sounds by the art of
> communication...The art of literature thus works with loaded dice; its
> material is charged with meanings they have absorbed through immemo-
> rial time...There is not the gap between raw material and material as
> medium in letters that there is in other arts.[29]

As Dewey appears to imply, the fact that words always carry socially
shared significances means that literature always relates to human
social realities, at least to some extent. Literary space, therefore, is
both a moral space and a socially produced space, and the experience
of literature is always invested with the significances attendant on the
collective and concrete dimensions of our existence. Ultimately, how-
ever, these can only be evoked through the exercise of conjuring up a
literary "space" that assists us in exploring the—necessarily individual
and abstract—conceptual framework of the world in which we live,

thereby aiding our appreciation of our temporal and spatial "place in the universe."

NOTES

1. Gaston Bachelard, *The Poetics of Space* (Boston, MA: Beacon Press, 1994), p. 9.
2. Most of the relevant material is written in Spanish. In English, see, for example, my study, "*Allí en la tierra estaba toda su vida*: Patterns of Place and Space in the Work of Rulfo," in Dylan Brennan and Nuala Finnegan (eds) *Rethinking Juan Rulfo's Creative World: From Isolation to Connectedness* (Oxford: Legenda, forthcoming 2015), and Ciaran Cosgrove, "Abstract Gestures and Elemental Pressures in Juan Rulfo's *Pedro Páramo*," *The Modern Language Review*, 86, 1, January 1991: 79–88. Among the most pertinent studies in Spanish are Diógenes Fajardo Valenzuela, "*Pedro Páramo* o la inmortalidad del espacio," *Thesaurus: Boletín del Instituto Caro y Cuervo*, 44, 1, 1989: 92–111; Francisco Antolín, *Los espacios en Juan Rulfo* (Miami: Ediciones Universal, 1991); Gustavo C. Fares, *Imaginar Comala: el espacio en la obra de Juan Rulfo* (New York: Peter Lang, 1991); and C. Fiallega, "Los muertos no tienen tiempo ni espacio: el cronotopo en *Pedro Páramo*," in Pol Popovic Karic (ed) *Juan Rulfo: perspectivas críticas. Ensayos inéditos* (México, DF: Siglo XXI, 2007), pp. 117–37.
3. Octavio Paz, *Corriente Alterna* (Mexico, DF: Siglo Veintiuno, 1967), p. 18.
4. Hugo Rodríguez-Alcalá. "Miradas sobre *Pedro Páramo* y *La divina Commedia*," in Claude Fell (ed) *Juan Rulfo: Toda la Obra* (Madrid, Paris, Mexico, Buenos Aires, Sao Paolo, Lima, Guatemala, San José de Costa Rica, Santiago de Chile: ALLCA XXE, 1992), pp. 773–84, p. 671.
5. Original: "Aunque ya traía retrasado el miedo. Se me había venido juntando, hasta que ya no pude soportarlo. Y cuando me encontré con los murmullos se me reventaron las cuerdas." (Fell, *Obra*, p. 235; all page numbers for original quotations from *Pedro Páramo* refer to the edition of the novel included in that volume. All translations into English in this chapter are by the author.)
6. Original: ¿La ilusión? Eso cuesta caro. A mí me costó vivir más de lo debido. Pagué con eso la deuda de encontrar a mi hijo, que no fue, por decirlo así, sino una ilusión más; porque nunca tuve ningún hijo. Ahora que estoy muerta me he dado tiempo para pensar y enterarme de todo... (Fell, *Obra*, p. 237).
7. Original: "Y mientras viví, nunca dejé de creer que fuera cierto; porque lo sentí entre mis brazos, tiernito, lleno de boca y de ojos y de manos..." (Fell, *Obra*, p. 237).
8. Fell, *Obra*, p. 238.

9. Original: "Lo supe ya muy tarde, cuando el cuerpo se me había acha-
parrado, cuando el espinazo se me saltó por encima de la cabeza,
cuando ya no podía caminar" (Fell, *Obra*, p. 238).

10. Original: "Y de remate, el pueblo se fue quedando solo; todos
largaron camino para otros rumbos y con ellos se fue también la
caridad de la que yo vivía" (Fell, *Obra*, p. 238).

11. Original: "Me senté a esperar la muerte. Después de que te encon-
tramos a ti, se resolvieron mis huesos a quedarse quietos. "Nadie me
hará caso", pensé. Soy algo que no le estorba a nadie" (Fell, *Obra*,
p. 238).

12. Original: "Ya ves, ni siquiera le robé el espacio a la tierra. Me enter-
raron en tu misma sepultura y cupe muy bien en el hueco de tus
brazos. Aquí en este rincón donde me tienes ahora" (Fell, *Obra*, p.
238).

13. Original: "Ya déjate de miedos. Nadie te puede dar ya miedo. Haz
por pensar en cosas agradables porque vamos a estar mucho tiempo
enterrados" (Fell, *Obra*, p. 238).

14. It is worth noting that, as well as being a major writer, Rulfo had—
and continues to have—a very significant reputation as a photogra-
pher. While composing his most famous short stories and the novel
Pedro Páramo, he had begun his career in photography. See Andrew
Dempsey, *Juan Rulfo, fotógrafo* (Mexico, DF: Consejo Nacional para
la Cultura y las Artes, Dirección General de Publicaciones, 2005).

15. Original: "Volví a ver la estrella junto a la luna. Las nubes deshacién-
dose…Las parvadas de los tordos. Y en seguida la tarde todavía llena
de luz" (Fell, *Obra*, p. 232).

16. Original:

Hay multitud de caminos. Hay uno que va para Contla; otro que
viene de allá. Otro más que enfila derecho a la sierra. Ese que se
mira desde aquí, que no sé para dónde irá—y me señaló con sus
dedos el hueco del tejado, allí donde el techo estaba roto—. Este
otro de por acá, que pasa por la Media Luna. Y hay otro más, que
atraviesa toda la tierra y es el que va más lejos.

(Fell, Obra, p. 227)

17. Original: "Nunca salgo. Aquí donde me ve, aquí he estado sempiter-
namente…Bueno, ni tan siempre. Sólo desde que él me hizo su
mujer. Desde entonces me la paso encerrada, porque tengo miedo
de que me vean" (Fell, *Obra*, p. 228).

18. For discussion of the theme of spatiality in Borges, see, for instance,
my *Borges and Space* (Oxford: Peter Lang, 2012); also: Marina Martín,
"Borges, the Apologist for Idealism," in *Proceedings of the Twenti-
eth World Congress of Philosophy*, Boston, MA, August 10–15, 1998,
http://www.bu.edu/wcp/Papers/Lati/ LatiMart.htm> [accessed
January 15, 2015]; Beatriz Sarlo, *Jorge Luis Borges: A Writer on
the Edge* (London: Verso, 2006); Nataly Tcherepashenets, *Place and*

Displacement in the Narrative Worlds of Jorge Luis Borges and Julio Cortázar (New York: Peter Lang, 2008).

19. See, for instance, Maurice Blanchot, *The Space of Literature*, translated, with an introduction, by Ann Smock (Lincoln: University of Nebraska Press, 1989); Calin-Andrei Mihailescu and Walid Hamarneh, *Fiction Updated: Theories of Fictionality in Contemporary Criticism* (Toronto: University of Toronto Press, 1996), and David James, *Contemporary British Fiction and the Artistry of Space: Style, Landscape, Perception* (London and New York: Continuum: 2008), Chapter 1, "Landscape and Narrative Aesthetics."

20. See Margaret Anne Doody, *The True Story of the Novel* (New Brunswick: Rutgers University Press, 1977).

21. "La Biblioteca de Babel," in Jorge Luis Borges, *Ficciones* (Madrid: Alianza, 2004); original published in 1944.

22. See William Goldbloom Bloch, *The Unimaginable Mathematics of Borges' Library of Babel* (Oxford: Oxford University Press, 2008).

23. "El libro de arena," in Jorge Luis Borges, *El libro de arena* (Buenos Aires: Ultramar-Emecé, 1975).

24. Bernard Westphal, *Geocriticism* (New York: Palgrave Macmillan, 2011), pp. 18–19.

25. Westphal, *Geocriticism*, p. 18.

26. See, for instance, Guillermo Martínez, *Borges y la matemática* (Barcelona: Seix Barral, 2006); Floyd Merrell, "Science and Mathematics in a Literary Mode," in Edwin Williamson (ed) *The Cambridge Companion to Jorge Luis Borges* (Cambridge: Cambridge University Press, 2013), pp. 16–28.

27. See Daniel Balderston, *Out of Context: Historical Reference and the Representation of Reality in Borges* (Durham: Duke University Press, 1993), Chapter 3, "The Labyrinth of Trenches without any Plan," pp. 39–55.

28. "Tlön, Uqbar, Orbis Tertius," in Jorge Luis Borges, *Ficciones* (Madrid: Alianza, 2004).

29. John Dewey and Jo Ann Boydston (ed) *The Later Works of John Dewey, Volume 10, 1925–1953: 1934, Art as Experience* (Carbondale, IL: Southern Illinois University Press, 2008), p. 244.

Bibliography

Antolín, Francisco. *Los espacios en Juan Rulfo* (Miami: Ediciones Universal, 1991).

Bachelard, Gaston. *The Poetics of Space* (Boston: Beacon Press, 1994).

Balderston, Daniel. *Out of Context: Historical Reference and the Representation of Reality in Borges* (Durham: Duke University Press, 1993).

Blanchot, Maurice. *The Space of Literature*, translated, with an introduction, by Ann Smock (Lincoln: University of Nebraska Press, 1989).

Borges, Jorge Luis. *El libro de arena* (Buenos Aires: Ultramar-Emecé, 1975).
———. *Ficciones* (Madrid: Alianza, 2004).
Cosgrove, Ciaran. "Abstract Gestures and Elemental Pressures in Juan Rulfo's *Pedro Páramo*," *The Modern Language Review*, 86, 1, January 1991: 79–88.
Dempsey, Andrew. *Juan Rulfo, fotógrafo* (Consejo Nacional para la Cultura y las Artes, Dirección General de Publicaciones, 2005).
Dewey, John and Jo Ann Boydston (eds) *The Later Works of John Dewey, Volume 10, 1925–1953: 1934, Art as Experience* (Carbondale, IL: Southern Illinois University Press, 2008).
Doody, Margaret Anne. *The True Story of the Novel* (New Brunswick: Rutgers University Press, 1977).
Fajardo Valenzuela, Diógenes. "*Pedro Páramo* o la inmortalidad del espacio," *Thesaurus: Boletín del Instituto Caro y Cuervo*, 44, 1, 1989: 92–111.
Fares, Gustavo C. *Imaginar Comala: el espacio en la obra de Juan Rulfo* (New York: Peter Lang, 1991).
Fell, Claude (ed) *Juan Rulfo: Toda la Obra* (Madrid, Paris, Mexico, Buenos Aires, Sao Paolo, Lima, Guatemala, San José de Costa Rica, Santiago de Chile: ALLCA XXE, 1992).
Fiallega, C. "Los muertos no tienen tiempo ni espacio: el cronotopo en *Pedro Páramo*," in Pol Popovic Karic (ed) *Juan Rulfo: perspectivas críticas. Ensayos inéditos* (México, DF: Siglo XXI, 2007), pp. 117–37.
Goldbloom Bloch, William. *The Unimaginable Mathematics of Borges' Library of Babel* (Oxford: Oxford University Press, 2008).
James, David. *Contemporary British Fiction and the Artistry of Space: Style, Landscape, Perception* (London/New York: Continuum: 2008).
Martínez, Guillermo. *Borges y la matemática* (Barcelona: Seix Barral, 2006).
Merrell, Floyd. "Science and Mathematics in a Literary Mode," in Edwin Williamson (ed) *The Cambridge Companion to Jorge Luis Borges* (Cambridge: Cambridge University Press, 2013), pp. 16–28.
Mihailescu, Calin-Andrei and Walid Hamarneh. *Fiction Updated: Theories of Fictionality in Contemporary Criticism* (Toronto: University of Toronto Press, 1996).
Paz, Octavio. *Corriente alterna* (Mexico, DF: Siglo Veintiuno, 1967).
Richardson, Bill. *Borges and Space* (Oxford: Peter Lang, 2012).
———. "*Allí en la tierra estaba toda su vida*: Patterns of Place and Space in the Work of Rulfo," in Dylan Brennan and Nuala Finnegan (eds) *Rethinking Juan Rulfo's Creative World: From Isolation to Connectedness* (Oxford: Legenda, forthcoming 2015).
Rodríguez-Alcalá, Hugo. "Miradas sobre Pedro Páramo y *La divina Commedia*," in Claude Fell (ed) *Juan Rulfo: Toda la Obra* (Madrid, Paris, Mexico, Buenos Aires, Sao Paolo, Lima, Guatemala, San José de Costa Rica, Santiago de Chile: ALLCA XXE, 1992), pp. 773–84.
Westphal, Bernard. *Geocriticism* (New York: Palgrave Macmillan, 2011).

CHAPTER 3

BRIDGING GAPS; BUILDING BRIDGES: FIGURES OF SPEECH, SYMBOLIC EXPRESSION, AND PEDAGOGY

Christiane Schönfeld and Ulf Strohmayer

The coexistence of language and space involves more than matters of approximation and equivalence. Beyond simple binaries expressed perhaps most vividly in Saussurean terms, beyond, in fact, any simple invocation of structure, language in a quite fundamental sense *is* space: without the spatiality embedded *within* and practiced *across* the Saussurean bar between signifier and signified, the very notion of "approximation" would be unthinkable.[1] But between such post-structural meditations and assumed structural properties, language has arguably always displayed an uncanny flexibility to act spatially by adopting meaning to suit acknowledged indirect needs. The terms for such openly "shifty" or "spatial" companions are part of the linguistic repertoire and as such part of rhetoric: from metonymy to allegory, from synecdoche to metaphor, words can and often do derive their power from the fact that they embody spatial characteristics of sorts. But in-and-of-itself, the spatial structure of language only ever extends so far; for it to acquire meaning and power, it needs to be practiced, recognized, and enacted in concrete settings by people familiar with the multiple possible dances around Saussure's dividing line. As Paul

Ricœur has argued in his seminal *The Rule of Metaphor*, metaphors, in particular, can only ever be partially accounted for when understood as a substitutive trope of resemblance; in addition, "metaphor presents itself as a strategy of discourse that, while preserving and developing the creative power of language, preserves and develops the *heuristic* power wielded by *fiction*."[2] And, crucial for our discussion in this chapter, Ricœur goes on to argue that "[t]here are probably no words so incompatible that some poet could not build a bridge between them..."[3] We propose to explore this hermeneutical interpretation of figures of speech in general and of metaphors in particular. We do so from a position that refuses to work from the assumption of a fundamental difference between referential and non-referential language; in so doing, we accord pedagogical value and a pedagogical role to the conscious deployment and use of metaphors (or metaphorical extensions) in the arts, broadly conceived.

Such engagement ought not to be mistaken for an attempt at taming, normalizing, or controlling figures of speech. Read through the lenses of Lacanian psychoanalysis, it remains doubtful whether such an attempt could ever succeed; but even without anyone being in control of the space that allows language to function, languages take roots. Metaphors, in particular, are not an exception to this universal phenomenon; on the contrary, the way in which they acquire and express meanings within their own linguistic confines illustrates the importance of context in processes of communication. The resulting interplay between space—as the structural invisible that allows language to be—and place—as the equally structural visible that allows language to communicate—is what concerns us in this chapter. We contend that it is in this interplay that we can recognize an original form of displacement not as the exception to an otherwise regular form of linguistic "placement" (as the prefix "dis-" would lead us to suspect) or "normality" but as the condition of possibility for meaning to emerge.

Translated into the terminology developed in the present volume, we intend to posit the interplay between space and place as a key contributor to the articulation of the two axes that inform the book's underlying matrix. At the same time, the notion of "interplay" should alert us to the fact that these axes are never fixed but (in-)form a realm of possible articulations: to be human is to be able to oscillate between the adopted poles ("Abstract-Concrete"; "Individual-Collective") along axes that differentiate as much as they provide linkage. We would go further and posit "metaphor" as a mode of being-in-the-world that defines the extent and workings of

both axes; pragmatically speaking, we furthermore sense that a more overtly "spatial" figure of speech allows the interplay between space and place to be more readily acknowledged and discussed; similarly, the focus on one specific metaphor—that of the bridge—will allow us to explore the ramifications of this constellation through a rather well-known and commonly used trope that is both local wherever it is encountered, and eminently "spatial" at the same time. Deployed to denote "linking" attributes of one kind or another, we shall contend that the metaphorical use of bridges often denotes more than what its simple translation into connective relationships approximates. There is, in other words, a linguistic overspill present in the use of spatialized language, an excess that can render any "bridge" in question ambiguous. A metaphorical bridge, in the words of Paul Ricœur, thus identifies something that "is not" and "is like"[4] simultaneously. Crucial for our discussion further on, such a designation accords to such "bridges" a quite specific, if equally metaphoric, form of "home-lessness," rendering them as places that provide neither shelter nor security, to employ a characterization of metaphors in general once coined by Hans Blumenberg.[5] Indeed, the notion of a "figure of speech" aptly summarizes the spatial qualities attaching to this and other tropes since it introduces bodily qualities that resonate in space. The example adopted here further adds to this spatiality by embedding it in a context of relations and mobility: "to cross a bridge" is to be aware of at least two sides that require or invite to be linked in some manner or another. Equally, "to burn bridges" or "to cross a bridge when we get to it" point toward life-path related, relational moments of real or anticipated significance.

As we intend to show in this contribution, the deployment of "bridges" in many cultural contexts serves to articulate a wide range of meanings and effect an equally broad number of responses. Crucial for our discussion—as indeed for the volume as a whole—is the ambiguity or open displacement that results: as boundary *and* link, transition *and* home, non-place *and* rite of passage, bridges function because—to use an expression gleaned from the realm of engineering—their weight-bearing capacity is rooted not in the pretence to singular forms of approximation but across, in-between, and on either side. Here, in the use of metaphors, the modernist ideal of clear-cut differentiations of the "either/or" kind quite regularly gives way to a hypermodern, process-orientated mode of thinking that invites categories of the "both-and" type. We will analyze the uses and repercussions of such spatialized language in a host of different situations before concluding with a series of short reflections on the use-value of such modes

of thinking, especially in transcultural pedagogical contexts. Using concepts and ideas developed most pointedly in the philosophy of Jacques Rancière, our aim is to argue for novel pedagogical practices emanating from an open embrace of symbolic forms of expression in individual and collective teaching practices. This "coda" to our discussion serves as a reminder that learning to address cultural displacements without recourse to some anchor or another is a key facet of any pedagogical practice worthy of our time and effort; embedding this knowledge in concrete, classroom-based practices is perhaps the best approximation of progressive pedagogies we can contemplate and seek to emulate. Our use of two films in the main body of the chapter is also intended to serve pedagogical purposes: working with widely available and iconic media deployments of bridges, we aim to place figures of speech at the centre of learning-based engagements.

BRIDGES AND HISTORICAL MATERIALITY

Mention of metaphors or related figures of speech as spatialized forms of language and of their use in everyday speech firmly places them in the phenomenological tradition. As such, metaphors in particular "serve to link order to place and space not only as a descriptive device, but also as a way of thinking and acting."[6] Paul Ricœur's earlier invocation of metaphor as a "living" engagement (the original French title of Ricœur's book refers to *la métaphore vive*—"the living metaphor")[7] is in line with this approach. Rather than seeing a metaphor as a lesser or predominantly "decorative" form of language, we argue for its irreducible phenomenological and material reality; in this view, metaphors create worlds that from thence serve as structural components for further, future world-making events. They are, in other words, a constitutional part of "situatedness," of being-in-the-world. As such, metaphors are also intimately tied into the workings of culture and power: where they foment, we may and arguably should seek to uncover cultural dynamics at work. We apply this rather familiar logic in the following exposition to a set of material articulations that are used and have acquired meaning, in different contexts. Our focus on the bridge emerges from a conscious choice: its ubiquitous invocation in everyday cultural settings renders it uniquely poised to illustrate the argument sketched above. We aim to develop this further through the material itself: only in practicing language can its spatial qualities emerge and be used.

In using the metaphor of the "bridge," we are keenly aware of the fact that, first and foremost, bridges exist in real terms: they

possess a unique, if historically varied, set of associated materialities, scales, functions, and aesthetics. They are furthermore embedded in histories of different kinds (technological, art historical, functional, aesthetic, personal, etc.) and often survive longer than those surrounding landscapes that necessitated their construction in the first place. Even in this context, however, a context commonly referred to as "real," bridges have historically served functions that have acquired metaphorical meanings within specific cultures, economies, and social settings. Take, for instance, the difference between a modern bridge and the historically resonant reduction in socioeconomic functions directly associated with its contemporary morphology. In associating bridges all but exclusively with "bridging" functions, contemporary linguistic usage merely follows a historical trajectory that has resulted in the building type "bridge" involving little more than a crossing or linking maneuver. However, as any glance at remaining images of Old London Bridge up until 1758[8] or of maps depicting the four Parisian bridges existing until 1604[9] will reveal, bridges were not always exclusively delivering linking functions but existed as multi-functional, hybrid spaces instead. In fact, a medieval, built-over *urban* bridge was considerably more integrated into the surrounding fabric of its day, often inviting a stroll among homes, workplaces, and shops while being itself linked to wider worlds through waters flowing underneath, which in turn provided the raw energy to power watermills. Microcosms, such bridges *also* crossed a river; indeed, they often emerged because a river required a "bridging" function, but were never solely *about* such functionalities alone. Put differently, the isolation of a singular idea ("bridging," "crossing," "linking," or the like) emerging from a real element of the built environment did not resonate then in the same manner in which it resonates with contemporary bridges, inviting us to acknowledge a set of complex material and social constellations also contributing to the material reality of a bridge and of bridges.[10]

Crucial for our present perspective is furthermore an implied but elemental visual quality attaching to bridges: they can be seen, serve visually to link or *bridge*, while also facilitating a view themselves across a river, an urban landscape, or the like. Indeed, the very idea of vision, as Tom Conley has succinctly argued, required that which built-over bridges *could not* provide: a singular, "authored," and direct-able engagement between a modern self and his or her environments.[11] The emergence of such an identifiable standpoint as the condition of possibility for vision to emerge is significant since its adaptation within philosophical writings came not just to mark the

birth of the modern individual in Descartes' second meditation but simultaneously to mark the death knell of more complex, nuanced, and potentially hybrid notions of identity and selfhood that predated Descartes and materialized especially in the writings of Montaigne.

Hence, it is no surprise that bridges have become center points of urban planning and intervention. From the days of Henri IV and the construction of the *Pont Neuf* in early seventeenth-century Paris to present-day plans for a "garden bridge" in London, bridges have inspired and continue to form central innovations within the visible urban fabric. In fact, mention of the *Pont Neuf* and of the statue to the memory of Henri IV placed on its midst can serve as a reminder that the invention of an urban landscape through the creation of identifiable viewpoints on bridges was instantly used by those in power to visually legitimate their grasp of power,[12] while the proposed "garden bridge" points toward a kind of "functional spill-over" attaching to bridges as part of wider urban infrastructures,[13] an observation we can make apropos bridges in most parts of the urbanized world.[14]

CULTURAL SIGNIFICATION AND BRIDGES

With these historical qualifiers in mind, we should be able to contextualize metaphorical resonances attaching to bridges in a much broader and more multidimensional manner. With metaphors in turn resonating more directly with such a multilayered approach, we regard their deployment for analytical, as well as for pedagogical purposes, as second to none. By way of departure, let us note immediately the richness of allusions to bridges across cultural divides. While some of these will form the material backbone of our argument, even a cursory trail across the landscapes of cultural memory will uncover a plethora of representations, references, uses, and invocations that in-and-of-itself appear to point toward an excess of meaning attributable to the notion of "a bridge." We lack the space for a more encyclopedic approach but should like to invoke the hyperbole often attaching to specific bridges as the "eighth"[15] or simply "one of the wonder(s)"[16] of the world, as well as their myriad uses in advertisement, art, and poetry, with the latter, according to Ricœur, presenting perhaps the most widely acknowledged, obvious example of spatialized forms of symbolic expression.

Equally prevalent, however, is the use of bridges to demark a fluid spatial and temporal extension into, from, or across some unknown, as exemplified by the image of a rainbow in many cultures, including the

reference to *bifröst* in the Old Norse prose poem *Edda*. In its most basic form, however, this "unknown" is, of course, encapsulated in timeless references to some afterlife or another. If Greek mythology deployed its Charon to cross the abyss formed by the river Acheron, other cultures depict this transitional space through symbolic invocations of bridges: from the Muslim *Al Sirat*, the bridge as narrow as a hair that joined heaven and earth, to the Inca's "bridge of hairs," or the Shinto *Ama-no-uki-hashi*, the "floating bridge of heaven," the cultural atlas abounds with mythological references to bridges. It is during the Enlightenment that this symbolic expression is increasingly being put into abeyance, when it is not cast aside altogether. Gotthold Ephraim Lessing's ironic use of Albrecht von Haller's earlier heroic reference to Alexander the Great's ("he" in Haller; "a sissy" in Lessing) impossible continuation of war beyond death is emblematic of a changing context, which survives nonetheless in culturally resonant forms to the present day:

> *Was tut der Mann von tausend Siegen?*
> *Die Memme weint, daß dort zu kriegen,*
> *Der Himmel keine Brücken hat.*
>
> How acts that man of a thousand victories?
> The sissy cries, for to wage war there,
> Heaven has no bridges.[17]

If pre-Enlightenment man or woman lacked control over the mythical bridges marking transitions toward some unknown or another world, their modern-day counterparts also meet their angel on a bridge, as perhaps epitomized by George Bailey, played by Jimmy Stewart, in Frank Capra's 1939 film, *It's a Wonderful Life*. More in keeping with the Enlightenment spirit of critique and potential non-metaphysical modes of existence is perhaps the leap of faith that Indiana Jones (played by Harrison Ford) makes across an invisible bridge in *Indiana Jones and the Last Crusade* (1989), the third installment of the well-known cinematic adventure story. Alternatively, we may recognize in the autonomy accorded to a bridge in Franz Kafka's 1916/17 short story of the same name ("Die Brücke"), in which a bridge speaks and acknowledges both time and existence, a thoroughly enlightened attitude and sentiment.

> *So lag ich und wartete; ich musste warten. Ohne*
> *einzustürzen kann keine einmal errichtete Brücke*
> *aufhören, Brücke zu sein.*

> Thus I lay and waited; I had to wait. No bridge, once
> erected, can cease to be a bridge without collapsing.

When eventually trampled upon by modern man and, as a result, collapsing into the abyss, Kafka's bridge metaphor broadens out to become a contemporary reflection on a plethora of possible connotations, including allusions to gender, violence, nature, power, and knowledge, all of which expand, broaden, and negate simple acts of connecting and linking.

Significant in the context of the present discussion is the ambiguity that from thence characterizes the symbolism attaching to bridges. Much as the Pont Mirabeau in Apollinaire's eponymous poem signifies a transitional space, a complex interaction between a materially present "here" and fluid pasts and futures, modern bridges often emerge as ambiguous spaces that rupture as often as they link:

> *Passent les jours et passent les semaines*
> *Ni temps passé*
> *Ni les amours reviennent*
> *Sous le pont Mirabeau coule la Seine*
>
> Pass the days, pass the nights
> Neither time past
> Nor love comes back
> Under the Mirabeau bridge flows the Seine[18]

And if the fluidity of bridge metaphors owes its characteristic at least in part to the proximity of many, if not most, bridges to water, as the physical element to be traversed, this latter element also affords bridges a unique vantage point from which to observe a spatial doubling of sorts: it is on bridges that the mirroring capability of water is perhaps most apparent, creating a reflection that often effectively submerges the materiality of the city within a separating body of water. Henry Wadsworth Longfellow's invocation of the West Boston Bridge in his 1845 poem, *The Bridge*, speaks directly to and about this relationship.

> *I stood on the bridge at midnight,*
> *As the clocks were striking the hour,*
> *And the moon rose o'er the city,*
> *Behind the dark church-tower.*
> *I saw her bright reflection*
> *In the waters under me,*

Like a golden goblet falling
And sinking into the sea.

Eighty-four years later, this "mirroring" capacity is transferred back to the vantage points afforded by the bridge itself in Federico García Lorca's 1929 poem "Sleepless City (Brooklyn Bridge Nocturnal)" (called originally *Ciudad sin sueño*), a phantasmagoric exploration of New York City from what is arguably its most famous bridge. In this poem, an original condition of possibility, perhaps of modernity but certainly of a state shaping the everyday lives of many, is turned sideways out toward a surrounding context, itself all the while masking its own being part of that state: vision, or rather, a panoramic ability to assess, to take in, to survey while standing on bridges reveals urban horrors galore to anyone willing to bear witness but especially to "aquel muchacho que llora porque no sabe la invención del puente" ("that boy who cries because he doesn't know about the invention of bridges").[19]

And, lest we forget, such surveying acts of cruelty do not always leave a surveyor in a passive position: the invocation of the *Pont des Suicides* in what Louis Aragon believed to be the spatial equivalent of the Surrealists' ambitions—the nocturnal landscape of the *Parc des Buttes Chaumont* in Paris denying the rhetorical power of the *ainsi* or "thus"[20]—points toward a space revealing that "toute vérité m'atteint que là où j'ai porté l'erreur" ("truth lay folded between the errors I carried within me").[21]

If poetry employing bridge-related symbols begets its own spatialities, these latter far from exhaust the kind of *work* this particular metaphor can accomplish. Our prior passing allusion to film may have opened a door in this respect; as a distinctly modern technology, we would expect film to produce its own spatial allusions and open novel possibilities. In saying this, we acknowledge that metaphors in film, as in other pictorial media, ought to be analyzed differently due to undeniable a priori structural differences between image and text; as a result, any contextualization of "bridges" as pictorial, rather than linguistic metaphors, is beset with a considerable amount of questions and concerns. At its most basic, any invocation of spatiality within the realm of pictorial metaphors is immediately rendered banal and inconsequential because it merely postulates an ever-present condition of possibility of their very existence: constitutionally, film cannot *not* be metaphorical. And yet, unable not to speak or write about images (photographs, films, paintings, and so on), lest images would speak for themselves, we would appear to have to enter into a relational,

spatially constituted rapport between image and word, a rapport that we contend is often metaphorical along a host of axes and contexts. Furthermore and technically, this relational process is further complicated by the fact that the cinematic presence of a bridge is also inevitably preconfigured through a written invocation, be that in a written script or, as in one of our examples, in a novel adapted to film. Our discussion below, however, should not be read as an extension of arguments attaching to the "metaphoric" nature of film as such.[22] Rather, we wish to employ the displacement ascribed to the work emanating from, through, and on bridges in films critically to allude to what are ultimately pedagogical imperatives. Ambiguity attaching to substitutions, we contend, materializes as a key tension that works by being recognizably present while also being "like" something else, even if this "something else" is *also* a bridge.

THE SPATIALITY OF FIGURATIVE EXPRESSIONS: TWO CASE STUDIES

To demonstrate these tensions and ambiguities in the following pages, we should like to reflect on distinct deployments of a bridge in two well-known films: *Die Brücke*, a German-language film directed by Bernhard Wicki, and *Les Amants du Pont-Neuf*, a 1991 French-language film by Leos Carax. In Wicki, the "something else" alluded to above is the postwar German consensus bridging the Third Reich into a kind of invisible state; in Carax, it becomes part of a postmodern critique of an ocular-centric consumerism. We have adopted these two examples for their pedagogical value but also because the spatialities emanating from their use of a bridge are remarkably dissimilar and thus allow for a wider discussion attaching to symbolic expression more generally.

Bernhard Wicki's compelling antiwar film *Die Brücke* (*The Bridge*, 1959) is an adaptation of a third-person autobiographical novel by the journalist Manfred Dorfmeister, which was written in 1954 and eventually published in 1958 under the same title but using the pseudonym Manfred Gregor. The place alluded to in the title refers to a strategically insignificant bridge that a group of seven German boys of 15 or 16 years of age, having been drafted into the Wehrmacht during the final days of the Second World War, are ordered to defend against advancing American troops. Approaching the unnamed bridge and donning their oversized Wehrmacht uniforms, a *rite de passage* is set in motion involving all seven young soldiers. Rites of passage, as defined by Arnold van Gennep in 1908, include the journey from the liminal

space of boyhood through to manhood[23]; it is in this ambiguous place that both novel and film situate their narratives. As a journey, however, the paths of all seven boys remain unfinished, ending for six of them in a paralysis of pain and death.[24] For the only surviving boy—he who later becomes the author of the book—the memory of his friends' fears and gaping wounds, and of their lifeless and torn bodies as they lay on and around this minor German bridge, continues to be an eternal hell from which there is no escaping, as the author states in the afterword to his novel.[25]

The metaphor of the bridge is thus a tangible, if ambiguous, one, and becomes apparent even in this all-too brief synopsis: facilitating a largely incomplete journey in both filmed life and in the form of a rite of passage, its "bridging" function is disrupted while remaining visible throughout the film. A similar metaphorical interpretation would attach to the link provided between the dying moments of Nazi Germany's hold on the German people and the postwar silence characterizing especially the 1950s, in the era of West Germany's economic miracle, or *Wirtschaftswunder*. If this silence is pierced by the boy's screams on the bridge toward an increasingly certain future not attained by six of seven boys, it also provides the impetus for writing the novel in the first place. As its author recounted in an interview many years after the book's publication, it also became formative in the memory of a German woman dressed in black that he encountered when returning to the bridge the day after the battle, and whom he saw spitting on two of his dead friends, whose bodies were still lying on the bridge.[26] Not knowing whether it was disgust at their efforts that ended up needlessly prolonging the war and causing unnecessary destruction or, more generally, at their dogged support of this insane regime, that prompted this act of contempt, the memory of this incomprehensible, heartless action shocked the surviving boy at the time and impelled Gregor/Dorfmeister to write almost a decade later. With his text, he hoped to create an epitaph to his six friends, evoking their upbringing, their boyish charms and games, their naïveté, and their final demise in light of the inescapable horror of war.

In his adaptation of the text, Bernhard Wicki makes no mention of disdain for these boys but also leaves out any hint of valiant behavior in battle or heroic action on their part. The film opens with a close-up of flowing river water and the sound of an approaching airplane. As a bomb is dropped and explodes in the river, the camera tilts up to show the force of the explosion and the bridge above. The title of the film *Die Brücke* then appears superimposed on the bridge as the sound of sirens warns of imminent danger. Wicki here not only introduces

the place of the film narrative, but already focalizes on the rupture created by war and subsequent silence. He relates the bridge—as a space of needless suffering and death—to the countless crimes of the Hitler regime that should be acknowledged and addressed in a post-war Germany, which presented itself in the form of two competing states arguably in need of another linking device to heal postwar legacies and interpretations. If a divided Germany was ever to become a "home" again, a bridge needed to be built to that painful, horrifying past laden with German guilt. By eliminating both heroism and disdain, Wicki focuses our attention specifically on the deaths of and pain suffered by indoctrinated German children, on the selfish crimes of fearful adults, on the destructive mechanisms of the Hitler regime, and, more generally, on the insanity of war.

We see a clear pedagogical intent to Wicki's visual representation of the events as they unfold on and around the bridge. He mirrors Germany's moral and material collapse in close-ups of terrified and weeping, seriously wounded, and dying boys in oversized uniforms, and directly addresses some of the roots of the country's displacement both within and outside its new borders, in an effort to critically engage the audience and promote an antiwar message. As the camera retreats from the bridge littered with dead children and men in the closing sequence of the film, the loss of identity and home this country would have to face—Blumenberg's *Heimatlosigkeit* alluded to earlier in this chapter—becomes emblematic in the bridge's materiality. Wicki's metaphorical and actual use of a bridge, which could be anywhere in Germany and remains geographically undefined, becomes a "living" engagement, to evoke Ricœur's term once again, reconnecting the country's present (the time of the release of both book and film) with the past (the time of the events unfolding in either cultural representation). Here, in other words, the materiality of the bridge becomes one with its metaphorical and symbolic expression all the while rendering this "oneness"—the idea of a symbolic match between "origin" and metaphorical appropriation—multifaceted and ambiguous.

The bridge, serving as a symbol of both the human ability to unite that which is separate and of a separation of that which is united,[27] here functions as a threshold, a signifier of the milieu of the boys' *rite de passage* that does not lead to manhood but to death, highlighting this *other* threshold, the hell and void of the Hitler era and the Second World War that had been separated from 1950s German consciousness. Wicki's representation of the events described in Gregor's novel and the focalization on the materiality of the bridge emphasizes

the antiwar film's message that bridges into the past must be built in order to create the possibility of a decent future, and this rests entirely on the audience's willingness to acknowledge and critically reflect on the past.

We encountered our second example, the bridge central to Carax's film *Les Amants du Pont-Neuf* (*Lovers on the Pont-Neuf*, 1991), earlier in this chapter. The *Pont Neuf* formed an integral part of Henri IV's conscious transformation of the French capital during his reign between 1593 and 1610. Given its central location within the Parisian urban morphology, the inclusion of the Pont Neuf in many films as one among many locations will not surprise anyone (the most recent instance of which is the 2002 thriller, *The Bourne Identity*); *Les Amants du Pont Neuf*, however, accords the bridge a centrality not captured by the mere invocation of "a location." The story told in the film is a simple one. Alex (Denis Lavant), a young homeless and drug-abusing street artist with a shaven head to banish lice, meets Michèle (Juliette Binoche), a young bourgeois painter suffering from a degenerative eye disease and determined to sketch in the streets until she goes blind, on the Pont Neuf in Paris after returning from a night in a municipal facility. Together with an older *clochard*, Hans (Klaus-Michael Grüber), the three continue to inhabit the bridge, which was closed to the public at the time during a period of extensive restoration. The three make a living from petty theft (Alex and Michèle spiking drinks in cafés to steal the purses of sleeping Parisians) and live through the celebrations of the bicentennial of the French Revolution in 1989. The courtship between Alex and Michèle—which sees them drinking cheap red wine, riding the Métro, and briefly escaping to the sea—is disrupted when a two-year stay in prison separates the two, a time during which Michèle's ailment is cured. Importantly, Alex's conflict with the law is caused by his desire to preserve the status quo: while setting fire to search posters displayed all over Paris announcing that a cure had been found for Michèle's eye disease, a billsticker dies accidentally. A dramatic *happy end* reunites the two on the bridge and leads them toward an uncertain, open future when they both jump into the Seine and are picked up by a passing river boat.

It should be noted right away that the ending is a pure homage to the closing moments of Jean Vigo's 1934 utterly poetic film, *L'Atalante*, with its allusion to an open-ended escape by two reunited lovers on a river boat. More central to our present discussion, however, is the ironic and metaphorical deployment of the Pont Neuf in the film. Here the "is not" and "is like" invoked by Paul

Ricœur become fully submerged in a seemingly self-identical and straightforward place: the Pont Neuf in Paris, announced in the title of the film and providing the anchor for much of the film's unfolding story. It is important to remember that the Pont Neuf occupies a recognized place not just in the French capital but in French culture more generally, as exemplified by numerous etchings of the bridge throughout the centuries, by poems and stories (culminating in "Sur le Pont Neuf j'ai rencontré" by Louis Aragon), as well as several Impressionist paintings (Camille Pissarro, Pierre-Auguste Renoir, Claude Monet, and others), by photographs (Brassaï, Henri Cartier-Bresson, and others), and by films (such as Robert Bressons's 1971 *Quatre nuits d'un rêveur, Four Nights of a Dreamer*). As such, it is a bridge *known* to many, providing a recognized "is" as a point of departure: if in the seventeenth century "faire le Pont Neuf" implied doing something extraordinary,[28] later on "se porter comme le Pont Neuf" implies to be in rude health, according to a well-known French proverb. However, the work accomplished by the film—or rather by the images and stories that make the film—is the subversion of any semblance of a tautological identity, achieved by placing the bridge in a series of image-dependent analogies, that is, similes and metaphorical allusions. For instance, we encounter the bridge in a state of abeyance: it is taken out of circulation by not being used as a bridge—knowledge about bridges to the contrary, this one, here, does not link or connect. One of the earlier shots including the bridge makes clear its temporary status (as "undergoing restoration") by including a large traffic sign alluding to its provisional closure. But the suspension of the bridge's "is" does not stop with the absence of cars, buses, and humans traversing the Seine at this pivotal site. By simultaneously providing, for the duration of the film until its eventual denouement, a home for the three main protagonists, the film furthermore visually merges "is" and "is like" into a heretofore never present "is not." The Pont Neuf, we remember, was the first postmedieval bridge in Paris not to be financed through houses built on either side of its thoroughfare main axis; the resulting mono-functionality, although occasionally challenged throughout the ages, remains an epoch-begetting novelty in the annals of urban functional morphologies.[29] On the bridge, Alex, Hans, and Michèle find a temporary home when the absence of houses was—and soon will be again— a defining characteristic of this "new" bridge that now happens to be the oldest bridge existing in Paris. Carax's openly spatial allusion will form an explicit reference point in Patrice Leconte's 1999 black-and-white *La fille sur le pont* (*Girl on the bridge*) when, early in the film, a suicidal Adèle (Vanessa Paradis) says

to Gabor (Daniel Auteil), a passer-by, that "I don't live on bridges" only to hear the telling riposte, "I do."

The absence of traffic and the presence of a temporary home for SDF (*sans domicile fixe*, or homeless) persons on the bridge is matched by a third filmic inversion of the historical presence that "is" the Pont Neuf. As we have stated earlier, the construction of the bridge formed a central condition of possibility for the invention of urban landscapes through the facilitation of an uncluttered and unobstructed view from the bridge. The visually spectacular style of *Les Amants* repeatedly pays homage to this historical development; at the same time, however, it subverts it when its central storyline revolves around the threat of blindness afflicting the female character in the film. In between, and thus working with and around a most fragile spatiality, the film becomes a candid metaphor of modernity: the threat of blindness that hangs over Michèle is the threat of becoming other, of no longer being able to function according to socially established norms. By portraying this peril as a necessary if not at all sufficient condition of love, Carax renders one of the Gordian knots of modernity visible. Its solution, however, remains a violent choice that in the film is portrayed by the final leap into an invisible unknown; just as the written word in *spoken* communication becomes visibly erased, any attempt that we make to solve the problems relating to vision in a *visual* manner will always eventually encounter its conditioning other in risk.[30] What are perhaps the most direct of attempts at taking the condition of visual possibility out of circulation—if only for two weeks in the form of Christo and Jeanne-Claude's "wrapping" of the Pont Neuf in 1985—has to have recourse to the material and metaphorical use of cloth to accomplish its goals: "The concealment caused by the fabric challenges the viewer to reappraise the objects beneath and the space in which it exists."[31]

After this, it will not come as a surprise to see that the spatialized figure of speech the Pont Neuf has become forms the penultimate of sites in Bruno Latour's 1998 project *Paris: Invisible City*. Here Latour picks up the context that allowed *Les Amants* to work on its metaphorical place: a bridge taken out of circulation. In Latour, the allusion is to the "perpetually renewed work on the Pont-Neuf,"[32] literally leaving no stone untouched:

> To replace every stone worn by time there's a new stone, carved in an open-air workshop on the Quai des Orfèvres by a sculptor, an expert in the trade. Physiologists claim that the body lasts several decades owing to movement in which each cell is replaced by a flow of fresh proteins

to occupy the exact place and function of the aged cells whose debris scatters in the wind. For a biologist the living body therefore differs from a stone bridge only in the pace of its renewal.[33]

Among the "stones" customarily replaced must also be counted the paves or cobblestones that secure its surface against the elements. On the Pont Neuf, these not only mark the site of the first roadway in Paris to be thoroughly paved in its entirety,[34] they also partake in another metaphorical legacy of French culture in the form of an infamous slogan used during the May 1968 student rebellion: *Sous les pavés, la plage!* ("Under the cobblestones, the beach!"). *Les Amants* plays with these allusions to renovation and revolt: an early shot displays a mound of cobblestones removed from the surface of the bridge, while a weekend getaway by Michèle and Alex to an unnamed beach becomes a totemic image of freedom and sexual liberation.

Wicki's deployment of an unnamed bridge as a singularly resonant space that comes into its own metaphorically, as well as Carax's historically resonant, multilayered use of a real existent bridge, directly demonstrate what we should like to call, somewhat paradoxically perhaps, *the singularity of spatial ambiguity.* Noël Carroll alludes to this characteristic when applying the term "homospatiality"[35] vis-à-vis filmic metaphorical representations, an analytical possibility we regard as being presented by both films. The term "homospatiality," as derived from the work of the French mathematician and engineer Henri Poincaré, was introduced into the human sciences by Albert Rothenberg, according to whom, "[h]omospatial thinking consists of actively conceiving two or more discrete entities occupying the same 'space,' a conception leading to the articulation of new identities."[36] In both films discussed here, a bridge carries the weight of a complex series of allusions and resonances that extend within and across literature, film, and history; both bridges accentuate the eminently spatial relationship between "being" and "being like" to advance a unique form of critique.

We could argue that this idea finds a counterpoint outside of filmic representations in a series of postcards produced by the Welsh artist Tim Davies in which he eliminated anything resembling context, concentrating instead solely on the recognizable materiality of specific existing bridges. The resulting "floating" images thus stress the modern act of "bridging" while leaving the "to-be-bridged" unrepresented (see figure 3.1).

Here, in other words, the metaphorical value of a bridge resides in its ability not to connect but to become a connection *itself,* not

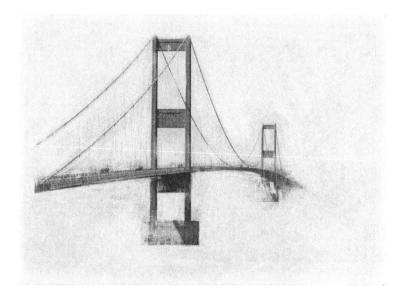

Figure 3.1 Tim Davies, *Severn Bridge*, from the series *Bridges*, 2009

to emphasize that which requires a *bridge* but that which *bridges*. This move from noun to verb exemplifies the work that metaphors can achieve, whether they are anchored in reality or not. Or they may be both anchored in reality and not anchored in it, as the multilayered examples of two bridges in the former Yugoslavia, the *Mehmed Paša Sokolović* Bridge in Višegrad and the *Stari Most* in Mostar amply demonstrate: the former created the template for Ivo Andrić's novel, *Bridge on the Drina*, while the latter acquired universal meaning when it was destroyed during the Bosnian conflict in 1993.

Freed from direct and exclusive connective contexts, bridges are then able to metaphorically express substantive novel meanings. Take, by way of example, Gustav Deutsch's use of bridges spanning the Parisian *Périphérique* ring-road in his 1988 short *Non, je ne regrette rien (Der Himmel über Paris)*. In this film, instead of linking the city of Paris to its surrounding hinterland, bridges disrupt an ongoing, pointless journey, and dissect it by restarting Edith Piaf's signature song every time the vehicle passes underneath a bridge. What is more, this dialectical inversion of the "bridging" motif is not visible as such but becomes apparent only when experienced in conjunction with its accompanying soundtrack: bridges, it would appear, can indeed

Figure 3.2 Gustav Deutsch, still from the short film *Non, je ne regrette rien* (*Der Himmel über Paris*, 1988), short film, 1988

resonate metaphorically in ways that exceed purely visual articulations (see figure 3.2).

Alternatively, we could consider the eponymous use of bridges by the German expressionist group *Die Brücke*. As one of its founders, Karl Schmitt-Rottluff reminisced, it was the complexity of the term, its embeddedness within concrete metaphorical meanings that did not prescribe a program while reaching toward an uncertain future, that recommended it to the group.[37] Reality, too, was not far from this invocation of space; founded in the city of Dresden in 1905, which had been represented through the pictorial incorporation of its bridges across the Elbe since the days of Canaletto, the group of artists played on the historical and local multilayeredness of the "bridge" metaphor in more than one sense.

We could continue, as indeed a separate book devoted entirely to spatiality and symbolic expression in bridges would and should. From the recent and direct deployment of the Øresund Bridge in the TV series *Bron/Broen*, to largely implied allusions to bridges using both bridges and non-bridge-like "bridging gestures" in the form of materializing travel trajectories in Fatih Akin's film *Auf der anderen Seite/Yaşamın Kıyısında* (*The Edge of Heaven*, 2007), or to

symbolizing emotional links between Nazi and post-Nazi Germany in Helmut Käutner's film *Unter den Brücken* (*Under the Bridges*, 1946) and his *Die letzte Brücke* (*The Last Bridge*, 1954)—a potential list of material inclusions could be rather exhaustive and potentially none-too-telling. We are confident, however, that any such study examining the topic of bridges would exemplify two principles guiding symbolic expression. On the one hand, following Ricœur, we can witness the unfolding of an open but circular spatiality that reconnects, however partially, a metaphor with its originating materiality. On the other hand, following Derrida, we can simultaneously observe the many accidents, differentiations, and accumulations of "added value" that metaphors produce.[38] These two principles attaching to metaphorical spatiality ought not to be misread as constituting a duality of concerns or practices that could be ordered. Rather, they create an attempt to afford metaphors a life of their own, without succumbing to the ever-present temptation of resolving these possibilities into a type of Hegelian synthesis by invoking either an author or director "in control" or a guiding linguistic principle capable of "ordering" a constitutive spatiality.[39] Instead of order (a subcategory of the economy, according to Derrida), we propose dialogue or debate: thoroughly pedagogical practices, both.

CODA

Our efforts at unpacking cultural meanings through the lens provided by bridges that are at once real, represented, and metaphorical, have led us to a final threshold: the conscious deployment of such meanings, articulations, and processes in the classroom, or in other pedagogical environments. Here we are particularly interested in the transcultural significations arising from work with bridges; virtually all of the examples invoked and used in this chapter have been creatively deployed in our own pedagogical endeavors in numerous classrooms in Europe and beyond.[40] Indeed, we would invite readers to think about progressive classroom-based activities involving bridge-building exercises within a host of differently articulated practices. Contrasted with a hierarchical vision of the classroom, with its dominant notions of "up-skilling" and "adding value" to the student-as-client (where it does not embrace a no-less-prevalent ethos of social engineering), we should like to use this final part of our chapter for a brief discussion of an openly spatialized, progressive pedagogy. Bridges, we contend, are particularly useful in this context seeing that their metaphorical content may appear to be unambiguously tied to a "bridging" function;

as "homospatial" metaphors, they point toward a possible place that is at once weight-bearing while not providing a settled home or space of control; they oscillate between the polar opposites introduced in the Introduction to the present volume. Being at once "abstract" and "concrete" while continuously bridging between "individual" and "collective," they invite the formulation of new definitions and practices. This view mirrors that of Richard Rorty's conceptualization of metaphor as a different way of seeing than could have been produced in their absence.[41]

Crucially, use of the bridge as a metaphor allows for a doubling of this displacement. Its homospatial qualities are of a different kind than the one alluded to by Carroll; whereas for him, key to the work accomplished by and through the bridge is the process of disenchantment—"confronted with an obviously false statement the listener searches for some other significance that it might have"[42]—the bridge functions precisely by working on the basis of familiar, perhaps even all-too familiar, references. Here, in other words, metaphor attaches not to an obvious linguistic displacement but to the multilayeredness of its inherent spatiality. Derrida's invocation of Heidgggger's notion of *Geflecht* or "interlacing"[43] is perhaps as good an approximation of the resulting plurality in singularity as we are likely to achieve: a different kind of *e pluribus unum* that allows for the "one" to be continuously challenged by the "many."

In other, collectively resonating, terms bridges here hold the promise of becoming the antithesis to the proverbial box we occasionally pretend to want to break free of, or that we invite our students critically to engage with. On a bridge, we are "in-between"; in a classroom, what better place to teach as an aspirational, new home? Practically speaking, "bridges" here become, in the words of the German pedagogue Klaus Prange, "hinges between showing and learning"[44]: they embody at once the spatiality that has been central to our argument and the impossibility of a metaphor in the absence of originary gestures.

Concretely, we maintain that the familiarity of the bridge and its uncomplicated, often intuitive, "transport" into the metaphorical realm provide an ideal vehicle for the kind of egalitarian pedagogical practices envisaged by Jacques Rancière, especially in his 1987 book *Le Maître ignorant: cinq leçons sur l'émancipation intellectuelle* (*The Ignorant Schoolmaster: Five Lessons in Intellectual Emancipation*).[45] According to Rancière, presupposing equality involves the formulation of practices that "give, not the key to knowledge, but the consciousness of what an intelligence can do when it considers itself

equal to any other or considers any other equal to itself."[46] Embarking on a journey toward learning not from a secure vantage point of categorically secured knowledge working itself back toward a student body but starting with and from a shared metaphorical approximation offers a genuine advantage in this respect. *From there, work ensues:* work toward an understanding that need not reaffirm a preestablished vanishing point or *telos* but sees itself contributing to the formulation and material shaping of the same. Pedagogy here becomes almost the antithesis to policy in remaining stubbornly situated and anchored in those concrete materials available locally.[47] The cumulative effect of engaging in such activity would lead to the invention in a classroom of those practices required for active citizenship.

On a metaphorical bridge, we suggest, things can thus be other than they are or appear to be. Freed from exclusive references to some or other "bridging" functionality, while still remaining utterly familiar, the spatiality we have explored throughout this chapter furthermore invites a pedagogical assessment of what Rancière conceptualized as the *partage du sensible*, the "distribution (or partition) of the sensible": a kind of naturalized pregiven order or condition of possibility that resembles Michel Foucault's *episteme* in all but temporal extension.[48] In working from the metaphorically known place "in-between"—the bridge under discussion in the present chapter— toward a critical interrogation of (cultural, social, technological, and economic) spaces to-be-connected, that which heretofore was deemed to be logical, natural, or simply existing can be rendered strange or possibly different. Pedagogically, such a method would amount to an inversion of what Rancière analyzed under the heading of "symbolic montage" in his 2003 *Le destin des images* (*The Future of the Image*; the example used in the book is of Jean-Luc Godard's later work):

> Between elements that are foreign to one another it works to establish a familiarity, an occasional analogy, attesting to a more fundamental relationship of co-belonging, a shared world where heterogeneous elements are caught up in the same essential fabric, and are therefore always open to being assembled in accordance with the fraternity of a new metaphor.[49]

Rancière himself developed this line of reasoning further in his 2008 *Le spectateur émancipé* (*The Emancipated Spectator*) in which he introduced the notion of a "pensive image," which is characterised by its "dis-appropriate similarity,"[50] a concept highly reminiscent of Poincaré's "homospatiality" discussed earlier in this chapter. For us, this "pensive" image captures much that is at stake in thinking the

spatiality of the bridge as a form of symbolic expression: it charac-
terises "a zone of indeterminacy" between "the common notion of
the image as duplicate of a thing and the image conceived as artistic
operation."[51] The bridges we discussed in this chapter, but espe-
cially those conceived by Wicki and Carax, dwell in and unfold their
visual and metaphorical power in this zone, while acknowledging that
as a zone, this form of indeterminacy characterizes intimately famil-
iar ground. In this configuration, a symbolic bridge marks a form
of mobility that transcends simple acts of "crossing" or "bridging";
rather, it moves from that which is familiar to that which is not. In the
terminology employed by Simmel (discussed earlier in this chapter),
it oscillates between "bridge" and "door," and it is arguably in this
manner that learning is transformed, that is, by becoming part of
critique. For us, such a pedagogy is highly reminiscent of the "syl-
labus growing" set of practices emanating from Olafur Eliasson's
Institut für Raumexperimente (*Institute for Spatial Experiments*) in
Berlin.[52] In experiments of the kind explored by Eliasson and his
team, the cultural centrality of seeing—seeing *from* bridges and *seeing*
bridges—is rendered ambiguous from a shared and thus unambigu-
ous starting position. Between individual and society, and drawing
from both, at once abstract and concrete, bridges exemplify what
such a nonhierarchical, genuinely progressive pedagogy might be able
to accomplish. In keeping with the theme of the bridge and the
visually anchored metaphorical language it inspires, we may refer to
this goal as aiming to "emancipate" spectators capable of translating
between metaphors[53]—and what better goal for educational activity
to aspire to?

ACKNOWLEDGMENTS

We should like to thank both Tim Davies and Gustav Deutsch for the
generosity they bestowed upon us by answering our questions and
allowing us to use their works in the production of this chapter.

NOTES

1. See Gunnar Olsson, "The Social Space of Language," *Environment
and Planning D: Society and Space*, 5, 1987: 249–62.
2. Paul Ricœur, *The Rule of Metaphor: The Creation of Meaning in
Language*, translated by R. Czerny (London: Routledge, 1978), p. 5.
3. Ricœur, *The Rule of Metaphor*, p. 111.
4. Ricœur, *The Rule of Metaphor*, p. 6.

5. It is not insignificant that Blumenberg uses the Heideggerian noun "Heimatlosigkeit," rather than the more widely used German term "Obdachlosigkeit." See Hans Blumenberg, *Schiffbruch mit Zuschauer: Paradigma einer Daseinsmetapher* (Frankfurt am Main: Suhrkamp, 1997), pp. 93–94.

6. Tim Cresswell, "Weeds, Plagues, and Bodily Secretions: A Geographical Interpretation of Metaphors of Displacement," *Annals of the Association of American Geographers*, 87, 2, 1997: 330.

7. See Paul Ricœur, *La métaphore vive* (Paris: Le Seuil, 1975); English Translation: *The Rule of Metaphor: The Creation of Meaning in Language* (London: Routledge, 1978).

8. See Patricia Pierce, *Old London Bridge* (London: Headline, 2001).

9. See Ulf Strohmayer, "Bridges: Different Conditions of Mobile Possibilities," in T. Cresswell and P. Merriman (eds) *Mobilities: Practices, Spaces, Subjects* (Farnham, Surrey: Ashgate, 2010), p. 123.

10. See Ulf Strohmayer, "Engineering Vision: The Pont-Neuf in Paris and Modernity," in A. Cowan and J. Steward (eds) *The City and the Senses: Urban Culture Since 1500* (Basingstoke: Ashgate, 2007), pp. 75–92.

11. Tom Conley, *The Self-Made Map. Cartographic Writing in Early Modern France* (Minneapolis: University of Minnesota Press, 1996), pp. 179–86.

12. See Strohmayer, "Bridges: Different Conditions of Mobile Possibilities," pp. 119–36.

13. Rowan Moore, "London's Garden Bridge: Barking Up the Wrong Tree?" *The Guardian*, September 14, 2014, www.theguardian.com/artanddesign/2014/sep/14/london-garden-bridge-barking-up-wrong-tree.

14. See, for instance, for Frankfurt am Main in Germany, Albert Speer, "Frankfurt ist ein Modell für die Welt," *Frankfurter Allgemeine Zeitung*, August 24, 2013, www.faz.net/aktuell/wirtschaft/staedteplaner-albert-speer-frankfurt-ist-ein-modell-fuer-die-welt-12545484.html.

15. Richard Haw, *The Brooklyn Bridge: A Cultural History* (New Brunswick: Rutgers University Press, 2005).

16. Patricia Pierce, *Old London Bridge* (London: Headline, 2001).

17. Own translation. Other translations in this chapter are also by the authors, unless otherwise indicated.

18. English translation: Charles Bernstein, *Recalculating* (Chicago: University of Chicago Press, 2013), p. 161.

19. Trans. G. Simon and S. F. White; see Julia Kasdorf and Michael Tyrell (eds), *Broken Land: Poems of Brooklyn* (New York: NYU Press, 2007), pp. 45–46.

20. See Louis Aragon, *Nightwalker*, translated by F. Brown (Englewood Cliffs, NJ: Prentice Hall, 1972), pp. 184–85; the bridge features in segment XIV, 204–14.

21. Aragon, *Nightwalker*, p. 93.
22. See Trevor Whittock, *Metaphor and Film* (Cambridge, MA: Cambridge University Press, 1990) for a concise early summary, and both Noël Carroll, "A Note on Film Metaphor," *Journal of Pragmatics*, 26, 1996: 809–22, and Charles Forceville, "The Identification of Target and Source in Pictorial Metaphors," *Journal of Pragmatics*, 34, 2002: 1–14, for developments of the underlying psychological logic.
23. See Victor Turner, *From Ritual to Theatre: The Human Seriousness of Play* (New York: PAJ, 1982), p. 24.
24. For further analysis see Christiane Schönfeld, "Representing Pain in Literature and Film: Reflections on *Die Brücke (The Bridge)* by Manfred Gregor and Bernhard Wicki," *Comunicação & Cultura*, 5, 2008: 45–62.
25. Manfred Gregor, *Die Brücke* (Munich: DVA, 2005), p. 211.
26. As cited in Christiane Schönfeld, "Erfolg und Misserfolg von Verfilmungen: Manfred Gregors *Die Brücke* und die Nahaufnahmen des Krieges in Kino und Fernsehen," *Germanistik in Ireland*, 7, 2012: 99–100.
27. See Simmel, "Brücke und Tür," *Der Tag. Moderne illustrierte Zeitung*, 2.
28. Jacques Zimmer, "Les Amants du Pont-Neuf: Histoire de l'oeil," *La Révue du Cinéma*, 475, 1992: 22.
29. See Margorie Nice Boyer, *Medieval French Bridges: A History* (Cambridge, MA: The Medieval Academy of America, 1976), and Hillary Ballon, *The Paris of Henri IV: Architecture and Urbanism* (Cambridge, MA: MIT Press, 1991).
30. See Jacques Derrida, *Mémoires d'aveugle: L'autoportrait et autres ruines* (Paris: Réunion des musées nationaux, 1990), p. 11.
31. Adam Blackbourne, quoted in Megan Koboldt, "I Feel like the New Bridge: A Geo-Historical Analysis of Christo and Jeanne-Claude's *Le Pont Neuf Wrapped*, 1975–85," *Site*, 95 2, 4, 2013: 44–47.
32. Bruno Latour and Émilie Hermant, *Paris ville invisible*, quoted from the English translation by Liz Carey-Libbrecht and Valerie Pihet (2006), www.brunolatour.fr/sites/default/files/downloads/PARIS-INVISIBLE-GB.pdf, p. 99.
33. Latour and Hermant, *Paris ville invisible*, p. 99.
34. See Ulf Strohmayer, "Engineering Vision: the Pont-Neuf in Paris and Modernity," in A. Cowan and J. Steward (eds) *The City and the Senses: Urban Culture since 1500* (Basingstoke: Ashgate, 2007), pp. 75–92.
35. Carroll, "A Note on Film Metaphor," 811 and passim.
36. Albert Rothenberg, "Visual Art: Homospatial Thinking in the Creative Process," *Leonardo*, 13, 1980: 18.
37. As quoted in Ulrike Lorenz and Norbert Wolf (eds), *Brücke: Die deutschen „Wilden" und die Geburt des Expressionismus* (Köln: Taschen, 2008), p. 6.

38. Jacques Derrida, *Margins of Philosophy*, translated by A. Bass (Chicago: University of Chicago Press, 1982); see in particular "White Mythology: Metaphor in the Text of Philosophy," pp. 207–72; see also Derrida's "The *retraite* of Metaphor," in P. Kamuf and E. Rottenberg (eds) *Psyche: Inventions of the Other* (Stanford: Stanford University Press, 2007), pp. 48–80; Leonard Lawlor, *Imagination and Chance: The Difference between the Thought of Ricœur and Derrida* (Albany: SUNY Press, 1992), and Eftichis Pirovolakis, *Reading Derrida and Ricœur: Improbable Encounters between Deconstruction and Hermeneutics* (Albany: SUNY Press, 2010).

39. Jacques Derrida, "White Mythology: Metaphor in the Text of Philosophy," in *Margins of Philosophy* (Chicago: University of Chicago Press, 1982), pp. 268–69.

40. For a particular example of such a transcultural deployment see Moray McGowan, "Brücken und Brücken-Köpfe: Wandlung einer Metapher in der türkisch-deutschen Literatur," in Manfred Durzak and Nilüfer Kuruyazici (eds) *Die andere Deutsche Literatur: Istanbuler Vorträge* (Würzburg: Königshausen & Neumann, 2004), pp. 31–40.

41. Richard Rorty, *Contingency, Irony, and Solidarity* (Cambridge, MA: Cambridge University Press, 1989), p. 16 and passim.

42. Carroll, "A Note on Film Metaphor," 813.

43. Derrida, "The *retraite* of Metaphor," p. 60.

44. Klaus Prange, *Die Zeigestruktur der Erziehung: Grundriss der operativen Pädagogik* (Paderborn: Schöningh, 2005), p. 109.

45. Jacques Rancière, *Le Maître ignorant: cinq leçons sur l'émancipation intellectuelle* (Paris: Fayard, 1987); *The Ignorant Schoolmaster: Five Lessons in Intellectual Emancipation*, translated by K. Ross (Stanford: Stanford University Press, 1991).

46. Rancière, *The Ignorant Schoolmaster*, p. 68.

47. Oliver Davis, *Jacques Rancière* (Cambridge, MA: Polity, 2010), p. 31.

48. See Michel Foucault, *The Archaeology of Knowledge*, translated by A. M. Sheridan Smith (London: Tavistock, 1972), p. 191; see also Gabriel Rockhill, "The Silent Revolution," *SubStance*, 33, 1, 2004: 54–76; on the difficulty of translating Rancière's term, see Joseph Tanke, "Why Rancière Now?" *Journal of Aesthetic Education*, 44, 2, 2010: 5.

49. Jacques Rancière, *The Future of the Image*, translated by G. Elliott (London: Verso, 2007); see Toni Ross, "Image, Montage," in J.-P. Deranty (ed) *Jacques Rancière: Key Concepts* (Durham: Acumen, 2010), p. 166.

50. Jacques Rancière, *The Emancipated Spectator* (London: Verso, 2009), pp. 116 and 121.

51. Rancière, *The Emancipated Spectator*, p. 107.

52. See in particular the set of practices detailed by Eric Ellingsen in "Syllabus Growing," *Institut für Raumexperimente*, www.

raumexperimente.net/single/syllabus-growing/introduction [accessed January 12, 2015].
53. See Rancière, *The Emancipated Spectator.*

Bibliography

Aragon, Louis. *Le paysan de Paris* (Paris: Gallimard, 1926).
———. *Nightwalker*, translated by F. Brown (Englewood Cliffs, NJ: Prentice Hall, 1972).
Ballon, Hillary. *The Paris of Henri IV: Architecture and Urbanism* (Cambridge, MA: MIT Press, 1991).
Bernstein, Charles. *Recalculating* (Chicago: University of Chicago Press, 2013).
Blumenberg, Hans. *Schiffbruch mit Zuschauer: Paradigma einer Daseinsmetapher* (Frankfurt am Main: Suhrkamp, 1997).
Boyer, Margorie Nice. *Medieval French Bridges: A History* (Cambridge, MA: The Medieval Academy of America, 1976).
Carroll, Noël. "A Note on Film Metaphor," *Journal of Pragmatics*, 26, 1996: 809–22.
Cazeaux, Clive. *Metaphor and Continental Philosophy: From Kant to Derrida* (London: Routledge, 2007).
Christo and Jeanne-Claude. *The Pont Neuf Wrapped, Paris 1975–85*, www.christojeanneclaude.net/projects/the-pont-neuf-wrapped [accessed January 12, 2015].
Conley, Tom. *The Self-Made Map: Cartographic Writing in Early Modern France* (Minneapolis: University of Minnesota Press, 1996).
Cresswell, Tim. "Weeds, Plagues, and Bodily Secretions: A Geographical Interpretation of Metaphors of Displacement," *Annals of the Association of American Geographers*, 87, 2, 1997: 330–45.
Davis, Oliver. *Jacques Rancière* (Cambridge, MA: Polity, 2010).
Derrida, Jacques. *Margins of Philosophy*, translated by A. Bass (Chicago: University of Chicago Press, 1982).
———. *Mémoires d'aveugle: L'autoportrait et autres ruines* (Paris: Réunion des musées nationaux, 1990).
———. "The *retrait* of Metaphor," in P. Kamuf and E. Rottenberg (eds) *Psyche: Inventions of the Other* (Stanford: Stanford University Press, 2007), pp. 48–80.
Forceville, Charles. "The Identification of Target and Source in Pictorial Metaphors," *Journal of Pragmatics*, 34, 2002: 1–14.
Foucault, Michel. *The Archaeology of Knowledge*, translated by A. M. Sheridan Smith (London: Tavistock, 1972).
Gregor, Manfred. *Die Brücke* (Munich: DVA, 2005).
Haw, Richard. *The Brooklyn Bridge: A Cultural History* (New Brunswick: Rutgers University Press, 2005).
Kasdorf, Julia and Michael Tyrell (eds). *Broken Land: Poems of Brooklyn* (New York: NYU Press, 2007).

Koboldt, Megan. "I Feel Like the New Bridge: A Geo-Historical Analysis of Christo and Jeanne-Claude's *Le Pont Neuf Wrapped*, 1975–85," *Site*, 95 2, 4, 2013: 44–47, www.site95.org/2013/06/18/i-feel-like-the-new-bridge-a-geo-historical-analysis-christo-and-jeanne-claudes-le-pont-neuf-wrapped-1975-85-by-megan-koboldt [accessed January 12, 2015].

Latour, Bruno and Émilie Hermant. *Paris ville invisible* (Paris: La Découverte, 1998).

——. *Paris: Invisible City*, translated by Liz Carey-Libbrecht and Valerie Pihet (2006), www.bruno-latour.fr/sites/default/files/downloads/PARIS-INVISIBLE-GB.pdf [accessed January 12, 2015].

Lawlor, Leonard. *Imagination and Chance: The Difference between the Thought of Ricœur and Derrida* (Albany: SUNY Press, 1992).

Lorenz, Ulrike and Norbert Wolf (eds). *Brücke: Die deutschen „Wilden" und die Geburt des Expressionismus* (Köln: Taschen, 2008).

McGowan, Moray. "Brücken und Brücken-Köpfe: Wandlung einer Metapher in der türkisch-deutschen Literatur," in Manfred Durzak and Nilüfer Kuruyazıcı (eds) *Die andere Deutsche Literatur: Istanbuler Vorträge* (Würzburg, Königshausen & Neumann, 2004), pp. 31–40.

Moore, Rowan. "London's Garden Bridge: Barking Up the Wrong Tree?" *The Guardian*, September 14, 2014, www.theguardian.com/artanddesign/2014/sep/14/london-garden-bridge-barking-up-wrong-tree [accessed January 12, 2015].

Olsson, Gunnar. "The Social Space of Language," *Environment and Planning D: Society and Space*, 5, 1987: 249–62.

Pierce, Patricia. *Old London Bridge* (London: Headline, 2001).

Pirovolakis, Eftichis. *Reading Derrida and Ricœur: Improbable Encounters between Deconstruction and Hermeneutics* (Albany: SUNY Press, 2010).

Prange, Klaus. *Die Zeigestruktur der Erziehung: Grundriss der operativen Pädagogik* (Paderborn: Schöningh, 2005).

Rancière, Jacques. *Le Maître ignorant: cinq leçons sur l'émancipation intellectuelle* (Paris: Fayard, 1987).

——. *The Ignorant Schoolmaster: Five Lessons in Intellectual Emancipation*, translated by K. Ross (Stanford: Stanford University Press, 1991).

——. *The Future of the Image*, translated by G. Elliott (London: Verso, 2007).

——. *The Emancipated Spectator*, translated by G. Elliott (London: Verso, 2009).

Ricœur, Paul. *The Rule of Metaphor: The Creation of Meaning in Language*, translated by R. Czerny (London: Routledge, 1978).

Rockhill, Gabriel. "The Silent Revolution," *SubStance*, 33, 1, 2004: 54–76.

Rorty, Richard. *Contingency, Irony, and Solidarity* (Cambridge, MA: Cambridge University Press, 1989).

Ross, Toni. "Image, Montage," in J.-P. Deranty (ed) *Jacques Rancière: Key Concepts* (Durham: Acumen, 2010), pp. 151–68.

Rothenberg, Albert. "Visual Art: Homospatial Thinking in the Creative Process," *Leonardo*, 13, 1980: 17–27.

Schönfeld, Christiane. "Representing Pain in Literature and Film: Reflections on *Die Brücke* (*The Bridge*) by Manfred Gregor and Bernhard Wicki," *Comunicação & Cultura*, 5, 2008: 45–62.

——. "Erfolg und Misserfolg von Verfilmungen: Manfred Gregors *Die Brücke* und die Nahaufnahmen des Krieges in Kino und Fernsehen," *Germanistik in Ireland*, 7, 2012: 81–102.

Simmel, Georg. "Brücke und Tür," *Der Tag. Moderne illustrierte Zeitung*, 683 ("Morgenblatt"), September 15, 1909: 1–3.

Speer, Albert. "Frankfurt ist ein Modell für die Welt," *Frankfurter Allgemeine Zeitung*, August 24, 2013, www.faz.net/aktuell/wirtschaft/staedteplaner-albert-speer-frankfurt-ist-ein-modell-fuer-die-welt-12545484.html [accessed January 12, 2015].

Strohmayer, Ulf. "Practicing Film: the Autonomy of Images in *Les Amants du Pont-Neuf*," in D. Dixon and T. Cresswell (eds) *Engaging Film: Anti-Essentialism, Space and Identity* (London: Rowan & Littlefield, 2002), pp. 93–208.

——. "Engineering Vision: The Pont-Neuf in Paris and Modernity," in A. Cowan and J. Steward (eds) *The City and the Senses: Urban Culture since 1500* (Basingstoke: Ashgate, 2007), pp. 75–92.

——. "Bridges: Different Conditions of Mobile Possibilities," in T. Cresswell and P. Merriman (eds) *Mobilities: Practices, Spaces, Subjects* (Farnham, Surrey: Ashgate, 2010), pp. 119–36.

Tanke, Joseph J. "Why Rancière now?" *Journal of Aesthetic Education*, 44, 2, 2010: 1–17.

Turner, Victor. *From Ritual to Theatre: The Human Seriousness of Play* (New York: PAJ, 1982).

Whittock, Trevor. *Metaphor and Film* (Cambridge, MA: Cambridge University Press, 1990).

Zimmer, Jacques. "*Les Amants du Pont-Neuf*: Histoire de l'oeil," *La Révue du Cinéma*, 475, 1992: 21–22.

CHAPTER 4

SPATIALITY, PLACE, AND DISPLACEMENT IN TWO GAELIC SONGS

Lillis Ó Laoire

Henri Poincaré, an early but enduring theorist on spatiality, argued that "[a]bsolute space is nonsense, and it is necessary for us to begin by referring space to a system of axes invariably bound to our body."[1] This chapter proceeds from a reading of this claim, arguing that it is culture, produced by acting bodies, which humanizes space and makes it into place. Recent critiques of space and place across a range of disciplines divide approaches to these concepts along two different lines, one of "the production of place by capital and global forces" and a second of the phenomenological and social, encompassing "senses" or [a] "more generally cultural construction of place."[2] The latter is the primary methodology followed here, although the chapter partially attempts to recognize the "advantages of cross-fertilising these two currents."[3] The discussion centers on two songs from Tory Island, in County Donegal (Ireland), a subaltern Atlantic island culture, situated in what has come to be called the "Celtic Fringe."[4] I will show that both texts represent coherently localized expressions of spatiality, place, and displacement, while the implications of transnational global flows are also evident. In one of the texts, the notion of "home" is evoked in significant and striking detail. That concept depends on an idea of "away" that foregrounds a dispiriting trajectory of instability and insecurity, emphasizing its fatal danger

for those seeking their fortune abroad. This evocation longs vainly for the notion of the grounded, emplaced sense of belonging that characterizes home.

The memory of a way of life plays an important role in the second text, recalling hard labor, risk, and peril from personal experience, of a kind now past and little known to most of the present Irish generation. An aesthetic valorization of that past tacitly underpins the commemorative impulse in this text. Although the song also commends the prosperity of the present, a sense of unsettled disquiet at its debilitating effects is also apparent. Approaching song and singing from the perspective of space and symbolic expression therefore needs some grounding. A fascinating research paper about a South African culture provides a productive parallel from which to proceed. Angela Impey's claim that music may be perceived as an archive of experiences, a site of collective memory, or "a 'primary symbolic landscape' of a people"[5] provides a compelling catalyst for developing this idea. Another persuasive statement by Impey suggests that "[s]ound, perhaps more than any of the other senses, has an enveloping, affective character that creates in us an awareness of proximity, connectedness and context and thus plays a significant role in the analysis of social, historical and political experience."[6]

I argue for a link between such claims and Gaston Bachelard's idea that all inhabited space must be considered a home.[7] My work has explored how the habitation and affective configuration of space into place occurs through the enactment of music, dance, and song in Tory Island.[8] In summary, space is turned into place through such enactments and performances, a mimetic process in Paul Ricœur's sense of the reconfiguration and augmentation of reality according to culturally constituted horizons of understanding.[9] Performance renews bonds of kinship and affection through the repeated engagement of music, dance, and song in a never-ending circle of reciprocal activities that re-create and affirm community. In the same way, such enactments can serve to minimize conflict and allow those dwelling in small communities to live with their disagreements and cohabit in relative cohesion. Although focused on Tory Island, a similar model operates in many small places throughout Europe, if Anthony Cohen is to be believed. The expression of symbolic boundaries helps to build communities; Cohen holds that rural communities throughout Britain and Ireland contain a complex array of symbols used expressively in order to convey aspects of community. As he says, "[T]he distinctiveness of communities, and thus, the reality of their boundaries...lies in the mind, in the meanings which people attach to them, not in

their structural forms . . . [T]his reality of community is expressed and embellished symbolically."[10]

Musically keyed texts in performance represent one significant expression of such symbolic embellishment that, far from being passively decorative,[11] "provide[s] the means by which the hierarchies of place are negotiated and transformed,constructing trajectories rather than boundaries across space."[12]

One such example concerns a young Tory Islander who died shortly after emigrating to the United States in 1909. Though his death certificate records the cause of his demise as typhoid fever, narratives linked to a specific song in Tory connect his death explicitly with homesickness, *cumha*, in Irish, a pining or longing to return to his native place. Elsewhere I have explored in detail how and what that song means to its singers and listeners.[13] Here, however, I examine how two other songs, dealing specifically with place in different ways, symbolically express ideas of belonging, emplacement, and displacement in disparate ways through the musically keyed texts. Additionally, the songs imply contexts beyond the local, which serve to further emphasize and valorize the importance of the native place.

"IS TRUA NACH BHFUIL MÉ IN ÉIRINN"

The first is known in Tory as "Is trua nach bhfuil mé in Éirinn" ("It's a pity I'm not in Ireland"). The first line indicates dramatically that place and separation from it supply a dominant trope.[14] It is useful to remember, however, that the song is a lyric rather than a ballad. It does not tell a linear story, but rather gives a series of interconnected impressions from different perspectives, a feature of many Gaelic songs. From these images, a story (in Irish, *brí, údar* or *scéal*) can be interpreted.[15] The music links the impressions as does their performance in a sequential configuration approved by singers and listeners. Discussion around song texts is a common feature of island discourse. Much debate, often quite heated, centers on the correct enunciation and order of stanzas. Such debates represent another aspect of locality, in that the agreement or disagreement about form constitutes an intersubjective and collective way of knowing held among colocated individuals bound together by ties of kinship. Here is the original text followed by a translation into English:

> *Is trua nach bhfuil mé in Éirinn san áit ar tógadh mé i dtús mo shaoil*
> *Ná faoi bhruach na Binne Móire ná ag an Éirne lena taobh*

Sin an áit a bhfaighinn t-aos óg ann, a thógfadh an brón seo
 is an tuirse díom
Is dá mbeinn bliain eile arís níb óige go mbeinn ag gabháil leofa arís

Cheannóchainn garradh dá n-éireochadh liom
Chuirfinn mustard bhreá aird ann agus bláth bán ar chrann
Chuirfinn síol coirce, síol eorna, síol a ndéantar dó'n lionn
Gurb é síoról na gcartaí a d'fhág an mála ar mo dhroim

Bliain mhór agus an t-am seo bhí mé i mo chónaí i gCnoc a' Sciobóil
Bhí mo theach mór á dhéanamh ag saortha istigh i gCorcaigh
Bhí mo cheann ar bharr spice le gaoth mhór mhór agus le fearthainn
Má tá roinnt agam do Mháire an Phéarla m'anam gléigeal
 nár thé na bhFlaitheas

Ag gabháil fríd an bhaile ó dheas dom nach mé a bhí lag tinn
Is ar philleadh arís 'na bhaile domh cha rabh duine ar bith liom
Bhí mo mhuintir uilig i gcorraí liom nuair a bímse amuigh go mall
Is go bhfuil a fhios ag mo mhuire mháithrín gur mar seo
 mar a bhí an geall

Mar éiríos an ghealach, ná mar luíos an ghrian
Nó mar théid an lán mara fá na cuanta seo siar
B'fhearr liom i mo luí i bhfiabhras ná bheith i bpianta móra báis
Ná boltaí a bheith ar mo dhianchorp is cead a bhfáscadh go cruaidh

A' gcluin sibh mise a mhná óga, go deo deo i mo dhéidh
Ná bígí ag ól leis na fearaibh óga ná ag creidbheáil a scéil
Seachnaígí i dtigh an óil iad is in gach gábh a mbeidh siad ann
Nó beidh siad arís 'bhur mbréagnú i dtigh na cúirte ag
 an ribbage man.

'Dhearthráir, a Rí na Páirte, tabhair mo chás leat uilig 'na bhaile
Mo stocaí agus mo bhróga agus mo chlóca atá dubh daite
Tabhair scéala ionnsair mo mháithrín tá faoi dhólás go mór sa bhaile
Go bhfuil rópa cruaidh cnáibe ag gabháil in áit mo charabhata.[16]

Translation:

It's a pity I'm not in Ireland, where I was raised at the start of my life
Or below the bank of Binn Mhór[17] or at the Erne by its side
There I'd find the young people, who would lift the
 sorrow and gloom from me
And If I were only another year younger, I'd be going out
 among them again.

I would buy a garden if I could succeed
I'd plant fine tall mustard in it and the trees would bloom fair
I would plant oats there and barley, the seed from which beer is made
And it's the ceaseless drinking of the quarts that left
 the bag on my back.

This time last year I was living in Cnoc a' Scióbóil[18]
My spacious house being built by craftsmen in Cork
My head atop a spike exposed to stormy winds and rain
If I have dealings with Máire an Phéarla, may my spotless
 soul not go to Heaven

As I went through the southern village how weak and sick I was
And when I returned home again, nobody was with me
My family were all angry with me because I was out so late
And my dear mother knows that this is how the wager was.

As the moon rises or as the sun sets
Or as the tide flows toward the bays to the west
I'd prefer to be lying in a fever than to be in great pains of death
Than to have locks restraining my body and allowed to squeeze it hard.

Do you hear me young women forever behind me
Don't be drinking with the young men or believing their yarns
Avoid them in the taverns and in each difficulty they may be in
For they will deny everything you say later in the court
 with the ribbage man.[19]

O brother, by the King of affection [God], bring my situation
 home with you
My socks and my shoes and my black-colored cloak
Bring the news to my mother who is grieving greatly at home
That a hard hempen rope will replace my cravat.

The above local variant is known in multiple forms in many parts of Ireland. This complex of texts generally alludes more or less to the male speaker's misfortune and his poor situation.[20] The speaker usually refers clearly to his encounter with the law, and states that he has been accused in the wrong. The speaker also awaits his hanging in the morning; the striking difference between the *rópa crua cnáibe*, the hard hempen rope, that will replace his cravat is especially graphic. The beginning of his misfortune is linked to the incessant drinking that has turned him into a vagabond, which is another trope common to male speakers in these songs.[21] The mood is one of abject misery, being

contrasted with his carefree youth just a short time previously. The disparity is emphasized in terms of place. When he was in Ireland, he was prospering with a big house being built. The reference to his head on a spike is unclear, suggesting perhaps an ill omen. This temporal blurring, however, only adds to the sense of the speaker's confusion and numbing fatigue.

In Tory Island, the accompanying narrative of the text relates that the speaker of the song is in America. Clearly, he is an Irishman, an identity foregrounded in the first line and in the language in which the song is composed, Irish. He is in jail for a crime he says he did not commit. The offence, according to the Tory narrative, centers on a sexual assault or rape of a woman, *Máire an Phéarla* (Mary of the Pearl). In fact, he denies having had any dealings with her, but his fate is sealed; he is to be hanged. It is a gripping scene projecting a strong didactic message. The story of unhappy love carries the added twist of a criminal conviction for a sexual crime. Such a scenario reminds us of other similar situations in Irish folklore and history. One well-known example concerns Sir Séamus Mac Coitir, a seventeenth-century Cork Jacobite, hanged on a trumped-up charge of ravishing Elizabeth Squibb, a Quaker. Another Ulster story concerns an outlaw, Séamus Mac Murchaidh, the subject of a fine song also known in Tory, whose betrayal to the authorities was popularly attributed to a jealous sweetheart.[22] My focal narrative and the others I have referred to briefly above encompass unofficial tellings of history where the abject, prostrate body facing annihilation acts as a site through which power, resistance, and victimhood are enacted.[23] The song "Is trua nach bhfuil mé in Éirinn," then, gives us insight into what Guy Beiner calls a "complex and decentralized historical model,"[24] or, in Paul Carter's terms, a "ground truthing," where "the spatial history of a society" may be read.[25] Such orally transmitted narrative operates at the level of an emplaced community history, often an alternative to official history,[26] linking the outward trajectory of displacement by emigration with misfortune and death. The discussion and debate that emanate from deep memory remain a central element of "history telling," a discourse engaged in throughout Ireland. [27]

However interesting the relationship may be between such songs on a wider level, which may also be regarded as an emplaced, culturally contextualized, and localized history, I am more interested here in those characteristics that express the special identity and selfhood of the Tory Islanders and of their particular place in the world. Those traits can be recognized in the local peculiarities of dialect, in the singers' musical style, and in the story attached to the song. All such

features may remain implicit without connecting them specifically to Tory Island, but they may also be highlighted as specific embedded markers of identification, because of the numerous occasions upon which the song has been performed at various events over the years. The lively "dynamic of presence, audience and exchange" means that the song is well known to many islanders, if only because they recognize it and are able to follow it from beginning to end as they listen to it being sung.[28] They acknowledge it as an element in their island heritage so that, when it is performed, community may emerge, a specific structuring of space through symbolic expression. The performance and multisensory reception of the song greatly augment its polysemy over and above what is available from the text alone. Group identity constitutes a symbolic interpretation of spatiality, eking out a locus for dwelling that recognizes a specific body of narrative and a community history. As Lauri Honko claims, identity constitutes "a set of values, symbols and emotions joining people, through constant negotiation, in the realization of togetherness and belonging."[29]

Therefore, following Cohen, community identity and sense of emplacement are most strongly distinguished in the symbols used to differentiate themselves from others.[30] Songs and singing are not the only ways through which symbolic difference is constituted, but the understanding is nevertheless important. In addition to the meanings attributed to songs as symbolic boundary markers, they also constitute an important element in the endless argument essential to any vibrant community. Each participant in this debate asserts that their own interpretation of the matter at hand, be it song or narrative, is the best and most correct. Undoubtedly there is a measure of audacity, not to say bluster, in some of these claims, but these are necessary qualities in order to thrive and provide variety in the monotony of island life. The sense of hopefulness and optimism generated from such lively discussions assists in supporting people to overcome the many struggles they face as islanders. A salient example of such optimism in the face of adversity may be found in Róise Uí Ghrianna's autobiographical story, *Róise Rua*.[31]

Although it accesses the narratives of the past, such debate is centered firmly on the present. It negotiates and appropriates change in ways amenable to community norms. This element of tradition is constituted as a "modern dialogue," with an emphasis on current matters and an orientation toward the future.[32] Gadamer's view of tradition as a fusion of old and new into something of living value is particularly apposite here.[33] Symbolic spatial concerns are also enmeshed in their temporality. Songs and other elements of culture, both material

and intangible, participate in creating, through symbolic expression, "a strategy to produce community."[34]

Much symbolic expression happening in a specific space concerns conversation, repartee, disagreement, oral history, storytelling, singing, music, and dance, revealing the fundamental locality of language to such concerns; in Appadurai's terms, these are "complex social techniques for the inscription of locality onto bodies," leading to "the production of 'natives.' "[35] Their power was especially evident in the way that the Tory community deployed these symbols when threatened with evacuation in the late 1970s and early 1980s, in line with State policies. The argument was economic: island life was too costly to maintain levels of services that could be better and more cheaply provided by relocating the community to the mainland. This powerful reasoning, one that has become current again in our age, almost succeeded in having the island abandoned, but some islanders resisted and stayed. The "islandness" of the culture provided a powerful symbolic weapon in the mounting of the counterargument to the dominant economic narrative.

Assisting the islanders was the mythology of the Blasket Islands (located off the southwest coast of Ireland) that had provided a central idea for strategies of nation-building in the early part of the Irish state's history. Tomás Ó Criomhthain's iconic book, *The Islandman*,[36] provided a heroic archetypal model of the struggle against destructive forces, a symbol that other islanders drew upon. This work had achieved international fame in translation in the 1930s and 1940s and had been appropriated by the Irish state to form part of its founding narrative. Such rural imagery remains inextricably bound to official national mythology, however subconsciously. Indeed, it may be argued that the state's guilt is also enshrined in the contradiction that it celebrated Blasket Island literature, on the one hand, while failing to prevent the population of inhabitants who produced it from being depleted and dispersed by emigration, on the other. The last permanent inhabitants left the Blaskets in 1953, while evacuation of Tory is still a potential reality. Despite the provision of services, the population has never recovered its size, and there is a constant struggle to maintain numbers at the school. In this context, the Blasket Island Heritage Centre may be mentioned as a symbolically relevant space. A beautiful building, constructed on the mainland directly opposite the Great Blasket in Dún Chaoin, County Kerry, it houses substantial cultural collections related to Blasket and West Kerry literature and folklore. This impressive structure and its holdings stand as a fitting tribute to the literary flowering that characterized cultural activities

on the Blaskets in the early twentieth century. However, the monument also enshrines an irony as a mark of respect to a way of life that expired under a native government based in Dublin, whose founding myth appropriated an authenticity provided by Blasket writers. This incongruity was not lost on the writer Brian O'Nolan, who satirized the contradictions of cultural nationalism in his 1941 work, *An Béal Bocht,* even though the work was received generally as a mocking of the writers themselves.[37]

In discussing songs from a historical perspective and fitting them into a framework of cultural agency, as instances of symbolic expression closely linked to spatialities, places, and displacements, lapsing into romantic idealization about a past would be easy. Although the entertainments of the past were organized according to strict aesthetic principles calculated to inspire the best performances, and although they did frequently achieve the physical and symbolic integration that characterized a big night, these entertainments were few and occurred in the context of lives challenged by the circumstances of subsistence farming and fishing, and necessarily supplemented by seasonal migration undertaken in order to earn scarce and much-needed cash.

This first song that I have discussed reveals intimate connections between the individual, community, and language in the place where it has been held and transmitted over the years as an element of symbolic expression. Additionally, the song contains general ideas about a historically affected consciousness in localized tropes found elsewhere in Irish tradition. This understanding resides in no one item but in the whole ever-shifting corpus of performance, both of song and narrative. A focus on particular items, however, can serve to illustrate the whole. The continuance of composition in a community could be regarded as a sign of cultural vibrancy. Although not as prolifically as song-making practices in Connemara in County Galway (in the west of Ireland), the Tory community has seen the making of a number of recent songs.

"Bádaí na dTrí Seoil"

Our second song is another of those referred to above, titled "Bádaí na dTrí Seoil" ("The Three-Sailed Boats"). In it, the poet, Éamonn Ghráinne Mac Ruairí (1928–2010), alludes briefly but significantly to the great changes that have swept through his community since his youth in the 1930s. His song memorializes that time and its practices, through the choice of the now-obsolete sailing yawls as a symbol of his theme. Despite the hardships he endured, he pays tribute to his own

past and to his predecessors, making a plea for a distinctive emplaced identity tied to a culture and a way of life. This song received immediate acclaim when first performed publicly in Tory in 2003. Strikingly, although most of the assembled listeners were hearing the song sung for the first time by its maker, as I watched, they were able to finish some of the song's lines before they had been sung. On hearing the song, those who remember the days of sail, before motorized engines, think of their parents and others of the older generation, and the song brings the topic of social and cultural change into conversation as part of a continuing commentary on the community's life. As before, I give the full text with English translation in the following:

Anocht is mé ag meabhrú liom thart siar fán Ghaineamh Mór
Ar na curaigh is ar na bádaí ar na rámhaí is ar na seoil
A Rí nár mhéanar dá bhfeicfinn iad ag gabháil síos an Camas Mór
Is an fhoireann ag teannadh an éadaigh orthu is ag cur an
* sprait insa tseol mhór.*

Nár dheas dá bhfeicfeas muid na bádaí seo arís ag teacht anoir
* ag Uamhaigh an Toir Mhóir*
Cuid eile acu ag Carraig an Mhullacháin is iad istigh
* in imeall an chobhair,*
Fear na Binne ag Ulaidh Mhórada is a bhearad go hard ina láimh
Is na scadáin ag déanamh srotha is iad istigh ag an Bhoilg Bhán.

Nár mhéanar a tchífeadh na bádaí seo arís agus iad faoi trí seol
Fear na stiúrach is an scód ar a ghlúin aige is é ag amharc
* amach faoin tseol*
Na two pins ar thaobh an fhoscaidh ag cur na farraige go hard
Is fear eile i bpoll an taomtha is an capán ina láimh

Nach iomaí sin lá breá garbh bhí muid ag tarraingt ar tír mór
Le jib is le seol tosaigh is le cos déanta den tseol mhór
An Corrán ar Ghob an Iarthair againn is an ghaoth ag éirí ard
Is muid ag brath a ghabháil an Clochán ach bhí an fharraige rómhór

Le smaointiú siar ar an tsaol atá ann tá an t-am i bhfad níos fear
Níl bád le cur síos ná aníos againn ná curach le cur ar snámh
Níl bairneach le baint de chloch againn tá an t-iasc sna siopaí le fáil
Níl móin le tabhairt as tír mór againn tá an gual níos fusa a fháil

Ach caithfimid smaointiú ar na fir seo anois mar go
* bhfuil siad uilig ar lár*
Nach iomaí sin lá mór fada a chaith siad amuigh ar an aibhléis mhór

Ag roiseadh is ag cornadh le sruth líonta agus le sruth trá
Tá súil as Rí na nGrást agam go bhfuil áit acu níos fearr.

Translation

Tonight as I continue to reminisce round west by the Gaineamh Mór
On the currachs and on the boats, on the oars and on the sails,
O Lord, how happy I would be if I were to see them going
 down the Camas Mór
With the crew making fast the sails and putting the *sprait*
 into the mainsail.

How nice it would be if we saw these boats once more coming
 westward at Uamhaigh an Toir Mhóir
Still others at Carraig A' Mhullacháin at the verge of foam
The cliff watchman at Ulaidh Mhórada with his cap held
 high in his hand
The herring coursing with the current inside at the Boilg Bhán.

How happy for those who would see these boats again arrayed with
 their three sails
The steersman with the sheet on his knee looking out under the sail
The two pins[38] to the leeward side sending the sea skywards
And another man in the bailing pit with the bailer in his hand.

Many's the fine blustery day we left to go to the mainland
With a jib and a foresail and the mainsail partly furled,
Horn Head aligned with Gob an Iarthair and the wind rising
And though we expected to go by the Clochán the sea
 was too agitated.

When one thinks now of life today, times are much better;
We don't have to launch or beach the boats, nor even float a currach
We don't have to harvest limpets from the rocks, the fish can
 be found in the shops,
We don't have to bring turf from the mainland, coal is
 much more readily available.

But we must now remember these men because they have all fallen
How many long days they spent out on the great ocean,
Unfurling and furling sail again with the flooding and the ebbing tide.
I hope to God in Heaven that they have a better place now.

Conceived of as a memorial for a way of life now completely trans-
formed, the song also serves as an intangible monument to its maker,

since his death in 2010. The author was one of the island's prominent arbiters who commanded respect from all, and the song is an authoritative statement on the worth and value of that life. It does not idealize the past and its hardships, although it values cooperation and resilience in the face of adversity. It assumes familiarity with the place-names of the island, and their quality heightens the chronotopic effects of the song, evoking locations intimately familiar because of the long days of fishing mentioned.[39] In verse four, the song refers to the three-pointed alignment of the boat, Corrán Binne (Horn Head) and Gob an Iarthair, respectively. The latter place-name refers to the northernmost point of Inis Big (Inishbeg), off Inis Bó Finne (Inishbofin Island), the position representing the halfway mark on the nine-mile crossing between the mainland and Tory. This reference metonymically represents the traditional method of navigating by triangulation, before radar, requiring extensive familiarity with local conditions and the landmarks of the coastline in order to be able to sail safely. This anthropocentric system places the sailor and his craft at the center of the universe, at one with his place and at home there.

The present-day context accentuates consumerism: all necessities are available in the shops and no more back-breaking labor is necessary to acquire fish or fuel. Far from condemning the ease of modern life, the song says life is *níos fearr*—better. However, one gets the obliquely expressed impression of a dilemma. We gather that the speaker feels that unearned ease is not necessarily a good thing, since it has reduced identification with the island and the sense of community solidarity brought about by enduring a shared level of hardship. It has also curtailed resourcefulness. The song intimates that a consumerist lifestyle contributes to a lack of memory, condemning those who lived lives of hardship and toil to being forgotten by their descendants. Foregrounding a gendered view once again, the song exhorts listeners to remember these men who worked so hard and expresses the hope that they now inhabit a better place in the afterlife. All in all, this powerful text speaks to and for islanders whose lives it commemorates, conferring dignity and meaning on them in a way perhaps not achieved since the early twentieth century when Éamonn's grandfather, Éamonn Dooley Mac Ruairí (1855–1931), made a number of similar songs. Consequently, the song invokes both a temporal historical trajectory and a sociocultural one, a stimulus to the debate about the sustainability of local communities in the face of modern living conditions. In this way, it resonates closely with the first item discussed in this chapter, since both are connected to each other through their intensely local mode of expression and to trajectories of time and space

that continue to influence the lives of those who perform and listen to them. The sentiment differs from Tomás Ó Criomhthain's famous phrase *mar ná beidh ár leithéidí arís ann* ("for the like of us will never be again"),[40] in that it accepts the conveniences of modernity, while rejecting the willful shedding of historical consciousness.

An additional comment may be made about the air. Like many poets, Éamonn chose an air that already existed, but he chose his tune very carefully, having considered and rejected other metrically suitable melodies. The tune he selected is the one used for a Galway song made by a poet from An Trá Bháin on Garumna Island in Connemara. Known there as "Amhrán an Bhá" or "The Song of the Drowning" it is also known as "Currachaí na Trá Báine" ("The Curraghs of Trá Bháin").[41] Made in Boston, it laments a nineteenth-century drowning tragedy that remains an emotive anthem of place and people there, achieving fame far beyond its local area through the singing of well-known traditional singers.[42] Éamonn's choice was an acknowledgment of the song's power and thematic affinity, accessing its symbolic position in the repertoire of Gaelic oral poetry to augment the efficacy of his own.

"Bádaí na dTrí Seoil" transmutes a deep well of experience into a lasting testimony of place, space, and vivid expression, showing the close connection between environment, the surroundings in which the life was lived, and the individual and the community. It reveals the connectedness that community members felt toward their way of life and their place. Additionally, through its music, it universally expresses solidarity with other communities, who share livelihood, collective experience, and language with the Tory islanders and who, like them, are confronted with the trials and predicaments of modernity. The emotions engendered by such performances instill and augment strong feelings of attachment to place. This may be even more intensely felt in the present day when the community is much depleted and when a majority of young people have left the island to find employment and educational opportunities elsewhere. Islanders' feelings of longing for (*cumha*) and belonging to (*dúchas*) home are heightened because of the rapid flux in which today's society functions, with the question of the future of the island very much in the balance.[43]

NOTES

1. Henri Poincaré, *The Foundations of Science* (Lancaster, PA: Science Press, 1913), p. 257.

2. Arturo Escobar, "Culture Sits in Places: Reflections on Globalism and Subaltern Strategies of Localization," *Political Geography*, 20, 2001: 152–53.

3. Escobar, "Culture Sits in Places," 153.

4. Robin Fox, *The Tory Islanders: People of the Celtic Fringe* (Cambridge, MA: Cambridge University Press, 1978).

5. Angela Impey, "Sound, Memory and Dis/placement: Exploring Sound, Song and Performance as Oral History in the Southern African Borderlands," *Oral History*, 33, Spring 2008: 35.

6. Impey, "Sound, Memory and Dis/placement," 34.

7. Gaston Bachelard, *The Poetics of Space* (Boston: Beacon Press, 1994), p. 5.

8. Lillis Ó Laoire, *On a Rock in the Middle of the Ocean: Songs and Singers in Tory Island, Ireland* (Lanham: Scarecrow Press, 2005).

9. Paul Ricœur, *Time and Narrative*, Volume 1 (Chicago: University of Chicago Press, 1984), pp. 80–85.

10. Anthony Cohen, *The Symbolic Construction of Community* (London: Routledge, 1985), p. 98.

11. According to the OED, an obsolete meaning of "embellish" is "to brighten (in feeling)" or "cheer." It is useful to invoke that particular signification in this context, despite its outmoded status in the dictionary, <http://www.oed.com.libgate.library.nuigalway.ie/view/Entry/60839?redirectedFrom=embellish#eid> [accessed August 27, 2014].

12. Martin Stokes, *Ethnicity, Identity and Music: The Musical Construction of Place* (Oxford: Berg, 1994), p. 4.

13. Ó Laoire, *On a Rock*, pp. 183–231.

14. For a traditional sean-nós rendering by Éamonn Mac Ruairí, see *Seoda Sean-nós as Tír Chonaill* (CD), CICD 118, (Indreabhán: Cló Iar-Chonnachta, 1996), track 2. For a version with accompaniment by Micheál Ó Domhnaill and The Bothy Band, <http://www.youtube.com/watch?v=_Wa4lF4MeSo> [accessed August 27, 2014].

15. Hugh Shields, *Narrative Singing in Ireland: Lays Ballads, Come-All-Yes and Other Songs* (Dublin: Irish Academic Press, 1994), p. 74.

16. This setting of the words is from the recitation of Teresa McClafferty, a great authority on her family's songs, which she acquired at home from older relatives in her youth during the 1930s.

17. The place-names database <http://www.logainm.ie> names at least six locations bearing this toponym, one in Donegal, one in Limerick, three in Mayo, and one in Roscommon [accessed August 27, 2014].

18. The database <https://www.logainm.ie> lists five places with this name in Ireland: in Carlow, Clare, Kildare, Mayo, and Dublin [accessed August 27, 2014].

19. I am at a loss to understand this term.

20. This is a song found in many other variants throughout Ireland and which is related to songs such as "Príosún Chluain Meala" from Munster and to another song sung in Munster, "Amárach Lá 'le Pádraig." See Margaret Hannigan and Séamus Clandillon, *Londubh An Chairn: Songs of the Irish Gaels* (Oxford: Oxford University Press, 1925), p. 44, for a version of "Príosún Chluain Meala." "Amárach Lá 'le Pádraig" may be heard on *Seosamh Ó hÉanaí, Ó Mo Dhúchas, Sraith 1 & Sraith 2* (Baile Atha Cliath, Gael Linn, 2007), disc 1, track 10.

21. See Sean Williams and Lillis Ó Laoire, *Bright Star of the West: Joe Heaney, Irish Song Man* (New York: Oxford University Press, 2011), pp. 159–76.

22. See Colm Ó Baoill, iar-eag., *Amhráin Chúige Uladh*(Muireadhach Méith, eag., Indreabhán: Cló Iar-Chonnachta, 2009); Breandán Ó Buachalla, "The Making of a Cork Jacobite," in Patrick O'Flanagan and Cornelius G. Buttimer (eds) *Cork: History and Society* (Dublin: Geography Publications, 1993), pp. 469–98, and Padraigín Ní Uallacháin, *A Hidden Ulster* (Dublin: Four Courts Press, 2003), pp. 246–49. Seosamh Mac Grianna's excellent story, "Séamus Mac Murchaidh" is also important here; see Mac Grianna's, *Pádraic Ó Conaire agus Aistí Eile* (Baile Átha Cliath: An Gúm, 1936).

23. Caroline Magennis, "What Does not Respect Borders: The Troubled Body and the Peace Process in Northern Irish Fiction," *The Canadian Journal of Irish Studies*, 36, 1, 2010: 89–91.

24. Guy Beiner, *Remembering the Year of the French* (Madison: University of Wisconsin Press, 2007), p. 169.

25. Paul Carter, *Ground Truthing: Explorations in a Creative Region* (Crawley: University of Western Australia Press, 2010), p. 9.

26. Henry Glassie, *The Stars of Ballymenone* (Bloomington: Indiana University Press, 2006), p. 126.

27. Beiner, *Remembering the Year of the French*, pp. 81–85.

28. John Miles Foley, *How To Read an Oral Poem* (Urbana: University of Illinois Press, 2002), p. 85 and passim.

29. Lauri Honko, "Traditions in the Construction of Ethnic Identity and Strategies for Ethnic Survival," *European Review*, 3, 2, 1995: 131–46, p. 134.

30. Anthony Cohen, *The Symbolic Construction of Community* (London: Routledge, 1985), pp. 11–21.

31. Lillis Ó Laoire, "Augmenting Memory, Dispelling Amnesia: The Songs of Róise Uí Ghrianna," *Dublin Review of Books*, 17, Winter/Spring 2011, <http://www.drb.ie>.

32. Sharon MacDonald, *Reimagining Culture: Histories, Identities and the Gaelic Renaissance* (Oxford: Berg, 1997), p. 11.

33. "In a tradition this process of fusion is continually going on, for there old and new are always combining into something of living value,

without either being explicitly foregrounded from the other," Hans-Georg Gadamer, *Truth and Method* (New York: Continuum, 1989), p. 306.
34. Sharon MacDonald, *Reimagining Culture*, p. 213.
35. Arjun Appadurai, *Modernity at Large: Cultural Dimensions of Globalization* (Minneapolis: University of Minnesota Press, 1996), p. 179.
36. Tomás Ó Criomhthain, *An tOileánach*, Seán Ó Coileáin (ed) (Dublin: Talbot Press, 2002).
37. Myles Na gCopaleen (aka Brian O'Nolan/Flann O'Brien), *An Béal Bocht* (Cork: Mercier, 1997); English translation by Patrick C. Power, *The Poor Mouth* (London: Paladin, 1988).
38. Pronounced *tuppins*.
39. Mikhail Bakhtin, *The Dialogic Imagination: Four Essays* (Austin: University of Texas Press, 1981), pp. 84–85.
40. Ó Criomhthain, *An tOileánach*, pp. 327–28. Thomas O'Crohan, *The Islandman*, translated from the Irish by Robin Flower (Oxford: Oxford University Press, 1951), p. 244.
41. Máirtín Mac Donnchadha, "Amhrán na Trá Báine," *Bliainiris*, 2001, 104–27.
42. See, for example, the version sung by Joe Heaney from Carna, Co. Galway, in the Joe Heaney Archive: <http://www.joeheaney.org/default.asp?contentID=781> [accessed August 28, 2014].
43. Peter McQuillan, *Native and Natural: Aspects of the Concepts of Right and Freedom in Irish* (Cork: Cork University Press, 2004), pp. 20–54.

BIBLIOGRAPHY

Appadurai, Arjun. *Modernity at Large: Cultural Dimensions of Globalization* (Minneapolis: University of Minnesota Press, 1996).
Bachelard, Gaston. *The Poetics of Space* (Boston: Beacon Press, 1994).
Bakhtin, Mikhail. *The Dialogic Imagination: Four Essays* (Austin: University of Texas Press, 1981).
Beiner, Guy. *Remembering the Year of the French* (Madison: University of Wisconsin Press, 2007).
Carter, Paul. *Ground Truthing: Explorations in a Creative Region* (Crawley: University of Western Australia Press, 2010).
Chamberlin, J. Edward and Levi Namaseb, "Stories and Songs across Cultures: Perspectives from Africa and the Americas," *Profession* (Modern Language Association of America), 2001: 24–38, http://www.jstor.org/stable/25607180.
Cohen, Anthony. *The Symbolic Construction of Community* (London: Routledge, 1985).
Escobar, Arturo. "Culture Sits in Places: Reflections on Globalism and Subaltern Strategies of Localization," *Political Geography*, 20, 2001: 139–74.

Foley, John Miles. *How To Read an Oral Poem* (Urbana: University of Illinois Press, 2002).

Fox, Robin. *The Tory Islanders: People of the Celtic Fringe* (Cambridge, MA: Cambridge University Press, 1978).

Gadamer, Hans-Georg. *Truth and Method* (New York: Continuum, 1989).

Glassie, Henry. *The Stars of Ballymenone* (Bloomington: Indiana University Press, 2006).

Hannigan, Margaret and Seamus Clandillon, *Londubh An Chairn: Songs of the Irish Gaels* (Oxford: Oxford University Press, 1925).

Honko, Lauri. "Traditions in the Construction of Ethnic Identity and Strategies for Ethnic Survival," *European Review*, 3, 2, 1995: 131–46.

Impey, Angela. "Sound, Memory and Dis/placement: Exploring Sound, Song and Performance as Oral History in the Southern African Borderlands," *Oral History*, 36, 1, Spring 2008: 33–44.

MacDonald, Sharon. *Reimagining Culture: Histories, Identities and the Gaelic Renaissance* (Oxford: Berg, 1997).

Mac Donnchadha, Máirtín. "Amhrán na Trá Báine," *Bliainiris*, 2001: 104–27.

Mac Grianna, Seosamh. *Pádraig Ó Conaire agus Aistí Eile* (Baile Átha Cliath: An Gúm, 1936).

Magennis, Caroline. "What Does not Respect Borders: The Troubled Body and the Peace Process in Northern Irish Fiction," *The Canadian Journal of Irish Studies*, 36, 1, 2010: 89–91.

McQuillan, Peter. *Native and Natural: Aspects of the Concepts of Right and Freedom in Irish* (Cork: Cork University Press, 2004).

Na Gopaleen, Myles (ed). *An Béal Bocht* (Cork: Mercier, 1997).

Ní Uallacháin, Pádraigín. *A Hidden Ulster* (Dublin: Four Courts, 2003).

Ó Baoill, Colm. *Amhráin Chúige Uladh* (Indreabhán: Cló Iar-Chonnachta, 1997).

Ó Buachalla, Breandán. "The Making of a Cork Jacobite," in Patrick O'Flanagan and Cornelius G. Buttimer (eds) *Cork: History and Society* (Dublin: Geography Publications, 1993), pp. 469–98.

Ó Criomhthain, Tomás. *The Islandman*, translated by Robin Flower (Oxford: Oxford University Press, 1951).

Ó hÉanaí, Seosamh. *Ó Mo Dhúchas, Sraith 1 & Sraith 2* [CD] (Baile Atha Cliath: Gael Linn, 2007).

Ó Laoire, Lillis. "Augmenting Memory, Dispelling Amnesia: The Songs of Róise Uí Ghrianna," *Dublin Review of Books*, 17, Geimhreadh/Earrach 2011, http://www.drb.ie [accessed January 11, 2015].

——. *On a Rock in the Middle of the Ocean: Songs and Singers in Tory Island, Ireland* (Lanham: Scarecrow Press, 2005).

Poincaré, Henri. *The Foundations of Science* (Lancaster, PA: Science Press, 1913).

Ricœur, Paul. *Time and Narrative,* Volume 1 (Chicago: University of Chicago Press, 1984).

Shields, Hugh. *Narrative Singing in Ireland: Lays Ballads, Come-All-Yes and Other Songs* (Dublin: Irish Academic Press, 1994).

Stokes, Martin. *Ethnicity, Identity and Music: The Musical Construction of Place* (Oxford: Berg 1994).

Williams, Sean and Lillis Ó Laoire. *Bright Star of the West: Joe Heaney, Irish Song Man* (New York: Oxford University Press, 2011), pp. 159–76.

CHAPTER 5

LIPS IN LANGUAGE AND SPACE: IMAGINARY PLACES IN JAMES DAWSON'S *AUSTRALIAN ABORIGINES* (1881)

Paul Carter

What happens when you try to understand where someone else lives? You want to give a sympathetic account of the environment they inhabit. You recognize that any representation of the place where they live, work, and die will reflect inherited conventions of classification, and that these will naturally foreground elements, experiences, and relationships considered vital in their practical philosophy for maintaining life and procuring well-being. You may possess a comparable cultural self-awareness; but, even if you have this introspective streak, you are constrained by the language you speak, and the circumstances of the interaction, to focus your inquiries on those features of the physical surroundings that signify to you. Such a constraint is not fatal to the discussion if the person you are interrogating is, in Peirce's terms, an "interpretant" of the "same description" as yourself,[1] but what if the generalized signs or symbols you are using—words, sentences, and even the performative conventions of speaking—correspond to no equivalent concept in your interlocutor's language or system of symbolic representation? Note that this is not strictly a Whorfian objection. It is not that your native informant is conceptually landlocked by his or her own language's lexical limitations: it is a lack of *semiotic correspondence* that creates the

difficulty. For example, an Indigenous Australian might have no dif-
ficulty in finding an equivalent word for "man," even if, on closer
examination, the semiotic range of the given word turned out to be
culturally specific. But what if s/he was asked to identify features in
the landscape that did not exist, objects for which "in the mind of the
auditor" there were no "corresponding signs."[2] Again, this would not
be a purely intellectual conundrum; in the context of colonization,
it might define the future. "A Symbol is a law," Peirce asserted, "or
regularity of the indefinite future."[3] Any discourse composed of "gen-
eral signs," as Peirce called words, embodies a *habit* of interpretation
or understanding.[4] But what if, so far as naming the country goes,
the two interpretants inhabit different *habitats*, different ecologies of
Logos? It is not simply that communication will be curtailed; rather,
the possibility of a future together will not exist. Unless there can
be translation, evolution toward a shared future place is, in Peircean
terms, strictly impossible.

 In a somewhat over-schematized way, this was the situation that
frequently confronted colonial surveyors, administrators, and settlers
in nineteenth-century Australia. The evidence of place-names like
"Mount Disappointment" or "Lake Illusion" suggests that the general
signs, or verbal symbols, available in the English language did not cor-
respond to the kinds of geographical object observed in the Australian
interior.[5] In applying these names colonists did in an informal way
what Peirce later recommended theoretically: they observed, say, an
object that looked like a lake or mountain (a sign that stood in an
iconic relation to the object); they thought they could perceive indi-
cations in the landscape (dried river beds, the likelihood of panoramic
views) that stood, as it were, in an indexical relationship to the object;
finally, on the basis of these particular signs they felt they could with
"more or less approximate certainty" generalize their observation in
the symbolic form of a word ("lake," "mountain"). However, as the
experiential sequel proved (and as the frequency on Australian maps of
ironic, even oxymoronic, place-names documents), appearances often
deceived: Australian landforms and hydrography were not characteris-
tically picturesque and fluviatile. Hence, as the Victorian settler and
amateur ethno-linguist, James Dawson, noted, "Every river which
forms one continuous stream during both summer and winter has a
name which is applied to its whole length...At the same time, every
local reach in these rivers has a distinguishing name."[6]

 Dawson was operating in a part of Australia whose landscape could
be assimilated to European habits; however, even his recognition
of the functional differentiation of parts of the "river" conceals

unsuspected complexities. For example, the rivers in question flowed through more than one language area: any "river" bore more than one name. As regards localities within the length of the river, not only were these characterized semi-independently of their setting, they might apparently bear more than one name. The distinguished scholar of southwest Victorian Aboriginal cultures, Ian Clark, states, "Some nine intralectal doublets have been recorded in the study area: four are of mountains, two are lakes, one is a swamp, one an island, and one a waterfall."[7] It is not only that different tribes have different names for the same object: even the same tribe, it seems, may name the object in more than one way.

These kinds of statement should not fuel Borgesian fantasy. They do not provide evidence of a "primitive mind" unable (in the famous Levy-Bruhl formulation) to think logically, that is, in terms of symbols whose semiotic field is sharply circumscribed. They are symptoms of a confusion that comes about because the English terms and the Indigenous terms do not correspond. Take the word "river." In his consolidated word list of Western Kulin languages (of which Dawson's Djabwurrung and Gundidjmara languages or dialects form a part), Blake groups Indigenous words for "river" under the heading "river/creek."[8] In Australian usage, a creek is a river that does not flow all the year round: it may be reduced to a chain of ponds or billabongs. This "river/creek" accommodation recognizes the fact that Dawson's category of "river" may be unnecessary: all rivers may be periodic flows that at other times are semi-independent chains of waterholes. In this case there is not, as it were, one water or water body but a variety of humid states and localities. There is no ideal state of which others are deformations or fallings off. The Rev. J. H. Stähle, head of the Church Mission, Lake Condah (in Gundidjmara country), stated "The tribe was divided into four classes, named Kerup (water), Bum (mountain), Direk (swamp), and Gilger (river)."[9] Stähle is not highly regarded as an authority on Indigenous culture; however, even if he understood little, he grasped that the different states of water were sufficiently marked in Aboriginal culture to underwrite the laws governing marriage.[10] Finally, by way of illustrating these semiotic mismatches, consider Dawson's statement that the Gundidjmara word for "river" ("Baarnk") also signified "Milky Way"[11] or the remark of another colonial authority, Robert Brough Smyth, that the name of the Hopkins River was "Barng."[12] Was Dawson's "river" a descriptive name, a proper name, or a figure of speech?

The question of what the names signify becomes pressing when questions of natural justice and historical reparation for land theft are

raised. When in the 1840s the government-appointed Chief Aboriginal Protector, George Augustus Robinson, attempted to survey the Aboriginal peoples who had survived the first wave of pastoral invasion, he encountered in southwest Victoria relatives of the people who would later provide James Dawson and his daughter, Isabella, with the linguistic content of *Australian Aborigines*. Whenever he could, Robinson recorded place-names as well as personal names. After one such interrogation, his native informant wafted his hand toward the horizon and said "My country!" It was certainly a poignant statement of dispossession, but what did it mean?[13] A prospect, a retrospect? An exclusively held territory, a shared region, a landscape—or, perhaps, given the central role that eel farming played in the local economy, a waterscape? In the 1980s the Victorian government auspiced an initiative aimed at "the restoration of Aboriginal place-names" in the Grampians National Park (again in southwest Victoria). The political significance of bringing to public consciousness "a valuable repository of information about Koorie customs and traditions" was indisputable, but how valuable was it culturally, if the principle of shared symbolic habits (on which the new double naming of features depended) was flawed? As Libby Porter has documented, the assumption of translatability facilitated a new colonization of Indigenous knowledge, as the "indigenization" of this landscape served mainly to legitimate and extend existing white settler place production and management ideologies.[14] It could be argued that the search for equivalent terms played into neocolonialist hands.

More optimistically, the proposal to restore Indigenous names to rock art sites and landscape features was one practical implementation of recommendations contained a century earlier in Dawson's 1881 publication, *Australian Aborigines*. Although the main focus of this book was on the languages spoken by the people who worked on his Kangatong property north of Warrnambool in the 1860s, Dawson was a lifelong collector of information about the way Indigenous people lived in his area—their habits, as we might say, and their habitat; and toward the end of his publication he expresses regret that the "opportunity for securing the native names of places" in southwest Victoria "has, in many cases, gone forever." The traumatic dislocations due to colonization, combined with white indifference, had caused the "names" of "features" to go unrecorded. "How much more interesting," Dawson muses, "would have been the map of the colony of Victoria had this been attended to at an earlier period of its history."[15] And not simply more interesting, but more inhabitable, for Dawson's campaign to rehabilitate Indigenous cultural

knowledge and environmental know-how was motivated not simply by a sense of natural justice but by a humanist vision of the just society. The argument that brings together his practical humanism, expressed across a range of interests, causes, and commissions, is that a direct relationship exists between social justice and environmental literacy: how can a recent immigrant population form place-based attachments unless it knows the place where it lives? And how is this going to be effected if the appropriate symbolic representations are not available? How, to put it in terms of this volume's spatial schema, can one bring about a transformation that leads to a new Concrete-Collective—different habits of spatiality converging on the production of a new creative region? In commissioning the noted landscape artist Eugen von Guerard to paint "Tower Hill" (a volcanic feature outside Warrnambool), Dawson was investing in the visualization of the landscape. In leading the campaign to gazette Mount Rouse as a nature reserve, he sought to create reflective and reflexive places where the costs of colonization (the clearing of the land and consequent loss of habitat) could be contemplated and, with education, corrected. The collection of Aboriginal words was integral to the project of conceptualizing the region in such a way that habit and habitat were practically and symbolically related. Unless the region's symbolic economy could be articulated, its long-term social and environmental sustainability must be in doubt.

In a situation where translation was understood to be critical to the planning and education of a future regional society, the question of translatability—the commensurability of different "descriptions" or habits—was obviously central. Translatability was not a Whorfian challenge—a matter of adjusting incommensurable systems of signification—but the precondition of growth. For a symbolic representation to emerge, some principle of generalization must be at work; but the process of growing abstraction is itself subject to the generation of further abstractions. It is interesting in our context of relating habit to habitat that Peirce saw a direct connection between this principle of logical immanence and biological evolution.[16] The tendency of life to evolve increasingly complex forms or interrelations in response to its changing environment finds an analogue in what Peirce refers to as a "habit-change," by which he means "a modification of a person's tendencies toward action, resulting from previous experiences or from previous exertions of his will or acts, or from a complexus of both kinds of cause."[17]

In the context of learning the symbolic repertoire for living sustainably in a new country, it is essential that habits can be modified. This is

possible presumably because any sign or symbol always conveys more than "any existential act": "no agglomeration of actual happenings can ever completely fill up the meaning of a 'would be.' "[18] Indeed, and this fact, which is common knowledge to poets, that the potential of the referent always exceeds what it conventionally refers to, is, in a higgledy-piggledy way, evoked in the brief discussion about the translation, or otherwise, of the term "river." The questioner's "river" and the informant's various responses to it establish the conditions of a "would-be" place, one accessible when the poetic or full symbolic potential of the sign is released.

Weaving theoretical arguments and historical instances together inevitably poses the question of intentionality: was James Dawson aware of the potential of his and his daughter's work to bring about a modification in the collective behavior of regional Victorian society? His efforts to promote mindfulness in fellow citizens are well-documented; he appreciated the direct link between a knowledge of the regional cultural and environmental heritage and the cultivation of a "sense of place"; and, with remarkable vigor, he identified the future of the just society with the enlargement of the public domain. Even if the "commons" was contracting under the pressure of pastoral expansion, the space of public education (and interest) was, in principle, enlarged through his program. However, Dawson was not a poet; and even less a theorist. His and Isabella's account of the people they worked with is distinguished by its empirical discretion; and, more interestingly for us, by its scrupulous preservation or acceptance of idiolectal differences (different individual pronunciations producing different spellings of what appear to be variants of one word). In an important sense, the language section of the book documents a language performance that unfolded intermittently over the ten years of Isabella's field research. The whole book is, in this Peircean sense, a symbolic representation—not of a people or a place but of the discursive situation itself in which its knowledge emerged, and to which the contents of the book are indexically related. It embeds different speaking positions, different voices, gendered knowledges—and the mold, as it were—of the questioners' ancestral habitat. Given the rareness of mist, snow, hail, frost, and sleet in southwest Victoria, one can be forgiven for detecting a Scottish bias in the design of the vocabulary. What Kaawirn Kuunawarn or Yarruun Parpur Tarneen (two of the elders who made the word lists possible) thought of when asked to translate "gloaming," one can only imagine.[19]

One indication that Dawson understood the novelty of his interests—and the purposeful originality of his language-getting

techniques—was his decision to name the property he moved to in the 1870s after the regional word for "lip," *wuurong*. The regional word for "habitation" was well known, and any white settler with a picturesque taste for the primitive—and there was in the wake of invasion a fashion for adopting Aboriginal words for private properties, as well as administrative units—would logically have selected *wuurn* or some variant.[20] Indeed, Dawson's first property sported an Aboriginal name (Kangatong). In this context Dawson's decision to call his second home after a part of the human mouth is unlikely to be accidental. The term *wuurong* featured in the names Dawson gave to the languages he recorded: Peek Whurrung (translated by the Dawsons as "kelp lip") and Chaap Wuurong ("broad lip"), later written as Djab*wurrung*). Perhaps, then, Dawson intended to commemorate the association of the place where he lived with the language project. Perhaps, though, the association was more precisely with *fluency*: this possibility seems to be circumstantially confirmed by the role the same word played in Aboriginal toponymy, where, according to Dawson, the word was found in place-names such as "Wuurong killing" ("Lip of waterhole," with reference to a "particular spring where a bunyip lives.") and "Bukkar whuurong" ("Middle lip"), referring to a

> bank between Lakes Bullen Merri and Gnotuk. A gap in this dividing bank is said to have been made by a bunyip, which lived at one time in Lake Bullen Merri, but, on leaving it, ploughed its way over the bank into Lake Gnotuk, and thence at Gnotuk Junction to Taylor's River, forming a channel across the country.[21]

Wuurong and its orthographic variants were, it appears, primarily associated with overflow: with the passage of air (breathing, speaking) or water (brimming waterholes, weirs, and channels). Home in this environment of translation was a place of passage, growth, and exchange.

Fluency in the languages of the country had its counterpart in the fluency of the habitat, notable for the aquaculture it supported. Dawson's interpretation of the regional Indigenous cultures was remarkable for its recognition of their productivity: when, in the 1970s, the archaeologist Harry Lourandos overhauled the primitivist hunter-gatherer model of precolonial Aboriginal societies, he based his work partly on the evidence of complex economic patterns derivable from the excavation of particular sites, and partly on Dawson's descriptions of the "great meetings," where disputes were resolved, goods exchanged, and treaties reaffirmed. Dawson unquestionably brought his own radically conservative biases to his description of

Indigenous life—strategically, perhaps, assimilating it to a kind of preindustrial smallholder model; but his great distinction was to recognize that the Gundidjmara and Djabwurrung produced the country that produced them.[22] The focus of the eel-trap design, which produced the abundance of produce underpinning the intensification of sociability witnessed at the great meetings, was the *lip*, the artificially constructed overflow where outgoing eels could most easily be trapped:

> Eels are prized by the aborigines as an article of food above all other fish. They are captured in great numbers by building stone barriers across rapid streams, and diverting the current through an opening into a funnel-mouthed basket pipe, three or four feet long, two inches in diameter, and closed at the lower end. When the streams extend over the marshes in time of flood, clay embankments, two to three feet high, and sometimes three to four hundred yards in length, are built across them, and the current is confined to narrow openings in which the pipe baskets are placed. The eels, proceeding down the stream in the beginning of the winter floods, go headforemost into the pipes, and do not attempt to turn back.[23]

In other words, *wuurong* referred not simply to a body part and its anthropomorphic analogue in the landscape: it referred to the climactic event in the regional economy, the production of the excess that transformed a subsistence culture into a trading one. From this perspective, Lourandos argued, groups of people were not separate and fixed in their habits. They were defined relationally and were codependent; and the spatiality of their lifeworlds should be reconceptualized on the model of the great meetings "in terms of 'relationality' and 'fluidity.' "[24]

In other words, the brief discussion of Dawson's use of *wuurong* offered here suggests that a considerable degree of self-awareness was involved in the language project. In contrast to the many other amateur language hunters in colonial Victoria, the Dawsons engaged in a concerted effort to understand the "habit" informing the symbolic representations their informants used. Granted the limitations and biases of the ancestral landscape James brought with him (and perhaps because of the unvarnished personalism this introduced into the conversation), Dawson's almost Marxist idealization of the Indigenous free laborer is revolutionary in this context precisely because it recognizes the Djabwurrung's "social labor" as a form of production. His attention to the interrelatedness of the natural world and the modes of economic production intuits a society that, in contrast

with the pastoral capitalist one in which he operated, where people suffered estrangement from one another, recognized "a totality of needs" that could only be met when each became a "means for the other." More ominously and importantly, Dawson's acknowledgment of the "sensuous human activity, practice" refracted through the Indigenous languages implied a recognition of the Indigenous peoples as historical subjects. "History," according to Marx, was "a conscious self-transcending act of origin." It was "in creating *a world of objects* by his practical activity, in his *work upon* inorganic nature," that Man was able to treat himself as "a universal and therefore a free being."[25] If the eel-farming communities had created their own world through the modification of the habitat, then, logically, they could do it again; and, through a kind of mutual "habit-change," colonists and colonized might, in future, when a principle of translatability had been established, enter into a just society.

So much for Dawson's humanistic sympathies, his primary openness to the humanity of his neighbors—which finds its expression in the unflagging curiosity he exhibited about their way of life and their ways of describing it. Because of his capacity to take what was happening around him at face value—not to pretend (as so many other colonists did) that the Aboriginal people were invisible—Dawson recorded what he encountered with a minimum of theoretical or cultural filters; his own biases shone through, but so did the prejudices of his Aboriginal workers and friends. The very theoretical incompleteness, the lack of academic sophistication in *Australian Aborigines*, thus allows, albeit accidentally, something of the non-commensurability or untranslatability of "habits" to come through. The passing notice of the fact that a river name was also the name of the Milky Way is a case in point. At the very least, it implies a sky-earth reciprocity missing in European conceptions of landscape. Similarly, although more subtly, the iconic classification of features in the landscape in terms of human body parts also illustrates a heightened sensitivity to the interrelatedness of human and nonhuman interests. But here we might pause because, although Dawson gives us tentative access to such ecological and spiritual senses of place, his "translation" also falls short of understanding their significance. In line with the Marxist (or, for that matter, utilitarian) theory of human progress, Dawson assumes the primacy of "man," whether conceived of as a self, an individual, or a productive unit of society. The environment, or habitat, may be the ground of survival and well-being, but it is, for the purposes of philosophical anthropology (and materialist history), a background or passive stage. It comes into useful

existence—available, that is, for symbolic representation—at the point where it is enclosed conceptually. And the new toponymy that Dawson imagined, in which Aboriginal names were restored, simply allowed a more finely grained enclosure of the environment's phenomenal spread.

In the Dawson word lists we find that the "Aboriginal Name" for the "northern peak of Mount Leura" is "Lehurra," which means "Nose"; another "Mount" is called "Puutch beem," translated as "High head."[26] These comparisons of topographical features to body parts are ubiquitous in the Australian ethnographic literature. Indeed, from a Western point of view—at least one influenced by phenomenological or psychoanalytic theories of concept formation—such projections of human interests onto the landscape are universal. However, the distinction between self and setting, between psychic and physical regions—the very distinction that makes the work of symbolic thought necessary—remains intact. Hence, while it may be true that "[i]n the final analysis the whole world is perceived in the image of one's own body,"[27] "[t]he dichotomy of the 'I' and the 'World' is implicit in all experience, in all verbal expression."[28] The "face" that "place" assumes, to borrow Edward Casey's formulation, may vary and evolve—Heidegger's "topology of Being" yielding to the new poetics and politics of Irigaray's "porous body-place"—but the fundamental assumption remains, that these representations of place are symbolic. The reconfiguration of places follows the reconceptualization of the body, a process that, as Casey notes, occurs against the background of "the global absolutes of Space and Time."[29] The expanded repertoire of place meanings he tracks, for example, is dialectically shaped, by a desire to inform space with human meaning: the new places symbolize attempts to denuclearize the individual, to redefine social relations, and to recuperate the "local absolute" of creativity. However, throughout these permutations, the difference between the individual and the setting is retained, and the identification between them remains symbolic, that is, representational in origin.

In this context, the interpretation of Indigenous place concepts that makes possible a "habit change" involves, in the first instance, questioning the figure-ground symbolic orthodoxy. Suppose that Indigenous selves are not conceptualized apart from (or even in relation to) the place where they live; suppose, further, that the identification of interests is methektic, or participatory, rather than mimetic, representationalist, so that the language of topopoiesis, the figurative language of place naming, is indistinguishable from the conduct

of everyday life and the function and form of performance. In a recent article Aaron Corn draws on collaborative work with Yolngu elders from northeast Arnhem Land to illustrate the proposition that "... [t]he physical human form, its natural environments and its traditional behaviors [are] phenomena that are given by the ancestors and patterned on their grand archetypal designs for life." Inverting the figure-ground assumption of individualist psychology present in Thass-Thienemann's account, Corn seeks to demonstrate how

> Yolngu nomenclature for human anatomy is used as a meta-language to describe the significances of the topographical features on country and on the formal features of Yolngu performance traditions. In this ontology, place does not exist either within or apart from space: regarding both as abstractions—and the western dialectical definition of them as false— it imagines an all-embracing place, diffused, relational and essentially poetic, that is, capable of generating intellectual content that makes sense of body, environment—and, not least significantly, social and political relations.

Corn adds, "the concept of the body extends from the corporeal to the corporate; from a body of limbs and organs, to a body of different people and patrifilial groups."[30]

There is a tendency in phenomenologically inclined post-ethnography to assume all Australian Aboriginal peoples hold, or have held, broadly similar views about the origins of the world and their place in it. As a result there is a tendency to retrodict onto former generations and communities, whose cultures are represented solely in the historical literature, present-day interests. A kind of latter-day cultural diffusionism is used, respectfully but problematically, to fill in the gaps in knowledge; a kind of ethnographic uniformitarianism is deployed, which assumes that what can be observed in the present provides the legitimate basis for interpreting what happened in the past. Hence, in drawing on Yolngu epistemologies to illuminate the Dawson word lists, circumspection is necessary.[31] However, it is clear from Dawson's reports of Western District "superstitions," "anecdotes," and place-names that early to mid-nineteenth-century Gundidjmara and Djabwurrung peoples held broadly comparable views. There is a striking resemblance, for example, between the Yolngu concept of *renggitj* "multi-party relationships through which disputes must be addressed and consensus reached before new knowledge and plans can be generated" and the "Great Meetings" that form the centerpiece of Dawson's essay: and it is telling to place Dawson's theatrical, gathering-of-the-clans conception of the event in

the Yolngu context, where *renngitj* refers, not to an occasional special event, but to a primary, originary site of personal, environmental, and social being:

> the *renngitj*, as a visible mark or imprint on the land, is characterized as a place of origin, the repository of all the names, as well as a kind of mapped visual expression of the connection between peoples and places which is to be carried out in the temporal sequence of the journey.[32]

To open out this account a little, we might consider the structural parallels that exist between the occlusion of Indigenous ontologies of place and space and the eradication of precolonial Irish "senses of place." This is not an arbitrary exercise in cultural comparativism: it is, again, inspired by Dawson's own perspicaciousness. It acquires an additional historical relevance because, although the evidence is circumstantial rather than documentary, a reasonable proportion of the Scottish and Irish immigrants to southwest Victoria in the mid-nineteenth century must have spoken Gaelic or, at the very least, have heard at firsthand the Indigenous stories of *their* landscape and its making. Nor, again, is it to assimilate Dawson, himself an economic migrant, to the unlettered culture of his Irish and Scottish brethren: in contrast with their largely rural origins, Dawson hailed from Linlithgow outside Edinburgh and from a family outstanding for its public service, its liberal humanism, and even its interest in Scottish traditions; in many ways Dawson's labors toward *Australian Aborigines* mirrored the interests and commitments of his father and brother in their native land. Dawson's own philosophy of land was pitched against incursions from the Irish as well as the English! In his early days in Warrnambool, he had been an opponent of "landlordism," the speculative privatization of large tracts of productive land. When, though, this was reversed, through the 1866 Duffy Act, and the land "unlocked," his attempts to buy back the blocks of land into which his own property had been subdivided reflected a strong resistance to outside incursions (notably from newly arrived Irish immigrants).[33] This said, though, as an observer of Aboriginal practices and beliefs, Dawson was alive to parallels with certain beliefs and customs still maintained in the old world. Thus, he noted in passing, "[i]t is a remarkable coincidence with the superstition of the lower orders in Europe, that the aborigines believe every adult has a wraith, or likeness of himself…"[34] and, more particularly in relation to his own place of origin, "[f]or pains in the joints, fresh skins of eels are wrapped round the place, flesh side inwards. The same cure is very common in Scotland for a sprained wrist."[35]

In terms of parallels between Aboriginal and Irish cultures of place-making, and the question of translatability, the most suggestive passage in *Australian Aborigines* concerns a certain "clever old witch":

> The aborigines had among them sorcerers and doctors, whom they believed to possess supernatural powers. In the Kolor tribe there was a sorceress well known in the Western district under the name of White Lady, who was the widow of the chief, and whose supernatural influence was much dreaded by all.[36]

It is clear that Dawson had difficulty in understanding her social role. On the one hand, "[t]his cunning woman possessed such power over the minds of her tribe that anything she fancied was at once given to her." On the other, she belonged to an odd social class:

> Witches always appear in the form of an old woman and are called kuin'gnat yambateetch, meaning "solitary," or "wandering by themselves." No one knows where they come from or where they go to; and they are seldom seen unless at great meetings... They belong to no tribe and have no friends; and, as everyone runs away on their approach, they neither speak to anyone nor are spoken to.[37]

However, it is this ambiguous appearance and circulation that reinforces the impression that, structurally at least, in terms of her social and cultural function, the White Lady corresponded to the Irish Cailleach Bhearra, "whose powers and activities have resulted in the shapes of hills, the courses of rivers, the location of islands and the presence in the landscape of numerous natural features."[38] Dawson's patronizing characterization of her as a wandering witch reflects his exposure to stories of the "Hag" in Scotland. And, again, it illustrates the fascinating mixture of perspicacity and prejudice that makes *Australian Aborigines* such an intriguing attempt to reconcile different symbolic "habits," while inadvertently drawing attention to their incommensurability; for while a "wandering" figure is always associated in European literature with the solitary exile and the outcast, in a pre-Enclosure world such privileged travelers would, like Dawson's Weeratt Kuyuut, be the medium of interregional communication and enhanced sociability.[39]

In Dawson's account, the White Lady is downgraded to a wandering witch, and the powers she might enjoy as an Indigenous Cailleach are disregarded. In *The Book of the Cailleach*, Gearóid Ó Crualaoich describes these powers as follows: (a) the creator of the landscape:

"This personage is regarded in traditional cosmology as the personifi-
cation, in divine female form, of the physical landscape within which
human life is lived and also of the cosmic forces at work in that land-
scape"[40]; (b) the giver of the laws: the folklore about the *cailleach* and
her *bean feasa*, the *seanchas*,

> has an original, technical meaning of a normative bent, insofar as it orig-
> inally signified traditional law; the formulation, in narrative account, of
> that which is correct, wise, true...Something of this moral and ethical
> sense of *seanchas*...is conveyed by the legends of the *cailleach* and the
> *bean feasa*;[41]

(c) they bear witness to "woman's time (the temporal of the
goddess)...cyclical, associated with reproduction and with cosmic
rhythm, with the eternal that underlies history..."[42]; (d) they are
associated with sacred sites, where the sacred site is sacred because it
is a site of assembly;[43] and (e) in relation to the later Celtic patriarchal
myths, she represents an older "territorial sovereignty queen":

> an overarching female matrix of sovereignty and fertile power that is as
> vast and as untamable as the wild, wide landscape, and that is yet as
> nurturing and as intimately fruitful for human beings and for human
> existence as are the services of the [midwife, the wise woman and the
> keening woman]...[44]

The White Lady stands in relation to what Stanner calls "the *logos*
of the Dreaming"[45]—bound up in hundreds of tales that represent "a
cosmogony, an account of the begetting of the universe, a study about
creation"[46]—as the *bean feasa* or "wise woman" stands in relation
to the overarching cosmogonic Cailleach. She is a shaman: Dawson
writes that on one occasion, "having left the camp for a while on a
moonlight night, she pretended, on her return, that she had been to
the moon."[47] In a similar way, W. H. Howitt, writing of the Kurnai
people of Gippsland (eastern Victoria) at the same period, reported
that the male Birraark, a man possessed of magical powers of commu-
nion with the dead, could on occasion be conveyed to the clouds.[48]
When the White Lady died, "Her head...and portions of the legs and
arms were buried in a cave near Mount Kolor, where she was born."[49]
Mount Kolor is Mount Rouse, which, intriguingly, Dawson identifies
as one of the places where "great meetings" were held periodically.
The White Lady is associated with access to the underworld as well
as the sky and, possibly, has a duty of care toward the Djabwurrung
equivalent of a *renngitj*, an increase site (where ceremonies were held

to increase the availability of a food source) or place of assembly. Because, though, writers like Dawson and Howitt impose a hierarchical and patriarchal model of social organization on Aboriginal society, the role of female power brokers can only be grasped fragmentarily, and much remains informed guesswork.

"One has not succeeded in 'thinking black' until one's mind can, without intellectual struggle, enfold into some kind of oneness the notions of body, spirit, ghost, shadow, name, spirit-site, and totem," wrote Stanner, again with remarkable perceptiveness.[50] In the context of getting the neglected place-names of southwest Victoria, this means that the names Dawson's Indigenous colleagues supplied could not be regarded as translations or equivalents of English names. Equally, where they named features that the colonists had overlooked, they could not be assumed to name them in the same way. Place-names, and therefore places, were conceived of as relational, performative, originary, and generative. The "local" was understood to contain the universal within it, and the communication of this property was not through the language of the dictionary but in song and dance. As a compassionate neighbor, Dawson perceived the impact that the missionary ban on ceremony had on Aboriginal people; and he took every opportunity to encourage the maintenance of "corroboree." However, this crosscultural patronage did not mean that Dawson *liked* this "leading amusement," whose "airs" he described as "doleful and monotonous."[51] In other words, in his campaign to rationalize Aboriginal society and to adapt its culture to a future place in colonial society, he missed the direct connection between the production and reproduction of place and the periodic performance of the songs, the designs and the dances that mythopoetically evoked its creation. In this sense, the "habit break" needed to understand how the Aboriginal landscape spoke to its people involved inhabiting the creativity. Only then could the habitual "kind of oneness" that Stanner describes be felt; for a "habit break" to occur, reasoning needed to be augmented with feeling, with the identification associated with friendship and love, whose aesthetic equivalent is singing and dancing together.

Here, again, there are Irish parallels—where, too, ethnographic and folkloric studies have traditionally privileged the linguistic and discursive elements of cultural production over their sung and danced components. In this context, Ó Laoire asserts the role played in social production by the "dance situation" in Tory Island society:[52]

[I]t constituted a liminal situation with an unpredictable quality not apparent in the everyday ... It was a special "sacred" site where serious

and divisive issues which pertained to life could be presented in a stylized and dramatized way, which could remove much of the fear they elicited, enabling participants to mediate them in a distanced context, although elements of risk and danger still remained, helping to increase the efficacy of such representations.[53]

But there is something much more important. Ó Laoire explains how the dance warms people up: to be warm (toward one another) is to feel a heightened sense of kinship, intimacy, and mutual obligation. It can resolve the intra-familial tension between mothers, fathers, and children. It is associated with a sense of place and communal identity. Creating warmth is like creating atmosphere: it is a quickening of social Eros that keeps the coldness of the outside world at bay, the ever-present shade of death. The dance and the singing and the telling were a form of clothing against the coldness of the world: around the fire the corroboree produced its own heat—intriguingly, Dawson's own vocabulary distinguishes between "heat" and "heat of the fire."[54]

Ian Keen remarks that a regional understanding of Indigenous society has implications for "postcolonial" relations. In what way are the insights that emerge, almost between the lines of *Australian Aborigines*, applicable to the renegotiation of postcolonial relations in Australia? Dawson intended his work to serve that end, and even if, like us, he is limited by his historical and cultural prejudices, he provided plentiful evidence of a society that was productive, evolutionary, and self-sustaining. His interest in a bicultural toponymy was a side product of his conviction that a future society that recognized the original land theft (and the squandering of the intellectual economy bound up in it) would be one that possessed a strong regional identity. His "region" was not imagined as an administrative enclosure, a bureaucratic machine for the systematic removal of people from the places where they lived, and for the unilateral enclosure and privatization of the commons. On the contrary, it was imagined interregionally, the political, educational, and legislative roles played by such respected elders as Weeratt Kuyuut being replaced by representatives working locally and regionally on behalf of the public interest. However, if this delegation of powers was to change anything, it needed to enter into the Aboriginal way of seeing "country"; it could not be a one-way translation of Indigenous terms that assimilated them to categories of environmental classification belonging to foreign "habits" of symbolic representation.

A starting point for this reform would be the reevaluation of water in the landscape. To recognize the regionally distinctive aquaculture was also to embrace a broader collective mindset, one that

associated water with flow, and flow with the cyclic production of wealth, social connectedness, and sense of place. Water, unlike the mountains, moved and connected. It transformed itself—and here Dawson's admittedly northern weather preoccupations are poetically apt, for water is at all times part of the atmosphere, pervasively inform-ing kind of breath pattern and environmental eddy. Even at the level of the near-universal identification of the environment with images of the human body, this implies a shift in perspective. The new iconic resemblances and indexical traces will be derived from a vitality defined in terms of relationality, flow paths, synapses, and circulations. "Waterholes" occupy a lowly place in the nomenclature of European hydrology. By contrast, in Indigenous cultures, "[r]elationships with water places are steeped in social and religious traditions, from which spring power, knowledge, well-being, good fortune."[55] Waterholes are not conceived as "wells" or water enclosures but lips, sites of turbulent transformation, where the smooth flow of time is perturbed so that the surface throws up images and sounds. As Tamasari and Wallace note, the "kind of oneness" described by Stanner implies a "corpo-real connection" to place that is expressed linguistically: hence proper names derived from such bodily parts as elbow or knee refer less to the iconic resemblance of the feature to those body parts, and more to the indexical association with ideas of flowing, intermingling, and the transferring and distributing of powers: "As knees and elbows are the main joints which give movement to a body, so knee and elbow names articulate specific individual and groups' emotional responses with relationships of identification, authority and ownership of places."[56]

In European, and specifically Irish, terms, a pre-Enclosure com-mons is evoked, one where the physical landscape within which human life is lived and the cosmic forces at work in that landscape continue to underwrite the laws of human conduct.

Ultimately, a "habit change" is brokered when the parties learn to think poetically. The capacity of symbolic representations (words, names) to mean more than they conventionally signify corresponds to Peirce's notion of the "would be": a verbal symbol is always poten-tially more than the sum of its inherited connotations only when the poetic logic informing it is recovered. In a way, colonial inves-tigators trying to understand the character of the people and the country recapitulated the stages through which, according to Peirce, the generalized symbol emerged. They had to test the veracity of the iconic test (was the "mountain" really a "mountain"?); they had to verify the reliability of the indices normally associated with it; and, finally, they had to affirm or abandon the symbolic representation previously descriptive of such "objects." A similar process has to occur

if a renegotiation of postcolonial landscapes and their governance is to occur. The regional toponymy, for example, has, first of all, to be examined for its iconic substrate. What, for example, does it mean poetically, to compare a lagoon to a bone? A double reconceptualization is required, of the constitution of the body and of the "body" of the waterscape. Then, second, the indexical associations proper to this new "object" have to be found. In the case of the "river" (Dawson's "baar"), they will be found to encompass the Milky Way (including the Coalsack, which Djabwurrung people imagined as a waterhole), the divisions of human society, and, interestingly, the first-person plural pronoun "Us" or "We" ("Baar gnatnaen").[57] Finally, there might emerge from this poetically grounded exercise in translation between symbolic systems a new environment of imaginary places—imaginary not because they do not exist but because their emergence involved an act of sympathetic identification in which (following the Vichian triad) human wit integrated recollection, imagination, and invention to invent a new poetic geography, one capable of sustaining us all. And this is possible because, as Peirce argued, "[a] law necessarily governs, or 'is embodied in' individuals, and prescribes some of their qualities. Consequently, a constituent of a Symbol may be an Index, and a constituent may be an Icon."[58]

NOTES

1. See Eliseo Fernández, "Peircean Habits and the Life of Symbols," *Semiotics*, 2010: 98–109, <http://www.pdcnet.org/collection/show?id=cpsem_2010_0098_0109&file_type=pdf> [accessed December 30, 2014].
2. Fernández, "Peircean Habits…," 103.
3. Fernández, "Peircean Habits…," 103.
4. Fernández, "Peircean Habits…," 103.
5. See Paul Carter, *The Road to Botany Bay* (London: Faber and Faber, 1987), Chapter 2.
6. James Dawson, *Australian Aborigines: The Languages and Customs of Several Tribes of Aborigines in the Western District of Victoria, Australia* (Melbourne: George Robertson, 1881), p. lxxviii.
7. Ian D. Clark, "Multiple Aboriginal Place Names in Western Victoria," in I. D. Clark, L. Hercus, and L. Kostanski (eds) *Indigenous and Minority Place Names—Australian and International Perspectives* (Canberra: ANU Press, 2014), pp. 201–208.
8. Barry J. Blake, *Dialects of Western Kulin, Western Victoria: Yartwatjali, Tjapwurrung, Djadjawurrung* (Melbourne: La Trobe

University, 2010), p. 148, http://www.vcaa.vic.edu.au/documents/alcv/dialectsofwesternkulinwesternvictoria.pdf.

9. Stähle quoted in Lorimer Fison and Alfred William Howitt, *Kamilaroi and Kurnai* (Melbourne: George Robertson, 1991), p. 275.

10. Blake similarly confuses these distinctions when he groups words for "lake" (also "marsh," "swamp") together. See Blake, *Dialects of Western Kulin, Western Victoria*, p. 118.

11. Dawson, *Australian Aborigines*, p. xxvi.

12. R. B. Smyth, *The Aborigines of Victoria*, Vol. 2 (Melbourne: Government Printer, 1876), p. 212. Other informants gave Smyth other names for the Hopkins: H. B Lane and/or W. Goodall offered "Pukrruhng" (187); another unidentified correspondent gave "Terong" (187). "Barr" seems to have been generic for river-like water, the Barwon River that flows near Geelong retaining this idea in its name.

13. As that outstanding humanist and anthropologist W. E. H. Stanner observed many years ago, the relationship between Aboriginal people and their ancestral estates has been essentialized, notably in the terms of the Mabo ruling. The "bond" is great but it does not prevent "migrations" to other places. See William Edward Hanley Stanner, *The Dreaming and Other Essays* (Collingwood, VIC: Black Inc., 2011), p. 153.

14. Libby Porter, *The Culture of Planning: Contesting Place in Settler Societies* (Farnham: Ashgate, 2010), pp. 82ff.

15. Dawson, *Australian Aborigines*, p. lxxviii.

16. See Fernández, "Peircean Habits...," 109. In a similar way, writers like Douglas Robertson and John Maynard Smith "measure biological evolutionary progress in terms of abrupt improvements in the way information is represented and transmitted inside living organisms." Gregory J. Chaitin. "Leibniz, Information, Math, Physics," <http://www.cs.auckland.ac.nz/~chaitin/kirchberg.html> [accessed December 18, 2014].

17. Fernández, "Peircean Habits...," 109.

18. Fernández, "Peircean Habits...," 109.

19. Dawson indicates that lists of English words were distributed among the participants at the word-getting sessions. The evidence of the word lists themselves is that Isabella (who had a basic knowledge of the languages) explained the meaning of unfamiliar terms, sometimes by reference to Indigenous terms for related concepts, sometimes by paraphrase or deictically or pantomimically. Hence, the resulting lexicon is a genuine act of "thirding," an accurate account of a new hybrid language arrived at performatively and indexically related to the process of its production.

20. *Wuurn* and *wurrong* may look somewhat similar but there is no question that Dawson distinguished them—lexically, semantically, and phonetically.

21. Dawson, *Australian Aborigines*, p. lxxix. For further discussion of Dawson's use of *wuurong* as the name of his homestead, see Paul Carter, "The Enigma of Access: James Dawson and the Question of Ownership in Translation," *Griffith Law Review*, 22, 1, 2013: 8–27.

22. See Harry Lourandos, "Aboriginal Spatial Organization and Population: South-Western Victoria Reconsidered," *Archaeology and Physical Anthropology in Oceania*, XII, 1977: 202–225.

23. Dawson, *Australian Aborigines*, p. 94. Again, it is interesting that no English word is equivalent to the kind of "stone barriers" described here. Elsewhere Dawson resorts to the term "dam," explaining that the baskets are placed in "a gap of the dam."

24. Franca Tamisari and James Wallace, "Towards an Experiential Archaeology of Place: From Location to Situation Through the Body," in Bruno David, Bryce Barker and Ian J. McNiven (eds) *The Social Archaeology of Australian Indigenous Societies* (Canberra: Aboriginal Studies Press, 2006), p. 209.

25. Gareth Stedman Jones, "Introduction," in Karl Marx and Friedrich Engels (eds) *The Communist Manifesto* (Hardmondsworth: Penguin, 2002), p. 131.

26. Dawson, *Australian Aborigines*, pp. lxxx, lxxxi.

27. Theodore Thass-Thienemann, *Symbolic Behaviour* (New York: Washington Square Press, 1968), p. 264.

28. Thass-Thienemann, *Symbolic Behahviour*, p. 203.

29. Edward Casey, *The Fate of Place* (Berkeley: University of California Press, 1997), p. 334.

30. Aaron Corn, "Ancestral, Corporeal, Corporate: Traditional Yolngu Understandings of the Body Explored," *Borderlands*, 7, 2, 2008: 1–17, p. 2.

31. For a skillful negotiation of these questions, see Franca Tamasari and James Wallace, "Towards an Experiential Archaeology of Place: From Location to Situation through the Body," which draws on Harry Lourandos's groundbreaking work in theorizing the social history of archaeological landscapes; Lourandos's fieldwork mainly took place in the region covered by *Australian Aborigines*.

32. Dawson, *Australian Aborigines*, p. 11. In Dawson's account, the "chief" of the Spring Creek tribe Weeratt Kuyuut was "both a messenger and a traveller"; "in more mature years he was considered such an honourable, impartial man, that he was selected on all occasions as a referee for the settlement of disputes"; "he travelled unmolested all over the country between the Grampian ranges and the sea..." As a primary function of the "messenger" was to convey information "such as the time and place of great meetings" to neighboring tribes, Dawson's description suggests that Weeratt Kuyuut operated within the framework of "renggitj places" or their equivalent. Such places were or might be physical locations but, essentially, they were like acupuncture points in the nervature of the region: they

generated every aspect of the law and traditional knowledge. Hence we learn from Dawson that Weeratt Kuyuut "taught the young people the name of the favourite planets and constellations" and also "the names of localities, mountain ranges, and lakes, and the directions of neighbouring tribes."(*Australian Aborigines*, p. 75).

33. The ironic restaging of Indigenous experiences of land theft in these permutations of land ownership has, of course, been widely noted. See, recently, Lindsay Proudfoot and Diane Hall, *Imperial Spaces: Placing the Irish and Scots in Colonial Australia* (Manchester: Manchester University Press, 2011), p. 113. In the 1851 census the largest group in Western District society was the English (609), "compared with 298 from Scotland and 275 from Ireland. The reason why the Scots are generally seen to be so numerically important was in fact because they formed a disproportionately high number of the squatters." (Don Garden, *Hamilton: A Western District History* (Hamilton: Hargreen Publishing, 1984), p. 29).
34. Dawson, *Australian Aborigines*, p. 51.
35. Dawson, *Australian Aborigines*, p. 57.
36. Dawson, *Australian Aborigines*, p. 55.
37. Dawson, *Australian Aborigines*, p. 52.
38. Gearóid Ó Crualaoich, *The Book of the Cailleach, Stories of the Wise-Woman Healer* (Cork: Cork University Press, 2003), p. 29.
39. See Note 32 above and Ian Keen, "A Continent of Foragers: Aboriginal Australia as a 'Regional System,'" in Patrick McConvell and Nicholas Evans (eds) *Archaeology and Linguistics: Aboriginal Australia in Global Perspective* (Melbourne: Oxford University Press, 1997), pp. 261–74. Keen argues that "pre-colonial Australia" should be considered as "a broad region...with networks of interaction, and with practices along a continuum from those with the shortest "local" scope to those with the widest regional range," (p. 272) and he asserts that "a regional-system perspective is as relevant to post-colonial relations as it is to pre-colonial social life." (p. 273).
40. Ó Crualaoich, *The Book of the Cailleach*, p. 10.
41. Ó Crualaoich, *The Book of the Cailleach*, p. 21.
42. Ó Crualaoich, *The Book of the Cailleach*, p. 27.
43. Ó Crualaoich, *The Book of the Cailleach*, p. 28.
44. Ó Crualaoich, *The Book of the Cailleach*, p. 29.
45. Stanner, *The Dreaming and Other Essays*, p. 72.
46. Stanner, *The Dreaming and Other Essays*, p. 60.
47. Dawson, *Australian Aborigines*, p. 55.
48. Fison and Howitt, *Kamilaroi and Kurnai*, p. 253.
49. Dawson, *Australian Aborigines*, p. 56. No explanation is given of the epithet "White": perhaps it evoked her ghostly quality or otherworldly powers. On the same principle, Padraig Ó Murchú relates how a man went looking for a sacred site only to find it had gone: "He stood there, wondering what had become of the well and t'wasn't long until

a woman, all dressed in white came up and asked him what he was looking for" (Ó Crualaoich, *The Book of the Cailleach*, p. 199). "The cailleach-goddess" has removed the well because of the disrespect shown to it by the invading forces, including patriarchal Christianity: a self-protective move that resonates with Aboriginal stratagems to protect their waterholes.

50. Stanner, *The Dreaming and Other Essays*, p. 59.
51. Dawson, *Australian Aborigines*, p. 80.
52. See also Lillis Ó Laoire, "Space, Place, and Displacement in Two Gaelic Songs," in this volume, Chapter 4.
53. Lillis Ó Laoire, *On a Rock in the Middle of the Ocean* (Indreabhán, Conamara: Cló Iar-Chonnachta, 2005), p. 153.
54. Dawson, *Australian Aborigines*, p. xix. Such communal events produce heartwarming, an intensification of affect. See Ó Laoire, *On a Rock in the Middle of the Ocean*, pp. 161ff. For Aboriginal parallels, see Amanda Kearney and John J. Bradley "Landscapes with Shadows of Once-Living People: The *Kundawira* Challenge," in Bruno David, Bryce Barker, and Ian J. McNiven (eds) *The Social Archaeology of Australian Indigenous Societies* (Canberra: Aboriginal Studies Press, 2006), pp. 194–195.
55. Marcia Langton, "Earth, Wind, Fire, Water: The Social and Spiritual Construction of Water in Aboriginal Societies," *Social Archaeology*, p. 145.
56. Tamisari and Wallace, "Towards an Experiential Archaeology of Place: From Location to Situation through the Body," p. 217. Viewed in this light, Dawson's translation of Aboriginal place-names grows eloquent: a "Large lagoon" has a name meaning "bone"; a "Waterhole" is called "Shoulder blade," and another "Backbone." (Dawson, *Australian Aborigines*, pp. lxxxi–lxxxii).
57. Dawson, *Australian Aborigines*, pp. xliii, xliv.
58. Fernández, "Peircean Habits," p. 103.

BIBLIOGRAPHY

Blake, Barry J. *Dialects of Western Kulin* (Melbourne: La Trobe University, 2011), http://www.vcaa.vic.edu.au/documents/alcv/dialectsofwesternkulinwesternvictoria.pdf [accessed January 19, 2015].
Carter, Paul. *The Road to Botany Bay* (London: Faber, 1987).
——. "The Enigma of Access: James Dawson and the Question of Ownership in Translation," *Griffith Law Review*, 22, 1, 2013: 8–27.
Casey, Edward. *The Fate of Place: A Philosophical History* (Berkeley: University of California Press, 2013).
Chaitin, Gregory J. "Leibniz, Information, Math, Physics," http://www.cs.auckland.ac.nz/~chaitin/ kirchberg.html [accessed December 18, 2014].

Clark, Ian, Luise Hercus, and Laura Kostanski (eds). *Indigenous and Minority Place Names: Australian and International Perspectives* (Canberra: ANU Press, 2014).

Corn, Aaron. "Ancestral, Corporeal, Corporate: Traditional Yolngu Understandings of the Body Explored," *Borderlands*, 7, 2, 2008: 1–17.

David, Bruno, Bryce Barker, and Ian J. McNiven (eds). *The Social Archaeology of Australian Indigenous Societies* (Canberra: Aboriginal Studies Press, 2006).

Dawson, James. *Australian Aborigines: The Languages and Customs of Several Tribes of Aborigines in the Western District of Victoria, Australia* (Melbourne: George Robertson, 1881).

Fernández, Eliseo. "Peircean Habits and the Life of Symbols," *Semiotics*, 2010: 98–109.

Fison, Lorimer and Alfred William Howitt. *Kamilaroi and Kurnai* (Melbourne: George Robertson, 1991).

Garden, Don. *Hamilton: A Western District History* (Hamilton: Hargreen Publishing, 1984).

Kearney, Amanda and John J. Bradley. "Landscapes with Shadows of Once-Living People: The *Kundawira* Challenge," in Bruno David, Bryce Barker, and Ian J. McNiven (eds) *The Social Archaeology of Australian Indigenous Societies* (Canberra: Aboriginal Studies Press, 2006), pp. 182–203.

Keen, Ian. "A Continent of Foragers: Aboriginal Australia as a 'Regional System,'" in Patrick McConvell and Nicholas Evans (eds) *Archeology and Linguistics: Aboriginal Australia in Global Perspective* (Cambridge: Cambridge University Press, 1997), pp. 261–274.

Langton, Marcia. "Earth, Wind, Fire, Water: The Social and Spiritual Construction of Water in Aboriginal Societies," in Bruno David, Bryce Barker, and Ian J. McNiven (eds) *The Social Archaeology of Australian Indigenous Societies* (Canberra: Aboriginal Studies Press, 2006), pp. 139–160.

Lourandos, Harry. "Aboriginal Spatial Organization and Population: South-Western Victoria Reconsidered," *Archaeology and Physical Anthropology in Oceania*, XII, 1977: 220–225.

Marx, Karl and Friedrich Engels. *The Communist Manifesto* (Hardmondsworth: Penguin, 2010).

Ó Crualaoich, Gearóid. *The Book of the Cailleach, Stories of the Wise-Woman Healer* (Cork: Cork University Press, 2003).

Ó Laoire, Lillis. *On a Rock in the Middle of the Ocean* (Indreabhán, Conamara: Cló Iar-Chonnachta, 2005).

Peirce, Charles Sanders. *A Syllabus of Certain Topics of Logic* (Boston: A. Mudge and Son, 1903).

Porter, Libby. *The Culture of Planning: Contesting Place in Settler Societies* (Farnham: Ashgate, 2010).

Proudfoot, Lindsay and Diane Hall. *Imperial Spaces: Placing the Irish and Scots in Colonial Australia* (Manchester: Manchester University Press, 2011).

Smyth, Robert Brough. *The Aborigines of Victoria*, Vol. 2 (Melbourne: Government Printer, 1876).

Stanner, William Edward Hanley. *The Dreaming and Other Essays* (Australia: Black Inc., 2010).

Stedman Jones, Gareth. "Introduction," in Karl Marx and Friedrich Engels (eds) *The Communist Manifesto* (Hardmondsworth: Penguin, 2010), pp. 1–180.

Tamisari, Franca and James Wallace. "Towards an Experiential Archaeology of Place: From Location to Situation Through the Body," in Bruno David, Bryce Barker, and Ian J. McNiven (eds) *The Social Archaeology of Australian Indigenous Societies* (Canberra: Aboriginal Studies Press, 2006), pp. 204–223.

Thass-Thienemann, Theodore. *Symbolic Behaviour* (New York: Washington Square Press, 1968).

Chapter 6

The Space of Language and the Place of Literature

Paolo Bartoloni

Introduction

Taking as its point of departure Heidegger's famous claim that "language is the house of being," this chapter mobilizes the dwelling metaphor to explore diverse modalities of inhabiting language according to particular forms of symbolic expression as they come to be employed in twentieth-century literature and thought. In this context, the Abstract-Collective zone of language is understood simultaneously as the generalized and abstract universal notion of a shared co-belonging and mutual appropriation of language and being, as well as the particular and concrete place from within which each one of us operates and reaches out to the world through his/her singular encounter and correlation with language.

Language moves; it moves from and to places, and in between places. It comes out of the subject who speaks it and reaches out to the listener/s, but it also goes inside the subject in order to be spoken. At times, however, language does not transit; it remains still, unpronounceable, unidentifiable, invisible, and silent, with us and yet without us. Who is saying this? Language itself. Let us take, for example, the Italian and the French expressions *non mi viene la parola*, *les mots ne me viennent pas à l'esprit*, which describe a temporal vocal aphasia and a lapse in communication in the manner of a justification. It is as if the speaker relates not so much his/her forgetfulness—a simple moment of amnesia—as the culpability of language that, for

some strange and inexplicable—as well as unexpected—reasons, has not reached its proper destination, that is the subject of utterance. The subject is ready and prepared to receive the word, and yet the word does not comply; it ignores and neglects the subject who, as a consequence, appears emptied, vulnerable, and fragile in his/her surprising mumbling in search of words.

But where is it that language has gone? And how is it possible to find it? Can we really look, search, for it; can we recover it, and, with it, our composure?

These are far from being rhetorical questions or simple conceptual games complicating the natural occurrences of day-to-day life. Rather, they respond to significant philosophical and cultural discussions that have permeated the twentieth century and informed aesthetic and ontological projects, which are at the basis of contemporary cultural and literary production. The strong link between language and humans is witnessed many times over in philosophy, linguistics, and critical theory. Heidegger's dictum quoted above ("Language is the house of being") is perhaps the quintessential emblem of this all-embracing co-belonging. Georges Perec, the poet of things, seems to echo Heidegger when he writes: "What is the proper idea of humanity?: language and morality; humanism."[1]

Humans are what they are because they use language, because they inhabit language; language is their space, which is also their place. Assuming that this is correct, the legitimate question that springs immediately to mind is the following: What kind of place is this, exactly? Unfortunately, Heidegger never attempted to describe the house of being, and give shape, form, and images to the rooms of language in which we move, sit, sleep, eat, and love. What are the colors of the rooms; how many rooms are there; how are they furnished; are there objects one can reach, touch, and feel; is this house dark or bright? Or rather, if Heidegger did describe the house of being, he did it by locating his house in the legends, myths, and traditions of the German language. Heidegger's house is situated in the culture and identity that one inhabits, and our language, which equates with us, is also our place, and the space from which we explore the world and make sense of it. What about extraterritorial, hybrid, and transnational languages and identities? Do they also have a house, and, if so, how does it function?

This chapter investigates the movements and the spaces of language, and its ability to morph, change, and adapt. It also interrogates language's right to claim its own place and specificity, which is also the landscape and geography of language as such. In the process, this

chapter will discuss the work of authors such as Maurice Blanchot, Michel Foucault, Martin Heidegger, Georges Perec, and Édouard Glissant. The central hypothesis is that the space of language, and the place we inhabit within it, is never static but always dynamic and in continuous transformation. In this context, the concept of the house of language might be useful but only if declined in the plural as the uprootable place of incessant reinvention and mobility.

THREE EXPERIENCES OF LANGUAGE

In *Idea of Prose*, and more specifically in the section "The Idea of Matter," Giorgio Agamben writes: "Where language stops is not where the unsayable occurs, but rather where the matter of words begins."[2] In the aphoristic style so typical of *Idea of Prose*, Agamben presents the reader with two moments, which are simultaneously temporal and spatial. He writes about ending and beginning, and arrival and departure; he writes of the moment in which language stops, which, according to him, is also where language as a thing begins. To fully understand Agamben's idea, one must read a few more lines into the paragraph: "Those who have not reached, as in a dream, this woody substance of language, which the ancients called *silva* (wildwood), are prisoners of representation, even when they keep silent."[3]

In this very dense text, Agamben offers three elements revolving around language and pertaining to it in one form or another, which describe three modes or experiences of language: representation, unsayability, and language as such. These are also the three fundamental places of literary expression, which can be roughly reconnected first to the idea of literature as representing the world, then to the inadequacy of literature to represent the world, and finally to literature as self-reflexive. While in the first two cases language is an instrument of knowledge and understanding applied to the world, in the third case language is autonomous from and independent of any given outside. By positing language as a tool that is positively employed to make sense of the world, language becomes the critical medium through which the subject enters a process of discovery and investigation of the object under scrutiny. It is through representation that authors order and clarify the world—as Paul Ricœur so powerfully stated in the essay "On Interpretation"[4]—and subsequently offer their represented interpretation for the education and entertainment of others.

By challenging the ability of language to represent, it is not the instrumentality of language that is undermined but rather its capacity to conjure a readily interpretable landscape. Confronting the

unsayable does not mean rejecting the conventionally utilitarian use of language, it means instead to observe and contemplate a negative space, the void, and the black hole into which traditional values and models of cognition have been sucked. It is not just a matter of comparing and contrasting, for instance, realism and nihilism, modernism and postmodernism, but of inquiring into the relation between language and being and its complicated rapport of mediation.

If language is the house of being, is it just there to serve, as an instrument, the individual, and to make the individual comfortable in his/her continuous pursuing of self-centered knowledge? In this case language itself is reduced to an object, which can be employed at will whenever it is required and replaced when it is no longer necessary. But as we know, from psychoanalysis to name only one source, language cannot be so easily switched off. And, as we have already seen, it cannot so easily be summoned either, since sometimes it does not come to the subject.

The third experience or place of language, that is language as such, can perhaps help take this discussion a step further. In this case language is not an object to be employed in order to see presence (representation) or absence (the unsayable) but a medium to observe, as if through a magnifying glass, its being, nature, form, and mechanisms. Here, language becomes the object of inquiry rather than the instrument with which to conduct the inquiry. It is in this sense that language as such is a thing in its own right, and much more than a simple tool. Language becomes a thing when our demands on it are no longer directed to something outside language. But what is the use of this experience of language, or rather, what kind of place do we inhabit when language is no longer an object but a thing?

Heidegger would argue that this is the authentic place of being, and that language as the house of being is precisely the space of an encounter where utilitarian instrumentality is abandoned, or, as he put it more aptly, renounced.

THE HOUSE OF BEING

The reflection on language as "the house of being" permeates Heidegger's work from "Letter on Humanism" (1946) onward.[5] Heidegger returns insistently to this reflection, especially with regard to poetic language, and the affinities between poetic language and being. Heidegger is said to believe that philosophy does not begin with thought, but with astonishment, surprise, errancy;[6] in a word, with poetry. And in fact, the entrance into philosophy through poetry

gradually becomes Heidegger's favorite route to thinking and for thinking. It is no accident, then, that his attention to and investigation of poetry increase dramatically from the mid-1930s, especially from the 1934–1935 lectures on Hölderlin's hymns to Germany and the Rhein.[7] It is in the poetry of Hölderlin first, and later in that of Rilke, George, and Trakl that Heidegger looks for that unique trigger to his thought. It does not come as a surprise either if, in the same period, also known as *Kehre*, Heidegger's dealings with pre-Socratic thought, especially Parmenides, Heraclitus, and Anaximander, assume the character of poetic readings. It is also perhaps because of Heidegger's penchant for poetry—and of course, because of his "poetic" style of philosophizing—that some commentators have labeled him, and not always favorably, a poet rather than a philosopher.[8]

In the collection of lectures/essays delivered in 1957–1958 and brought together under the title *On the Way to Language* (*Unterwegs zur Sprache*),[9] we find a text that is of particular interest in the discussion of the relation between language and being. I am referring to "Words" ("Das Wort"). This lecture is a close reading of a poem by Stefan George, "The Word" ("Das Wort"). It is also a further attempt on the part of Heidegger to think through the meaning and significance of the statement "language is the house of Being" that he had made in *Letter on Humanism*.

"Words" starts with a puzzling reference to a place (*Ort*): "From where we are now (*von diesem Ort*)," writes Heidegger, "let us for a moment think what Hölderlin asks in his elegy 'Bread and Wine'..."[10] The first inclination is to interpret "place" as the locus where the thinking is occurring, in this case Heidegger's *On the Way to Language*. We look at the book to see which essay precedes "Words." In the English translation, the essay in question is "On the Way to Language," which is therefore assumed as the place from which the thinking triggered by Hölderlin's elegy, and Heidegger's subsequent investigation, ought to start. The two lectures seem to dovetail rather nicely since the last two pages of *On the Way to Language* engage explicitly with the relation between language and Being in ways that are germane to "Words." Not only does Heidegger insist on the connection language/Being, but he explains it by arguing that "Language is the house of Being because language, as Saying, is the mode of Appropriation."[11]

Through Saying language appropriates Being by keeping being, the thing, present. But in order to achieve the presencing of being—Heidegger also calls this presencing "face to face" (*das Gegeneinander-über*)—humans must attain a special relation to language,

which also implies a transformation of language. "In order to pursue in thought the being of language and to say of it what is its own, a transformation of language is needed which we can neither compel nor invent."[12] In other words, through Saying, language guards being. But in order to turn this concealment in language into an unconcealment in language, Heidegger invites humans to accomplish a particular exposure to language, which requires a transformation of the relation with language. Language must be approached differently.

It is rather instructive that, in order to bring his argument to a close, Heidegger chooses to quote a passage from Wilhelm von Humboldt that seems to contradict his entire conceptualization. Here is the quotation: "Without altering the language as regards its sounds and even less its forms and laws, *time*—by a growing development of ideas, increased capacity of sustained thinking, and a more penetrating sensibility—will often introduce into language what it did not possess before."[13]

Everything seems to fit apart from the last significant statement, "time will often introduce into language what it did not possess before," which means that, for Humboldt, being is not at home in language. It might be introduced into it as long as changes of knowledge and sensibility are brought to bear on language. What kind of place is this from which Heidegger bids us farewell, only to greet us again at the following station as if Humboldt had never been mentioned?

And, in fact, this is not the *place*. If one looks at the German edition of *Unterwegs zur Sprache*, one soon realizes that "Das Wort" is preceded by "Das Wesen der Sprache" ("The Nature of Language") and followed by "Der Weg zur Sprache" ("On the Way to Language"). This is the original order of the three lectures, which has been radically altered in the English translation for reasons about which one can only speculate. Was it perhaps thought that "The Nature of Language" and "Words" were too similar, the latter being almost a repetition of the former? Would the reader in English perhaps object less to the book should the uncanny similarities between "The Nature" and "Words" be mitigated by interspersing them with "On the Way"?

In "The Nature of Language" Heidegger sets the tone for the three lectures on language, which he considers as individual parts of a whole. In "The Nature of Language," he expressly says that the purpose of these lectures is to "undergo an experience with language"[14] that might be "helpful to us to rid ourselves of the habit of always hearing only what we already understand."[15] Heidegger wishes to experience, and perhaps write, a language, whose relation with him is different from the one he has with traditional—one might be tempted

to say metaphysical—language. In other words, Heidegger intends to experience a meeting with a language that, remaining the same, says things differently. It is in this sense that the article "a" before language is strictly incorrect. This is not another language, it is instead the same language that relates to us, and us to it, differently. Heidegger explains this further: "In experiences which we undergo *with* language, language itself brings itself to language. One would think that this happens anyway, any time anyone speaks. Yet at whatever time and in whatever way we speak a language, language itself never has the floor."[16]

As we now see, in Heidegger's terminology "*a* language" is not language. Language is that which speaks "itself as language." When does this happen? "Curiously enough," answers Heidegger, "when we cannot find the right word for something that concerns us, carries us away, oppresses or encourages us."[17]

As an example of the coming of language to itself, Heidegger discusses Stefan George's poem "Das Wort," whose final line reads: "Where words break off no thing may be" (*Kein ding sei wo das wort gebricht*). What is at stake here is precisely what Heidegger draws attention to when he refers to the breaking of words in the face of "something that concerns us."

This is the *place* from where Heidegger can continue his analysis of George's poem, together with his investigation of thinking and poetry. As Heidegger tells us, Stefan George first published "Words" "in the 11th and 12th series of *Blätter für die Kunst* in 1919."[18] He later included it "in the last volume of poems published in his life-time, called *Das Neue Reich*."[19]

George's poem is about the poetic journey, and the experience of confronting the mystery of life, in the hope of giving this mystery concreteness through language. But this hope is destined to remain unfulfilled since not even the depth of poetry, its magic and inspiration, can say the unsayable. So while the poet holds the mystery in his hands, waiting for poetic language to transform the mystery into the reality of a presence, the mystery slips away, as the poet learns that there is no word that can "enfold these depths." The last two stanzas read: "And straight it vanished from my hand,/ The treasure never graced my land . . . / I then sadly learned renunciation:/Where word breaks off no thing may be." ("Worauf es meiner hand entrann/ Und nie mein land den schatz gewann . . . / So lernt ich traurig den verzicht:/ Kein ding sei wo das wort gebricht").

Heidegger's investigation focuses on the last two lines, and especially on the notion of renunciation (*Verzicht*). The question and the

philosophical problem that Heidegger engages with is whether this renunciation simply leaves the poet empty-handed in the face of such negativity and emptiness. What takes place in the following pages is a great feat of rhetorical and philosophical bravura through which Heidegger turns the notion of renunciation from its conventional negative meaning into a positive one. This reversal of fortune might or might not do justice to George's poem, but it certainly says a great deal about Heidegger's philosophy. In other words, while the exegetical interrogation of George's poem is far from being exhaustive, the conceptual conclusions at which Heidegger arrives are striking and of utmost importance, especially in relation to a philosophical trend characterizing the second half of the twentieth century.[20]

But how is it that "renunciation" becomes positive, and therefore ontologically relevant and consubstantial to Heidegger's mode of thinking? The key to this question must be looked for in the verb that accompanies renunciation in George's poem: "to learn" (*So lernt ich traurig den verzicht*). According to Heidegger, the poet in "Das Wort" is not simply renouncing, he has learned renunciation.[21] To Heidegger the difference between "renunciation" and "learning renunciation" is of paramount importance. To him learning means "to become knowing,"[22] that is, to enter a process of active engagement with thinking, and, in this particular case, with language. Heidegger equates this process with a journey, and with a movement of discovery. The subject places himself/herself underway through the action of learning. But what is it that the poet learns? He learns renunciation. For Heidegger, this renunciation translates into the active affirmation of the predisposition to experience language as language, that is, language as such. While it is true that the thing remains unsaid, it is also true that it remains close to language, adhering to language unsaying. Heidegger's punch line comes a little later in the essay when, as already discussed, he argues that language's Saying resides precisely in its non-saying:

> [T]his renunciation is a genuine renunciation, not just a rejection of Saying, not a mere lapse into silence. As self-denial, renunciation remains Saying. It thus preserves the relation to the word. But because the word is shown in a different, higher rule, the relation to the word must undergo a transformation. Saying attains to a different articulation, a different *melos*, a different tone. The poem itself, which tells of renunciation, bears witness to the fact that the poet's renunciation is experienced in this sense—by singing of renunciation.[23]

It is this qualification that allows Heidegger to distinguish between a lower tone of language (the saying with a small "s") and a higher

tone of language (the Saying with a capital "S"). The latter is brought about through a special exposure to language that is achieved through renunciation. It is this availability to be with language as language that, according to Heidegger, brings about the coming "face to face with what is primevally worthy of thought, and which we can never ponder sufficiently."[24] Hence the philosopher, thanks to the self-affirmation of the poet through renunciation, can contemplate and listen to the mystery of the word, whose echo resounds in the singing of the language that has renounced its saying.

But exactly what is this renunciation? Is it the romantic celebration of losing oneself in contemplation? It might very well sound like a mystical experience in which, paraphrasing a romantic Italian poet, Giacomo Leopardi, the shipwrecking of the subject in the mystery of life becomes sweet. And yet in Heidegger this sweetness is not so much romantic as phenomeno-ontological. As early as the beginning of the 1920s, Heidegger was lecturing about the need to place oneself before the world (*Vorweltlich*),[25] which meant to resist, and indeed abolish, reified and culturally institutionalized attitudes to things. He preached the philosophical significance of looking at things as such in order to regain them to their "worldliness."[26] In the lecture *Das Wort*, Heidegger uses a similar term, "bethinging" (*die Bedingnis*), which becomes the higher rule of the word "which allows the thing to presence as thing."[27] In reality, Heidegger never allowed his phenomenological education to wander too far away from him.

LANGUAGE AND THING

In the essay "Das Ding" ("The Thing"),[28] Heidegger offers a classic phenomenological example to clarify his conceptualization of thingness in relation to poetry and language. He thinks of the work of the potter, and the making of a jug. The modeling of the jug, that is, its construction into a form, takes place from nothing, but more importantly it retains the nothing from which it is produced by encasing it within itself. The jug as a finished object is empty, and yet it is precisely this emptiness that, for Heidegger, is at the core of the jug's very existence, and usefulness, in that to be of use the jug must be emptied in order to be filled, emptied and filled again, and so on. The jug as object, which is predicated on its ability to be used, is designed on a thing whose center is a void.[29] This image becomes, for Heidegger, a kind of metaphor for poetry and art, insofar as poetry, as Heidegger discussed in the essay "Words," is characterized by a language that must be aware and determined to protect the other from itself (the void), which, although present within the language of poetry, remains

unsayable by it. Poetry itself is a jug made of language at the center of which lies a void that poetry, in order to be successful poetry, must not fill. Poetic language, according to Heidegger, must learn to renounce the desire to say and express the void within it and simply live with it.[30] It is, in other words, the presence of an extralinguistic thing, the "thing as such," that although necessary to the work of art and in a constant relation to it, is always already external to it.

The space of language that Heidegger describes in his writings is certainly not that of representation, which has been renounced; it is perhaps closer to negativity and the unsayablity of language, with a proviso though, that within this unsayability language cohabits with the thing itself. In this "house," language, being, and thing are together, but more importantly they are in constant mediation as well as being interchangeable, and thus potentially turned into things as such, whose presence is necessary yet unrepresentable. How are we to interpret this space?

In Jacques Lacan, whose work reconnects directly with Heidegger's discussion of thingness, this is the space of desire, fetishism, and symbolic expression. Although Lacan's interrogation of the thing originates from psychoanalytic concerns, and especially Freud's articulation of *das Ding*, the conclusions he arrives at are instructively similar to those reached by Heidegger. Lacan too employs, as does Heidegger, the work of the potter as an example to introduce the relation between art and its propulsive cause.[31] The void that, in Heidegger, comes close to a certain nihilism of Nietzschean origin, assumes in Lacan different hues without, however, losing its quintessential ontological and aesthetic significance. For Lacan too, the thing of art is the unsayable that inhabits every act of artistic creation.[32] But while in Heidegger the thing is akin to an original truth, the power of which resides in its manifestation as potentiality—as that, in other words, which is apprehensible in the experience of nonrepresentation—in Lacan the thing becomes a strong metaphor for the desire to reconnect with the void of the inevitable loss, be it God or the mother figure.[33] Art becomes, therefore, a process of sublimation, the purpose of which is that of constructing fetishes and objects through which to contemplate the thing of art. Of course, this is a false hope insofar as the object is a mere simulacrum of the thing, while the thing itself stays invisible yet present.[34] It is precisely this invisibility within presence that distinguishes Lacan's discussion of art and the fetish from Plato's famous attack on art as the process of inane repetition and mimesis of reality. While for Plato art reproduces only the external and superficial traits of reality, for Lacan art plunges deep into the core of the real,

that is, inside the thing of reality itself.[35] It follows that if for Plato truth, the real, and the origin are forever external to art, for Lacan they are in art yet simultaneously outside it.[36] The Lacanian space of desire, fetishism, and symbolic expression morphs into the powerful literary places of Bataille's and Klossowksi's writings, for example, in which erotic and intimate excesses dominate and propel the literary process.

THE NEUTER

There are, however, other outcomes, interpretations, and explorations of the space opened up by Heidegger. One further example is provided by the work of Maurice Blanchot, and his concept of the neuter. Blanchot entitles one of his most important theoretical works *The Space of Literature* because he wishes to reflect on the task of literature and the work of the literary author, and he cannot do so unless he conceptualizes literature as a world and a place in which language is at one and the same time the map and the signature, whose traces decree the configuration of the landscape and also the lines of the cartography. Language and words provide the orientation in a space, which, according to Blanchot, can exist only when the writer "gives up saying 'I'."[37] The subjectivity of the Cartesian presence is suspended, and its absence—which could be construed also as the renunciation to subsume the world to the speaking and observing "I"—is taken by an erring and incessant language. Blanchot employs adjectives indicating movement, such as "erring," "incessant," and "interminable," to denote a sense-making experience that is conducted in a space where the traditional metaphysical values opposing subjectivity and objectivity are discharged and perhaps even defused, since Blanchot's conceptualization is strongly and deliberately motivated by the wish to recast the function of literature away from representational motives predicated on the presence of the "I." In *The Space of Literature* he writes,

> Writing is the interminable, the incessant. The writer, it is said, gives up saying "I." Kafka remarks, with surprise, with enchantment, that he has entered into literature as soon as he can substitute "He" for "I." This is true, but the transformation is much more profound. The writer belongs to a language which no one speaks, which is addressed to no one, which has no center, and which reveals nothing. He may believe that he affirms himself in this language, but what he affirms is altogether deprived of self.[38]

It is as if, following Heidegger's intimation, Blanchot describes a space in which words are free to roam and to trace a geography according to new modalities of exploration in which subject, object, space, and time are mutually interconnected and equally mediated by a language that has become a free sign, and language as such. The intermediality that Blanchot alludes to in the passage just quoted is explicitly announced a few pages later when he writes that "That is why the work is a work only when it becomes the intimacy shared by someone who writes and someone who reads it, a space violently opened up by the contest between the power to speak and the power to hear."[39]

As we see, Blanchot's stress is on a new space that language carves out through a reconfiguration of the relation between the "I" who speaks and the context in which the "I" takes up the pen. This is the space of the neuter in which the supremacy of the subject is abolished and where words become reverberating sounds, echoes, traces, and signs intermingling between "you," "I," "them," and the "Others." In reference to this last term, on page 51 of *The Space of Literature*, Blanchot writes,

> This is an essentially errant word, for it is always cast out of itself. It desig-
> nates the infinitely distended outside which takes the place of the spoken
> word's intimacy. It resembles the echo, when the echo does not sim-
> ply say out loud what first is indistinctly murmured, but merges with
> the whispering immensity and is silence become reverberating space, all
> words' exterior.

Blanchot's narrative works, and especially *Awaiting Oblivion*, are intri-
cately constructed soundscapes in which rooms, objects, and people are sound boards from which words resonate, disperse, and echo by incessantly intermingling as if in a music score, the pages of which is the space of literature. It is not by chance that when Foucault was in the process of thinking a new epistemological framework that rejected humanist underpinnings, such as the centrality and the prominence of the subject, he privileged the work of authors such as Sade, Bataille, Klossowski, and Blanchot, where language becomes pure desire (Sade) and even thing as such (Blanchot).

In the essay "La pensée du dehors,"[40] Foucault illustrates his theory of a new relational mode based on the dislocation of subjectivity by focusing, precisely, on the writings of Blanchot. What emerges from this essay is a language that goes outside of its conventional func-
tion and enters a neutral space in which subject and object cohabit in the absence of hierarchies and attempts at possession and coercion of the object of knowledge on the part of a language at the service

of an inquiring subject. Language becomes free of the ordering sub-
ject and entertains a new rapport with the thing of language, which is
thus simultaneously in language and outside language. It is precisely
at this juncture, which is also the threshold of representation and con-
sciousness, that Foucault's thought meets Lacan's concept of "thing."
On this point, it is important to quote a central passage of Foucault's
essay:

> It is necessary to reconsider thinking. It must be thought not so much
> as the expression of interiority—a kind of central certainty from which
> it cannot be displaced—as the experience of a limit at which it will be
> continuously questioned. Arrived at the border of its very self, thinking
> will not emerge from the positivity of dialectic contradiction, but instead
> from the void in which it erases itself. It must proceed towards this void,
> accepting in turn its effacement within the rumour, the negative immedi-
> acy of what it says, and the silence which is not the secret of an intimacy,
> but the pure outside in which words unfold indefinitely.[41]

Foucault emphasizes the experience of a language that is located in
between the identity of the conscious subject and that of an outside
devoid of identity and authenticity. The challenge confronting this
language and the subjectivity that inhabits it is to embrace the outside
and let the familiar and the known accept and enter the experience of
out-of-place, the different, and the unknown.

THE LANGUAGE OF THINGS

This is also the poetic experience embarked upon by Francis Ponge
in his collection of poems, *Le parti pris des choses* (*On the Part of
Things*), a book originally published in 1942,[42] some years before
the theoretical investigations of Heidegger, Blanchot, and Foucault.
In this exceptional little book of poetry, Ponge attempts to use lan-
guage as if it were a camera that provides images of things, objects,
and animals. Ponge's is not a representational language; it is rather an
assemblage of words that adhere to things by becoming themselves
things, amorphous and chameleon-like, in which the presence of the
"I," either as a speaking voice or an observing eye, disappears among
the folds of a choral and anonymous language. Let us take for instance
the beginning of "Le mollusque" ("The Clam"):

> The clam is a being—almost a quality. It doesn't need a bone structure
> but only an armour, something like the colour inside a tube. In this
> instance nature has renounced to present the plasma into a form. Nature

shows only that it cares for it by carefully guarding it inside a casket, whose internal side is the most beautiful.[43]

Although the description may evoke the scientific language of anatomical laboratories, the objectivity of the view clashes with a disenchanted aesthetic taste, which appears to be the opposite of the Romantic sublime, as it faces the wonders of nature. As a matter of fact, most of Ponge's poems are devoted to quotidian events and things, and to small, almost insignificant animals: boxes, candles, oranges, doors, bread, slugs, a piece of meat, a clam. In the essay "La mesure de l'homme (l'éthique du dire selon Francis Ponge)," Laurent Adert argues first that Ponge's writing happens as if under dictation, or rather as if the author delegated the opportunity to tell their stories to the very subjects of the stories in order to present themselves as they are ("... voire de lui céder la parole, afin que s'exprime sa 'faç d'être,' sa manière spécifique de se présenter ou de se donner"),[44] and second that Ponge has thought a space in which world and words are no longer positioned in two different places, but have come instead to intermingle at the moment when the silent world meets language. This space, as Adert argues, is the conjunction between "to be" and "to say" ("conjonction entre être et dire").[45] If it is true that Ponge believed that language is the place of humans, as indicated at the beginning of this chapter, then this place is shared with objects, things, and animals. This is a house that invites the other to enter and to take an equal place among the life of words.

OUTSIDE LANGUAGE

As the above examples indicate, twentieth-century authors and thinkers have made a determined and deliberate attempt to reconceptualize the modalities of relation between language and world, and to create a space of artistic production in which language acquires autonomy in relation to what is outside it. In other words, language is no longer at the sole service of the object of narration, which, perceived as a separate and singular entity, language, and therefore literature, must decipher through representation. Authors such as Heidegger, Blanchot, and Ponge question the utilitarian and conventional use of language as a simple communicative tool. By contrast, they wish to open up a space of investigation, which is also an imaginative space, in which literature could reformulate our understanding and experience of the world predicated on quasi-sensual, and visceral, encounter with words. Of course, this experience takes different hues

and directions, from Heidegger's mysticism, to Blanchot's errancy to Ponge's sophisticated and refined literary account of day-to-day life. If this is the space of a significant cross-section of twentieth-century literature, what is its place in the context of cultural discourse? In other words, what does this literature offer and provide? Some would argue that these experimentations emancipate literature from the joke of the mimetic impulse, and of representation and didacticism. Literature is not only there to impart a lesson about what is outside of it, but also, if not more importantly, to dig deep into the aesthetic process and the form of creative production. Literature is as much about itself as it is about the other from itself, yet for far too long it has neglected the confrontation with itself and the negotiation of its own space. It was now time, the same critics would argue, that literature's glance was directed inward at its own specificities and singularities.

Others have criticized the formal and aesthetic turn of twentieth-century literature as a dangerous severance with reality and the world. In *L'adieu à la Littérature*, the French critic William Marx argues that literature's search for autonomy and independence from reality has also introduced its gradual demise and loss of status in contemporary societies. Paradoxically, according to Marx, literature's strenuous attempt to focus on its space has jeopardized its place as a model and judge of taste, values, and education. In this context it is interesting to note that some of Marx's criticisms are directed at style and language. Marx argues that a large section of twentieth-century literature is deliberately "sans style" ("without style"),[46] and that several authors prefer to write about nothing, rather than stop writing.[47] Furthermore, he adds that authors like Bataille are consciously opposed to writing well, as they see the beautiful style as the emblem of the old literary tradition:

> The refusal of beautiful and pleasing writing was largely shared in the twentieth century. An exemplary case is Bataille, who deformed the style of some of his novels in a deliberate act of profanation against the old idea of literature.[48]

What is of interest in Marx's discussion, especially in the context of the present chapter, is the link between the autonomy of literature and language, and the relation between the author and language experimentations. One could paraphrase Marx's discussion by formulating the question as to whether twentieth-century authors inhabit the same space and house of language as the authors of other historical periods. As a matter of fact, twentieth-century authors, at

least according to Marx, have abandoned good style, and have come
to inhabit a space and a language that appears to be outside language
or, rather, outside the language that we used to know. It is instruc-
tive in this context to note, en passant, that the Italian critic Marco
Carmello has titled his recent book on the Italian author Antonio
Pizzuto as *Extragrammaticalità* (*Outside Grammar*); according to
Carmello, Pizzuto's experimentations in the 1960s can be construed
as a deliberate attempt to exit language ("L'uscita dalla lingua").[49]

It would be disingenuous to believe, however, that this alleged
movement outside language is the end of the special relation enter-
tained between humans and language, as expressed by Heidegger
and Ponge. It is rather a reconceptualization of this relation, which
becomes also, if not primarily, a modality of mediation, encounter,
and interchange, in which the dynamics between the individual and
language are no longer based on utilitarian functions. In a word, lan-
guage is not simply there to be used; it can also use, becoming an
active agent of unsuspected meanings and experiences. It becomes, in
Blanchot's term, an errant language. In this context it is instructive to
go back to Marx's discussion of a literature "without style," and place
his claim in the proper context. It is the writings of Samuel Beckett,
a plurilingual author whose work was written and published both in
English and French, that Marx focuses on when he writes,

> The very principle of Beckett's project is predicated on the fundamental
> decision to write in French without abandoning English. This decision
> opens a sort of void at the heart of the work, between the two linguistic
> modes of the system; the first tends towards style and the second rejects
> style or looks for a style of non-style.[50]

It is clear that Marx is alluding to a relation with language that
is rather different from the project of national languages that had
prevailed for both cultural and political reasons up until the mid-
twentieth century. One could certainly argue that Beckett chooses to
inhabit a house that up until then was deemed inhospitable. Beckett's
experimentation is no longer based on representational language, but
it also goes further than Blanchot's errant language, and enters the
interstitial language of cultural thresholds, which is gradually becom-
ing the natural space of contemporary literature: the literature of
globalized, cosmopolitan, and international authors. If it is correct
to identify the space of contemporary literature as interstitial, what is
its place in the context of society at large? In other words, does this
space of literature have anything to tell us?

TRANSNATIONAL LANGUAGE

Some answers to this question may be looked for in the work of another author. I am referring to Édouard Glissant, the Martinican poet, novelist, and essayist who has articulated with fascinating incisiveness the idea of creolization. Not only is Glissant engaged with thinking a different methodological approach in the context of aesthetic, social, and political encounters between subjects and objects, he also believes strongly that this new methodological approach is eminently suited to the world today, and that literature can play an enormously significant role in advancing these new sets of cognitive parameters:

> In France they say that poetry is dead. I believe that poetry, or if you like the exercise of the imaginary, the prophetic vision of both the past and remote spaces, is the only mode that we have to write ourselves in the unpredictability of world relations.[51]

In books such as *Introduction à une poétique du divers* and *Poétique de la relation*,[52] Glissant proposes the idea of "tout-monde," that is, an encounter of subjectivities who are strongly rooted in a locality and who choose to live these localities not in an essentialist and self-enclosed way that would exclude the other. By contrast, these subjectivities employ their specificity and particularity, including language, to meet the other, and allow for a space in between to be created in which reciprocal and mutual knowledge and understanding will be nourished. In order for this to take place, Glissant argues that it is necessary to abandon systemic ideas and concepts of knowledge, as predicated by Cartesian thought, and embrace what he calls chaos theory, that is, a set of methods of experience based on unpredictability, creativity, and imagination that will bring about new modes of sustainable encounters and co-belongings founded on rhizomatic roots, rather than on blood-and-territory roots.

> I stress once again the notion of chaos, when I say *chaos-monde*, I return to what I said in relation to creolization: there is *chaos-monde* because there is the unpredictable. It is the unpredictability of world relations that decrees and determines the notion of *chaos-monde*.[53]

In Glissant, subject and object meet on a territory that is mutually theirs to share and cultivate according to their own specific experiences. It is not a neutral space, it is rather a space-world and a world

of engagement predicated on the idea of sharing. It is a multilingual world, not in the sense that everybody speaks and writes in 10 or 20 languages, but a world in which each text and each speech act is aware and takes into consideration all the other languages spoken, and in which the disappearance of even one language, no matter how remote this might be, is a loss to all languages and the beginning of their demise, and the plurality and diversity that this brings about.

> To write in the presence of all the languages of the world does not mean to know all the languages of the world. It means that in the current literary context and in that of the relation between poetics and *chaos-monde*, I can no longer write as a monolingual author. It means that I experience and negotiate my language not so much within a synthesis as within a linguistic openness that enables me to think the relation amongst the languages spoken today on earth—relations of domination, cohabitation, absorption, oppression, erosion, marginalization—as the result of an enormous drama in an enormous tragedy in which my language can no longer be safe and which it cannot be removed from.[54]

It is perhaps from this idea of *tout-monde* and of the multiplicity and mutual empowerment of languages that a new understanding of the space and place of literature and language can emerge. The world is, of course, culture, time, space, location, imagination, and symbols, that is, a complex network of meanings that have a direct as well as indirect connection to the subject. The subject is located in culture and language, and yet culture and language locate the subject. In the context of a transnational and global culture, the modalities of mutual recognition and interaction have been transformed, and the subject must relearn its engagement with language. It is precisely here, at the threshold of the new millennium, that a new reconceptualization of the relation between humans and language can make a significant contribution.

NOTES

1. "Mais quelle est la notion propre de l'homme: la parole et la morale. L'humanisme"; Francis Ponge, *Il partito preso delle cose*, bilingual edition, translated into Italian by Jacqueline Risset (Turin: Einaudi, 1979), p. 46. Unless otherwise indicated, all translations into English in this chapter are by the author.
2. Giorgio Agamben, *Idea of Prose*, translated by Michael Sullivan and Sam Whitsitt (New York: State University of New York Press, 1995), p. 37.

3. Agamben, *Idea of Prose*, p. 37.
4. Paul Ricœur, "On Interpretation," in *From Text to Action: Essays in Hermeneutics II*, translated by Kathleen Blamey and John B. Thompson (London: The Athlone Press, 1991), pp. 2–20.
5. Martin Heidegger, "Letter on Humanism," in Martin Heidegger and David Farrell Krell (eds) *Martin Heidegger: Basic Writings* (London: Routledge, 1993), pp. 213–65.
6. Rüdiger Safranski, *Martin Heidegger: Between Good and Evil*, translated by Ewald Osers (Cambridge, MA: Harvard University Press, 1999).
7. Martin Heidegger, *Gesamtausgabe, Band 39: Hölderlins Hymmen 'Germanien' und 'Der Rhein*, edited by Susanne Ziegler (Frankfurt: Vittorio Klostermann, 1980).
8. See Anthony Gottlieb, "Heidegger for Fun and Profit," *New York Times Book Review*, 1, 1990: 22, 23; and Allan Megill, *Prophets of Extremity: Nietzsche, Heidegger, Foucault, Derrida* (Berkeley: University of California Press, 1985); see also Miles Kennedy, "The Politics of Space: Poetical Dwelling and the Occupation of Poetry," this volume, Chapter 10.
9. Martin Heidegger, *On the Way to Language*, translated by Peter Hertz (New York: Harper and Row, 1982).
10. Heidegger, *On the Way to Language*, p. 139. Original: "Denken wir von diesem Ort aus für einen Augenblick an das, was Hölderlin in seiner Elegie Brod und Wein (VI. Strophe) frägt." *Unterwegs zur Sprache* (Stuttgart: Verlag Günther Neske Pfullingen, 1959), p. 219.
11. Heidegger, *On the Way to Language*, p. 135. Original: "Haus des Seins ist die Sprache, weil sie als die Sage die Weise des Ereignisses ist." *Unterwegs zur Sprache*, p. 267.
12. Heidegger, *On the Way to Language*, p. 135. Original: "Um dem Sprachwesen nachzudenken, ihm das Seine nachzusagen, braucht es einen Wandel der Sprache, den wir weder erzwingen noch erfinden können." *Unterwegs zur Sprache*, p. 267.
13. Heidegger, *On the Way to Language*, p. 136. Original: "Ohne die Sprache in ihren Lauten, und noch weniger in ihren Formen und Gesetzen zu verändern, führt die Zeit durch wachsende Ideenentwicklung, gesteigerte Denkkraft und tiefer eindringendes Empfindungsvermögen oft in sie ein, was sie früher nicht besaß." *Unterwegs zur Sprache*, p. 268.
14. Heidegger, *On the Way to Language*, p. 57. Original: "Mit der Sprache eine Erfahrung machen." *Unterwegs zur Sprache*, p. 159.
15. Heidegger, *On the Way to Language*, p. 58. Original: "Könnte es förderlich sein, wenn wir uns abgewöhnen, immer nur das zu hören, was wir schön verstehen." *Unterwegs zur Sprache*, p. 160.
16. Heidegger, *On the Way to Language*, p. 59. Original: "In Erfahrungen, die wir mit der Sprache machen, bringt sich die Sprache selbst zur

Sprache. Man könnte meinen, das geschähe doch jederzeit in jedem Sprechen. Allein, wann immer und wie immer wir eine Sprache sprechen, die Sprache selber kommt dabei gerade nie zum Wort." *Unterwegs zur Sprache*, p. 161.

17. Heidegger, *On the Way to Language*, p. 59. Original: "Seltsamerweise dort, wo wir für etwas, was uns angeht, uns an sich reißt, bedrängt oder befeuert, das rechte Wort nicht finden." *Unterwegs zur Sprache*, p. 161.
18. Heidegger, *On the Way to Language*, p. 140.
19. Heidegger, *On the Way to Language*, p. 140.
20. On Heidegger and poetry, see also Gerard L. Bruns, *Heidegger's Estrangements: Language, Truth, and Poetry in the Later Writings* (New Haven and London: Yale University Press, 1989).
21. Heidegger, *On the Way to Language*, p. 143.
22. Heidegger, *On the Way to Language*, p. 143.
23. Heidegger, *On the Way to Language*, p. 147. Original:

Wiel dieser Verzicht ein eigentlicher Verzicht ist und keine bloße Absage an das Sagen und somit kein bloßes Verstummen. Als Sichversagen bleibt der Verzicht ein Sagen. So wahrt er das Verhältnis zum Wort. Weil jedoch das Wort sich in einem anderen, höheren Walten gezeigt hat, muß auch das Verhältnis zum Wort eine Wandlung erfahren. Das Sagen gelangt in eine andere Gliederung, in ein anderes melos, in einen anderen Ton. Daß der Verzicht des Dichters in diesem Sinne erfahren ist, bezeugt das Gedicht selber, das den Verzicht sagt, indem es ing singt.

(*Unterwegs zur Sprache*, p. 228)

24. Heidegger, *On the Way to Language*, p. 155. Original: "Gelangen wir vor das uralt Denkwürdige, dem nie genug nachgedacht werden kann." *Unterwegs zur Sprache*, p. 237.
25. Martin Heidegger, "Zur Bestimmung der Philosophie. Mit einer Nachschrift der Vorlesung 'Uber das Wesen der Universitat und des akademischen Studiums'," in Bernd Heimbüchel (ed) *Heidegger Gesamtausgabe*, B and 56/57 (Frankfurt: Vittorio Klostermann, 1987), p. 113.
26. Heidegger, *Zur Bestimmung der Philosophie*, pp. 71–72.
27. Heidegger, *On the Way to Language*, p. 151. Original: "Das Wort läßt das Ding als Ding anwesen." *Unterwegs zur Sprache*, p. 233.
28. The essay "The Thing" (*Das Ding*) was first delivered in the form of a lecture at the Bayerischen Akademie der Schönen Künste on June 6, 1950, and later collected in the volume *Vorträge und Aufsätze* (1936–1953), and translated into English in 1971; see Martin Heidegger, *Poetry, Language, Thought*, translated by Albert Hofstadter (New York: Harper and Row Publishers, 1975), pp. 163–86.
29. "Sides and bottom," writes Heidegger,

of which the jug consists and by which it stands, are not really what does the holding. But if the holding is done by the jug's void, then the potter who forms sides and bottom on his wheel does not, strictly speaking, make the jug. He only shapes the clay. No—he shapes the void.

("The Thing," p. 169)

30. In the essay "Word" (*Das Wort*), Heidegger employs the concept of renunciation ("Verzicht") to claim that the power of poetry, its true "Saying"—which Heidegger emphasizes through the use of the capital "S"—resides precisely in its non-saying: "Because this renunciation," he writes,

is a genuine renunciation, not just a rejection of Saying, not a mere lapse into silence. As self-denial, renunciation remains Saying. It thus preserves the relation to the word. But because the word is shown in a different, higher rule, the relation to the word must undergo a transformation. Saying attains to a different articulation, a different *melos*, a different tone.

(*On the Way to Language*, p. 76)

31. Jacques Lacan, *Le Séminaire livre VII: L'Éthique de la psychanalyse* (Paris: Seuil, 1986), p. 146; *The Ethics of Psychoanalysis, 1959–1960*, translated by Dennis Porter (London: Routledge, 1992), p. 121.

32. "La création de la poésie consiste à poser, selon le mode de la sublimation propre à l'art, un objet que j'appellerai affolant, un partenaire inhumain" (*Le Séminaire*, p. 180); "By means of a form of sublimation specific to art, poetic creation consists in positing an object I can only describe as terrifying, an inhuman partner" (*The Ethics*, p. 150).

33. "... le Souverain Bien, qui est *das Ding*, qui est la mère, l'objet de l'inceste, est un bien interdit, et qu'il n'y a pas d'autre bien" (*Le Séminaire*, p. 85); "... the Sovereign Good, which is *das Ding*, which is the mother, is also the object of incest, is a forbidden good, and that there is no other good" (*The Ethics*, p. 70).

34. "La question de *das Ding* reste aujourd'hui suspendu à ce qu'il y a d'ouvert, de manquant, de béant, au centre de notre désir" (*Le Séminaire*, p. 102); "The question of *das Ding* is still attached to whatever is open, lacking or gaping at the center of our desire" (*The Ethics*, p. 84).

35. La fonction de cette place [of poetry] est d'être ce qui contient les mots, au sens où contenir veut dire retenir, par quoi une distance et une articulation primitives sont possibles, par quoi s'introduit la synchronie, sur laquelle peut ensuite s'étager la dialectique essentielle, celle où l'Autre peut se trouver comme Autre de l'Autre.

(*Le Séminaire*, p. 81)

The function of this place is to contain words, in the sense in which contain means to keep—as a result of which an original distance

and articulation are possible, through which synchrony is intro-
duced, and it is on the foundation of synchrony that the essential
dialect is then erected, that in which the Other may discover itself
as the Other of the Other.

<div align="right">(The Ethics, p. 66)</div>

36. "…das Ding est justement au centre au sens qu'il est exclu" (Le Séminaire, p. 87); "…das Ding is at the center only in the sense that it is excluded" (The Ethics, p. 71).
37. Maurice Blanchot, The Space of Literature, translated by Ann Smock (Lincoln: University of Nebraska Press, 1982), p. 26.
38. Blanchot, The Space of Literature, p. 26.
39. Blanchot, The Space of Literature, p. 37.
40. Michel Foucault, "La pensée du dehors," in Daniel Defert and François Ewald (eds) Dits et écrits, 1954–1988 (Paris: Éditions Gallimard, 1994), pp. 518–39.
41. De là, la nécessité de convertir le langage réflexif. Il doit être tourné non pas vers une confirmation intérieure—vers une sorte de certitude centrale d'où il ne pourrait plus être délogé—, mais plutôt vers une extrémité où il lui faut toujours se contester: parvenu au bord de lui-même, il ne voit pas surgir la positivité qui le contredit, mais le vide dans lequel il va s'effacer; et vers ce vide il doit aller, en acceptant de se dénouer dans la rumeur, dans l'immédiate négation de ce qu'il dit, dans un silence qui n'est pas l'intimité d'un secret, mais le pur dehors où les mots se déroulent indéfiniment.

<div align="right">(Foucault, "La pensée du dehors," p. 532)</div>

42. Original edition: Francis Ponge, Le parti pris des choses (Paris: Gallimard, 1942). Quotations included here are from the bilingual French/Italian edition of 1979, translated by Jacqueline Risset.
43. Le mollusque est un être—presque une—qualité. Il n'a pas besoin de charpente mais seulement d'un rempart, quelque chose comme la couleur dans le tube. La nature renonce ici à la présentation du plasma en forme. Elle montre seulement qu'elle y tient en l'abritant soigneusement, dans un écrin dont la face intérieure est la plus belle.

<div align="right">(Francis Ponge, Il partito preso delle cose /Le parti pris des choses, bilingual edition, p. 38)</div>

44. Laurent Adert, "La mesure de l'homme (l'éthique du dire selon Francis Ponge)," Versants, 48, 2004: 282–99, p. 284.
45. Adert, "La mesure de l'homme," p. 286.
46. William Marx, L'adieu à la littérature: Histoire d'une dévalorisation XVIII-XX siècle (Paris: Les Èditions de Minuit, 2005), p. 176.
47. Marx, L'adieu à la littérature, p. 181.

48. "Au cours du XXe siècle, la haine de la belle écriture fut un sentiment largement partagé: de manière exemplaire, Bataille ne s'appliqua-t-il pas à gauchir savamment le style de certains de ses romans, en un acte délibéré de profanation des vieux idéaux de la littérature." Marx, *L'adieu à la littérature*, p. 146.

49. Marco Carmello, *Extragrammaticalità: Note linguistiche, critiche e filosofiche sull'ultimo Pizzuto* (Torino: Ananke, 2012), p. 9.

50. C'est le principe même du projet beckétien qui s'exprime en cette décision fondatrice, celle d'écrire en français sans pour autant abandonner l'anglais, de manière à créer une sorte de vide au cœur de l'œuvre, entre les deux moitiés linguistiques du système, la première qui fut écrite en style et la seconde qui fut "sans style" (ou avec le style du non-style).

 (Marx, *L'adieu à la littérature*, p. 177)

51. On dit en France que la poésie est morte. Je crois que la poésie, et en tout cas l'exercice de l'imaginaire, la vision prophétique à la fois du passé et des espaces lointains, est de partout la seule manière que nous ayons de nous inscrire dans l'imprédictibilité de la relation mondiale.

 (Édouard Glissant, Introduction
 à une poétique du divers.
 (Paris: Gallimard, 1996), p. 90)

52. Édouard Glissant, *Poétique de la relation* (Paris: Gallimard, 1990).

53. Une fois de plus, en ce qui concerne la notion de chaos, quand je dis chaos-monde, je répéterai ce que j'ai précisé à propos de la créolisation: il y a chaos-monde parce qu'il y a imprévisible. C'est la notion d'imprévisibilité de la relation mondiale qui crée et détermine la notion de chaos-monde.

 (Glissant, Introduction à une
 poétique du divers, p. 37)

54. Mais écrire en présence de toutes les langues du monde ne veut pas dire connaître toutes les langues du monde. Ça veut dire que dans le contexte actuel des littératures et du rapport de la poétique au chaos-monde, je ne peux plus écrire de manière monolingue. C'est-à-dire que ma langue, je la déporte et la bouscule non pas dans de synthèses, mais dans des ouvertures linguistiques qui me permettent de concevoir les rapports des langues entre aujourd'hui sur la surface de la terre—rapports de domination, de connivence, d'absorption, d'oppression, d'érosion, de tangence, etc.—, comme le fait d'un immense *drama*, d'une immense tragédie dont ma propre langue ne peut pas être exempte et sauvé.

 (Glissant, Introduction à une poétique
 du divers, p. 40)

BIBLIOGRAPHY

Adert, Laurent. "La mesure de l'homme (l'éthique du dire selon Francis Ponge)," *Versants*, 48, 2004: 282–99.

Agamben, Giorgio. *Idea of Prose*, translated by Michael Sullivan and Sam Whitsitt (New York State University of New York Press, 1995).

Blanchot, Maurice. *The Space of Literature*, translated by Ann Smock (Lincoln: University of Nebraska Press, 1982).

Bruns, Gerald L. *Heidegger's Estrangements: Languages, Truth, and Poetry in the Later Writings* (New Haven and London: Yale University Press, 1989).

Carmello, Marco. *Extragrammaticalità. Note linguistiche, critiche e filosofiche sull'ultimo Pizzuto* (Torino: Ananke, 2012).

Foucault, Michel. "La pensée du dehors," in Daniel Defert and François Ewald (eds) *Dits et écrits, 1954–1988* (Paris: Éditions Gallimard, 1994), pp. 518–39.

Glissant, Édouard. *Poétique de la relation* (Paris: Gallimard, 1990).

——. *Introduction à une poétique du divers* (Paris: Gallimard, 1996).

Gottlieb, Anthony. "Heidegger for Fun and Profit," *New York Times Book Review*, 1, January 7, 1990: 22, 23.

Heidegger, Martin. *Unterwegs zur Sprache* (Stuttgart: Verlag Günther Neske Pfullingen, 1959).

——. *Poetry, Language, Thought*, translated by Albert Hofstadter (New York: Harper and Row Publishers, 1975).

——. *Gesamtausgabe, Band 39: Hölderlins Hymnen 'Germanien' und 'Der Rhein*, edited by Susanne Ziegler (Frankfurt: Vittorio Klostermann, 1980).

——. *On the Way to Language*, translated by Peter Hertz (New York: Harper and Row, 1982).

——. "Zur Bestimmung der Philosophie," in Bernd Heimbüchel (ed) *Heidegger Gesamtausgabe*, B and 56/57 (Frankfurt: Vittorio Klostermann, 1987), p. 113.

——. "Letter on Humanism," in Martin Heidegger and David Farrell-Krell (eds) *Martin Heidegger: Basic Writings* (London: Routledge, 1993), pp. 213–65.

——. *Vorträge und Aufsätze* (Stuttgart: Klett-Cotta, 2004).

Lacan, Jacques. *Le Séminaire livre VII. L'Éthique de la psychanalyse* (Paris: Seuil, 1986).

——. *The Ethics of Psychoanalysis, 1959–1960*, translated by Dennis Porter (London: Routledge, 1992).

Marx, William. *L'adieu à la literature. Histoire d'une dévalorisation XVIII-XX siècle* (Paris: Les Èditions de Minuit, 2005).

Megill, Allan. *Prophets of Extremity: Nietzsche, Heidegger, Foucault, Derrida* (Berkeley: University of California Press, 1985).

Ponge, Fracis. *Le parti pris des choses* (Paris: Gallimard, 1942).

——. *Il partito preso delle cose*, Bilingual edition, translated by Jacqueline Risset (Turin: Einaudi, 1979).

Ricœur, Paul. *From Text to Action: Essays in Hermeneutics II*, translated by Kathleen Blamey and John B. Thompson (London: The Athlone Press, 1991), pp. 2–20.

Safranski, Rüdiger. *Martin Heidegger: Between Good and Evil*, translated by Ewald Osers (Cambridge, MA: Harvard University Press, 1999).

CHAPTER 7

DREAMING WELL-BEING INTO BEING: DUALITIES OF VIRTUAL-ACTUAL COMMUNITIES

Karen Le Rossignol

INTRODUCTION

How plastic is a virtual village operating as a spatial entity? This chapter explores whether this spatial entity can provide strategies, through narratives, for a community to problem-solve with the aim of increasing its well-being.

A duality is usually seen as an opposition or a contrast between two concepts or aspects, in this case the contrast between a virtual and actual community. No matter the type of community, whether it is a collective, a collaboration, or a village, it has its own storylines; it has a capacity to develop spatial narratives related to the actual place. In forming an abstraction of that community into a virtual village, the emphasis on narrative arts connectivity takes on a "plasticity." This plastic shaping can mold both the virtual and actual entities into potential problem-solving creative imaginings or dreamings. The plastic process of virtual village storytelling may shape community well-being through the abstraction of a virtual world community or network of practice. It may also be integrated into the actual narrative and cultural life of the community.

CONTEXT

This chapter explores a research project design that is an abstraction of actual communities through virtual village creation. The actual community is tasked with remaking or reforming cultural relationships through narrative art-making. The scenarios, the characters, and storylines or plots for the virtual villages are created, developed, and produced by groups of volunteer participants across more than one community. The global virtual villages have community "hubs" that form an abstraction of the real communities from which these participants come. They may be a pub, a café, or a meeting hall, but they are created to provide narrative parallels to the actual situations. This parallel to the realities of their communities enables participant shape-shifting, both in imaginative story-making and in motivation to develop skills to tell those stories digitally.

The *Memphis Manifesto*[1] talks of building a creative community of ideas. Creative communities are "vibrant, humanizing places, nurturing personal growth, sparking cultural and technological breakthroughs, producing jobs and wealth, and accepting a variety of life styles and culture."[2] These communities provide the circulation of ideas: "Ideas take root where creativity is cultivated and creativity thrives where communities are committed to ideas."[3] The members of the *Creative 100* at the Memphis Manifesto Summit developed ten points for a creative community. Point 7 focused on place:

> *Invest in and build on quality of place.* While inherited features such as climate, natural resources and population are important, other critical features such as arts and culture, open and green spaces, vibrant downtowns, and centers of learning can be built and strengthened. This will make communities more competitive than ever because it will create more opportunities than ever for ideas to have an impact.[4]

The sense of place for these creative communities is strongly related to a sense of community well-being. The community policy is tied to discovering ways to measure aspects that affect that sense of well-being, in a breadth of issues including open spaces, arts and culture, traffic and parking, and recreation and fitness. Knowing how a community is managing through such measures provides critical information that will assist decision-making, particularly in regional, isolated, or remote communities. The research design examined throughout this chapter extends the concept of a creative community of ideas to problem-solving and decision-making through a (plastic) virtual world environment. Plasticity is not only about a virtual world being made

into different shapes; it implies molding or altering, perhaps by a response to previous experiences. This virtual world does not in a sense exist except as an abstraction, dealing with ideas rather than particular events.

Spatial narrative finds meaning in the cultural, political, and economic spaces of an entity such as a rural community. It traces the storylines of the people who track through that village space, working their own molding of the environment. In his discussion of spatial narrative in 1945, Joseph Frank[5] talked of "a model of narrative that challenges traditional notions of linear progressions in time."[6] As Lichty puts it,

> For Frank, the creation of space is the linking of narrative to non-linear time [...]. But by breaking with the use of linear time in the creation of narrative, by collapsing time into layers, these writers [Eliot, Proust, and Joyce] have created random access ordering now familiar in online media.[7]

One of the advantages of using a virtual world environment is the capacity of participants in a community to reshape that virtual world through their creative problem-solving, in a nonlinear time. The plastic virtual world is perfectly suited to storytelling and to changing its shape through narratives that reveal creative strategies for well-being.

SCENARIOS AND ROLE PLAYS FOR VIRTUAL WORLDS

The research design described in this chapter has grown from a pedagogy of using associational narratives in virtual learning environments across undergraduate and postgraduate programs in creative writing. The focus on virtual worlds is centered on the following Confucian statement: *Tell me and I'll forget. Show me and I'll remember. Involve me and I'll understand.* It is tied into scenarios and role plays as a way of engaging with concepts in an experiential way.

The immediate influences in developing a virtual world learning environment have been as follows:

- the use of scenarios to problem-solve in ways that cut across the learner's or participant's expected way of thinking, that is, considering other points of view in coming to decisions;
- the use of role plays to explore stories that may illuminate how the world works, that is, the external world brought into the imagination of the player(s).

The lesson from using scenarios and role plays is that making something into a game means there is less responsibility and fear involved in the actual decision-making, although the thinking processes are replicated. It is more open to experimenting and thinking innovatively, to designing the answers after reflection rather than in the heat of the moment. Scenarios are hypotheticals, usually based on real situations (or modeling them), that enable participants to be challenged to change. Role plays are more game focused, with characters in a narrative and a plot that dictates the way the participants react (in character). By playing the pattern of decision-making or thinking, this might transfer to real patterns.

Both of these—scenarios and role plays—and other forms of what is now called a "serious game" are based on a pedagogy of experiential learning. By doing the tasks as characters, the supposition is that the learning will be transferred by the participants into real-world situations as they perceive the relevance of those scenarios and role plays. The learning is personalized through the individualized actions of the learner, even when the situation is not quite real.

Print-based scenarios/role plays were the first step in a pedagogy of developing narrative with a capacity to transfer learning to real situations. The role plays and scenarios engaged participants to a point. It was a valid approach, but could be so much stronger if the leap could be made by participants into believing that these role plays were relevant. That is, they had to have some connection to the real world. Although the participants/learners played the game, there was still an element of holding back. They were not totally committed because they knew that what was on paper in front of them was make-believe, not part of their real world.

The move to website-based worlds, created using photographs and minimal text, with some interaction with story development, suggested more complex and reality-based stories about that world. The visuals peopled the world, believable characters were leading the action, the plots became the catalysts for change in that world, and the environment (Pacific island, country town) provided a richer tapestry of belief.

Current virtual worlds, such as *Second Life*™ and *World of Warcraft*™, are often quoted and perceived as totally 3D, immersive, and otherworldly, arising from gaming developments. The approach to virtual world environments as storytelling opportunities encourages a 3D perspective. There is a digital repository (or website) that creates dimensions of character and plot through a 2D website space that requires movement through various pages and stories. The other

dimension is the imagination of the participant. The world they enter is immersing them in stories and characters. It is not the environment of a created avatar, but of themselves as part of this world. They can walk in or out easily; it is very accessible. They can take the lessons they gain from this world and transfer that learning to the real world, the local community, or workplace and see that connection all the time. They don't really disappear into the virtual world; they drop in and test ideas within it. If the lessons stick, they will transfer to the real world. Stickiness is about motivation to join the community and get involved or engaged.

DEFINING VIRTUAL VILLAGES

The next step from the virtual learning environments in designing a broader research purpose was to expand the concept into virtual villages with a capacity to move beyond learning institutions into the actual communities, both local and global. Virtual villages have been defined as capacity-building spatial entities, accessing technological and educational resources that potentially enable community partnerships. An example is the City of El Paso Virtual Village Project.[8] This project has developed public computer centers to aid urban and rural community residents to feel less isolated both in digital terms and in communicating with the members of their communities. Another example, from a smaller local community viewpoint, is University of the Village, developed by Falmouth University, with particular success in St. Agnes in Cornwall. This project linked Next Generation Access Broadband with supporting community-based learning, in order to increase economic development and find ways to use technologies, particularly superfast broadband, in developing digitally connected village communities.[9]

The virtual villages mentioned above combine a sense of community with a specific, technology-related purpose. They may develop IT capacity or provide stronger linkages with other networks such as the academic research team in the University of the Village. The focus is on the interaction between the village, or community, and technological connections. The plastic quality comes from the shaping force of the technology rather than the issues of the community.

Another approach to the development of virtual communities is to concentrate on social networks beyond specific geographical and political boundaries. These are interested in developing the communities' social capacities in order to have linkages across community

stories and culture, to share mutual interests or goals, and to problem-solve regional issues using interrelated global capacities. Communities of practice are groups of people who share a concern or a passion for something they do and who learn how to do it better as they interact regularly. It is not *intentional* learning, given aspects such as the interaction among participants, their passion, and the wish to improve the way things are done, which are all primary components of Wenger's definition of communities of practice.[10] This does fit the concept of a virtual world, which stands alone. The interactions are vital and are best put together within story/narrative because that takes away the judgment and the problem-solving pathways already established by former patterns within the learning environment.

Coupled with this sense of a virtual village is the need to harness digital convergence in a communal environment. Cathy Gonzalez, training/computing administrative manager of the University of North Texas, talked in 2004 about the amount of knowledge in the world doubling every eighteen months:

> The "half-life of knowledge" is the time span from when knowledge is gained to when it becomes obsolete. Half of what is known today was not known 10 years ago. The amount of knowledge in the world has doubled in the past 10 years and is doubling every 18 months according to the American Society of Training and Documentation (ASTD).[11]

For the digital participant, it has become a matter of where to find information and knowledge, rather than the how and what of a knowledge base.

According to Henry Jenkins, Web 2.0 is capable of coping with the challenge of participatory cultural exchanges.[12] This includes low barriers for engagement and a community that provides strong support for sharing creations with others. Informal mentors assist in learning technologies and social processes, and there is a shared recognition that people are free to participate when they are ready. The participatory culture endorses the belief that people's contributions matter. The virtual villages discussed in this chapter are designed for potential archipelagos of interrelated cultural exchange. They are participatory, experiential, and sustainable through engagement in problem-solving storylines.

Regional or isolated communities are spatial entities as well as a collective of individuals. They need to engage with their own spatial narratives to develop a cultural collective and to improve the well-being of

that community. The virtual village research project design described below is a spatial entity re-created in a two-dimensional Web environment, but with the extra dimension of the social networks peopling that virtual world. There is a parallel reality between the virtual world or village representations of a mythical town, where stories are imaginatively picturing problems and strategies, and the real community playing the parts of the characters of that mythical town. The design of these parallel realities is based on a range of learning philosophies and pedagogies that have grown from the use of virtual learning environments in an academic framework, teaching creative writers how to develop their social advocacy skills. The dual realities of the research design are abstractions of a spatial entity parallel to an entity anchored in the actual community, in an iterative cycle of comparison.

VIRTUAL WORLD ENVIRONMENTS AND NARRATIVE

The narrative design is based on Web environment hubs or communities. The virtual world community can become the center of imaginative engagement, but reality is in the situation and it is replicating reality at one remove. The community *feel*, associated both with the story and the situations (which are multiple and therefore confusing at first), is vital to the sense of reality. The virtual world is both caught up in the language of the participants, the actual community, and separate to it, an abstraction that is plastic. The participants in the virtual villages, designed as social and cultural networks, are more motivated to take part because they can tell part of the story themselves, without it being at risk of being "wrong." Engagement in the story comes via immersion in their own shaping of the outcomes from the story.

This is in line with Bruner's model of three modes of representation: enactive or action based, iconic or image based, and symbolic or language based.[13] Bruner saw these not as levels of development into knowledge, but as a kind of spiral learning, moving into and out of each of the three modes to take on the new behavioral activity and to progress it into deeper knowledge with each spiraling reiteration. The first stage is an engagement with the virtual world to learn new skills in telling stories, learning how to use film, radio, and e-newspapers at a basic level of having fun with storylines. This is enactive as the participants create the stories that match the characters of their virtual village. They move out of this mode, reflect on it, and find a resonance in the parallel between the imagined story and their community's reality. The second phase of engagement leads to a

community of practice, where networks identify how to trust each other in the storytelling process and take it to a more metaphorical level. The stories help to identify strategies to increase well-being and to resolve issues that are important to that community. The third mode of representation is the exchange of the stories (in film, audio, and e-news) between different global virtual villages. This sharing may even involve intertwined storylines—immigrants from one virtual village may travel to others to explore common issues and themes. At this level or mode there is a deeper level of reflection on the value of the problem-solving in the real or actual community, and more globally across other isolated communities. The virtual world community becomes the center of imaginative engagement, but reality is in the situation and in replicating reality at one remove. The community "reality" is vital to the sense of relevance of this imagined world.

ASSOCIATIONAL NARRATIVE

Narrative is explored by Bruner in terms of "how we come to endow experience with meaning."[14] Bruner details narrative as combinations of plot linking events together, action and interaction, and character itself. However, it is in talking about discourse as enabling the reader to "write" his or her own virtual text that there are links to the narrative design of these virtual worlds. Bruner talks of three unities: presupposition with implicit rather than explicit meanings; subjectification with reality seen through the protagonist's consciousness; and multiple perspective, a set of prisms that each catch some part of the narrative.[15] The design approach takes strong nonlinear relationships into the virtual learning communities to develop the narratives of the community writer/learner as part of the discourse of that virtual world. The virtual worlds are designed around developing fragments of narrative engagement in a storytelling that is other than didactic or linear, that needs to be searched and unearthed, and that does not offer a "right" answer to a problem. It combines some elements of presupposition, subjectification, and multiple perspectives.

Bruner has since talked of narrative as having a dual purpose (in this instance referring to schools and learning):

> to make the strange familiar and ourselves private and distinctive. If pupils are encouraged to think about the different outcomes that could have resulted from a set of circumstances, they are demonstrating usability

of knowledge about a subject. Rather than just retaining knowledge and facts, they go beyond them to use their imaginations to think about other outcomes, as they don't need the completion of a logical argument to understand a story. This helps them to think about facing the future, and it stimulates the teacher too.[16]

This comment applies not only to schools but to communities of practice or learning. The narrative mode deals in human intention and action, expressing timeless events or imaginative leaps into particularized experience. This is located in time and place.[17] According to the *Collins Dictionary*, the word "association" means a mental connection of ideas, feelings, or sensations. Free association is a spontaneous mental process whereby ideas, words, or images suggest other ideas, in a nonlogical chain reaction. Associational narrative in the context of this project is the use of fragments such as individualized story tasks (interviews with local characters, presenting the outcomes from a local council meeting) crafted as segments (elements of a television or radio program). These segments will have a resonance for the learner, such as social advocacy to change entrenched community attitudes and to find other solutions. The learning involved in this associational narrative is in the development of resonance, in this case belonging to a social stance and advocating for change that becomes parallel to a real-life situation.

The stories created for the scenarios start out for learners as fictions, creating characters and plot, within a given context or environment or place. The scenarios are fictions but the outputs relate to nonfictional creative tasks in the real world they are modeling. Creative nonfiction has arisen from the factual basis of situation integrated with the fiction techniques of engagement. Part of the technique of twenty-first-century creative nonfiction writing is its sense of leaping gaps—gaps in memory, gaps in chronological story. "It might be that the modern reader/viewer is more accustomed to disjunctiveness than to strict continuity."[18] This is one of the major reasons why the storylines within the virtual worlds are not linear, why they have a sense of Root's description of disjunctiveness in their internal and external structuring. Internal structuring, the elements of story within the virtual worlds, is related to linking fragments. They may be part of a mosaic, a series of episodes, and a segment that starts to provide resonance as it reveals its relevance. A fragment is like a piece broken off or detached, while a segment is one of the parts into which something naturally separates or is divided. The virtual world design and scenarios work with segments, even if the learners at first only see fragments.

The design and scenarios follow the freedoms of association of the personal essayist:

> No one is freer than the essayist—free to leap out in any direction, to hop from thought to thought, to begin with the finish and finish with the middle, or to eschew beginning and end and keep only a middle. The marvel of it is that out of this apparent causelessness, out of this scattering of idiosyncratic seeing and telling, a coherent world is made. It is coherent because, after all, an essayist must be an artist, and every artist, whatever the means, arrives at a sound and singular imaginative frame—or call it, on a minor scale, a cosmogony.[19]

The narrative strategies adopted in developing a virtual world learning environment are the use of scenarios and role plays. Scenarios and roles plays are a representation of the essayist's approach to leaping in any direction. The narrative flow available within virtual villages scenarios illuminates different perspectives and enables more diverse problem-solving strategies through finding a form of "cosmogony."

Associational narrative is an extension of fragments (building into resonant segments) of narrative engagement in storytelling, a non-linear approach. The virtual world storytelling of the virtual village explores possibilities for fragments to coalesce into cogent entities, in which segments are drawn together as stories, and examines the storytelling as a creative disruptive text, which resonates beyond the known and the familiar. It has the capacity to find creative strategies for global virtual village community problems and develop well-being through engagement in stories.

STORYTELLING IN THE VIRTUAL VILLAGE

The design of these virtual villages as social networks and cultural exchange points requires that they have a common series of tasks—a radio program, a television show, and a e-newspaper—and common themes to explore in interlinked stories. The stories are both virtual and imagined, shaped to the reality of participants' sense of their own space or community. These are the plastic spatial narratives.

The narrative storylines are based in a virtual environment that is recognizable as a spatial entity, albeit with "constructed" names. There is the small town of Abermacroth's Community Hall in Scotland, the Cornish pub in St. Tristell, and the Australian café in Warrabundy, South Western Victoria. These are abstracted

environments for the participants, with story enmeshed in a spatiality they can mold while still recognizing it as a partial reality.

Within each site or hub there is an access and display point—a computer, radio, newspaper rack, and television. Each created community has some common contextual points, that is, abstract representations of storytelling methods. They have a maritime link; the actual communities are small and relatively remote; they struggle economically. The stories told within each virtual village, over a particular time-span, can be shared across geographical and political boundaries through digital convergence. The global virtual villages can explore mutual interests and compare goals, reducing their isolation and increasing community well-being in a global community of learning practice.

The design of this project entails each virtual community's responding to imagined or created situations, which parallel their own realities in their regional communities. This is expressed by creating characters that are part of an ongoing storyline. It may involve local public transport difficulties for an aging population or economic issues requiring creative and entrepreneurial microbusinesses to sustain the virtual village. These storylines unleash the imagination of participants from the local community, so they are freed to find innovative solutions that are not circumscribed by local politics or geographies. The narratives are anchored in the realities of those actual communities, with a resonance and capacity to share across a global archipelago of similar virtual village communities. This design is itself anchored in experiential and immersive learning pedagogies.

RELEVANT EXPERIENTIAL AND PROBLEM-BASED PARTICIPANT DESIGN

Dewey's educational philosophy and pedagogy, dating back to the early twentieth century, is still relevant in the twenty-first-century context and underpins the approach to virtual worlds as connected communities or villages. He argues for education and learning as being social and interactive and suggests that learners will prosper and engage with the environment where they are able to experience and have some control over the curriculum. Learners will attach content to prior experiences, which will then engage them more fully with the new knowledge they are being asked to absorb. He stated, "If knowledge comes from the impressions made upon us by natural objects, it is impossible to procure knowledge without the use of objects which impress the mind."[20] One of the pedagogical outcomes of Dewey's

theory, Problem-Based Learning (PBL), reinforces an interest in active learning approaches. Barrows[21] defines the Problem-Based Learning model as student centered, taking place in small groups, with facilitators who guide rather than teach, with problems that focus the group's learning to stimulate the cognitive process, and with new knowledge acquired through self-directed learning. PBL is grounded in the principle of a simulated real world and a professional context and comes from a constructivist perspective on learning. The instructor is a guide who challenges the learning process, rather than assuming and enforcing the role of knowledge provider. Therefore, two vital elements in this PBL model are feedback and reflection related to the learning, and group dynamics. Learners are active in constructing their social knowledge, through personal interpretations of the worldview of their experiences and interactions. PBL is intended to move the learner through theory to practice in solving the knowledge problem(s).[22] This provides a strong pedagogy for designing a virtual community for a mixed group of learners.

The ability to be adaptable, to have the capacity to change with the requirements of their careers, is an important attribute for the virtual village participant of the twenty-first century. Transformation in learning is also potentially about transforming the learning space, or the knowledge space as an academic framework. A movement to performativity matches well with the movement away from internalized, individualistic learning theory, as the educational technologies encourage connected, socially adept networks and collaborations within workplace/industry contexts.

CONSTRUCTIVISM AND SOCIAL CONSTRUCTIVISM

Constructivist pedagogy emphasizes individual agency, where learners construct their own meaning, building on previous experience. Constructivism as a general approach indicates a form of active learning which develops knowledge through experience. Experiential learning is, as Kolb has defined it, "the process whereby knowledge is created through the transformation of experience."[23] The experiential learning model of Kolb combines concrete experience with reflection, conceptualization, and active experimentation, in a constant cycle that synthesizes experience, reflection, and theory. Each iteration of this learning cycle increases knowledge and practice through deeper understanding, as indicated earlier by consideration of Bruner's three modes of representation. According to Melvin L. Silberman,[24] experiential learning incorporates a direct involvement at emotional

and intellectual levels, using projects or work-based activities that are very similar to or replicate workplace experiences. This transformative experience potentially requires immersive and imaginative simulations and situations to bring the learning closer to the day-to-day work-place experiences, particularly in aspects such as interpersonal skills and communications. It is within this experiential design that the transformative experience can mobilize problem-solving for a rural or regional community.

Current trends in learning, whether in an academic environment or a community center, have developed, from a constructivist viewpoint, elements such as student-centered learning, the teacher as facilitator, discovery, and collaborative, project-based, and task-based learning. Taking this into a more socially based community-of-learning environment, social constructivism grew from constructivism to use social settings for groups to collaboratively create shared artefacts with the same meaning. By sharing each person's point of view, there is a greater capacity for participants to build knowledge that might not be possible to be achieved through individual efforts.

Jonassen[25] proposed eight characteristics that differentiate constructivist learning environments. These include environments that provide multiple representations of reality, presenting the complexity of the real world. The environments focus on knowledge construction using authentic tasks within a meaningful context. There is also a focus on real-world or case-based settings with reflection on experiencing those worlds or cases. The focus is on collaborative construction of knowledge through social negotiation rather than competition among learners for recognition. Thus the concept of a global virtual village emerges as a potential learning design in partnership with rural and regional communities. Motivation for learning is dependent on the learner's confidence. Finding the volition and emotion in learning, where volition is more important in the learning than intellect, provides potential emotional motivation.[26] The learning design entails approaching material from the participants' perspective and values and acknowledging their diversity.

This social constructivist-based collaborative model encourages participants to become more independent and to internalize their learning. It is an interactive model, encouraging and promoting discussion both in formal training formats and among peers in teams and collaborations. The facilitator's role also requires a development of trust and relationships with the learners and modeling of professional values and ethical dimensions within the content.[27]

CONNECTIVISM AS A MODEL WITHIN SOCIAL CONSTRUCTIVISM

The ability to synthesize and recognize patterns and connections is a valuable skill within an experiential workplace or community learning environment. The principles of connectivism, according to George Siemens,[28] relate to developing learning processes for connecting specialized nodes or information sources, encouraging learning and knowledge in a diversity of opinions, and developing the capacity to know more rather than focus on what is known. The nurturing and maintaining of connections will facilitate continual learning and enable the ability to see connections between fields, ideas and concepts. The aim of the connectivist approach is to be current, that is, to have accurate, up-to-date, and timely knowledge. This is an interesting match with the need of a social network or virtual village to develop capacity and opportunity to connect in lateral and layered ways. This may not necessarily be a model separate to social constructivism but an extension of social constructivism into the digital. The key focus for connectivism is the individual and their personal network. Learning is no longer an internal, individualistic activity because of the impact of the new learning tools and environmental changes on what it means to learn. Thus the learning space is also moving toward a more connectivist model, which is not constrained by traditional narrativity of knowledge transfer. It is potentially mobile, more strongly collaborative, and a flexible design for rural and regional engagement and well-being.

MILLENNIAL LEARNERS AND SOCIAL LEARNING COMMUNITIES

A millennial learner (roughly defined as those born since 1982) has been socialized within a digital environment, a part of the new capitalism of affinity groups and communities of practice. James P. Gee talks of the new capitalism involving teams and collaboration to keep up-to-date with knowledge.[29] Work is also more project based. Commodities of the old capitalism have transferred to centrality on design: the ability to design new identities, affinity groups, and networks. An affinity group, according to Gee, is a group with affiliations that primarily have shared practices or a common endeavor, rather than "shared culture, gender, ethnicity or face-to-face relationships."[30] Gee talks about communities of practice as an extension of affinity groups. Knowledge

in the communities of practice[31] is intensive (specialist knowledge of individuals) and extensive (each person shares knowledge and functions with others). This is also distributed across people, tools, and technologies and is dispersed. There are three characteristics that are crucial to a community of practice: a shared domain of interest, the community within that domain sharing the information in order to learn from each other, and the practitioners of that community having a shared repertoire of resources.[32]

Etienne Wenger also talks of community dimensions with three modes of belonging: engagement, imagination, and alignment. The communities are built positively by considering the elements of joint enterprise or levels of learning energy, the mutuality or depth of social capital, and the repertoire or degree of self-awareness. These dimensions of progress help foster a community that can design itself in a range of areas such as organization of events, leadership, connectivity, membership, projects, and artefacts.[33] The community of learning practice, the dual virtual and real community of the virtual village, is a group of people who share a set of problems and/or passion about a topic and who interact on a persistent basis through the pedagogy of immersive social learning.

Gee also discusses the design of networks, creating links between people and organizations, and between people and various sorts of tools and technologies. These people, within communities of learning practice, and digitally connected or networked to blended learning/knowledge sharing, are millennials. Gee suggests that millennials need to be "shape-shifting portfolio people," free agents shaping their skills, experiences, and achievements to meet changing requirements.[34] There is a shift of focus by millennial learners from these validated sources to an accessible range of information sources that are not necessarily validated. These include their peers, and they seem more comfortable with a communal approach to sharing knowledge.

Charles Dede also forecasts changes in physical and technological space and place: wireless everywhere, multipurpose habitats, augmented reality, and mirroring.[35] It is this last prediction that led to incorporating in the research design a virtual world narrative pedagogy that would attempt to replicate the physical setting. It would also provide "magical" capabilities for immersive experience. The interest in presence within virtual environments leading to psychological immersion has informed the design of the virtual worlds of this global archipelago.

COMMUNITIES OF LEARNING / PRACTICE

Communal learning may also be extended to consider communities of practice. Wenger talks of these as being defined along three dimensions:

> *What it is about*: its *joint enterprise* as understood and continually renegotiated by its members;
>
> *How it functions*: the relationships of *mutual engagement* that bind members together into a social entity;
>
> *What capability it has produced*: the *shared repertoire* of communal resources (routines, sensibilities, artifacts, vocabulary, styles, etc.) that members have developed over time.[36]

In comparison to a virtual world community, a community of practice has a shared domain of interest, a community engaged in joint activities and discussions, and a practitioner base. Communities of practice may engage in problem-solving, requesting information, seeking experience of others, reusing ideas or assets, coordinating for synergy, discussing developments or issues, managing visits, and mapping knowledge and gaps. The term "community of practice" indicates an engagement in practice and the informal learning that arises from it. This matches the virtual village concept design.

COMMUNITY OF LEARNING

Wenger talks of communities of practice as groups of people who share a concern or a passion for something they do and learn how to do it better as they interact regularly. Making something into a game ensures there is more openness to experimenting and thinking innovatively, as participants design the answers after reflection within the game, rather than in the heat of the moment of a real-world situation. The idea of a community of learning that is randomized, that is, with no pathways to follow, just the need to explore and develop the story, can cause participants to feel lost. Many students react this way at the start of the scenario and in fact that can be a danger in having an open-ended scenario or role play. However, the virtual world environment is designed in such a way that the motivation to become involved is enhanced through a sense of game and fun or through humor. There are some signposts, but the actual navigation signs are combined with both external catalysts for initiating the exploration of

the virtual world and visual signs and designs within the world that lead the learners into imaginative immersion.

Conclusion

There are several key elements in designing a virtual village. Following on from Wenger, it should be a believable networked community of practice and learning. With a playful games quality, it can engage participants in the storytelling that parallels their actual lives within the community. There are real-world problems, although they are at one remove by the nature of the fictionalized process of the virtual community. Storylines may operate over a period of time, with catalysts to change and to challenge the status quo. This can lead to associational and nonlinear connections, and resource-rich potential narratives for exploration. There is no clear end point or solution, just a series of reflections that may lead to rethinking the problems or issues. It is an active and collaborative learning space and an iterative cyclic process.

This plastic shaping of an abstraction, the virtual village, into a spatial entity with relevance to creative problem-solving explores the value of virtual or digital storytelling. The research design is embedded in the actual community to extend the cultural life, to mirror the realities of constant change and strategies to resolve issues arising from challenges to that community's well-being.

Notes

1. Richard Florida, "The Memphis Manifesto" (*Creative 100*, 2003), <http://www.creativeclass.com/_v3/creative_class/2007/12/06/the-memphis-manifesto/ date> [accessed December 20, 2014].
2. Florida, *The Memphis Manifesto*.
3. Florida, *The Memphis Manifesto*.
4. Florida, *The Memphis Manifesto*.
5. Joseph Frank, "Spatial Form in Modern Literature," *Sewanee Review*, 53, April 1945: 221–40, 433–45, 643–65; see Joseph Frank, *The Idea of Spatial Form* (New Brunswick, NJ: Rutgers University Press, 1991).
6. Patrick Lichty, "Joseph Frank and the Collapse of Narrative Flow" (n.d.), <http://lichty.networkedbook.org/art-in-the-age-of-dataflow-joseph-frank-and-the-collapse-of-narrative-flow/> [accessed October 20, 2014].
7. Lichty, "Joseph Frank..."

8. City of El Paso Virtual Village Project, n.d., "El Paso's Virtual Village: Your Pathway to Success," <http://www.urbanlibraries.org/el-paso—s-virtual-village–your-pathway-to-success–innovation-92. php?page_id=46> [accessed October 20, 2014].

9. Mike Wilson, "Connected Communities: University of the Village" (Arts and Humanities Research Council, n.d.), <http://www.ahrc.ac. uk/Funding-Opportunities/Research-funding/Connected-Commun ities/Scoping-studies-and-reviews/Documents/University%20of%20 the%20Village.pdf> [accessed October 20, 2014].

10. Etienne Wenger, "Communities of Practice: A Brief Introduction" (2006), <http://wenger-trayner.com/wp-content/uploads/2012/ 01/06-Brief-introduction-to-communities-of-practice.pdf > [accessed October 20, 2014].

11. Cathy Gonzalez, "The Role of Blended Learning in the World of Technology" (2004), <http://www.unt.edu/benchmarks/archives/ 2004/september04/eis.htm> [accessed October 20, 2014].

12. See, for instance, Henry Jenkins' lecture on "Participatory Culture," <https://www. youtube.com/watch?v=AFCLKa0XRlw> [accessed December 18, 2014].Jerome Seymour, Bruner, *Toward a Theory of Instruction* (Cambridge, MA: Belkapp Press, 1966).

13. Bruner, *Toward a Theory.*

14. Jerome Seymour Bruner, *Actual Minds, Possible Worlds* (Cambridge, MA: Harvard University Press, 1986), Chapter 2, "Two Modes of Thought," pp. 11–43.

15. Bruner, "Two Modes of Thought," pp. 25–6.

16. John Crace, "Jerome Bruner: The Lesson of the Story," *The Guardian*, March 27, 2007, <http://www.theguardian.com/ education/2007/mar/27/academicexperts.highereducationprofile > [accessed October 28, 2013].

17. Bruner, "Two Modes of Thought," pp. 13–14.

18. Robert L. Root, "Collage, Montage, Mosaic, Vignette, Episode, Segment," in Michael Steinberg (ed) *The Fourth Genre: Contemporary Writers of/on Creative Nonfiction* (London, New York: Longman, 2005), p. 379.

19. Cynthia Ozick, "Introduction: Portrait of the Essay as a Warm Body," in *The Best American Essays 1998* (Boston, MA: Houghton Mifflin, 1998), p. *xv.*

20. John Dewey, *Democracy and Education: An Introduction to the Philosophy of Education* (New York: WLC Books, 2009; original work published 1916), pp. 217–18.

21. Howard S. Barrows, "Problem-Based Learning in Medicine and Beyond: A Brief Overview," *New Directions for Teaching and Learning*, 68, 1996: 3–12.

22. Kellah M. Edens offers a good example of this; see her "Preparing Problem Solvers for the 21st Century through Problem-Based Learning," *College Teaching* 48, 2, 2000: 55–60.

23. David Kolb, *Experiential Learning* (Paramus, NJ: Financial Times/Prentice Hall, 1983), p.41.
24. Melvin L. Silberman, *The Handbook of Experiential Learning* (Hoboken, NJ: Pfeiffer, 2007).
25. David H. Jonassen, "Instructional Design Models for Well-Structured and Ill-Structured Problem-Solving Learning Outcomes," *Educational Technology Research and Development*, 45, 1, 1997: 65–94.
26. Ronald Barnett, "Willing to Learn in Higher Education," Keynote Address, AISHE *Inaugural Conference*, Dublin, 2004.
27. Orison Carlile and Anne Jordan, "It Works in Practice But Will It Work in Theory? The Theoretical Underpinnings of Pedagogy," *Emerging Issues in the Practice of University Learning and Teaching* (Dublin: AISHE, 2005).
28. George Siemens, "Connectivism: A Learning Theory for the Digital Age" (2004), <www.elearnspace.org/Articles/connectivism.htm> [accessed October 20, 2014].
29. See James P. Gee, Chapter 3, "New Times and New Literacies," in Mary Kalatzis, Gella Varnava-Skoura and Bill Cope (eds) *Learning for the Future* (Common Ground Publishing: Melbourne, 2002), pp. 59–83.
30. Gee, "New Times and New Literacies," p.67.
31. Etienne Wenger, Richard Arnold McDermott and William Snyder, *Cultivating Communities of Practice* (Boston, MA: Harvard Business School Press, 2002).
32. Etienne Wenger, "Communities of Practice: A Brief Introduction" (2006), <http://wenger-trayner.com/wp-content/uploads/2012/01/06-Brief-introduction-to-communities-of-practice.pdf> [accessed October 20, 2014].
33. Etienne Wenger, "Communities of Practice and Social Learning Systems," *Organisation*, 7, May 2000: 225–46, <http://org.sagepub.com/cgi/content/refs/7/2/225> [accessed September 25, 2013].
34. Gee, "New Times and New Literacies," p.75.
35. Chris Dede, "Planning for Neomillenial Learning Styles: Shifts in Students' Learning Style Will Prompt a Shift to Active Construction of Knowledge through Mediated Immersion," *Educause Quarterly*, 28, 1, 2005: 7–12.
36. Wenger, "Communities of Practice: Brief Introduction."

Bibliography

Barnett, Ronald. "Willing to Learn in Higher Education," Keynote Address, AISHE *Inaugural Conference*, Dublin, 2004.
Barrows, Howard S. "Problem-Based Learning in Medicine and Beyond: A brief overview," *New Directions for Teaching and Learning*, 68, 1996: 3–12.

Bruner, Jerome Seymour. *Toward a theory of instruction* (Cambridge, MA: Belkapp Press, 1966).

——. *Actual Minds, Possible Worlds* (Cambridge, MA: Harvard University Press, 1986).

Carlile, Orison and Anne Jordan. "It Works in Practice but Will It Work in Theory? The Theoretical Underpinnings of Pedagogy," in Geraldine O'Neill, Sarah Moore, and Barry McMullin (eds) *Emerging Issues in the Practice of University Learning and Teaching* (Dublin: AISHE, 2005).

City of El Paso Virtual Village project. n.d., "El Paso's Virtual Village: your pathway to success," <http://www.urbanlibraries.org/el-paso—s-virtual-village–your-pathway-to-success–innovation-92.php?page_id=46> [accessed October 20, 2014].

Crace, John. "Jerome Bruner: The Lesson of the Story," *The Guardian*, March 27, 2007, <http://www.theguardian.com/education/2007/mar/27/academicexperts.highereducationprofile> [accessed October 28, 2013].

Dede, Charles. "Planning for Neomillenial Learning Styles: Shifts in Students' Learning Style Will Prompt a Shift to Active Construction of Knowledge through Mediated Immersion," *Educause Quarterly*, 28, 1, 2005: 7–12.

Dewey, John. *Democracy and Education: An Introduction to the Philosophy of Education* (New York: WLC Books, 2009), pp. 217–18. (Original work published in 1916).

Edens, Kellah M. "Preparing Problem Solvers for the 21st Century through Problem-Based Learning," *College Teaching*, 48, 2, 2000: 55–60.

Florida, Richard. "The Memphis Manifesto," *Creative 100*, 2003, <http://www.creativeclass.com/_v3/creative_class/2007/12/06/the-memphis-manifesto/ date> [accessed October 20, 2014].

Frank, Joseph. "Spatial Form in Modern Literature," *Sewanee Review*, 1945, <http://lichty.networkedbook.org/art-in-the-age-of-dataflow-joseph-frank-and-the-collapse-of-narrative-flow/> [accessed October 20, 2014].

——. *The Idea of Spatial Form* (New Brunswick, NJ: Rutgers University Press, 1991).

Gee, James P. "New Times and New Literacies," in Mary Kalatzis, Gella Varnava-Skoura and Bill Cope (eds) *Learning for the Future* (Melbourne: Common Ground Publishing, 2002), pp. 59–83.

Gonzalez, Cathy. "The Role of Blended Learning in the World of Technology" (2004), <http://www.unt.edu/benchmarks/archives/2004/september04/eis.htm> [accessed October 20, 2014].

Jenkins, Henry. *TEDxNYED*, Lecture on "Participatory Culture," <https://www. youtube.com/watch?v=AFCLKa0XRlw> [accessed December 18, 2014].

Jonassen, David H. "Instructional Design Models for Well-Structured and Ill-Structured Problem-Solving Learning Outcomes," *Educational Technology Research and Development*, 45, 1, 1997: 65–94.

Kolb, David. *Experiential Learning* (Paramus, NJ, USA: Financial Times/Prentice Hall, 1983).

Lichty, Patrick. "Joseph Frank and the Collapse of Narrative Flow" (n.d.), <http://lichty.networkedbook.org/art-in-the-age-of-dataflow-joseph-frank-and-the-collapse-of-narrative-flow/> [accessed October 20, 2014].

Ozick, Cynthia. "Portrait of the Essay as a Warm Body," Introduction to *The Best American Essays* (Boston, MA: Houghton Mifflin, 1998).

Root, Robert L. and Michael J. Steinberg. *The Fourth Genre: Contemporary Writers of/on Creative Nonfiction* (London, New York: Longman, 2005).

Sheridan, Mary P. and Jennifer Rowsell. *Design Literacies: Learning and Innovation in the Digital Age* (London and New York: Routledge, 2010).

Siemens, George. "Connectivism: A Learning Theory for the Digital Age" (2004), <www.elearnspace.org/Articles/connectivism.htm> [accessed October 20, 2014].

Silberman, Melvin L. *The Handbook of Experiential Learning* (San Francisco: Pfeiffer, 2007).

Wenger, Etienne. "Communities of Practice and Social Learning Systems," *Organisation*, 7, 2000: 225–46.

——, Richard Arnold McDermott and William Snyder. *Cultivating Communities of Practice* (Boston, MA: Harvard Business School Press, 2002).

——, "Communities of Practice: A Brief Introduction" (2006), <http://wenger-trayner.com/wp-content/uploads/2012/01/06-Brief-introduction-to-communities-of-practice.pdf> [accessed October 20, 2014].

Wilson, Mike. "Connected Communities: University of the Village" (Arts and Humanities Research Council, n.d.), <http://www.ahrc.ac.uk/Funding-Opportunities/Research-funding/Connected-Communities/Scoping-studies-and-reviews/Documents/University%20of%20the%20Village.pdf> [accessed October 20, 2014].

CHAPTER 8

BETWEEN A ROCK AND NO PLACE: URSULA MEIER'S *HOME* (2008)

Conn Holohan

INTRODUCTION

In her discussion of the "geography of cinema," Elisabeth Bronfen comments on the notion of "home" in the following terms:

> Home as a place does not exist [...] The concept *home* refers to an impossible place, a utopia—but also to an extimate place, [...] a symbolic fiction that makes one's actual place of habitation bearable.[1]

The fact is that there is no spatial figure more central to the operation of narrative cinema than that of the house or home. The home is *the* privileged space of narrative resolution, a space of restoration in which the stability of identity and the permanence of romantic and familial relations can be affirmed. Hollywood cinema, in particular, constructs the home as a space apart from the vagaries of everyday life and, through its visual and narrative strategies, insists that there is no place quite like it. Yet it is not merely in cinema that we find such an insistence on the centrality of home to human identity and social relations. As the literary critic Rosemary George has argued, all narrative can be conceived of as "the search for the location in which the self is 'at home,' " for the space where conflict between the individual and their environment ceases.[2] If, in our consideration of cultural expression, we must take cognizance of the human desire to *produce* space, as Bill Richardson suggests in the Introduction to this volume, then

the spatial figure of the home is necessarily central to this endeavor. The home is, in Richardson's terms, a "moral space," which articulates both an intensely personal relationship to an actual physical location and a shared set of meanings around terms such as "inclusion," "containment," and "community." As J. Macgregor Wise argues, "cultures are ways of territorializing, the ways one makes oneself at home"[3]; it is through a shared understanding of belonging that a space becomes one in which we may collectively belong.

In his phenomenological study of the architecture of the house, Gaston Bachelard insists on the home as a fundamental category of human experience. It is, he asserts, "the non-I that protects the I" and the intermediary between subject and object, between self and external reality, which makes that relationship bearable.[4] However, despite being seemingly fundamental to both human culture and our lived experience of space, Elisabeth Bronfen's assertion, quoted above, is a statement to the effect that home remains a fictive rather than an actually existing place. Using her term, we can say that home is a "symbolic fiction" that functions to mediate our relationship to the external world. Home is an image of belonging, a utopian fantasy that confers order and stability upon the transient spaces of everyday life that we actually inhabit. Without it, as Bachelard asserts, "man would be a dispersed being."[5]

If home is a symbolic fiction, the question that arises is one about the terms in which this fiction is articulated. In cinema, as in everyday life, the home is imagined to have distinct spatiotemporal qualities that distinguish it from its spatial surrounds. By paying close attention to the qualities that cinema confers upon the home, we may learn something of what is at stake in our desire for spatial belonging. For, if home is a fundamental category of experience, it is also one that is frequently experienced as under threat. It is the necessity of protecting the home from some external force that animates many cinematic narratives, and even the ubiquitous happy ending of Hollywood cinema cannot entirely dispel the fear of spatial dissolution that such threats reveal. As Bronfen suggests, "Hollywood happy endings are often fragile, infected by a disturbing reminder of what cannot be."[6] Thus, our emotional investment in the category of home presupposes and reveals an underlying anxiety that this seeks to assuage. This is articulated in psychoanalytical terms by Bronfen, who reminds us that, for Freud, the *heimlich* necessarily and already contains the *unheimlich* within it.[7] In this chapter, the tension between our emotional commitment to the home-space and the necessary repressions that such commitment entails will be explored by detailed analysis

of the 2008 French film *Home*, directed by Ursula Meier. As suggested by its title, this film brings to an explicit level the narrative and visual investment in the home-space that remains implicit within most narrative cinema. By reading the film through the spatial theories of Marc Augé and Doreen Massey, as well as through the generic prism of melodrama, this chapter seeks to situate the home within the spatiotemporal categories that collectively constitute our globalized postmodern culture.

URSULA MEIER'S *HOME*

Home[8] tells the story of a young French family who live in a house right on the edge of an abandoned motorway. The house is surrounded by fields on all sides and can only be accessed by a kind of dirt-road through the countryside. The exact circumstances of how the family ended up here are never explained, but the film hints at a past trauma in the mother's life that this house has provided refuge from. The film opens in the midst of a cheerfully exuberant game of street hockey that is taking place at night between the members of the family. The playful competitiveness between parents and siblings, which is captured in these opening exchanges, serves to emphasize the warmth of the bonds between them. Determined attempts to score are interspersed with the father's teasing of his three children and wife. Filmed in medium-shot and close-up, the scene's constantly moving camera and swift edits capture the game's vibrant energy while at the same time preventing the viewer from clearly orientating herself in the story world. In the background is absolute darkness, while it is only the occasional glimpses of road markings that give any sense of the game's location. Denied any establishing shot that might contextualize the action, we are thrust into an uncertain outdoor space, but one in which the protagonists appear clearly comfortable. Their comfort seems confirmed when, moments later, the film's title, *HOME*, is superimposed in large letters across the scene. Through this act of labeling, we are apparently presented with the eponymous space in which the film's story will unfold.

There is, however, an irony in these opening moments that only becomes clear in subsequent scenes. This scene of familial ease and belonging has in fact been taking place on the uncompleted motorway beside which the protagonists live. This space, labeled as "home," is in fact the kind of anonymous public space of transit, which seems the very opposite of any understanding of home. Motorways, by their very nature, are intended to lift us out of a localized sense of place

and put us into motion. Unlike the local road on which we can stop or turn off at will, the motorway demands mobility and only permits us to exit back into the local at predetermined intervals. Motorways are, in anthropologist Marc Augé's term, "non-places," "spaces of supermodernity" in which any sense of the local or of history is sacrificed for a homogeneity of purpose, which is ultimately determined by the social and economic structures of global capitalism.[9] These are spaces from which historical time has been evacuated, in which time only persists as a measure of distance or speed. However, here, the motorway's incomplete status means it has not yet been incorporated into the global flow of people, goods, and capital, for which it is designed. It is in a liminal state, functioning as a kind of residue or ruin on which time has therefore been inscribed. Its nonfunctioning status allows it to be reclaimed by the family as a space of play, thereby incorporating it into a rather different spatiotemporal order from that outlined by Augé, that of the home and domestic family life.

The precise qualities of this domestic spatiotemporal order are given clear articulation in the scene that follows the opening credit sequence. As the hockey match fades out, the film cuts to the face of the youngest child, Julien (Kacey Mottet Klein), in the bathroom, his mother, Marthe (Isabelle Huppert), visible behind him. We hear the sound of him urinating before watching him climb naked into the bath where his oldest sister, Judith (Adélaïde Leroux), is already sitting with a cigarette in mouth. The camera moves gently between the characters as the father, Michel (Olivier Gourmet), wanders into the bathroom looking for his cigarettes and Judith stands up to hand them to him, completely untroubled by her own nudity. He ambles out again as Julien and his sister commence splashing water over each other while Marthe gently requests some calm. Michel soon returns through the open door of the bathroom as Judith exits, casually drying herself. Smiling good-naturedly, he challenges his son to a competition to see who can keep their head under the water the longest. His wife tries to maintain a semblance of order to the bathroom routine before succumbing to Michel's playacting. The scene ends with a medium close-up of Michel and Marthe embracing on the floor while Julien jumps up and down excitedly beside them—a seemingly perfect image of domestic bliss.

If, *qua* Bronfen, home is a "symbolic fiction," then this scene clearly indicates the terms in which this fiction is expressed, offering, as it does, such an attractive image of home life. It is the spatial and temporal characteristics with which a space is imaginatively endowed that determine its status as a home. The characteristics evident in this

scene are, first, a sense of temporal ease that prioritizes leisure over utility. We witness the bathroom become a space of playful interaction rather than remaining merely functional, despite Marthe's attempts to regulate the activity of those within it and ensure that her son readies himself properly for bed. The father wanders in and out of the bathroom without any clear purpose while both brother and sister are easily diverted by contest and play. If we have described the motorway as an example of public space defined by utility, then here the home functions as an escape from the regulation of time, which such an emphasis on usefulness requires. Home is the space where our time is our own. The second, crucial, characteristic of the home-space as depicted in this scene is its lack of internal boundaries. This is given most obvious expression in the comfortable nudity of the brother and sister and the manner in which the characters wander in and out of the bathroom, a space that is usually considered the most private in the house. The absolute boundary that the home establishes between inside and out here seems to dissolve all internal boundaries and to constitute the interior space of the home as open and fluid.

Thus, in these opening two scenes we are introduced to the two spaces that the film will set in opposition: the intimate, relational space of the family home, and the public, transactional space of transit, that is, the motorway. This public/private spatial dichotomy is clearly a foundational opposition in Western society and culture and is implicated in everything from the regulation of sexuality to the very understanding of a public sphere upon which our political systems are based. In cinema, the opposition between the public spaces of capitalist exchange and the private sphere of the emotional life has been addressed most consistently within the genre of melodrama. Although a contested term within film studies, I use "melodrama" here to refer in particular to the cycle of films aimed primarily at women that were produced in Hollywood between the 1930s and 1950s, so that I might connect those films back to an earlier literary and stage tradition. By considering *Home* in relation to the generic structure of these films, I will argue, we can more clearly delineate the spatial tensions that animate its narrative.

The desire to imagine the home as a space apart from the flows of capitalist exchange has been traced in literary and stage melodrama by critics such as Peter Brooks, for whom melodrama constructed a domestic space in which an eternal moral order could be reasserted against the accelerated temporality of industrial capitalism.[10] Martha Vicinus relates the social and economic changes that shaped literary melodrama as a genre in the nineteenth century to a specific focus on

the home, arguing that through the operations of melodrama, family and the domestic space become the sole image of stability within an era of flux. She asserts that "Faced with cataclysmic religious, economic, and social changes, most Victorians could feel powerless on occasion, believing that all traditional values were in danger of being turned upside down. The family became the refuge from change and the sustainer of familiar values."[11]

Thus, the centrality of the home in melodramatic narratives stems from its particular temporal and spatial character, offering as it does an image of stability and endurance against the fragmentation and flux of the world beyond its doors.

This imaginative investment in the home can be clearly seen in the Hollywood melodramas of the 1930s, many of which gave expression to the elevated status of the home-space by including it in their title. Films such as *East Lynne* (Frank Lloyd, 1931) and *The House on 56th Street* (Robert Florey, 1933) explicitly construct the home-space as an object of narrative desire, one which their female protagonists are denied due to their inability to conform to appropriate models of feminine behavior. Indeed the infiltration of an inappropriate femininity is the biggest threat to the home in many melodramas, a threat that leads to the recurring images of maternal sacrifice in films such as *Stella Dallas* (King Vidor, 1937), *The Secret of Madam Blanche* (Charles Brabin, 1933), and *The Old Maid* (Edmund Goulding, 1939). In each of these films, the heroine deliberately excludes herself from the domestic life of her child so that he or she may be raised within a space that is untainted by the mother's sexual past or class background. The opposition between stability and flux that the home-space gives expression to is often quite literally narrativized in these films as, once excluded from the home, the protagonist becomes a wanderer, living a life of impermanence, unable to replace her one true attachment to the home from which she has been exiled. Desire in these films is always a desire to return, a desire for recurrence rather than change, a feature that, as we shall see, is central to the spatiotemporal qualities of the domestic space in *Home*.

The threat to the family living space in *Home* is specifically depicted in the terms suggested above; the conflict between stasis and mobility, stability and change. Early in the film it becomes clear that the motorway, which had remained idle and unfinished for years, is due to be completed and become operational. As the opening hockey sequence indicated, the border between the interior space of the family home and the exterior space of the empty motorway is initially a porous one. Fittingly, the first indication of the motorway's

impending arrival into their lives occurs while the family are sitting together watching television on the grass verge between their house and the road. The fragility of this makeshift living room becomes suddenly apparent when the young son casually mentions that he saw a car with construction workers on the motorway that day. The other family members are at first disbelieving of him, but in the next scene we see workers in high-visibility jackets methodically clearing the family's possessions from the patch of motorway in front of the house. The following evening, when the father drives his usual route home through the fields, he is shocked to be confronted by a steel barrier preventing his passage across the motorway. For the first time a fixed boundary is asserted between the home and the road, distinguishing absolutely between the apparently incompatible spaces of each. Henceforth, the family will be forced to navigate a treacherous crossing of the motorway each day simply to access the route to work or school. As the amount of traffic on the motorway rises, they are increasingly forced inward in order to avoid the noise and fumes that penetrate their house. As the film progresses, the easygoing openness that had characterized their relationship to the home-space comes into an increasingly conflictual encounter with the relentless purposefulness of the road that borders it.

Nevertheless, the family members are at first somewhat sanguine in their response to these changes and attempt to sustain a sense of connectivity between their domestic space and the now undeniably public space of the road. On the eve of its opening, the father and son sit wrapped in a blanket on the side of the road, betting which direction the first car on the road will come from, thereby overlaying this moment of disruption with a comforting sense of family ritual. There is a certain naive enthusiasm to these initial efforts to continue the daily routines that constitute their family life. The playful use of the motorway as a hockey pitch with which the film began is indicative of the manner in which the family members attempt to imaginatively incorporate the newly active highway into the space of their home. For example, when the two youngest children, Julien and Marion, return home from school on the day of the motorway's opening, they are unable to cross the road to the house until the traffic has calmed down for the evening. In the meantime, their mother throws food across the road to them in a scene which aptly captures the novelty of the motorway's intrusion into their lives at this early stage. The scene is presented through a series of shot/reverse-shots from either side of the road that portray the conversation between mother and children. We first see Marthe shouting from behind the guardrail of

the motorway, before cutting to the children similarly framed on the opposite side as they reply. All the while, the stream of cars that flash through the foreground repeatedly disrupt the shots. The framing and editing therefore include the public space of the motorway, replete with passing cars, within the private space of a family conversation, thereby collapsing the distinction between the two. It attempts, as it were, to "placeify" this seeming non-place. Furthermore, the scene is shot through with a sense of fun as the mother acrobatically winds up her arm in her attempt to fling the bag full of food across the road. Her apparent success is met with cheers by her children before a passing car punctures the bag, which had not quite reached the other side. The playful tone of the scene indicates that the opening of the motorway is not initially experienced as a moment of traumatic rupture by the family but as a surmountable obstacle around which the ritual of family life can continue.

It is this insistence on ritual that enables the family to maintain continuity in the face of a potentially devastating change in their living arrangements. The film emphasizes the centrality of ritual to family life, particularly in the aftermath of the motorway's opening. Prior to this moment, the film had already taken care to establish Judith's daily routine of sunbathing in the garden as well as the daily comings and goings to and from work and school and the domestic tasks that fill Marthe's day. Through these rituals, these recurrent daily acts, the family members carve out and demarcate individual and collective spaces that they can inhabit. The repetition of acts attaches meaning to the spaces in which these acts occur and therefore bestows a permanence upon the particular spatial arrangements that constitute the home. However, despite our psychological investment in this sense of permanence, the tenuousness of any fixed spatial arrangement lurks at the edge of our consciousness. It is this always-existing threat to the stability of the home-space that is played upon by the horror genre, in which this space of refuge is frequently where we encounter the very dangers that such a space is assumed to exclude. The first moment of rupture of the home's imagined stability in *Home* occurs on the morning of the motorway's opening. Although the scene presents us with the most comforting of domestic rituals, the family breakfast, its reassuring tone is undercut by the visibility of the motorway through the kitchen window, reminding us of the change that is about to disrupt the integrity of this space. When, midpoint through the scene, a blue car flashes past the window, we experience a visceral sense of intrusion, as this public mobility visually infringes on the ritual repetitions of the domestic space. This passing car is the first flickering intimation of

the breakdown in all spatial certainties that the family will increasingly experience. The next day, when they make a pointed effort to eat lunch together on the lawn despite the necessity of wearing ear plugs, this act of defiance only serves to emphasize the effort required to maintain the ritualized time of the family home and thereby constitute it as a distinct space.

The emphasis on ritual as a means of ensuring the home's persistence through time again connects *Home* back to the particular spatial and temporal concerns of melodrama. As suggested above, melodrama is primarily concerned with the desire to preserve an existing space or return to one that has been lost rather than the drive to conquer or transform space anew. This set of spatial concerns has consequences for the temporal structure of the films that constitute the genre. As Tania Modleski argues, "Unlike most Hollywood narratives, which give the impression of a progressive movement towards an end that is significantly different from the beginning, much melodrama gives the impression of a ceaseless returning to a prior state."[12]

Reminiscence and repetition often form the emotional core of these films, conferring upon the films themselves the restorative qualities of ritual. In her analysis of *Letter from an Unknown Woman* (Max Ophuls, 1948), Modleski draws on Julia Kristeva's discussion of "women's time" to oppose the "temporal modalities" of repetition and ritual to those of progress and history within the film's narrative unfolding. If the temporal categories that Modleski draws upon are gendered, both as originally conceptualized by Kristeva and in the analytical uses to which they are put, they also imply distinctive relationships to space, which become quite explicit when considered in relation to Meier's more recent film.

The opposing temporal categories of repetition and change, ritual and history are explicitly put into conflict within *Home* in the increasingly antagonistic relationship between the domestic space of family life and the motorway that intrudes upon it. If ritual and recurrence is the defining temporal characteristic of any home-space, then it is difficult to think of a space that more clearly challenges that type of relationship to time than the motorway. Kristeva herself describes the linear and historical in terms of "time as departure, progression and arrival,"[13] a seemingly apposite summary of the kind of transactional relationship to time and space that the motorway creates for its users. As is true of cinematic melodrama more generally, *Home*'s narrative puts the space of repetition and restoration into crisis through its encounter with an external world characterized by ceaseless flux. However, the starkly visual nature of this opposition

within the film functions to make this conflict all the more explicit and reveals just what is at stake in the desire to demarcate a space that may be called "home." The absolute distinction in our cultural imaginary between these different spatial categories draws upon what Doreen Massey refers to as the "dubious" duality "so popular and persistent—between space and place."[14] As Massey points out, these terms are persistently counterposed within a set of oppositions that include global/local, abstract/felt, and objective/subjective.[15] Michel de Certeau emphasizes this subjective, felt quality in his description of places as "fragmentary and inward turning histories, pasts that others are not allowed to read, accumulated times that can be unfolded"[16] It is the overlaying of personal history through memory and ritual that, for de Certeau, transforms space into place.[17] However, the precarious nature of such accumulations is revealed within *Home* in the increasingly desperate attempts of the family to sustain the inward turning, exclusionary quality of their carefully constructed sense of place. Their exposure to the passing traffic on the motorway opens their pasts up to being "read"; it disturbs their ritual experience of place with the potential dislocations of space. As a passing truck honks its horn at Judith's bikini-clad body or as Marthe retreats from the clothesline self-consciously clutching the underwear that had been hanging there, they become all too aware of the porousness of place, of the always-existing danger that it will disperse back into what is merely space.

This absolute opposition between inward-turning place and abstract, generalized space is central to the "symbolic fiction" that is home. However, as Massey suggests in her use of the adjective "dubious," this opposition is itself a fictional one. As she argues, to insist on the actuality of place implies an understanding of space "as somehow originarily regionalized, as always-already divided up."[18] It sets up an opposition "between place (as meaningful, lived and everyday) and space (as what? the outside? the abstract? the meaning*less*)?"[19] Crucially, our imaginative investment in essentialized divisions of place (such as home or nation) prevents a recognition of "space as the product of interrelations; as constituted through interactions, from the immensity of the global to the intimately tiny."[20] Thus, all space is necessarily outward facing, provisional, and produced within the network of spatial relations that constitute contemporary global capitalism. Such an assertion refutes any absolute distinction between place as "relational, historical and concerned with identity"[21] and the "non-places" of supermodernity that fail to attain place's felt qualities. While the home is imagined as a space apart from the everyday interactions

of capitalist life, possessing its own temporal rhythms and innate order, it is nevertheless a constituent element of capitalist work-practices and exchange. This is illustrated historically by the correlation between changes in industrial practices and the organization of family life and domestic space.[22] In other words, rather than standing apart from the social and economic flux, as was imagined by Victorian melodrama, the home is implicated in and is a fundamental component of the spatial structures of our social and economic systems.

To acknowledge the provisional, relational nature of space is to undermine the enduring quality of the home as a center of felt value. While Massey correctly argues that such an understanding of space as open is necessary to establish a progressive spatial politics, it also provokes anxiety as the certainties of spatial belonging begin to slip away. *Home* begins with the non-place of the motorway remade as home, but increasingly in the film it is the home that becomes a non-place. Even the radio, a medium so central to our imaginative constructions of family life, contributes to this encroachment of the non-place. The only station that the family seem able to pick up is "Radio Motorway," which, in its ceaseless attempts to construct an emotional relationship to the utilitarian space of the motorway, can only remind us of the dangers of appealing to the "authentic" in any segmentation of space into place. In order to sustain the illusion of the home as a place apart, the members of the family are forced to retreat inward: sharing a single bedroom, escaping the ubiquitous exhaust fumes with protective clothing, and, eventually pursuing this inward escape to its logical conclusion, bricking up all the doors and windows to the house. It is as if the only way to sustain the spatiotemporal qualities of the home is to completely evacuate those competing forms of time and space given expression by the motorway. By bricking up the windows and sealing off the house, they ensure the triumph of ritual over history; it is an emphatic gesture against change. However, in the process, this space becomes a travesty of a home: it loses the very qualities of belonging that the family seeks to protect. It becomes defined by excess—an excess of closeness, an excess of time—an excess of those very traits that, as we saw in the film's opening scenes, ordinarily establish the home as desirable and apart. It is an excess that drives the eldest daughter to abandon the family home for the freedom of the exterior. In these final scenes, the *heimlich* is overwhelmed by its uncanny other and we understand that to reject history for repetition is ultimately to be on the side of death.

However, the film does not leave us with such a bleak conclusion and, at the last minute, Marthe refuses death in an act of willed

defiance. Rousing herself from the torpor that has afflicted all the family within their airless cocoon, she takes a hammer to the bricked-up doorway, gasping at the air that floods in. The camera cuts to an exterior shot and we watch them emerge, one-by-one, blinking into the sunlight. As "Wild Is the Wind" rises on the soundtrack, they wander dazedly through the fields that border the motorway, the camera tracking alongside them. Suddenly we cut away and are watching the fields race past as if from the perspective of a passing vehicle. Unexpectedly, the family reappear once again in our frame of vision and the camera turns to gaze briefly back at them while we continue speeding past. Then they are gone; the camera tracks onward, past their abandoned home, as the credits appear over an expanse of field and sky. The director Ursula Meier describes these final moments as follows:

> There is only movement in the last shot, seen from the road perspective. We therefore go back to the starting point of *Home*: from a car, I had seen houses on the edge of the motorway and I told myself it would be interesting to reverse that gaze. Actually, *Home* is a road movie in reverse.[23]

Thus, in this final shot we leave the family behind; we no longer share their own particular spatial fiction; they become fleeting objects in the vision of a passing motorist. Yet, their image remains, like a third term between the protective fiction of the homely place and the knowledge of its function within a global capitalist space. As Meier states, in this image "there is only movement," and yet this is not only the utilitarian movement of the motorway, the non-place that has ever lurked outside the door. These final images reject the binary opposition that has set intimate, relational place against public, transactional space. While we speed by, carried onward by the relentless logic of the motorway, the family flit past our vision, like a stain on the road's pristine, functional space. Ambling indifferently by the camera, their perverse movements remind us that other trajectories are possible.

NOTES

1. Elisabeth Bronfen, *Home in Hollywood: The Imaginary Geography of Cinema* (New York: Columbia University Press, 2004), p. 73.
2. Rosemary Marangoly George, *The Politics of Home: Postcolonial Relocations and Twentieth Century Fiction* (Berkeley and Los Angeles: University of California Press, 1999), p. 3.
3. J. MacGregor Wise, "Home, Territory and Identity," *Cultural Studies*, 14, 2, 2000: 300.

4. Gaston Bachelard, *The Poetics of Space* (Boston, MA: Beacon Press, 1994), p. 5.
5. Bachelard, *The Poetics of Space*, p. 7.
6. Bronfen, *Home in Hollywood*, pp. 25–6.
7. Bronfen, *Home in Hollywood*, p. 23.
8. *Home*, directed by Ursula Meier (Switzerland: Soda Pictures, 2008).
9. Marc Augé, *Non-Places: An Introduction to Supermodernity*, translated by John Howe (London: Verso, 2008).
10. Peter Brooks, *The Melodramatic Imagination: Balzac, Henry James, Melodrama, and the Mode of Excess* (New Haven and London: Yale University Press, 1995).
11. Martha Vicinus, "Helpless and Unfriended: Nineteenth-Century Domestic Melodrama," *New Literary History*, 13, 1, 1981: 127–43, 131.
12. Tania Modleski, "Time and Desire in the Woman's Film," in Christine Gledhill (ed) *Home Is Where the Heart Is: Studies in Melodrama and the Woman's Film* (London: BFI, 1987), p. 330.
13. Julia Kristeva, "Women's Time," *Signs: Journal of Women in Culture and Society*, 7, 1, 1981: 17.
14. Doreen Massey, *For Space* (London: Sage, 2005), p. 68.
15. Massey, *For Space*, p. 183.
16. Michel De Certeau, *The Practice of Everyday Life*, translated by Steven Rendall (Berkeley: University of California Press, 1988), p. 108.
17. See further discussion of de Certeau's ideas in Catherine Emerson, this volume, Chapter 9.
18. Massey, *For Space*, p. 6.
19. Massey, *For Space*, p. 6. Original emphasis.
20. Massey, *For Space*, p. 9.
21. Augé, *Non-Places*, p. 63
22. See, for example, Tamara K. Hareven, *Family Time and Industrial Time: The Relationship between the Family and Work in a New England Industrial Community* (Cambridge, MA: Cambridge University Press, 1982).
23. Mathieu Loewer, "Interview Ursula Meier: A Road Movie in Reverse," *Cineuropa*, 2008, <http://cineuropa.org/ff.aspx?t=ffocusinterview&lang=en&documentID=87119&treeID=1635> [accessed June 20, 2012].

BIBLIOGRAPHY

Augé, Marc. *Non-Places: An Introduction to Supermodernity*, translated by John Howe (London: Verso, 2008).
Bachelard, Gaston. *The Poetics of Space* (Boston, MA: Beacon Press, 1994).
Bronfen, Elisabeth. *Home in Hollywood: The Imaginary Geography of Cinema* (New York: Columbia University Press, 2004).

Brooks, Peter. *The Melodramatic Imagination: Balzac, Henry James, Melodrama, and the Mode of Excess* (New Haven and London: Yale University Press, 1995).

De Certeau, Michel. *The Practice of Everyday Life*, translated by Steven Rendall (Berkeley: University of California Press, 1988).

George, Rosemary Marangoly. *The Politics of Home: Postcolonial Relocations and Twentieth Century Fiction* (Berkeley: University of California Press, 1999).

Hareven, Tamara. *Family Time and Industrial Time: The Relationship between the Family and Work in a New England Industrial Community* (Cambridge, MA: Cambridge University Press, 1982).

Kristeva, Julia. "Women's Time," *Signs: Journal of Women in Culture and Society*, 7, 1, 1981: 13–35.

Loewer, Mathieu. "Interview Ursula Meier: A Road Movie in Reverse," *Cineuropa*, 2008, <http://cineuropa.org/ff.aspx?t=ffocusinterview& lang=en&documentID=87119&treeID=1635> [accessed June 20, 2012].

Massey, Doreen. *For Space* (London: Sage, 2005).

Modleski, Tania. "Time and Desire in the Woman's Film," in Christine Gledhill (ed) *Home Is Where the Heart Is: Studies in Melodrama and the Woman's Film* (London: BFI, 1987), pp. 326–38.

Vicinus, Martha. "Helpless and Unfriended: Nineteenth-Century Domestic Melodrama," *New Literary History*, 13, 1, 1981: 127–43.

Wise, J. Macgregor. "Home, Territory and Identity," *Cultural Studies*, 14, 2, 2000: 295–310.

CHAPTER 9

OP WEG NAAR BROXEELE: THE PRODUCTION OF SHARED SPACES

Catherine Emerson

The collective spaces examined in this chapter are situated on the frontier between the concrete and the abstract zones: they are real places that take on imagined significance or, conversely, things that are not real space that we talk about using spatial metaphors and approach with a territorial mentality. These are the spaces that people create in communities, and it is worth lingering for a second on the creative metaphor. Spaces can be created, *produced*; this language does not disturb us because we are used to using the word "space" with both a concrete and an abstract meaning. Michel de Certeau contrasts geometric, geographical space with a poetic, anthropological experience of space, but he uses the same word, *espace*, to talk about both, arguing that the first is like the immutable text and the second is like the ephemeral reading.[1] Concrete spaces are there to be discovered, but the way in which we discover them creates abstract spaces that we invest with meaning. In this chapter we shall examine some very concrete spaces: a street corner in Brussels, a commune in northern France, and the inside of a moving coach that carries a group of people from one to the other. Reflecting on the way in which these are linked to form a territory of the imagination, which in media environments is treated as if it were a physical territory, we shall see the way in which these environments themselves, whether on the page or online, seem to take on spatial characteristics.

The starting point for our examination is the activities of a Brussels folklore society, the Order of Friends of Manneken Pis. Taking their name from that of the urinating statue topping a drinking fountain that stands on a street corner in the city center (see figure 9.1), the Order is firmly identified with a particular spot in the physical world. Operating almost as a representative of the municipal council, the Order of Friends coordinates the multiple ceremonies that take place at the foot of the statue of Manneken Pis, many revolving around

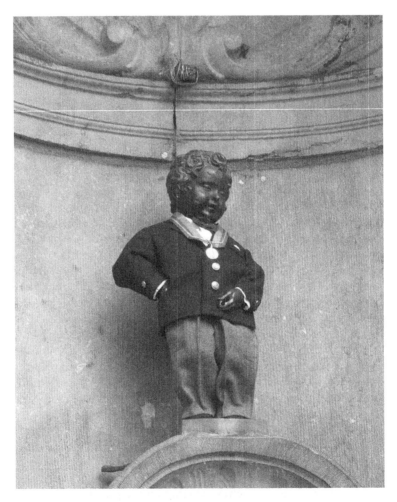

Figure 9.1 The *Manneken Pis* statue located at the corner of rue du Chêne and rue de l'Étuve in Brussels (photo © C. Emerson)

the donation of clothing to the urinating statue.[2] It is the Order that welcomes donating organizations to the corner on which the statue stands, and its president acts as master of ceremonies.

So in the festive life of the city, the Friends of Manneken Pis have a very specific physical territory that is considered theirs. Beyond this, as a not-for-profit organization with legal standing under Belgian law, the Order is obliged to nominate a concrete place that will serve as its headquarters. In December 2004, when the current statutes were drawn up, the headquarters of the organization was fixed at the address of a bar-restaurant called *La Légende* half a block down the street from the fountain, with the proviso that this could be transferred anywhere else in Belgium by a vote of the AGM.[3] At the same time, the purpose of the organization was defined as follows:

> To promote the cultural, tourist, philanthropic and commercial development of Brussels in general and more particularly to maintain the traditions surrounding the character of Manneken-Pis.[4]

This was a reversal of the priorities of the organization when it was originally constituted in April 1958; research and dissemination of information about the statue were the primary purpose of the then Friends of Manneken Pis, while the wider culture of Brussels and the Brabant region were secondary objects of study.[5] In that earlier constitution, the headquarters of the organization could also be moved away from its original legal address in the Brussels World Fair, but not outside the greater Brussels area. With the passage of time, the physical restrictions on the association seem to have relaxed somewhat, along with a broadening focus on the culture of the region as distinct from just the statue. Nevertheless, the spatial focus—the statue, the street corner, the city, and the region—has remained integral to the way that the association has defined itself over more than half a century.

The redefinition of the Friends of Manneken Pis as an Order places the organization in a particular sociohistorical context, one that looks to the guilds of the late Middle Ages for its legitimacy. Like many Belgian associations organized around the general principle of "folklore," the Order of Friends has adopted some of the external trappings associated with Low Countries craft and devotional guilds. For some associations, these trappings include the use of Latin in their ceremonies or the wearing of specific robes or headgear. For the Friends of Manneken Pis, their membership of an order is signaled by the wearing of a collaret in the red and green heraldic colors of the city of Brussels from which hangs a medallion depicting the statue. In this

way, the members of the Order signal that they belong to a partic-
ular sort of association, conceived as a brotherhood with a common
purpose. By calling themselves an Order, the Friends of Manneken
Pis bring into play historical associations with orders of chivalry and
religious orders, both of which, like the devotional guilds of the late
Middle Ages, had a spiritual dimension as well as a professional one.
Through their name and their dress, the Friends of Manneken Pis sig-
nal their adoption of a devotional relationship with the fountain that
stands as their patron. Their dress also signals their identification with
a place, Brussels, whose heraldic colors they wear. While the Friends
remain in the city, this seems to denote a relationship of pride in their
environment and provides representative local color when they greet
visitors from outside, but this relationship changes when the Friends
travel.

And travel they do, as is demonstrated by sequences of short videos
that they upload to the video-sharing website YouTube. The title of
the current chapter is that of one of these videos, the first of a sequence
of nine, uploaded in June 2011. The sequence documents the journey
made by the Order to a small village in Northern France, Broxeele,
where they attend a ceremony inaugurating a replica urinating statue,
dancing to the strains of a brass band, before returning to their coach
and travelling back to the Belgian capital.[6] In this, and in other similar
sequences of videos, the uploader, styled *mannekenpismascotte*, is anx-
ious to demonstrate not only that the Order of Friends of Manneken
Pis is involved in activities outside of Brussels but that they travel phys-
ically to do so. The third video in the Broxeele sequence is typical of
the sort of clip that does this. Like the two videos that precede it, and
the final video in the sequence, it is shot from a moving coach, demon-
strating to the viewer that the group are moving collectively from their
habitual location to a foreign space.[7] The emphasis is on the foreign
landscape moving past the coach window, signaled by the visual cue
of the bilingual emergency exit sign on the glass. The fact that it is in
French and Dutch indicates that the bus is Belgian, just as the tricolor
sash worn by the mayor in the next video in the sequence demon-
strates that the group are now in France.[8] For much of this clip the
travelers themselves do not appear; only their voices are heard, and we
occasionally see the backs of their heads. What we hear again under-
lines the foreignness of the territory being explored, as occupants of
the bus comment on the statue of the Virgin that they see outside,
with one woman remarking that she knows she is abroad now. The
comments made by the occupants of the bus demonstrate that the
members of the group are approaching their travel from the point of

view of the paradigms that we commonly associate with tourism. As they travel through the French countryside, they are selecting objects for their gaze that are, for them, emblematic of the idea "French countryside." The statue of the Virgin is one, and so too is a cow, which we as viewers do not see, but which one of the voices off tells us is there.[9] Toward the end of the video, a female voice identifies the church and tells us that it is "her" church, by which she means the church that she is using as a landmark to locate the party's final destination.[10] She has appropriated the local landmark and invested it with her own meaning.

These are the practices of tourism, but the purpose of the group's travel is not straightforwardly touristic, in that the end objective of the trip is not the simple fact of having travelled. An alternative model of mobility that might suggest itself is that of pilgrimage, reminiscent of the devotional guilds of the later Middle Ages on which the Order of Friends seems to be modeled. Like the journey of the Friends of Manneken Pis, the pilgrimage is teleological: it has an endpoint, which justifies the journey, and an encounter with the Other, which gives the trip meaning. The Order of Friends of Manneken Pis has adopted the trappings of the medieval guilds in the service of an apparently secular patron.[11] It therefore follows that their travel could be regarded as a secular reinterpretation of the religious practice of pilgrimage for the twenty-first century, in the manner that Justine Digance defines the latter as "undertaking a journey that is redolent with meaning."[12] It is noteworthy that in presenting this definition, Digance places as much emphasis on the journey as on the destination. Although the journey has a goal, there is a sense in which the journey itself is the goal, as the pilgrim perceives travel toward the goal in terms of a quest. This travel then becomes ritualized; as Digance comments, "the pilgrim's route is preordained through the annals of time so that to deviate in any way would be to undermine the authenticity of the experience."[13] The journey is as much a part of the pilgrim experience as the destination and this was as true of medieval pilgrimages is it is today. The wife in the eighth episode of the late fourteenth- or early fifteenth-century *Quinze joies de mariage* torments her husband to allow her to go on a pilgrimage because of the opportunities for flirting on the way and for talking about her experiences when she gets back.[14] Although she is implicitly criticized for her lack of respect for the religious solemnity of her journey, the work is a piece of social satire, so it seems clear that the anonymous author intended the attitude portrayed to be recognizable among his contemporaries. Medieval pilgrims profited from the social aspect of their peregrinations but they also invested them with ritual

significance, as the number of documented pilgrim routes in Europe attests.

The Order of Friends of Manneken Pis demonstrates a parallel attitude when its members display videos of their journeys online. Anxious to both show the activities at the endpoint of the journey and document the journey itself, they are re-creating the paradigms of travel of the medieval devotional guilds. They are also making manifest their understanding of the physical geographical space to which they are related and in which they move, and of the abstract meanings that they attach to it. In these videos the Order of Friends of Manneken Pis are not merely travelling to a destination but also displaying publicly that they have made the trip. Individual members are marked with visible signs of their origin, wearing ribbons in the red and green civic colors of Brussels, which reveal their foreign origin when they are away. The fact of making the journey unifies them as a group: when they meet in Brussels they travel separately, participate in Manneken-Pis-related activity, and then return home. When they gather to go somewhere else, the group nature of their activity extends not only to the actual event, the focus of their folklore mission, but also to the journey to and from the place where this occurs. Geographical displacement also has the effect of changing the representative nature of the group. In Brussels, the Friends of Manneken Pis stand for the statue because this is what marks them out as different from other Brussels folk groups. Outside of Brussels, they come to represent their city and, when they cross a border, their country. Their prominent use of the Brussels colours clearly indicates their origin when they leave the city. In the classic paradox of movement, then, the Friends of Manneken Pis only really enact their association with a physical location when they leave that location.

That this should be true of a group dedicated to Manneken Pis is even more paradoxical, given the complex relationship that statue has with questions of physical location and community identity. The urinating statue standing on a street corner in what was once the extramural suburbs of medieval Brussels has served as a marker of place since at least the mid-fifteenth century. Then, in the first unambiguous mention of the fountain, it appeared as one of the landmarks that marked the boundaries between administrative districts of the city outside the then city walls.[15] Perhaps there was a certain amount of humor in this, given that many animals mark their territory by weeing, but it is a fact that the statue is—and always has been—very firmly associated with the street corner on which it stands. Because it is a statue, it does not easily depart physically from the position in which

it has been placed and this means that it can serve as a permanent marker of that place.[16] Indeed, the rare occasions when the statue has been moved by human agency appear to have been prompted by the close association between the fountain and its particular spatial location. Repeatedly stolen, especially in the period following the Second World War, Manneken Pis was the target of student associations from rival towns seeking to establish their reputation over that of Brussels. When, for example, the Antwerp Vikings made off with the statue in January 1963, the success of their escapade depended upon the fact that the public expected to see the urinating statue at the corner of rue du Chêne and rue de l'Étuve, making its removal anywhere else a demonstration of the prowess of those doing the removing. Similarly, it is believed that the statue was removed by the residents of Brussels for its own protection when the city was in a state of siege in 1695.[17] If this is true, it indicates once again that the statue's place on that particular street corner was one that held such importance for residents of the city that extraordinary measures were required to preserve it in a time of war. Certainly the frequency with which the story is retold together with the repeated attempts by students to kidnap the statue reveal that by the twentieth century, the concrete location of the statue had been invested with such significance that its absence from that place was read as emblematic of extraordinary circumstances.

In the normal course of affairs, then, Manneken Pis does not move and this permits its secure identification with a number of spatial entities, a particular part of a particular city, and then, in a series of metonymical relationships, with various larger entities—the city itself, the nation (Belgium) of which Brussels has become the capital, and the supranational geographical unit of the European Union. One need only look at Bernhard Müller's 1992 essay *Manneken Pis: Der gefährliche Gang der Schweiz nach Europa* to see that the statue can be used to discuss any question that the speaker associates with the topic "Brussels."[18] In the event, Müller is writing about his feeling that his native Switzerland's independence is threatened by the European Union, which he compares to Manneken Pis mainly because the statue is in Brussels, the political capital of the EU, but also because both the fountain and the supranational body are cute and beloved of Americans but irresponsibly young and naive (in the case of Europe, economically so). The comparison works precisely because Manneken Pis is immovable and therefore firmly geographically situated. However, it is a comparison that can only be made from an external perspective. A Brusseler who views Manneken Pis as representative of a specific corner of a specific pair of streets would never

arrive at the metaphor that Müller develops. Just as the Friends of
Manneken Pis are very parochial if they remain in Brussels, but take
on a grander significance when they travel, so the statue itself can be
made to symbolize a wider geographical entity when it is viewed from
the perspective of the outsider.

In a metaphorical sense, then, it is necessary that Manneken Pis
travel in order for it to be able to assume the full range of abstract
meanings associated with its fixed physical location. Only when viewed
out of its spatial context does Manneken Pis achieve the wider rep-
resentative functions that unite social groups around it and ideas of
nationality and community. If we talk about space as something that
can be produced, this is what the Order of Friends of Manneken Pis
are doing when they display the rituals of the journeys they undertake
to represent the statue in other locations.

There is another sense, however, in which the collective identifi-
cation with physical location can take on an abstract significance that
transcends the concrete geographical space, and again this can be illus-
trated using the example of Manneken Pis. The statue is frequently
claimed as representative of the working-class Brussels district of the
Marolles. In 1946, the Royal Racing Club de Bruxelles, a local soc-
cer club, donated a goalkeeper's outfit to the statue of Manneken Pis,
explaining that, in this costume, the statue would be able to play for
the under-12 Marolles side and would even be able to relieve himself
during the match, such was the overwhelming superiority of the side.[19]
The gifting of costumes to cement a relationship between the city and
the donating agency is a practice that arose after the First World War
and became more popular after the Second World War, and so the fact
that one of the city's football teams gave a costume to the fountain is
not in itself exceptional. However, the fact that it explained the gift in
terms of an imagined Marolles youth side is interesting from a number
of perspectives. First, neither the Royal Racing Club de Bruxelles nor
Manneken Pis has any geographical relationship with the Marolles.
The Marolles is a working-class area of Brussels whose boundaries are
well understood. Although the area is not always precisely defined,
it is close to the corner on which Manneken Pis stands but is never
claimed to include that corner.[20] Similarly, although the Royal Racing
Club moved between venues in its 69-year history, it never played in
Marolles. Why, then, should the football club claim a Marolles iden-
tity for the statue dressed in its strip? The answer lies in the nature
of spatial identities, which are at once firmly linked to localities and
physically independent of them. The Royal Racing Club is not alone
in claiming Manneken Pis as a citizen of the Marolles, but it does so

not because it believes, wrongly, that the fountain is on a street corner in that district but because there are values and identities that are associated with both Manneken Pis and Marolles.

Marolles is an archetypal inner-city working-class area traditionally associated with a characteristic dialect that combines features of both French and Dutch and an impish sense of humor exhibited especially by the street boys, known (in both French and Dutch) as *ketje*. Perhaps because it is working class and bilingual in a city that is officially bilingual (though with varying degrees of fluency), it is often considered to be the location of the authentic "old" Brussels.[21] Manneken Pis, too, is demonstrably old and disturbingly vulgar, to the extent that public urination breaches the acceptable norms of behavior. Of course, this vulgarity is mitigated somewhat by the fact that the statue represents (or rather, appears to represent) a small child, and it can be mitigated even further by reference to the cultural trope of misbehavior associated with the *ketje* and located in Marolles. There are, of course, class implications in this association: "vulgarity" is, as the word's etymology suggests, a characteristic readily attributed to the lower social orders; thus, a kid from the Marolles weeing on the street is to be excused on grounds of both age and social mores. Saying that Manneken Pis is from Marolles, therefore, is not really falsifying its geographical origin but rather aligning it with a set of characteristics associated with an identity of which geography is only one component. And, of course, outside of Brussels, the distinction between Marolles and the city as a whole is far less clear-cut. To the extent that the Marolliens are regarded as representative of Brussels, then every Brusseler is a Marollien, once he or she leaves the city. Once again, it is the journey that concretizes the identification between the statue and the place.

It is a fact that has been officially recognized by the City of Brussels. And, indeed, this recognition is the reason that the Friends of Manneken Pis made the journey from Brussels to Broxeele in June 2011. *Broxeele*, as its name suggests, is the same sort of place as Brussels. Or rather, it originally had the same natural advantages, or disadvantages, as the Belgian capital, both names arising from an Old Dutch phrase meaning "home in the marsh." This topographical situation has been something that both Brussels and Broxeele have had to contend with over the centuries: each town is caught beside a river that is prone to flooding. However, whereas the French village is a tiny settlement of around 200 people, the Belgian capital has thrived. When, in 1979, Brussels celebrated its millennium, a decision was taken to present a replica Manneken Pis to its French namesake, in recognition of their common heritage. It was this statue that the

Friends of the Brussels Manneken Pis were visiting in 2011. To cele-
brate the thirty years of the Broxeele Manneken Pis, they came with
a second statue of Manneken Pis to present to the French town.[22]
Indeed, they came with two replica statues of Manneken Pis, since the
Order has acquired a mobile fountain with which it travels, and which
also mingles with the crowd in events held at the foot of the Brussels
fountain, spraying people with water to enliven the occasion.[23] A sim-
ilar mobilizing of the apparently static statue can also be found in
official discourse surrounding the fountain: as well as presenting the
gift of the Broxeele fountain as part of Brussels' millennium celebra-
tion, the occasion was marked by the creation of a diplomatic post for
an effigy of Manneken Pis, which circulated, bearing letters of accred-
itation, to the capital cities of each of the then eight countries of the
European Economic Community in turn.[24] Although the event was
clearly playful, it illustrates the extent to which, in official discourse
as well as in community festivities, Manneken Pis is regarded as the
representative of the Belgian capital.

Fifty years previously, too, a replica of the fountain was used
to cement relationships between Belgium and the Alsatian town of
Colmar, accompanied by the claim that the people of both regions
had suffered under the German occupation of the First World War
and had maintained their good humor. Here, the statue is asso-
ciated with shared values of persistent cheerfulness and disrespect
for (German) authority and, in doing so, the fountain strengthens
relationships between regions that define themselves as having been
unjustly occupied.[25] The Brussels Manneken Pis transferred to Colmar
is still recognizably the property of the Belgian capital, as is the replica
statue that arrives bearing letters of diplomatic accreditation; but its
appearance outside the context of Brussels gives it an added signifi-
cance. In travelling away from the street corner to which it is fixed,
Manneken Pis creates and reinforces political, ideological, and ety-
mological relationships between that street corner and other places.
In each instance, the movement of the statue has meaning espe-
cially because of the locatedness of the fountain's identity, and this is
developed by the way that the statues that travel are accompanied by
explanatory texts, displayed beneath the gifts to Colmar and Broxeele,
travelling with the Manneken Pis ambassador, which affirm that the
statue is from Brussels and that its journey has a particular meaning
in terms of consolidating community relations. For this reason, it is
significant that the Order of Friends of Manneken Pis post videos of
themselves on the way to Broxeele. The meaning of the gift—and its
associated message—that they transport can only be fully understood

if it is recognized that the Brussels fountain has a very precise spatial location and that it has moved outside this location to illustrate a point about community and connection between one place and another. The journey between the two locations can be understood in terms of Turnerian liminality: it is not one place nor the other, but it makes the physical connection between the two places and invites the spectators to make the mental comparison.[26] Brussels is like Broxeele because the two are linked by the journey of the partisans of one statue to pay homage to the other. Brussels is like Colmar for the same reason.

In terms of abstract spatial understanding, these symbolic journeys have a further, unexpected, implication, in that they are treated in the media as if they were territories in their own right. Collective subjects of discourse become places. An example of this can be seen in how the Belgian newspaper *Le Soir* reported on the gift of the Manneken Pis replica to Colmar in 1922. The journalist Louis Piérard, who reported from the journey to Colmar and the resultant ceremony, was named in his byline as *notre envoyé spécial*.[27] At the same time, businesses based in Brussels contributed Colmar-themed advertisements to appear alongside reports from Colmar. For a short period, the pages of the Brussels press devoted to the event became a section of the newspaper. As Benedict Anderson has observed, the Belgian press, like the press throughout the world, is conventionally laid out along territorial lines in the news section of the newspaper: Belgian national news, international news, and news from the Belgian regions.[28] Creating a separate but comparable section for news of Manneken Pis in Colmar makes a territorial claim for this subject: Manneken Pis in Colmar is a "country." Abstract ideas are spaces. In travelling to Colmar with a replica statue of Manneken Pis, the three anti-German satirists who had initiated the gift were staking a territorial claim over the Alsatian town, arguing that it was a place like Brussels and unlike Germany. This was a community appropriation of a concrete space, backed not only by their satirical newspaper, *Pourquoi Pas?*, but also by the mainstream press, as represented by *Le Soir*. At the same time, *Le Soir*'s treatment of the subject demonstrates that the appropriation is taking place simultaneously in the physical territory of the street corner and in the ideological territory of the newspaper page. Colmar is a real place, but Manneken Pis in Colmar is a separate abstract place.

Perhaps this should not surprise us, given the pervasive nature of spatial metaphors in our discourse. This is as true in new media as it is in older forms. Dan Hunter has illustrated the extent to which this metaphor is used in everyday life and specifically in the area of Internet communications, even though the law governing cyberspace

relationships explicitly holds that cyberspace is not a place but rather is subject to other territorial jurisdictions.[29] Nevertheless, the fact remains that we continue to refer to our online lives as a life in cyber*space* and there are numerous other spatial metaphors that are used to describe online relationships. This, then, throws new light on the actions of the Order of Friends of Manneken Pis in displaying videos of their journeys on YouTube. The way that this video-sharing site works is itself capable of being understood in territorial terms, since uploaders are encouraged to group their videos under the heading of "channels," to which viewers can then "subscribe." There is no money exchanged in this relationship, but viewers who subscribe to a particular channel will automatically see the videos made by that user when they visit the site. The idea is then that each user will be presented with an interface that reflects his or her personal interests, much as newspaper readers can negotiate their way round the publication by seeking particular rubrics. The difference is, however, that once the choices have been made, the site itself—and note again the spatial metaphor—appears differently to the user. In selecting the community that he or she will interact with, the individual user of YouTube physically changes the territory. Such developments toward individualization are viewed by Benedict Anderson and those who follow him as representing a fragmentation of the imagined communities that emerged in the nineteenth century.[30] It is, nevertheless, a fragmentation that uses some of the same techniques of the appropriation of metaphorical space through media that constructed communities in the first place. And, indeed, it still serves to construct communities, although they may be transnational in nature, or, like the Order of Friends of Manneken Pis, very specifically located in physical space and serving a niche community of interest.

Uploaders to YouTube, including mannekenpismascotte, are making territorial claims to the attention of the community of YouTube viewers that they address. They do this whether they intend to or not, since the concept is inherent in the way that the site itself operates: selecting a video will prompt a display of similar videos for the user to pursue his or her viewing. These will be the videos contributed by the same "channel" or that have a similar title. However, there are also practices of the YouTube community that extend the spatial parallels. Uploaders strengthen their community ties by posting videos as responses to those already on the site, and self-aware users regard this as a strategy for increasing their prominence among their public.[31] In spatial terms, they are staking a claim to their own territory, in ways that can be interpreted as encroaching on the

territories of others, or alternatively, as a form of collaboration where the common space is expanded by attracting a community of viewers with overlapping interests. The Friends of Manneken Pis do not do this. However, the way that they interact with the site demonstrates how they conceive of the communal space that they occupy. The uploader who has created the channel, mannekenpismascotte, for example, uses the alias only to post videos of the activities of the Order of Friends of Manneken Pis, suggesting that this area of his or her life is regarded as separate from others. Indeed, there may even be a number of people posting under the same "channel," since the descriptions of the videos appear sometimes in Dutch, more rarely in French, and increasingly in English. We might therefore imagine that mannekenpismascotte is a community effort, reflecting the activities of the Order of Friends of Manneken Pis, both by documenting their travels and by providing them with a further opportunity for interaction. In their case, the interaction does not seem to go much beyond the group filmed, as their channel has no subscribers and their videos have not been frequently played. Nevertheless, their tentative steps into the virtual territories of online communities confirm that off-line groups reproduce themselves in the online space and that both concrete and abstract space are conceived territorially by communities who occupy that space and invest it with meaning.

NOTES

1. Michel De Certeau, *L'Invention du quotidien 1. Arts de faire* (Paris: Gallimard, 1990), p. 142.

2. A schedule of such ceremonies is to be found on the Friends' website: http://ordre-manneken-pis.wikeo.be/ and a representative of the association sits *ex officio* on the council committee that decides whether a particular costume will be accepted. Ville de Bruxelles, "Garde-robe de Manneken Pis," règlement FR2005, stipulates that one of the six-person committee deciding on the donation of a costume should be someone with knowledge of the folklore of Brussels, such as a member of the Order of Friends of Manneken Pis or the Brussels Historical Society.

3. *Annexe au Moniteur Belge*, 2004-12-30/ 0181587. When *La Légende* closed, the legal address of the organization was transferred to 31–33, rue des Grands Carmes (*Annexe au Moniteur Belge*, 2013-04-24/0064376).

4. "L'association a pour but de favoriser l'essor culturel, touristique, philanthropique et commercial de Bruxelles en général, et

plus particulièrement de maintenir les traditions se rapportant au personnage de Manneken-Pis." (*Annexe au Moniteur Belge*, 2004-12-30/0181587).

5. *Annexe au Moniteur Belge*, 1958-05-12/ 1542.
6. Mannekenpismascotte, "Op weg naar Broxeele" 12-6-2011 (2), http://www.youtube.com/watch?v=BtPOD76gAWI [accessed August 21, 2014].
7. Mannekenpismascotte, "Manneken Pis—Broxeele" 12-6-2011 (3), <http://www.youtube.com/watch?v=vyQNaGIJhyo&feature=relmfu> [accessed August 21, 2014].
8. Mannekenpismascotte, "Manneken Pis—Broxeele" 12-6-2011 (4), <http://www.youtube.com/watch?v=PeVQhJX3EfA> [accessed August 21, 2014].
9. For the importance of the gaze, see John Urry, *Consuming Places* (London: Routledge, 1995), Chapter 8, "The Consumption of Tourism", pp. 129–40. Transcript of the opening sequence of the video: "[Man's voice] 'Tu as vu la madonne" [Woman's voice] "Elle a vu des vaches!" "Il y avait une madonne quand même" [Man's voice] "Ah oui, jolie!" [Woman's voice] "Maintenant je sais que je suis à l'étranger." Translation: "[Man's voice] "Did you see the Madonna?" [Woman's voice] "She saw some cows!" "There was a Madonna all the same" [Man's voice] "Oh, yes! That's pretty!" [Woman's voice] "Now I know I'm abroad!"
10. "Mon église". This phrase has already been used in the previous clip, Manneken Pis—Broxeele 12-6-2011 (2), <http://www.youtube.com/watch?v=RdQWlDJeZ9s>, where the other occupants have ridiculed their companion for its use.
11. In fact, the outward form of the Manneken Pis fountain owes a lot to the traditions of religious portraiture and in particular the Low Countries portrayals of the infant Jesus. As a result, there are a number of reactions to the urinating statue that draw on Christian devotional tropes. For an examination of this, see Catherine Emerson, "The Infant of Brussels: The Manneken Pis as Christ Child," *Irish Journal of French Studies*, 3, 2003: 94–108.
12. Justine Digance, "Religious and Secular Pilgrimage: Journeys Redolent with Meaning," in Timothy Dallen and Daniel Olsen (eds) *Tourism, Religion and Spiritual Journeys* (London: Routledge, 2006), p. 36.
13. Digance, "Religious and Secular Pilgrimage," p. 39.
14. Jean Rychner, *Les XV joies de mariage* (Geneva: Droz, 1967).
15. René Laurent, "L'Acte de 1453 concernant les limites des quartiers à Bruxelles," in Georges Despy, Maurice-Aururélien Arnould and Mina Martens (eds) *Hommage au Professeur Paul Bonenfant* (Brussels: Universa, 1965) pp. 467–78, p. 477.

Den zesten wijck, van Sinte Jacops poirte tot der Lakenhallen ende vandair, tot der Spieglbruggen, ende van Sinte Jacops poirte tot

dair dMenneken pist ende al de Stoofstrate tot der Hallen metter Volderstraten ende achter de Halle. Den sevensten wijck, vandair dMenneken pist tot der Steenpoirten ende vandair, de Guldestrate tot den wykete ende Pepercorenborre, de Gasthuystrate omtrent den Corenhuyse tot der Coe ende tot der beckerien aen Sinte Jans poel.

16. A documented history of the statue can be found in Vincent Heymans, *Monument à Manneken-Pis—angle rue de l'Etuve, rue du Chêne: Étude historique du monument et de ses abords* (Brussels: Ville de Bruxelles, Département Urbanisme Architecture Cellule Patrimoine Historique, 2003); details of cases when the statue has been moved are given in pp. 11–14.

17. This claim, though often reported, is open to doubt, since a contemporary satirical poem depicts the statue as having been damaged by the bombardment, indicating that it had not been removed to a place of safety. The poem is preserved in manuscript, Archives de la Ville de Bruxelles, liasse 620A. Two versions of it are discussed in Paul M. G. Lévy, "La Plus Ancienne Complainte de Manneken-Pis," *Les Cahiers Bruxellois*, 5, 3, 1960: 202–13.

18. Bernhard Müller, *Manneken Pis. Der gefährlicher Gang der Schweiz nach Europa* (Bern: Erpf, 1992).

19. June 10, 1946 Discours du président du Royal Racing Club de Bruxelles à l'occasion de la remise d'un costume de footballer, Brussels, Archives de la ville de Bruxelles, Fonds Lebouille, p. 78.

20. Louis Quiévreux defines the district as that found south of Notre Dame de la Chapelle between the Palais de Justice and the Rue Haute, Louis Quiévreux, *Marolles, cœur de Bruxelles* (Paris: Dutilleu, 1958), pp. 11–15.

21. For an examination of how French and Dutch interact in Brussels, see Jeanine Treffers-Daller, *Mixing Two Languages: French-Dutch Contact in a Comparative Perspective* (Berlin: De Gruyter, 1994).

22. "Trente ans du Manneken-Pis: 'La journée se prépare,'" *La Voix du Nord*, 27 May 2011.

23. An example of this can be seen in Mannekenpismascotte, "Feest Manneken Pis 3-9-2011," <http://www.youtube.com/watch?v=GFNGSdzFy14> [accessed August 21, 2014].

24. Jean Francis, *JULIEN dit MANNEKEN-PIS ou la petite histoire du ZIZI FRONDEUR bruxellois* (Brussels: Rossel, 1978), p. 125. I am very grateful to Seán Ó hAodha of the Irish embassy in Brussels for clarification on the precise diplomatic protocol of Manneken Pis's mission.

25. L[ouis]P[iérard], "Manneken Pis à Colmar. Fraternisation Belgo-alsacienne," *Le Soir*, October 2, 1922.

26. Victor Turner, *The Ritual Process: Structure and Anti-Structure* (London: Routledge and Kegan Paul, 1966), Chapter 3, "Liminality and Communitas", pp. 94–130.

27. P[iérard], "Manneken Pis à Colmar."
28. The idea is implicit in Benedict Anderson's *Imagined Communities: Reflections on the Origin and Spread of Nationalism* (London: Verso, 2006) and was developed in a public lecture given at NUI Galway on September 19, 2012. The same idea is discussed from a different perspective in Michael Billig, *Banal Nationalism* (London: Sage, 1995).
29. Dan Hunter, "Cyberspace as Place," *California Law Review*, 91, 2003: 439–519.
30. Benedict Anderson, "Globalization and Its Discontents," *Field Day Review*, 1, 2005: 177–88; see also Karen Le Rossignol, "Dreaming Well-being into Being: Dualities of Virtual-Actual Communities," this volume, Chapter 7.
31. For an account of how this operates, see Niclas Lundberg and Anders Söderman, *Establishment on YouTube*, Masters dissertation (Sweden: Umeå Universitet, 2011).

BIBLIOGRAPHY

Anderson, Benedict. "Globalization and Its Discontents," *Field Day Review*, 1, 2005: 177–88.

———. *Imagined Communities: Reflections on the Origin and Spread of Nationalism* (London: Verso, 2006).

Billig, Michael. *Banal Nationalism* (London: Sage, 1995).

Dallen, Timothy and Daniel Olsen (eds). *Tourism, Religion and Spiritual Journeys* (London: Routledge, 2006).

De Certeau, Michel. *L'Invention du quotidien 1. Arts de faire* (Paris: Gallimard, 1990).

Digance, Justine. "Religious and Secular Pilgrimage: Journeys Redolent with Meaning," in Timothy Dallen and Daniel Olsen (eds) *Tourism, Religion and Spiritual Journeys* (London: Routledge, 2006), pp. 36–48.

Emerson, Catherine. "The Infant of Brussels: The Manneken Pis as Christ Child," *Irish Journal of French Studies*, 3, 2003: 94–108.

Francis, Jean. *JULIEN dit MANNEKEN-PIS ou la petite histoire du ZIZI FRONDEUR bruxellois* (Brussels: Rossel, 1978).

Heymans, Vincent. *Monument à Manneken-Pis—Angle rue de l'Etuve, rue du Chêne. Etude historique du monument et de ses abords* (Brussels: Ville de Bruxelles, Département Urbanisme Architecture Cellule Patrimoine Historique, 2003).

Hunter, Daniel. "Cyberspace as Place," *California Law Review*, 91, 2003: 439–519.

Laurent, René. "L'Acte de 1453 concernant les limites des quartiers à Bruxelles," in Georges Despy, Maurice-Aururélien Arnould and Mina Martens (eds) *Hommage au Professeur Paul Bonenfant* (Brussels: Universa, 1965), pp. 467–78.

Lévy, Paul M. G. "La Plus Ancienne Complainte de Manneken-Pis," *Les Cahiers bruxellois*, 5, 3, 1960: 202–13.

Lundberg, Niclas and Anders Söderman. "Establishment on YouTube" (Masters dissertation, Umeå Universitet, 2011).

Mannekenpismascotte, "Manneken Pis—Broxeele" 12-6-2011 (3), <http://www.youtube.com/watch?v=vyQNaGIJhyo&feature=relmfu> [accessed January 28, 2013].

Mannekenpismascotte, "Manneken Pis—Broxeele" 12-6-2011 (4), <http://www.youtube.com/watch?v=PeVQhJX3EfA> [accessed January 28, 2013].

Mannekenpismascotte, "Op weg naar Broxeele" 12-6-2011 (2), <http://www.youtube.com/watch?v=BtPOD76gAWI> [accessed January 28, 2013].

Mannekenpismascotte, "Feest Manneken Pis 3-9-2011," <http://www.youtube.com/watch?v=GFNGSdzFy14> [accessed February 4, 2013].

Müller, Bernhard. *Manneken Pis. Der gefährlicher Gang der Schweiz nach Europa* (Bern: Erpf, 1992).

P[iérard], L[ouis]. "Manneken Pis à Colmar: Fraternisation Belgo-alsacienne," *Le Soir*, October 2, 1922.

Quiévreux, Louis. *Marolles, cœur de Bruxelles* (Paris: Dutilleu, 1958), pp. 11–15.

Rychner, Jean. *Les XV joies de mariage* (Geneva: Droz, 1967).

Treffers-Daller, Jeanine. *Mixing Two Languages: French-Dutch Contact in a Comparative Perspective* (Berlin: De Gruyter, 1994).

Turner, Victor. *The Ritual Process: Structure and Anti-Structure* (London: Routledge and Kegan Paul, 1966).

Urry, John. *Consuming Places* (London: Routledge, 1995).

CHAPTER 10

THE POLITICS OF SPACE: POETICAL DWELLING AND THE OCCUPATION OF POETRY

Miles Kennedy

In this chapter, by attempting to work within a specific version of the general framework of four zones outlined in the Introduction to this volume, I critique what I term the Heideggerian conception of Hölderlin's poetical dwelling, in order to examine and question the effaced underpinnings of much of what has been said about spatio-cultural studies up to this point. An examination of Tom Paulin's poetic riposte to this Heideggerian occupation as articulated in his 2002 poetry collection, *The Invasion Handbook*, is taken as an act of counter-occupation that points toward a more authentic and politically committed appraisal of poetical dwelling and human occupation itself.

The four zones of spatio-cultural studies sketched out in the Introduction to this volume are defined as consisting of (1) Abstract-Individual, (2) Concrete-Individual, (3) Abstract-Collective, and (4) Concrete-Collective. In this chapter the conception of the human relation to space as "occupation" is clarified by dealing with each of these general zones in terms of the lived situation, or camp, analogous to it. Each zone, or camp, built around this axis consists in an enclosed space opening onto the others, and this opening onto each other is rendered fuzzier by a spinning movement by which each can relate to or open out onto the next so that the overall effect is not dissimilar

to a pinwheel. The fundamental ontology or "concrete metaphysics" recovered by allowing these individual and collective, concrete and abstract zones to fuzz and blur into each other finds its foundation in the lived relation of self to a "larger whole," space. The nature of this larger whole is established by way of a return, through analysis of works by Heidegger, the "poetic-thinker," and Paulin, the "thinker-poet," to the very foundations of concrete metaphysics.[1] I hope that this discussion can go some of the way toward offering a counter-point to the deeply problematic Heideggerian tropes of "poetical dwelling" that have dominated Continental philosophy in general, and spatio-cultural studies in particular, and have "made homelessness constitutive of human being."[2]

In thinking about the occupation of poetry, as is so often the case in twenty-first-century philosophy, I feel the uncanny compulsion to glance over my shoulder, back to the last century, back over that hor-rendous broken spine still stubbornly attaching flailing arms and hands to the stinking rump and rotting legs of the twentieth century. I look back and, right away, the ghostly figure of Martin Heidegger looms up from the hanging flesh of a century not quite dead. It presents itself as a warning, a muddied and bloodied, gas-masked figure. "Stay out," it mouths. "Do not join in, do not commit, heed me, hear my silence; that way lies ruin"; and so, at least to begin with, I am afraid to go within and, instead, remain outside with Uncle Martin. Not outside the world, and not, indeed, outside the situation; none of us is beyond the world, and this is precisely why the question must be asked, why it asks itself: not outside the world, but outside the Concrete-Collective zone of poetry as a living, politically vibrant occupation.

Staying a while with the ghost of Uncle Martin, I ask first what the word "Occupation" means. Here I offer three reasonably common definitions of it, each represented by one of our specific groups or "camps": a *working* definition from the labor camp, a *national* def-inition from the army camp, and an *academic* definition from the university campus, and I clarify how Heidegger himself lived in each of these camps. To understand this effectively, we must realize from the outset that we are thinking here primarily in terms of situation rather than timeline, of where he was in life, where he chose to place himself, more than "when things happened." Always there, ever-present, blur-ring the divisions between these camps and drawing them together, is Heidegger's work on Hölderlin, which becomes more and more prominent as the Concrete-Collective he chose to be a part of steadily marches away from him like the First World War soldiers he witnessed trudging toward the front in 1916.[3]

As with all attempts at definition, just offering grammar and etymology is insufficient as these efforts at grasping fundamental meaning remain formal and empty unless they are contextualized in terms of the "life-world", their particular camp, and eventually realized in terms of concrete historical existence or Being. The three-fold structure of definition initially presented here reiterates and reflects Heidegger's adaptation of Plato's structure for the ideal state. Where Plato called for a future *Republic* to be constructed by the binding together of three hierarchically ordered camps in a single society—the guardians (or philosopher kings) at the top, the auxiliaries (or warriors) in the middle, and the artisans (or workers) at the bottom—Heidegger too hoped for a future based on a "three-fold commitment... once in the Labor service, again to the honor of the nation through Army service, and a third time in commitment to the spiritual order of the German people through the service of learning."[4] In other words, he called for a recognition of the connection and unity between the zones of the Concrete-Individual situation of labor service, the Concrete-Collective of army service, and the Abstract-Individual zone of learning service.

Where and what, though, in this scheme is the Abstract-Collective zone? It is widely held that, in Plato's ideal of the three-tiered *Republic*, we can find the seeds of totalitarianism. Karl Popper pointed this out as early as 1945 in *The Open Society and Its Enemies*.[5] Plato's famous or infamous exclusion of the poets, leaving them outside the gates of the *Republic*, can be interpreted as a proof of this latent totalitarianism. For Heidegger, nothing should lie outside the frame; totalitarianism is precisely that, total. In a letter to Hans-Peter Hempel as late as September 19, 1960, Heidegger revealed that he had always hoped "that National Socialism would acknowledge and absorb within itself all constructive and productive forces."[6] It is this drive toward totalization and absorption that spurs his attempt at the occupation of poetry and informs his fourfold structure. Recognizing the presence of this Platonic repetition and extension in Heidegger's writing and realizing its pattern here again will, it is hoped, open a path to grasping the significance of cultural life and work as "Counter-Occupation," or political dwelling, that has the capacity to retake that fourth zone.

The word "occupation" used in its first and most prevalent contemporary sense, its natural everyday sense, refers to occupation as what one does for pay, what one's job is. We can call this a definition of the Concrete-Individual, or a definition from the labor camp. This camp presents the rhetorical question, the question of "What one does? What one is good for?." This question is answered, in large

part, by reference to the inauthentic relation of the waiter to himself, for example, his merely "being" a waiter, a person being equal to or encompassed by one's external sign, that is, his or her value.[7]

In his 1954 essay "...Poetically man dwells...," Heidegger tried to distance himself from this everyday sense of occupation as work through his contention that, to "dwell" authentically, "Man" must strive to dwell poetically. "But..." he asked "...how is man—and this means every man all the time—supposed to dwell poetically?" in a situation in which "[o]ur dwelling is harassed by the housing shortage. Even if it were not so, our dwelling is harassed by work, made insecure by the hunt for gain or success, bewitched by the entertainment and recreation industry."[8]

In his effort to move from the specific concrete sense of having an occupation, the sense offered in the labor camp, to the essential sense of occupying oneself, Heidegger's appraisal of modern, postindustrial, conditions of life, seems to hold even truer today than it did at the time of writing. "*Work...gain...success...entertainment...recreation*" are now proposed as all-embracing standards for good living the world over, even as the ultimate ends of history. People fight in the streets and launch their own forms of counter-occupation in cities and towns from Madrid to Athens and from Cairo to Damascus right now in an effort to retain or attain access to this "good life."

Heidegger's list of what mid-twentieth-century Western Man was harassed by now reads like the lifeline of a flourishing postindustrial being, *working* hard at school in order to *gain* paid employment, achieving *success* in a chosen profession in order to afford periodic *entertainment*, and eventually, very near the end, retiring into a much anticipated state of continual *recreation*. Heidegger held that his sense of poetical dwelling was more authentic than this "everyday" sense of occupation in that it turned away from this underlying conception of occupation as "what one does" and toward a conception of human being as being aware of its own Being. To climb to the next rung of this ladder, then, we move along with Heidegger from this everyday, working, and maybe somewhat belabored definition of occupation as what one does for one's living, for oneself, and see if we cannot find our way to a more authentic comprehension of the experience of occupation on a level that transcends the self, toward something purportedly greater than the individual, the national level.

The second sense of "occupation" is the historical sense, the sense of political or Concrete-Collective occupation, occupation as the grounds of the often violent relationship between the occupied and

the occupier. We can understand this second sense of occupation as an effort at national definition, the definition of dwelling together as a people distinct from others, a definition from the army camp. In a letter to Hannah Arendt dated Winter 1932, Heidegger was compelled to distance himself from this camp by defending himself to his erstwhile lover and student against claims of "raging anti-Semitism" that had been circulating around the academic campus for at least "the past several years."[9] This was a defense that Arendt did not find convincing, and she broke off their personal relationship for almost twenty years following this communication. An editorial note in *Der Alemanne*, dated May 3, 1933, celebrated the official entry into the ranks of the Nazi Party—the army camp—of Dr Martin Heidegger, who, it noted, "for years has supported the party of Adolf Hitler."[10] A short notice in the *Breisgauer Zeitung*, a conservative national newspaper of long standing, from May 4, 1933, also drew public attention to the fact that "the Rector of Freiburg University, Professor Martin Heidegger, has made his official entry into the National Socialist Party";[11] the local paper of record in Freiburg from 1784 to 1943, the *Freiburger Zeitung*, of May 29, 1933, contained Heidegger's now infamous rectoral address "The self-assertion of the German University," from which we have already heard. On 1 October of the same year, while the university was still under Heidegger's stewardship, *Der Alemanne* noted that "the teaching licenses of the Jewish professors of Freiburg University were revoked."[12] Heidegger, then, was not only a party to but the leader of the National Socialist movement toward anti-Semitism at Freiburg University during that short period.

Heidegger attempted to ascend out of this political occupation to regain his place in the more rarified realm of learning service, the Abstract-Individual realm, by leaving the party and returning to purely academic pursuits. Tom Rockmore characterized Jacques Derrida's reading of Heidegger as an attempt to show that "as Heidegger turns away from metaphysics he also turns away from National Socialism."[13] Heidegger's turn toward poetical dwelling specifically was, he later claimed, a turn away from this dangerous path, the path toward militancy. On a more critical reading, we shall see that this purported turn is indicative only of Heidegger's fall back into a lauding of poetics due, at least in part, to a self-imposed alienation from the possibility of overtly political discourse that resulted from his short-lived but fervent association with Nazism, his dwelling within the army Camp. Here, the danger of coupling together poetical dwelling and political action can be most clearly seen. In what is widely regarded as "a new departure in his philosophic thought,"[14] Heidegger seemingly retreated or

"turned" away from his tremendously ill-fated participation in a key phase of the great Germanic play of masters and servants, back toward poetry, which, he declared, in "Hölderlin and the Essence of Poetry," is "the most innocent of all occupations."[15] This turn toward the "most innocent" of occupations, however, only served to subtly mask something of the more violent occupations from which it had turned. After all, in that fine piece of Orwellian logic, it is only those who are guilty that feel compelled to declare their innocence. This turn toward a more "innocent occupation" calls on us to look beyond this national sense of occupation to its third "most authentic" sense, the sense according to which human occupation is essentially proposed as the activity of occupying oneself, occupying one's mind; in other words, an academic definition, from the university campus.

We seem to get a little further in terms of our question about the meaning of "occupation" when we move, along with Heidegger, away from the rhetorical question of what one's job is, regardless of its answer, or the question of incorporating oneself within a national-istic political identity, derived ultimately from the accident of where one comes from, and on into this question about the "unworldly" realm of thought, what one thinks and how one chooses to occupy oneself. This is more appealing, perhaps, because it implies that occu-pation is directed toward occupying oneself rather than having to do, primarily, with jobs or the established structure of labor economy and capital that it seeks to critique. Occupation as occupying oneself, then, seems to be a step along the way to a more legitimate definition. It must be borne in mind, however, that this definition indulges in the ancient distinction between the "corruption" of material and political concerns and the "transcendence" of intellectual pursuits.

In contrast to the work-a-day definitions of "occupation" offered by the labor camp and the violent definitions of the army camp, Heidegger proposed a version of poetical "Dwelling," exemplified in his essays on the works of Friedrich Hölderlin,[16] that was purport-edly an exposition on a more authentic mode of being-in than merely having an occupation, being a waiter, a body, or simply inhabiting the locations of one's life, coming from somewhere, being a nation-alist. Here it should be borne in mind that Heidegger himself was a professional German philosopher. A professional philosopher in the sense that philosophy was his occupation, he addressed the world from the university campus, and a German philosopher in that he pro-posed in his rectoral address on "The Self-Assertion of the German University" to articulate "the spiritual order of the German peo-ple through the service of learning."[17] These observations may seem obvious but, nonetheless, should not be overlooked as we must keep

in view the spinning and fuzzing pinwheel effect as one zone of being as occupation blurs and melds into the next.

Heidegger formed a mask of academic innocence by way of the overt connection he made between himself, his thought, and "the most innocent of all occupations," that is, poetry, and Hölderlin's poetry in particular. However, he also subtly deployed this same "innocent occupation" as "the most dangerous of possessions."[18] Hölderlin's poetry was, for Heidegger, the epitome of what we have been calling the Abstract-Collective zone. This was the last zone, the last, and according to Heidegger himself, the highest realm of "constructive and productive forces" that had not been acknowledged and absorbed within "the movement."[19] By occupying this zone, he attempted to bring together his abstract philosophical concerns with the fundamentally collective drive of the Nazi era, thereby reiterating the "inner truth and greatness of National Socialism,"[20] as he had continually conceived of it. Heidegger's claim that "Hölderlin is in a preeminent sense *the poet of the poet*,"[21] the voice of the occupation within the occupation, of a nostalgia for the noble past of the German homeland, constitutes a claim that, in this "most innocent of occupations," Hölderlin, Heidegger (Who else? Who is in the background, or perhaps the bunker, here? Himself? He who cannot be named?), the homeland, the German language, the house of being, these, each and all, in this "most innocent of occupations," if in nothing else, could yet be the masters still.

Careful now, careful reading, let us slow down: "Hölderlin and the Essence of Poetry" was written in 1936, when Germany was only beginning its shift toward far less "innocent occupations." Heidegger could not, then, be reacting to the historical shift from master to servant that was to come later. Perhaps he was reacting only to his own fall from the role of rector at Freiburg in 1934, a fall he later implied was precipitated by jealousies and disagreements between himself and other Nazi party members, particularly younger more militant members within the university.[22] Is it possible, though, for a romantic man to compose an elegy to a love not yet dead? Just as Heidegger was early to see, and to embrace, Germany's turn toward a new more brutal national occupation in his 1936 references to "the first War," is it not possible that an intellect as powerful and a personality as astute as his could see its fall just as early? The first step in Heidegger's occupation of Hölderlin's poetry was to do just that, to take upon himself the mantle bestowed by Stefan George on Hölderlin, the title of "great seer of the German nation."[23]

Perhaps, though, it is too much of a stretch to attribute this prophetic power to Heidegger. Nonetheless, despite the stretch, this

effort to link his "most innocent" occupation of poetical analysis to his political life finds ever firmer ground within his own work. Heidegger described Hölderlin's recollection of a "stay in France" as evidence of "the extreme danger of his occupation" and immediately moved on to an analysis of Hölderlin's work as "ringing like a premonition."[24] Hölderlin, then, "the great seer of the German nation," provides Heidegger, as early as 1936, with a "premonition" of "the extreme danger" that an "occupation" in France will bring. Is this still too much of a stretch? Is it too hard to believe that Heidegger subtly shifted his political thought into poetical discourse in an effort to preserve something essential that he saw both emerging and passing away in National Socialism? Perhaps, but listen to these lines from the same essay: "The affirmation of belonging to this intimacy occurs through the creation of a world and its ascent, and likewise through the destruction of a world and its decline."[25]

The intimacy of authentic, poetical, dwelling, then, is felt, according to Heidegger, both in the historical sense of rising and the prophetic sense of falling. We cannot forget that Heidegger at the time of writing was still "in the midst of the storm," that his conception of that, and any, present held within itself both retentions of the past and projections toward the future.

It is claimed that Heidegger stopped being a Nazi in early 1934, when he stepped down from the rectorateship of Freiburg and turned to his more innocent academic occupations. Dana R. Villa, citing Lacoue-Labarthe, asserts that Heidegger's politics "is not to be found in the texts of 1933, but rather in those following the break with National Socialism," thus strongly indicating that this break took place in 1934 when he stepped down as rector. He complicates this assertion, however, by noting that, in 1935, Heidegger reasserts his vision of "the inner greatness of the National Socialist movement" and that "appealing to Hölderlin, Heidegger poeticizes this vision."[26] It is unclear, however, if this period (1934–1935) marked the end of his membership, or just of his *active* membership, of the Nazi party. It is also claimed in various sources that he never officially left the party until 1945, when, with the end of the war, it essentially left him.[27] It is certain that, in a classic reversal of fortunes, very much like the one he foresaw for Germany, Heidegger himself was stripped of his license and banned from all university teaching by an edict of the French-occupying power aimed at the "denazification" of German institutions at the end of 1946.[28] His Hölderlin-inspired premonition about the great danger for Germany of an occupation in France had come to pass.

In 1950, Arendt, who had testified in Heidegger's favor at his denazification hearing, takes up their relationship again after a nearly twenty-year gap, by which time Heidegger himself had, purportedly, been thoroughly denazified. He was permitted to begin teaching again in 1951. Arendt's return to this relationship with Heidegger is taken, then, as the key and most concrete moment in his turn away from Nazism, and in a sense it is the defining moment of his personal denazification. Surely, having spurned him once, she would not tolerate him if he still harbored these political views? In her 1969 national radio broadcast on the occasion of Heidegger's eightieth birthday, "Martin Heidegger at Eighty,"[29] Arendt tried to bring the matter of his politics to a close by explaining that it was an accident or "escapade," something like Thales falling down the well, a result of Heidegger's "un-worldliness." This explanation draws very obviously on the definition of occupation provided by the academic campus, while ignoring Heidegger's involvement in the labor and army camps, but, crucially, overlooks his ongoing occupation of poetry. Dana Villa depicts this as an attempt by Arendt to assert the "deeply un[rather than anti]-political nature of his thought."[30]

Heidegger's extended discourse on poetry, and on Hölderlin particularly, spans the very same period of his political cleansing, or denazification, and simultaneously proclaims Heidegger's connection to "the most innocent of all occupations," while deploying "the most dangerous of possessions." Heidegger concluded his *Introduction to Metaphysics*, which contains his infamous attempt to identify "the inner truth and greatness of National Socialism," with a fragment of Hölderlin's poetry.[31] His essay on Hölderlin's hymns, "Hölderlins Hymnen 'Germanien' und 'Der Rhein,' " was written in 1934–1935, during a time when "Heidegger is committed to thinking philosophically about the issues raised by National Socialism."[32] His work "Hölderlin and the essence of poetry" is from 1936, a year when, according to Richard Polt, he "still praises Hitler and Mussolini from the podium as 'the two men who have introduced counter-movements [to nihilism] on the basis of political formation.' "[33] "Remembrance of the poet," again a tribute to Hölderlin, was first conceived and written in 1942; his commentary on "Homecoming" was produced in 1944; and " . . . Poetically Man Dwells . . . ," his most far-reaching engagement with Hölderlin, was written in 1951.[34] So, for those of us who like time in a straight line, given the likelihood of his Nazism as early as 1927 and the uncertainty of his political status between 1934 and 1950, taken together with his well-documented refusal to discuss, in any meaningful way, the atrocities perpetrated by the Nazi regime, the

argument offered here is that this continual "innocent occupation" of studying Hölderlin's poetry strongly indicates that Heidegger's work was, and remained, "fascist down to its most intimate components" throughout that period.[35]

Is this, though, just more work of that old bone-saw, the argument *ad-hominem* or worse still *ad-nazium*, another attempt to cut Heidegger off at the knees? Is this effort to "make an opening through Heidegger" really just an effort to pick holes in him? All this about Heidegger's association with the Nazis has been said before.[36] The connection between his political stance and his academic work on poetics has long since been brought to light.[37] Much more significant than this reassertion of Heidegger's lifelong right-wing tendency, though, is the contention that, according to his own analysis, language, and poetry most of all, "is good for the fact that it guarantees that man can exist historically."[38] On this account, the previous reading is legitimate in Heidegger's own terms and calls us to look at his own historical existence, his own political life.[39] The point, then, is not just to uncover the political content effaced beneath the mask of "the most innocent of occupations," a political content that became a "dangerous possession" of philosophy in the late twentieth century (although that is a worthwhile endeavor in itself); given the critical account of Heidegger's occupation of poetry offered here, it should be clear that the point is to try and identify what can be done to launch a counter-occupation.

After that circuitous route through the library, undertaken for the sake of directness, let me be absolutely clear: Heidegger's purported turn from his short-lived, overt, and enthusiastic engagement with far-right politics toward the sublime and transcendental realm of poetics was in actuality merely a masking of his continual lauding of the essence of those politics, " . . . the inner truth and greatness of National Socialism . . . ," beneath the veneer of Hölderlin's poetic language. Villa identifies this masking as a further step from Plato through Nietzsche to Heidegger along the road of substituting artistic for political terms. Heidegger initially overtly linked this substitution to National Socialism and to his vision of "the destiny of the West," but later effaced those themes under an allegedly innocent call for progression along the self-same path.[40] In a certain sense, then, this "innocent occupation" of poetry propagated by Heidegger and reasserted by Arendt, surreptitiously leads back through the university campus to the Nationalist army camp and back to the working definition from the labor camp, back from the occupation of poetry, through a hidden and encoded version of nationalistic thinking, to

"doing philosophy" in a more pedestrian everyday sense, that is, working as an academic.

Through these violent historical interjections, from the labor camp, the army camp, and the university campus, we come to recognize that these seemingly diverse definitions of "occupation," and the definition of the occupation of poetry as an innocent occupation in particular, undermine their own structure by collapsing the distinction between the personal and the political. In other words, each definition is rooted in the "camp" that offers it, and its relation to the other camps, and is "true" only for so long as one or other camp holds sway. In order to better understand this intertwined politico-personal conception of Heidegger's occupation of poetry, I will move on to conclude with a discussion of the counter-occupation launched by Tom Paulin in his *Invasion Handbook*.

The Fourfold Scheme Revisited: Tom Paulin's Invasion Handbook, a Guide to Counter-occupation

In much the same way as how Alain Badiou, following Walter Benjamin, asserted that "the Fascist aestheticization of politics" can only be opposed by "revolutionary politicization of art,"[41] Heidegger's allegedly "innocent" occupation of philosophy by this same "aestheticization" can only be countered by an active and open "revolutionary politicization" or counter-occupation. Tom Paulin's *Invasion Handbook* has the potential to provide a spur to this revolutionary politicization and counter-occupation. Heidegger's occupation says "poetically Man dwells . . ." but Paulin replies, "politically Man dwells . . ." While I can agree with Heidegger that a life without poetry is not a full life, an "un-political" life is not a human life at all. Can I say that to live a full life we must have poetry and at the same time we must make a turn from "poetical dwelling" to "political dwelling," or am I inadvertently repeating once again the call for poets to be banished or to only allow some politically acceptable poets? No, this is a call for a recognition that philosophy is not "an innocent occupation," that the insertion of Heidegger's version of Hölderlin's "national prophecy" and nostalgic mourning, his occupation of Being, as a keynote in contemporary continental philosophy, is itself a subtle political act undertaken, at least initially, by Heidegger himself.

What would a "revolutionary politicization of art" look like, though? What would it read like? Am I talking about propaganda here? As always with these critical concerns, or rather the

concerns of criticism, as Heidegger knew well, examples serve best. In order to provide these examples, we turn to Tom Paulin's *Invasion Handbook* as a key expression of counter-occupation directed not against Hölderlin or German poetry but against Heidegger himself. In "Schwarzwald oder Bauhaus," Paulin presents the Heiddegger we met in the labor camp, the Concrete-Individual zone, Heidegger the worker, the university teacher, "the city dweller who thinks that he has gone out among the people," in his Black Forest holiday home. This is the professor who "condescends to have a long conversation with a peasant" about whether he should take up his "second invitation to teach at the University of Berlin."[42] Here Paulin poeticizes Heidegger the teacher, the soon-to-be rector, the waiter. Is this the great man in labor service? Paulin counter-occupies this first zone.

In "The Night of the Long Knives," we meet Heidegger again, this time in his abortive attempt to join the army camp, the Concrete-Collective zone. "No matter the Führer is uncultured/he has Heidegger says/such beautiful such sculptured hands"; but "when Herr Professor hears the sound/of killing on the airwaves/he looks over his shoulder and shivers."[43] This is a counter-occupation with no little force, no lack of aggression. Heidegger fled this second zone, Paulin implies, because it was not what he thought it would be, because the army camp is a rough, even a deadly, place, as Heidegger's fellow Swabian, Ernst Rohm, learned so well.

On Heidegger's re-ascending to "commitment to the spiritual order of the German people through the service of learning,"[44] Paulin is more charitable, placing him only "After Hegel..." in terms of philosophical rank at the beginning of the poem "Being and Time." Here, though, in the zone of the Abstract-Individual, the zone in which Heidegger's defenders argue he was truly at home, Paulin sets about his most fundamentally damaging counterattack. In his poem "Being and Time," he replies to Heidegger's idea that "we must get over the *in* of inclusion," writing that this inclusion is

> a concept that's stacked
> like chalk in a box
> but unlike those dry sticks
> — dry dusty sticks
> you could never lick
> it may survive
> all the hard and percussive knocks.[45]

Paulin's exemplary piece of political poetics from *The Invasion Handbook*, a collection of poems themed around the German plan for an

occupation of Britain during the Second World War, acknowledges Heidegger's great work and high standing in the first stanza by way of a comparison with Hegel and then moves across the gap, the break in the two verses, the turn from talk of Dasein to the great danger that pierces the heart of Heidegger's corpus, the political danger held in his fundamental view that "we must get over the *in* of inclusion." In this way, Paulin gets to the very core of Heidegger's antihumanism, perhaps even inhuman-ism, his consistent denial of the fundamental underpinning of authentic political dwelling as a structure of mutual inclusion.[46]

Being-in is essentially historical and temporal for Heidegger. The sense of being held within is very problematic in his account and he disabuses the reader of this sense on each occasion that it arises, often pointing out that Dasein's being-in is not "insideness" like chalk or matchsticks inside a box. This failure to comprehend the "in of inclusion" leaves Heidegger's Dasein alone, outside, an outsideness; this *être-la* is, as Bachelard had it, like the pointing of a finger outside and beyond human reality. In his 1953 essay "Building, Dwelling, Thinking," which was originally delivered in 1951, a year after his purported denazification, as a lecture titled "Man and Space,"[47] Heidegger distinguished between, on the one hand, "dwelling," which he characterized as a human mode of existence that has the potential to reveal the nature of Being as a whole in the form of a "four-fold" schema, and, on the other hand, "merely inhabiting," which, he held, does not participate in ontological revelation of this sort.

The introduction of this fourfold of Gods and Sky and Men and Earth, which, beginning with his influential 1936 essay on aesthetics titled "On the Origin of the Work of Art," is contemporaneous with his turn toward poetry and art, is regarded as one of the key indicators of his movement away from his early inquiry into ontological difference through the analysis of Dasein and toward his more esoteric later works on aesthetics and poetics. As discussed earlier, this period is often subtly hinted at as also marking Heidegger's turn away from Fascism. Even in this turn, though, as I have argued throughout, there are hints of Heidegger's "most innocent of occupations," hints of his attempt to conceal a lauding of Germanic national essence in the allegedly politically neutral discourse on aesthetics. Heidegger occupied Hölderlin's work in a way that Dieter Henrich described as "imperious,"[48] and by proclaiming Hölderlin "the poet of poets," he managed to occupy poetry itself as the last bastion of his deeply held belief in a certain kind of "inner truth." Is there evidence of this in his other writing? His Wagnerian-sounding quartet, or indeed the outline of four zones employed in this present work, can most easily

be envisioned as a schema, like a poster in wartime, a fourfold cross with each side or angle open to the next; what would that look like? In the notes for his 1935 lecture course, *Introduction to Metaphysics*, Heidegger presented his own "schema of the restrictions of Being" in the form of a cross, which we can assume he chalked on the board, given that "a piece of chalk" is mentioned repeatedly as an example of "this being here" in the same work, just two pages before his infamous comments on "...the inner truth and greatness of National Socialism..." thereby putting this "four-fold cross" image directly into that political context.[49]

It is that same "piece of chalk" Paulin refers to in his poem "Being and Time," giving us an image, a living image given flesh by his description of "dry dusty sticks you could never lick...," of Heidegger standing before a class, chalk in hand, expounding the virtues and "inner truth" of this new movement and rapidly sketching a white fourfold cross on the black background, within which, under the banner of which, all creative and productive forces should be gathered: the selfsame fourfold structure he continued to describe and clarify through the occupation of Hölderlin's poetry right up to 1951. It is by way of Paulin's poetic counter-occupation, his presentation of Heidegger through the application of what he once called "history proper,"[50] that we can come to see the grim figure Heidegger was sketching out in his continual work on "the most innocent of occupations."

"To dwell poetically," in Heidegger's sense, means "to stand in the presence of the gods and to be involved in the proximity of the essence of things."[51] This "poetical dwelling" is, then, a kind of mute stillness, of being brought to a stand before the gods, a kind of silent waiting, standing at attention. "Hölderlin and the Essence of Poetry" is a work of waiting, just as *Introduction to Metaphysics* is. Both works ultimately hold that it is "better to sleep than to be thus without companions."[52] This waiting itself, this silent dwelling, is not necessarily a bad thing; it depends entirely on what one is waiting for, which companions, which comrades? This is the exact difference between the *attendiste* and the collaborator. Contrary to this Heideggerian version of what he regarded as authentic, and "innocent," dwelling within the fourfold, human dwelling, in its purest sense, as Paulin's poem suggests, is dwelling as inclusion.

The activity of occupation is, by this account, both political and personal in nature. Occupation is the living expression of the comprehension of the essential condition in which "...politically Man dwells...." "Occupation," as a mode of political dwelling, brings

before us conflicting expressions of "the basic character of human existence,"[53] thus opening the possibility of approaching the question of Being through a different but equally fundamental direction than that which Heidegger chose: the direction of ethical space. Occupying this ethical space, as Paulin does, is an authentic mode of being-within, a mode of dwelling inside a space with others, cohabiting in a world of spatially related beings and, most fundamentally, authentically grasping ourselves as beings that are themselves spaces.

On the question of occupation then, we find that, in essence, "... politically Man dwells...." Politics is derived from *polis* meaning city, a space of mass living, and also from the *polis* meaning the people, the community of people who live together in a particular place under the same ethos, encountering space as "the 'in' of inclusion." Again we hear a dangerous sound, the bell ringing in mid-air, the people, the *Volk*. Here, as in the earlier violent historical interjections, the sharp dividing tone of nationalistic politicization clangs forth. The latent nationalistic aspect of occupation indicated earlier presents a looming danger of which we must be constantly aware. In ringing out the alarm, Paulin, in his counter-occupation, simultaneously sounds the call to its saving power, articulating the newly emerging sense of "people" as community rather than nation, a true and inclusive *international*. This new *international* is bound together in the uniquely twenty-first-century situation of dwelling close together in spite of distance, both metaphorical and literal, not only by and in ideology, by and in class, but by and in the generalized condition of human life and its ubiquitous mechanisms of mass communication that have never before been known. Let me be blunt: the trace and memory of the twentieth-century danger of nationalism that has come to occupy continental philosophy, even in its most innocent of occupations, cannot be forgotten or ignored but nor can it be allowed to terrorize and silence the possibility of a twenty-first-century internationalism. That, the Heideggerian call to silence and waiting, is the true danger: that occupation of poetry, of language, of thought must be made subject to a counter-occupation. For this counter-occupation we could do worse than to take as our initial guide Tom Paulin's *Invasion Handbook*.

NOTES

1. This loose division of discourse between "thinkers" and "poets" is borrowed from Martin Heidegger's short selection of poems titled "The Thinker as Poet." It is, at least to some extent, from this

attempt at bringing together poetry and philosophy that the porous division between "thinker" and "poet," "abstract" and "concrete," presented here, is drawn. See Martin Heidegger, "The Thinker as Poet", in *Poetry, Language, Thought*, translated by Albert Hofstadter (New York: Harper and Rowe, 1971), pp. 1–14. The status of poetic images, in general, and spatial images, in particular, as "concrete metaphysics" is discussed in more detail in my book *Home: A Bachelardian Concrete Metaphysics* (Bern: Peter Lang, 2011).

2. Karsten Harries paraphrasing Heidegger's *Building, Dwelling, Thinking* in *The Ethical Function of Architecture* (Cambridge, MA: MIT Press, 1997), p. 203.

3. Throughout his book *Martin Heidegger and the First World War: Being and Time as Funeral Oration* (Lanham, MD: Lexington Books, 2012), William Altman asks the intriguing question of how Heidegger could speak of "The Great War" as "the First World War" as early as 1934, giving a hint as to Heidegger's precognitive powers that are discussed here also.

4. The politically problematic nature of this 1933 text and consequent possibility that citing it may raise concern in the reader is dealt with more directly later in this chapter and is, in a sense, the main theme overall. See Martin Heidegger, "The Self-assertion of the German University," in *German Existentialism*, translated by Dagobert D. Runes (New York: Philosophical Library, 1965), p. 19.

5. Karl Popper, *The Open Society and Its Enemies* (London: Routledge, 1945).

6. Rüdiger Safranski, *Martin Heidegger: Between Good and Evil* (Cambridge, MA: Harvard University Press, 1999), p. 228.

7. Jean-Paul Sartre, *Being and Nothingness*, translated by Hazel Barnes (London: Methuen, 1972), pp. 55–9.

8. Martin Heidegger, "...Poetically Man Dwells..." in *Poetry, Language, Thought*, translated by Albert Hofstadter (New York: Harper and Rowe, 1971), p. 213–29.

9. Hannah Arendt and Martin Heidegger, *Letters: 1925–1975*, translated by Andrew Shields (New York: Harcourt, 2004), p. 52.

10. This editorial note from what was a National Socialist newspaper throughout the immediate prewar and wartime era is reproduced in Heidegger, *German Existentialism*, p. 13. See also Pierre Trotignon, *Heidegger: sa vie, son oeuvre avec un exposé de sa philosophie* (Paris: Presses Universitaires de France, 1965), pp. 1–4.

11. Heidegger, *German Existentialism*, p. 57.

12. Heidegger, *German Existentialism*, p. 54.

13. Tom Rockmore, *Heidegger and French Philosophy: Humanism, Antihumanism and Being* (New York: Routledge, 1995), p. 160. See also Jacques Derrida, *De l'esprit: Heidegger et la question* (Paris: Flammarion, 1990).

14. Werner Brock's introduction to Martin Heidegger, *Existence and Being* (Chicago: Henry Regnery, 1967), p. 8.

15. Heidegger, *Existence and Being*, p. 270

16. English titles: "Remembrance of the Poet," "Hölderlin and the Essence of Poetry," both in Heidegger and Brock, *Existence and Being*; "What Are Poets For" and "...Poetically Man Dwells...," both in Martin Heidegger, *Poetry, Language, Thought*; "Höderlin's Hymn 'The Ister,'" translated by William McNeill and Julia Davis (Bloomington: Indiana University Press, 1992), as well as the German language essays on "Hölderlins Hymnen 'Germanien' und 'Der Rhein'" (GA 39), "Holderlin's Hymne 'Andenken'" (GA 52). See also Richard Polt, *Heidegger: An Introduction* (London: University College London Press, 1999), p. 114.

17. Heidegger, *German Existentialism*, p. 19.

18. Heidegger, *Existence and Being*, p. 275.

19. Safranski, *Martin Heidegger*, p. 228.

20. Martin Heidegger, *Introduction to Metaphysics* (New Haven & London: Yale University Press, 2000), p. 212, H. 152.

21. Heidegger, *Existence and Being*, p. 271.

22. See the 1966 interview "Only a God Can Save Us" in *Der Spiegel*, translated in Gunther Neske and Emil Kettering (eds) *Martin Heidegger and National Socialism: Questions and Answers*, translated by Lisa Harries (New York: Paragon House, 1990).

23. Heidegger, *Existence and Being*, p. 169.

24. Heidegger, *Existence and Being*, p. 285.

25. Heidegger, *Existence and Being*, p. 274.

26. Dana R. Villa, *Arendt and Heidegger: The Fate of the Political* (Princeton, NJ: Princeton University Press, 1996), pp. 250–51. See also Heidegger, *Introduction to Metaphysics*, p. 213, H. 152.

27. Rockmore, *Heidegger and French Philosophy*, p. 165.

28. Berel Lang, *Heidegger's Silence* (London: Athlone, 1996), p. 14.

29. See Hannah Arendt, "Martin Heidegger at Eighty," translated from the German by Albert Hofstadter, *The New York Review of Books*, October 21, 1971: 50–4.

30. Villa, *Arendt and Heidegger*, p. 230.

31. Heidegger, *Introduction to Metaphysics*, p. 221, H. 157.

32. Polt, *Heidegger: An Introduction*, p. 154.

33. Polt, *Heidegger: An Introduction*, p. 155.

34. Heidegger, *Poetry, Language, Thought*, p. xxv.

35. Villa, *Arendt and Heidegger*, p. 230.

36. See Victor Farías, *Heidegger and Nazism* (Philadelphia: Temple University Press, 1989), originally published in Spanish as *Heidegger y el nazismo* (Rio de Janeiro, 1988); Günther Neske and Emil Kettering (eds) *Martin Heidegger and National Socialism: Questions*

and Answers (London: Continuum, 1990); Richard Wolin, *The Heidegger Controversy* (Cambridge, MA: MIT Press, 1993); Berel Lang, *Heidegger's Silence* (London: Athlone Press, 1996) and Emmanuel Faye, *Heidegger: The Introduction of Nazism into Philosophy*, translated by Michael Smith (New Haven and London: Yale University Press, 2005).

37. See Philippe Lacoue-Labarthe, *Heidegger, Art and Politics*, translated by Chris Turner (Cambridge, MA: Basil-Blackwell, 1990).

38. Heidegger, *Existence and Being*, p. 276.

39. Niall Keane delivered a thoroughly positive reading of Heidegger's contention that "Hölderlin's poetic thought is philosophically exemplary and futural," and asserted that "Heidegger's interpretation was... a critical appropriation," rather than the type of occupation I describe. What Keane leaves in absolute silence, as do many of Heidegger's defenders, is the sense of historical, lived context presented here. See Niall Keane, "The Silence of the Origin: Philosophy in Transition and the Essence of Thinking," *Research in Phenomenology*, 43, 1, 2013: 27–48.

40. Villa, *Arendt and Heidegger*, p. 248.

41. I am aware, even while writing this, that the assignations "fascist" and "revolutionary" are themselves dated and dating, almost clichés, or, if not that, relics of the last century. See Alain Badiou, "A New World. Yes, But When?" in *The Century*, translated by Alberto Tuscano (Cambridge, MA: Polity, 2007), p. 41.

42. Tom Paulin, *The Invasion Handbook* (London: Faber, 2002), p. 88.

43. Paulin, *The Invasion Handbook*, p. 96.

44. Heidegger, "The Self-assertion of the German University", p. 19.

45. Paulin, *The Invasion Handbook*, p. 83.

46. Paulin takes his example of "a piece of chalk" from a significant passage on the structure of "appropriateness for a definite use," in Heidegger's *Introduction to Metaphysics*; see Heidegger, *Introduction to Metaphysics*, p. 32, H. 23.

47. Heidegger, *Poetry, Language, Thought*, p. xxiv.

48. Dieter Henrich, *The Course of Remembrance and Other Essays on Hölderlin*, translated by Taylor Carman (Stanford: Stanford University Press, 1997), p. 294.

49. Heidegger, *Introduction to Metaphysics*, p. 210, H. 149.

50. Paulin criticized "many literary critics" for having "no interest in biography or in history proper." His *Invasion Handbook* was an attempt to create a document of that proper type. See Tom Paulin (ed) *The Faber Book of Political Verse* (London: Faber, 1986), pp. 15–21.

51. Heidegger, *Existence and Being*, p. 282.

52. Heidegger, *Existence and Being*, p. 291.

53. Heidegger, *Poetry, Language, Thought*, p. 215.

Bibliography

Altman, William. *Martin Heidegger and the First World War: Being and Time as Funeral Oration* (Lanham, MD: Lexington Books, 2012).

Ardent, Hannah. "Martin Heidegger at Eighty", translated from the German by Albert Hofstadter, *The New York Review of Books*, October 21, 1971: 50–54.

Arendt, Hannah and Martin Heidegger. *Letters: 1925–1975*, translated by Andrew Shields (New York: Harcourt, 2004).

Badiou, Alain. *The Century*, translated by Alberto Tuscano (Cambridge, MA: Polity, 2007).

——. *Polemics*, translated by Steven Corcoran (London: Verso, 2011).

Derrida, Jacques. *De l'esprit: Heidegger et la question* (Paris: Flammarion, 1990).

Descartes, René. *Key Philosophical Writings*, translated by Elizabeth Haldane and G. R. T. Ross (Ware, Hertfordshire: Wordsworth Editions, 1997).

Dostoevsky, Fyodor. *Notes from Underground*, translated by Richard Pevear and Larissa Volokhonsky (New York: Vintage Books, 1992).

Farías, Victor. *Heidegger and Nazism* (Philadelphia: Temple University Press, 1989).

Faye, Emmanuel. *Heidegger: The Introduction of Nazism into Philosophy*, translated by Michael Smith (New Haven and London: Yale University Press, 2005).

Harries, Karsten. *The Ethical Function of Architecture* (Cambridge, MA: MIT Press, 1997).

Heidegger, Martin. *German Existentialism*, translated by Dagobert D. Runes (New York: Philosophical Library, 1965).

——. *Existence and Being* (Chicago: Henry Regenery, 1967).

——. *Poetry, Language, Thought*, translated by Albert Hofstadter (New York: Harper and Rowe, 1971).

——. *Hölderlin's Hymn "The Ister,"* translated by William McNeill and Julia Davis (Bloomington and Indianapolis: Indiana University Press, 1992).

——. *Introduction to Metaphysics*, translated by Gregory Fried and Richard Polt (New Haven and London: Yale University Press, 2000).

Henrich, Dieter. *The Course of Remembrance and Other Essays on Hölderlin*, translated by Taylor Carman (Stanford: Stanford University Press, 1997).

Keane, Niall. "The Silence of the Origin: Philosophy in Transition and the Essence of Thinking," *Research in Phenomenology*, 43, 1, 2013: 27–48.

Kennedy, Miles. *Home: A Bachelardian Concrete Metaphysics* (Bern: Peter Lang, 2011).

Lacoue-Labarthe, Philippe. *Heidegger, Art and Politics*, translated by Chris Turner (Cambridge, MA: Basil-Blackwell, 1990).

Lang, Berel. *Heidegger's Silence* (London: Athlone Press, 1996).

Neske, Günther and Emil Kettering (eds) *Martin Heidegger and National Socialism: Questions and Answers*, translated by Lisa Harries (New York: Paragon House, 1990).

228 MILES KENNEDY

Paulin, Tom (ed.) *The Faber Book of Political Verse* (London: Faber, 1986).
——. *The Invasion Handbook* (London: Faber, 2002).
Polt, Richard. *Heidegger: An Introduction* (London: University College London Press, 1999).
Popper, Karl. *The Open Society and Its Enemies* (London: Routledge, 1945).
Rockmore, Tom. *Heidegger and French Philosophy* (New York: Routledge, 1995).
Safranski, Rüdiger. *Martin Heidegger: Between Good and Evil* (Cambridge, MA: Harvard University Press, 1999).
Sartre, Jean-Paul. *Being and Nothingness*, translated by Hazel Barnes (London: Methuen, 1972).
——. *Existentialism and Humanism*, translated by Philip Mairet (London: Methuen, 1973).
Trotignon, Pierre. *Heidegger: sa vie, son oeuvre avec un exposé de sa philosophie* (Paris: Presses Universitaires de France, 1965).
Villa, Dana R. *Arendt and Heidegger: The Fate of the Political* (Princeton University Press, 1996).
Wolin, Richard. *The Heidegger Controversy* (Cambridge, MA: MIT Press, 1993).

CONCLUSION

MAPPING, NOT THE MAP

Bill Richardson

The previous chapter has usefully confirmed one of the starting points for the overarching topic that this volume has been addressing: a discussion of spatiality may appear at the outset to be an exercise in intellectual abstraction divorced from everyday reality, and hence may not be seen as "relevant" when addressing the human dimensions of cultural activity; in fact, however, space and place impinge in a very concrete manner on how we live our lives. Their effects are felt by all of us, often in visceral and painful ways; thus, they have consequences for, and are reciprocally nuanced by, artistic products and culturally informed activities. This is what we have sought to demonstrate in this volume, and what we have observed within a variety of very different contexts and cultural forms. But whatever view we take on the controversial issue of Heidegger's political tendencies, the fact remains that his philosophical work has exercised huge influence on contemporary thinking about space, which suggests that, at a minimum, some of what he has written strikes a chord that we recognize and acknowledge as valid comment.

Certainly, Heidegger's emphasis on the notion of *dasein* bears reflecting on again, even briefly, at this point. It is a way of summarizing the nature of our being, and one that leads to the conclusion that not only are spatial concerns of relevance to any account we wish to offer of the fundamental parameters within which we move and have our being, but that our own *awareness* of the spatial dimension of our existence in turn *informs* how we move and have our being. Heidegger says,

> Within the question of Being, the human essence is to be grasped and grounded, according to the concealed directive of the inception, as *the site* that Being necessitates for its opening up. Humanity is the Here that is open in itself. Beings stand within this Here and set to work in it. We therefore say: the Being of humanity is, in the strict sense of the word, "*Being-here*" ("Da-sein"). The perspective for the opening up of Being must be grounded originally in the essence of Being-here as such a site for the opening up of Being.[1]

The aim of this volume has been to address that notion of "Being-here" in its many guises within a broad range of modes of expression.

Each of the various studies presented has explored ways of addressing issues of spatiality in relation to some specific instance of symbolic expression or cultural activity. Each of the selected topics represents a type of meaning-making, a mode of narrating, or of presenting significations that carry symbolic content. None of these is strictly limited in scope; rather, each serves as a focus for expressing some crucial dimension of our attempts at understanding ourselves and the world we live in. Centering variously on emotional, philosophical, physical, territorial, psychological, or social aspects of human life, the manifestations of symbolic and cultural expression that have been examined constitute a fairly broad sample of the many ways in which people signal meaningful relationships with the world in which they live. Each of these responds to a perceived need to address issues of signification, and each in its own way embodies some aspect of human meaning. In each instance, what has been addressed are important questions about how place and space impinge on these phenomena and how these phenomena raise questions about the spatial dimension of human existence. While it is obvious that this cannot be carried out in a comprehensive manner that would comprise an encyclopedic vision of human life, nevertheless a wide and diverse range of cultural forms have been scrutinized here.

Thus, topics addressed have ranged over key philosophical concerns around spatiality and its relation to temporality, discussions of literature, pedagogy, songs, place-names, and so on. In the course of these explorations, we have focused on how the very human business of the making of meaning is contingent on spatial aspects of our existence. The key questions that arise after examining these phenomena are these: How may these various aspects of spatiality relate to each other? Can there be said to be a relationship between them at all? Is it possible to make fruitful, but not reductive, generalizations that might serve to inform further research into spatial issues? To answer the latter question first, we may note that, as outlined in the Introduction, the issues

are addressed in ways that highlight many very different dimensions of spatiality, so that in some the emphasis is on philosophical issues, in others on social dimensions, in yet more on aesthetic concerns, or on issues of belonging, or even on issues of sensory representation. But, as we believe we have demonstrated in our discussion, no matter how different from each other the approaches to spatiality have been in each case, the studies have shown that there is a spatial thread that links them all, so that spatiality is seen to be germane to topics as diverse as a film or a national icon, or as different in form as literature and pedagogical practice.

The challenge that faces us in light of these commonalities is that of attempting to relate the various aspects of spatiality that we have identified to each other. This, surely, is where new ground may be broken, and where we may allow ourselves the imaginative space to attempt to "map" these various dimensions of the spatial. This aim can only be achieved in a very limited way within specific contexts, such as the project being carried out here. While accepting the limitations within which we operate, however, we may at least seek to identify some of the principal features of the human experience of space in terms of how it maps onto cultural and symbolic expression. In this volume, we have been engaged, in a tentative manner, in attempting to undertake this task.

Not only are we are concerned to address the ways in which the question "Where are we?" is articulated in different human contexts, but we are also interested in questions such as "Why are we?" and "How are we?," to the extent that these questions are suffused with spatial content, the conviction being that the spatial dimension helps us in the task of groping toward an answer to such questions. The result of this is the diagrammatic representation of spatio-cultural phenomena (figure I.2) presented in the Introduction, on page 5.

Having undertaken the various explorations of a diverse range of cultural phenomena in the intervening chapters, what strikes us about that diagram is the need to see it as essentially dynamic in nature. No one element mentioned in the diagram stands alone or should be seen as separate from any other; the spatial realities we have been examining relate in all cases to numerous aspects that are listed there, and none is exclusively linked to a particular individual dimension of spatiality. As a map, the diagram suggests this dynamic aspect by the fact that the two axes at the core of it intersect each other and are depicted as organic, leading outward in the direction of unknown limits that suggest unclear boundaries. Bearing this in mind, we need to acknowledge the fact that any single dimension or aspect of spatiality

referenced here will typically operate in conjunction with one or more other dimensions and aspects. A cultural phenomenon or artistic product that articulates some aspect of human spatiality is bound to articulate not just one feature having to do with space or place but, typically, several such dimensions.

As proposed in the Introduction, a simplified version of the schema outlined above is one in which we could give each of the zones a label along the following lines: zone 1 (the Abstract-Individual) could be summarized in the term *philosophy*; zone 2 (Concrete-Individual) could be labeled *psychology*; we could characterize zone 3 (Abstract-Collective) using the term *plasticity* (understood both as malleability and in terms of "plastic" qualities), and zone 4 (Concrete-Collective) with the term *power*.

Thus, in relation to the Abstract-Individual zone, centered on the notion of *philosophy*, we discussed literary space in Chapter 2, and saw how, in the particular cases of the authors Juan Rulfo and Jorge Luis Borges, their works facilitate a conceptualization of literary space centered on the individual reader. Each of these authors, in different ways, posits the notion of the relationship between the individual and the universe in which we are located, and draws attention to the fact of that relationship and to how it in turn relates to fundamental questions of life and death. In Chapter 3, we saw how those concerns relating to the Abstract-Individual zone played out in a very different context through an examination of the notion of the bridge. This liminal and essentially ambivalent figure was seen to function within a range of contexts, including film, as a self-conscious reminder of our essential "situatedness" and to point toward an opening up of new avenues of exploration in pedagogical practice.

In the second of our zones, the Concrete-Individual one, we suggested that the key concept could be summarized in the notion of *psychology*, understood in the sense of a concern with issues of identity. Thus, in Chapter 4, the psychology of identity was seen to be at play in the case of certain Gaelic songs, songs that are intimately bound up with their own place of origin, namely Tory Island off the northwest coast of Ireland. Not only do the texts of those songs reveal the importance of place to the Tory community and to individual narrators or singers, but the very enactment of the songs within the community, as well as the role of the performer, are themselves crucial to the kind of spatially informed meaning-making that gives concrete shape to the individual identities of the islanders. Shapes of another kind are key to the meanings explored in Chapter 5. There, we saw how landforms and place-names combined to give expression to

aspects of indigenous cultures in Australia that fitted only awkwardly, or not at all, with colonization by European settlers. In that study, we gathered that people, landscape, and place-names functioned as a means of relating individuals to cultural realities centered on notions of identity, and the intricacies of those symbolic relationships served to highlight the complexity of the links between different places and different cultures.

The third zone (the Abstract-Collective one) can be summarized in the notion of *plasticity*, a term intended here not just to denote malleability or flexibility but rather to signify the "plastic" dimensions of cultural expression, both in terms of an imagined spatial reality conjured up within, say, a work of art, and in terms of the very feel and texture of such a work of art itself. Language is necessarily plastic, in that sense, since its sensory qualities always impact on us, most obviously in its spoken form but also in the case of the written word. It appears that we are born with a generalized capacity for "language" in the abstract, and it is likely that this particular capacity is uniquely human[2]; but what we acquire, and use in collective contexts, is *a* language (or, often, more than one) and the characteristics of the particular languages we speak are essentially a function of spatial location. Through an "accident of birth," we live a particular linguistic experience, with particular phonic, lexical, and grammatical features that lend a specific shape to the language phenomena we deal with, either in terms of what we understand or what we produce. In Chapter 6, we saw how this entails a linkage between being and expression that lends itself to ambivalence: language is at the heart of literature, and thus enables that mode of expression to exist, yet it may be only when we, in Blanchot's words, "give up saying 'I'" and let the familiar and the known accept and enter the experience of out-of-place that we can truly express ourselves with an authenticity that overcomes simple dichotomies and that has the capacity to meet our expressive needs. Meanwhile, the plastic qualities examined in Chapter 7 related to the virtual world of online community formation, seen within a context of innovative pedagogical practice. By drawing attention to what is simultaneously abstract (*qua* virtual) and collective (since it centers on group bonding), that chapter explored the characteristics of these new-style communities whose spatiality is signaled in the use of terms such as "hyperspace" and "website," but which are necessarily also "placeless," or at least whose locatedness is contingent on symbolic values and intangible but nonetheless real commitments of a broadly "cultural" nature such as specialist interests, common goals, or the shared undertaking of specified mutually agreed activities.

The hypermodern qualities of motorways and contemporary travel were at the core of the final two studies, where the main focus was on the sociopolitical dimensions of spatiality that predominate in the Concrete-Collective zone on our map. Here, we suggest that the key notion at play is *power*. In the first of those studies, in Chapter 8, the visceral need felt by the family in Ursula Meyer's film to assert a "home" territory in which its members could potentially feel fully at ease with one another comes into conflict with the social and industrial forces engaged in the relentless modernization project of building a motorway; and the family comes off worse. In Chapter 9, the identity issues associated with the iconic figure of the Manneken Pis were seen to be highly complex and subject to contestation and to the vicissitudes associated with a variety of competing groups. These pledge allegiances and appropriate spatially informed symbols to assert rights and to project a narrative that entails the making of judgments about aspects of belonging and about inclusion in collectives whose "territories" they help to define. This zone represents the "sharp end" of spatiality and implies that space and place are often "historical" in nature: the assertion of rights over territories reminds us that geography is the first fact about history. Whether we are examining issues of social justice in the novels of Charles Dickens or the depiction of oppression in the songs of Bob Marley, we are obliged to take account of both the geographical context within which such cultural expression occurs and the ways in which themes such as property and possession, or affluence and deprivation, or wealth and poverty, are bound up with the exercise of control over places and with the resources associated with them.

Of course, these latter considerations can, and generally do, come into play not only in the context of the specific instances of cultural expression examined in Chapters 8 and 9, but also in all of the other contexts discussed in the book, whether this refers to the post-Revolutionary context of deprivation and oppression that is the backdrop for the work of the Mexican author Juan Rulfo or the conflicting versions of place-names in southeastern Australia, or the appropriation of community identities that we aspire to online. Rarely, if ever, is symbolic and cultural expression a resource-free issue or a phenomenon that stands independently of questions of power. And the same can be said in relation to the first three zones on our "map," summarized in the notions of *philosophy, psychology,* and *plasticity.* Ultimately, these too are apt to impinge on the creation of art and the expression of symbolic content of all sorts: icons, for example, imply something important about the relationship of the individual to

the cosmos; online communities are an obvious means of expressing identity, and songs, for instance, have a textural and sensory quality that is fundamental to our experience of them. All the above are *both* abstract and concrete, and relate to *both* individual and collective experience.

In that sense, then, the key concept being developed here is less the idea of a "map" and more the notion of "mapping": less a product or an entity, more a process and a gesture; less the stasis of schematic classification and more a means of conceptualizing a dynamic set of relationships among a variety of aspects of spatiality. All of these are important and all of their energies can be brought to bear on our appreciation of specific instances of symbolic expression.

What the framework in figure I.2 helps to emphasize is the fact that spatial concerns are as varied as human concerns in general, and, just as it is helpful to highlight the many ways in which artistic and cultural expression can happen, and to unpack the dimensions of those phenomena, so it is useful to be able to distinguish between different, and perhaps competing, dimensions of spatio-cultural phenomena. While this kind of mapping activity has clear limitations, it also has the obvious benefits associated with any such activity, and these relate mainly to the scope the map offers to enable us to situate phenomena in relation to one another, and to examine the degree to which artistic and cultural phenomena appear to succeed in describing a reality greater than themselves, even though it is a reality that also includes those phenomena. Hence, both what has been classically described as the "moral" dimension of artistic activity—and which is therefore of relevance to the spatio-cultural dimension of such activity—as well as the formal aspects of artistic and cultural endeavors,[3]—and by extension the formal features of relevance to the spatio-cultural dimension, are captured in this representation, and can be viewed within a more general context. Likewise, a fundamental human concern, that of the relationship between the individual and the wider world, is seen here to operate along an axis the outer limits of which are unknown and unknowable, but which corresponds to the sense that a basic universal concern with that relationship is crucial to our experience of any artistic or cultural phenomenon.

The general thrust of the studies presented in the volume therefore serves to suggest that what we ought to emphasize is precisely the dynamic nature of the process involved in "mapping." We are, in some sense, fundamentally "navigational" beings: not only do we concern ourselves with geographical location and emplacement in the physical realm, but we also seem to be equipped with a built-in capacity to

orient ourselves both psychically and philosophically,[4] with the aim of situating ourselves as individual people vis-à-vis the surrounding environment. It has probably never been more important for us to seek to understand the nature of this "navigational device" that apparently accompanies us throughout our lives; focusing on the links we have examined here between place and culture is at least an initial move in that direction.

One final example may help to summarize the kind of argument we make in this book. This is a "cultural artefact" of un-straightforward genre that brings into focus the main lines of inquiry implicit in the schema presented above. The "object" in question is a museum exhibit titled "Facial Casts of Nias Islanders," part of the collection on display in the room dedicated to twentieth-century history at the Rijksmuseum in Amsterdam in the Netherlands. A photograph of the exhibit is presented here as figure C.1 (page 237).

There is something unsettling about the exhibit, which shows seven rows of six face-masks made in plaster in 1910 by the Dutch anthropologist, J. P. Kleiweg de Zwaan (1875–1971), from the faces of people who were living on the island of Nias, in what is now Indonesia. The experience of seeing this exhibit, which looks as if it were a row of disembodied heads, is for most viewers an intense experience: the masks look out at us from the display case with blank eyes, inviting us to wonder about their provenance, their association with the people whose faces were used to make them, the circumstances in which they were made, the relationship between the anthropologist who carried out the work of casting them, the community in which he worked, and the political and social context that gave rise to those circumstances.

Spatial questions abound here, including questions about the geographical background just mentioned, the power relationships and the scientific (and colonial) context in which such activity could take place, the fact of their location in a museum in the capital city of the former colonial power of relevance to the exhibit, the characteristics of the display itself, with its array of "heads" that are detached from bodies, the juxtapositioning of this set of images of faces—made directly from the faces of the people in question—and how those juxtaposed images convey the individuality of each of the very varied facial expressions. The four central spatio-cultural concepts we have identified above (philosophy, psychology, plasticity, and power) are all necessary aspects of any account we wish to offer of this exhibit, or even of the image that is its photographic representation as presented here.

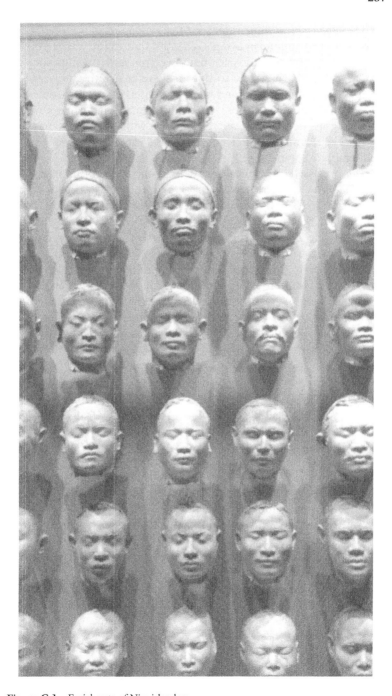

Figure C.1 Facial casts of Nias islanders

The *philosophical* dimension serves to remind us of the uniqueness of each individual human being's relationship with the widest possible contextual parameters of space-time: we are *located* beings, and the spatial qualities that adhere to this image reference that universal set of links that each of us has and that makes of us (as of the people here represented) creatures whose essence relates to Heidegger's notion of "being-in-the-world": we are as we are within ourselves and over against the surrounding universe as it exists within those wider spatial and temporal parameters.

The professed motivation for the initial making of the masks was scientific: they were created as an aid for anthropologists who wished to better describe and classify different types of human beings; this was part of an anthropometric project that exercised anthropologists such as Kleiweg de Zwaan in the early part of the twentieth century.[5] But the effect of the manner in which the masks are placed on display in the Rijksmuseum in Amsterdam for "consumption" by visitors a hundred years later makes of them a universal statement about the relationship between all of us as individuals and a set of cosmic spatiotemporal parameters whose meanings are always enigmatic.

The *psychological* aspect highlights questions of identity that also cry out to be examined: these masks, as well as simply presenting in a universal manner expressive faces of people who could be you, I, or "anyone," were also made in a particular place and at a particular time: the island of Nias, off the coast of Sumatra, formed part of the Netherlands Indies until the middle of the twentieth century. But this island was, and is, associated with certain cultural markers—the north dialect and (less prestigious) south dialect of the Nias language; the affiliations between the Nias and the neighboring Minangkabau ethnic groups, the traditional wooden houses with peculiarly imposing roofs that are typical of Nias Island, its ancestor statues, its unique musical tradition, the remnants of a "megalithic" culture and its heritage of war-dances and stone-jumping, and its particular maritime trading traditions—that make of it the kind of complex cultural grouping that most, if not all, people would claim to belong to. The people represented here were a particular group of individuals, with certain cultural characteristics in common but also showing traits of identity that made each one different from the others and from everyone else in the world, traits that we can see reflected in the very variety of expressions on the faces.

The *plastic* dimension addresses the issue raised above about the nature of the medium we are observing: whether this be a photograph of the exhibit or the exhibit as it exists physically at the museum, we view the masks and see them in relation to one another, arrayed in

a pattern that itself conveys the notion of "display" that makes us "observers" of them and turns them into a "performance" (of post-coloniality?, of protest?, of group identity? of individual identity?), an "event" of seeing that invites us to question the nature of our relationship to them and of their relationship to those who created them. Furthermore, we wonder about the manner in which these masks were made, what material they are made from (plaster which, at the time of casting, covered the individual's whole face except for straws inserted into the nostrils to allow the person to breathe), just as we are intrigued by the details of the expression frozen onto each mask, each one articulating what is sometimes an intense emotional sensation that is utterly convincing while always remaining mysterious.

Finally, we address the crucial questions associated with the fourth of our zones, which centers on the notion of *power*. The fact of the exhibit's location in Amsterdam is a clear comment on the relationship between two parts of the world situated more than 11,000 kilometers from each other. This is a postcolonial articulation of a relationship between the Netherlands and a community in a very remote country that came under the domination of this European power and eventually achieved liberation from it; this is also a comment on a colonial-style society that enabled a powerful, if humane, white male anthropologist to "investigate" scientific issues that he deemed important within the context of his location in a compliant subaltern community. We can only speculate on what these individuals thought of this venture, itself a process that entailed the "collecting of heads" in a society that had for centuries practiced ritualistic headhunting for reasons to do with status and various forms of power,[6] even as we note how they offer a queasy reminder of contemporary twenty-first-century beheadings taking place all too frequently in our time in the countries of the Middle East.

In bringing discussions of this and so many other instances of symbolic expression and cultural production to the attention of the reader of this book, we hope to have elucidated some of these issues and to have thrown light on how questions of place and space inform our very human nature.

NOTES

1. Martin Heidegger, *Introduction to Metaphysics*, translated by Gregory Fried and Richard Polt (New Haven and London: Yale University Press, 2000), pp. 219–20.
2. For different perspectives on this issue, see Steven Pinker, *The Language Instinct: The New Science of Language and Mind* (London: Allen Lane,

1994) and Vyvyan Evans, *The Language Myth: Why Language Is Not an Instinct* (Cambridge, MA: Cambridge University Press, 2014).

3. For a classic, lucid account of this matter, see Graham Hough, *An Essay on Criticism* (London: Duckworth, 1966).

4. This approach to spatiality chimes well with the "radically new form of cartography" advocated by Nicky Clayton and Clive Wilkins; see *Conversation Without Words*: Nicky Clayton and Clive Wilkins at TEDxOxbridge, <https://www. youtube.com/watch?v=-iavquY2OFo> [accessed December 19, 2014].

5. See J. P. Kleiweg de Zwaan, *Die Insel Nias bei Sumatra*, Vols. I–III (The Hague: Martinus Nijhoff, 1913–1915), particularly Volumes II and III, which examine such matters as head and face form, head measurements, face masks, and the craniological features of the Nias islanders. For perceptive interpretation of the meanings of the masks, see Fenneke Sysling, "Faces from the Netherlands Indies. Plaster casts and the making of race in the early twentieth century", *Revue d'histoire des sciences humaines* (forthcoming).

6. Headhunting continued to be practiced on the island of Nias until well into the latter half of the twentieth century; see "Headhunting," *World Ebook Library*, http://ebook.worldlibrary. net/articles/Head-hunting [accessed January 20, 2015].

BIBLIOGRAPHY

Clayton, Nicky and Clive Wilkins. *Conversation Without Words*: Nicky Clayton and Clive Wilkins at TEDxOxbridge, <https://www.youtube.com/watch?v=-iavquY2OFo> [accessed December 19, 2014].

Evans, Vyvyan. *The Language Myth: Why Language Is Not an Instinct* (Cambridge, MA: Cambridge University Press, 2014).

Heidegger, Martin. *Introduction to Metaphysics*, translated by Gregory Fried and Richard Polt (New Haven and London: Yale University Press, 2000)

Hough, Graham. *An Essay on Criticism* (London: Duckworth, 1966).

Kleiweg de Zwaan, J.P. *Die Insel Nias bei Sumatra*, Vols. I–III (The Hague: Martinus Nijhoff, 1913–1915).

Pinker, Steven. *The Language Instinct: the new science of language and mind* (London: Allen Lane, 1994).

Sysling, Fenneke. "Faces from the Netherlands Indies. Plaster casts and the making of race in the early twentieth century", *Revue d'histoire des sciences humaines* (forthcoming), <http://www.academia.edu/9516820/Faces_from_the_Netherlands_Indies._Plaster_casts_and_the_making_of_race> [accessed December 19, 2014].

CONTRIBUTORS

Paolo Bartoloni is Established Professor of Italian Studies at the National University of Ireland Galway, having previously taught Italian and Comparative Literature at the University of Sydney. He has published extensively on continental theory and philosophy, focusing especially on temporal and spatial thresholds. He is the author of *Sapere di scrivere. Svevo e gli ordini di* La coscienza di Zeno (2015), *Interstitial Writing: Calvino, Caproni, Sereni and Svevo* (2003) and *On the Cultures of Exile, Translation and Writing* (2008), among many other works.

Paul Carter is Professor of Design (Urbanism) at RMIT in Melbourne, and Creative Director at *Material Thinking*, a lab for analogical thinking, specializing in place applications. He is the author of many books, including *The Road to Botany Bay* (1987, 2010), *The Lie of the Land* (1996), *Repressed Spaces* (2002), *Dark Writing* (2008), and *Meeting Place: The Human Encounter and the Challenge of Coexistence* (2013). He is also a public artist, whose space designs, carried out in collaboration with others, include Relay (Sydney Olympics, 2000), Nearamnew (Federation Square, Melbourne), and Golden Grove (University of Sydney).

Catherine Emerson lectures in French at the National University of Ireland Galway. She has published on later medieval literature, especially the literature of history, and on the interaction between the text, its physical presentation, performance, and circulation. She is interested in how urban culture and social networks shaped the first century of printing and the formation of the medieval canon. Her latest book is *Regarding Manneken Pis: Culture, Celebration and Conflict in Brussels* (2015).

Conn Holohan lectures in film studies at NUI Galway. He has published journal articles and book chapters on cinematic space, as well as

a monograph on contemporary Irish and Spanish cinema titled *Cinema on the Periphery* (2010), in which he argues that film in Ireland and Spain must be read in relation to the particular processes of modernization that occurred within those countries. A member of the *Space, Place and Identity* research cluster at NUIG, he is currently researching the theme of utopian space in narrative cinema.

Miles Kennedy teaches philosophy and IT ethics at NUI Galway and has taught philosophy on outreach programs that prepare socially and economically disadvantaged students for entry into university. He has published articles and reviews on diverse topics in philosophy and ethics. His book, *Home: A Bachelardian Concrete Metaphysics* (2011), examines the notion of "the homely" in an attempt to articulate a fundamental insight about the human desire to have a space in which to set ourselves apart from "The World."

Karen Le Rossignol is Senior Lecturer in Professional and Creative Writing at Deakin University in Melbourne, Australia, and a steering group member of both the *Deakin Flows & Catchments* research team and *Experiential Learning in Virtual Worlds* interdisciplinary group. She has published extensively in media communications and creative industries areas and is currently working on *Freelancing in the Creative Industries* (forthcoming 2015). Her creative and academic practice includes developing virtual/digital world scenarios, assisting creative problem-solving, and community storytelling, for which she has won a number of teaching awards, both within the university and nationally.

Lillis Ó Laoire is Senior Lecturer in Irish, teaching folklore, language, literature and culture, at NUI Galway. He has published extensively on Gaelic song, including a book on song in Tory Island, County Donegal, Ireland, titled *On a Rock in the Middle of the Ocean: Songs and Singers in Tory Island, Ireland*, and a co-authored biography of the great Irish *sean-nós* singer Joe Heaney. An award-winning singer, he has performed in Ireland and abroad, including at festivals in Spain and Nova Scotia. He is currently researching the work of the folklore collector Seán Ó hEochaidh.

Felix Ó Murchadha is Professor of Philosophy at the National University of Ireland Galway. A former Fulbright Scholar, he has published on many aspects of Phenomenology, in particular on issues of time, religion, and violence. Along with numerous articles and book

chapters on these topics, his publications as sole author include *A Phenomenology of Christian Life: Glory and Night* (2013) and *The Time of Revolution: Kairos and Chronos in Heidegger* (2013) and, as editor, a collection titled *Violence, Victims, Justifications* (2006).

Bill Richardson is Established Professor of Spanish at the National University of Ireland Galway, and leader of the *Space, Place and Identity* research cluster at that University. Previously he taught Spanish at Dublin City University, where he was also Head of the School of Applied Language and Intercultural Studies. He has published books, articles, and chapters on linguistics and translation, as well as on a range of issues in diverse areas of Spanish and Latin American literature, culture, and society. He has a special interest in the work of the Argentinean author Jorge Luis Borges and published a book on that author, titled *Borges and Space*, in 2012.

Christiane Schönfeld is Head of the Department of German Studies at Mary Immaculate College (University of Limerick, Ireland). Among her publications are *Dialektik und Utopie* (1996), edited and coedited volumes such as *Commodities of Desire: The Prostitute in German Literature* (2000), *Denkbilder* (2004), *Practicing Modernity: Female Creativity in the Weimar Republic* (2006, with Carmel Finnan), *Processes of Transposition: German Literature and Film* (2007), and *Representing the "Good German" in Literature and Culture after 1945: Altruism and Moral Ambiguity* (2013, with Pól Ó Dochartaigh). She is one of the editors of the first critical edition of the works of Ernst Toller (2015).

Ulf Strohmayer teaches geography at the National University of Ireland Galway, where he is currently Professor in the School of Geography & Archaeology, having previously taught in Sweden, France, the United States, and Wales. His interests are rooted in social philosophies, historical geographies of modernity, and urban planning. His publications include a series of edited books (*Geography, History and Social Science*, 1995; *Space and Social Theory: Interpreting Modernity and Postmodernity*, 1997; *Human Geography: A Century Revisited*, 2004; and *Horizons Géographiques*, 2004), a jointly authored book, *Key Concepts in Historical Geography* (2014), and numerous journal articles and book chapters.

INDEX

Note: Locators followed by the letter 'n' refer to notes.

modernity, 34, 36–7, 67, 73, 99,
 180, 186
Motherwell, Robert
 Elegies to the Spanish Republic, 15
motorway, 16, 179–88, 234
Mottet Klein, Kacey, 180
Mount Disappointment, 106
Mount Kolor, *see* 'Mount Rouse'
Mount Leura, 114
Mount Rouse, 109, 118

narrative
 associational, 162–4
 Bruner, 162
 chronological sequencing in, 47
 curve of, 11
 definition of, 177
 disjunctiveness in, 163
 Frank and, 157
 idealized places, 27
 literary, and space, 41–55
 role in communities, 13
 virtual communities, 155–71
 see also 'cinema'; 'literature'
nationalism
 cultural, 95
 danger of, 223
National-Socialism (Nazism), *see*
 Heidegger
Netherlands, 236, 239
Netherlands Indies, 238
Nias Island
 cultural features of, 238
 'Facial Casts of Nias Islanders',
 236–9
non-place, 17, 27–8, 61
 motorway as, 180, 184, 187, 188

occupation
 of Belgium, 200
 see also 'Heidegger, Martin'
Ó Criomhthain, Tomás, 94, 99
 The Islandman, 94
Ó Crualaoich, Gearóid
 The Book of the Cailleach, 117–18
Old Maid, The, 182

O'Nolan, Brian
 An Béal Bocht, 95
Ophuls, Max, 185

Paulin, Tom
 'Being and Time', 220, 222
 The Invasion handbook, 219–23
 'The Night of the Long Knives',
 220
 'Schwarzwald oder Bauhaus', 220
pedagogy, 59–80 *passim*
 associational narratives and, 157,
 158
 constructivist, 166
 Dewey's, 165
 experiential learning and, 158
 immersive social learning, 169
 PBL and, 166
 virtual world narrative, 169
Peek Whurrung, 111
Peirce, Charles Saunders
 habit-change, 109–10
 notion of the "would-be",
 121–2
 signifying, 105–6
perception, *see* 'Kant';
 'Merleau-Ponty'
Perec, Georges
 as poet of things, 130
performance
 museum display as, 238–9
 place in Australia and, 115, 119
 song, 93
 Tory Island, 95, 99
Picasso, Pablo
 Guernica, 15
plasticity
 Abstract-Collective zone, 5, 11,
 232, 233
 virtual village, 155–7
Plato
 ideal state, 211
 mimesis, 138–9
 Republic, 211

Lightning Source UK Ltd.
Milton Keynes UK
UKOW06n2321180915

258874UK00006B/69/P